In the Frame

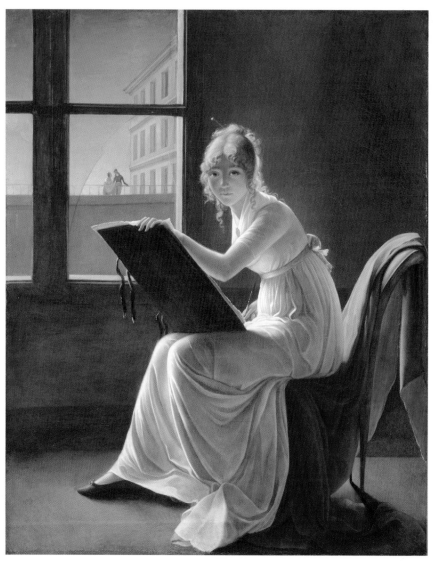

Frontispiece. Marie-Denise Villers, *Young Woman Drawing*, 1801, oil on canvas. Metropolitan Museum of Art, Mr. and Mrs. Isaac D. Fletcher Collection, bequest of Isaac D. Fletcher, 1917.

In the Frame

Women's Ekphrastic Poetry
from Marianne Moore
to Susan Wheeler

Edited by
Jane Hedley, Nick Halpern, and
Willard Spiegelman

DELAWARE
Newark: University of Delaware Press

Associated University Presses
2010 Eastpark Boulevard
Cranbury, NJ 08512

The paper used in this publication meets the requirements of the American National Standard for Permanence of Paper for Printed Library Materials Z39.48-1984.

Library of Congress Cataloging-in-Publication Data

In the frame : women's ekphrastic poetry from Marianne Moore to Susan Wheeler / edited by Jane Hedley, Nick Halpern, and Willard Spiegelman.
 p. cm.
Includes bibliographical references and index.
ISBN 978-0-87413-046-1 (alk. paper)
 1. American poetry—Women authors—History and criticism. 2. American poetry—20th century—History and criticism. 3. Ekphrasis. I. Hedley, Jane. II. Halpern, Nick. III. Spiegelman, Willard.
 PS151.I52 2009
 811'.54099287—dc22

 2008052141

Contents

Illustrations

Black-and-White Illustrations

7

Color Illustrations

Acknowledgments

THIS VOLUME'S GENESIS DATES TO THE MLA CONVENTION OF DECEMber, 2004, where earlier versions of the essays in part 4 were presented in the special session "Women's Ekphrastic Poetry." Several colleagues who came to that session were enthusiastic about the topic and had congruent work in progress, or knew of other scholars who did. Our fellow contributors were thus involved from the outset in deciding which poets to include and in teasing out the theoretical, political, and aesthetic issues their poems put in play. We are deeply grateful for these colleagues' friendship and patience throughout the entire process of bringing this volume into final form.

James Heffernan, John Hollander, and W. J. T. Mitchell have been cited in almost every essay: it would scarcely be hyperbolic to suggest that between them they created the subject of ekphrasis. We are indebted to them for creating the conditions under which the question of what women seek from ekphrastic encounters would seem worth raising. Sarah Lundquist's 1997 essay on Barbara Guest is an important precursor to the essays in this volume; other scholars whose work has been important to us, some of whom are among our contributors, will be cited in due course. The anonymous readers at University of Delaware Press made crucial suggestions for how to improve the volume, most of which we have gratefully implemented.

We thank the many colleagues at museums and university presses who have allowed us to cite and reproduce particular poems and images. Jonathan Galassi of Farrar, Straus and Giroux came to our rescue when we had some tricky copyright issues to negotiate. Cynthia Lamb, senior editor at Carnegie Mellon University Press, also went out of her way to be helpful. Bryn Thompson of Bryn Mawr College probably did not know what she was getting into when she agreed to do all the work involved in locating and securing permission to reprint the twenty-plus images in the volume; her efficiency, gimlet eye for detail, and supportive cheerfulness are much appreciated.

We are indebted to the staff as well as the editors at the University of Delaware Press and Associated University Presses for their high professional standards and ready expertise. Julien Yoseloff, director of Associated University Presses, was always there for us when we had

9

technical questions—of which, as novice editors, we had an abun-
dance. Donald Mell, editor-in-chief at the University of Delaware
Press, has been a good friend to this endeavor from the outset; we
thank him for his wise counsel and clear guidance. Karen Druliner,
managing editor at the University of Delaware Press, was usually the
first person we turned to with questions; we are also fortunate to have
had Christine Retz at AUP keeping us on task throughout the pub-
lication process. We would also like to thank Wyatt Benner, copy
editor extraordinaire.

The expenses of producing this volume were partly offset by a
grant from the Provost's Office at Bryn Mawr College; we would like
to thank former provost Ralph Kuncl for making these funds avail-
able to us. President Nancy Vickers's intellectual support for the
project has been steadfast from its inception. The Center for Visual
Culture at Bryn Mawr has contributed toward the expenses of the
volume and also toward a more intangible climate of welcome for
interdisciplinary work; Lisa Saltzman lent us her expertise and sup-
port as director of that Center, as did David Cast, Steven Levine, and
the other members of Bryn Mawr's art history department. Several
Philadelphia area colleagues, including Scott Black, Cristina Maria
Cervone, Alice Dailey, Kristen Poole, Katherine Rowe, and Lauren
Shohet made helpful suggestions for improving the introduction;
their collegial support is much appreciated.

Working together on this volume has been a very positive experi-
ence for us as editors. Because we had each other to turn to, obstacles
that might otherwise have seemed insurmountable never bogged us
down for long. The project took on a life of its own as a collaborative
endeavor; we have each other to thank for this, as well as our fellow
contributors.

<div align="center">ᔰ</div>

of Alfred A. Knopf, a division of Random House, Inc., and the Random House Group, Ltd.

Excerpts from *Try* by Cole Swensen reprinted with permission of the University of Iowa Press. Lines from "In the Evening," copyright © 1993 by Adrienne Rich, copyright © 1969 by Norton and Company, Inc.; "Mathilde in Normandy," copyright © 1993, 1951 by Adrienne Rich; "Love in the Museum," copyright © 1993, 1955 by Adrienne Rich; "Mourning Picture," copyright © 1993 by Adrienne Rich, copyright © 1966 by W.W. Norton & Company, Inc.; from *Collected Early Poems: 1950–1970* by Adrienne Rich, used by permission of the author and W. W. Norton & Company, Inc.

Lines from "Transcendental Étude," from *The Dream of a Common Language: Poems, 1974–77* by Adrienne Rich, copyright © 1978 by W. W. Norton & Company, Inc., used by permission of the author and W. W. Norton & Company, Inc.

Excerpts from Molly Peacock, "Girl and Friends View Naked Goddess" from *A Visit to the Gallery* (copyright 1997, The Regents, University of Michigan), copyright 1997 by Molly Peacock, reprinted by permission of the author.

Excerpt from "The British Museum" from *God* by Debora Greger, reprinted courtesy of Penguin books, a member of Penguin Group (USA) Inc.

Excerpt from "Bleedthrough" from *The Woman Who Died in Her Sleep* by Linda Gregerson, copyright © 1996 by Linda Gregerson, reprinted by permission of Houghton Mifflin Company (all rights reserved).

Excerpt from "Charity Overcoming Envy," from *The Poems of Marianne Moore* by Marianne Moore, edited by Grace Schulman, copyright © 2003 by Marianne Craig Moore, Executor of the Estate of Marianne Moore, used by permission of Viking Penguin, a division of Penguin Group (USA) Inc.

Excerpts from "Filling Station" and "Santarém," from *The Complete Poems, 1927–1979* by Elizabeth Bishop, copyright © 1979, 1983 by Alice Helen Methfessel, reprinted by permission of Farrar, Straus and Giroux.

Excerpts from "After Reading Mickey in the Night Kitchen for the Third Time before Bed," "Arrow," "Medusa," Stitches," from *Grace Notes* by Rita Dove, used by permission of the author and W. W. Norton & Company, Inc.

Excerpts from "The Venus of Willendorf" from *On the Bus with Rosa Parks* by Rita Dove, copyright © 1999 by Rita Dove, used by permission of W. W. Norton & Company, Inc.

Excerpts from "Agosta the Winged Man and Rasha the Black Dove" from *Museum,* Carnegie Mellon University Press, copyright © 1983 by Rita Dove, reprinted by permission of the author.

Excerpt from "Lady Freedom among Us" from *On the Bus with Rosa Parks,* W. W. Norton & Co., Inc., copyright © by Rita Dove, reprinted by permission of the author.

Excerpts from "The Debtor in the Convex Mirror" by Susan Wheeler, reprinted from *Ledger* with the permission of the University of Iowa Press.

"The Pietà, Rhenish, 14th C., the Cloisters" from SELECTED POEMS by Mona Van Duyn, copyright 2002 by Mona Van Duyn, used by permission of Alfred A. Knopf, a division of Random House, Inc.

Lines from "The Errancy," copyright ©1997 by Jorie Graham, reprinted by permission of HarperCollins Publishers and Carcanet Press.

Lines from "In Plaster," from *Crossing the Water* by Sylvia Plath, copyright 1971 by Ted Hughes, reprinted by permission of Harper-Collins Publishers. Lines from "Mirror," from *Crossing the Water* by Sylvia Plath, copyright ©1963 by Ted Hughes, originally appeared in *The New Yorker;* reprinted by permission of HarperCollins Publishers.

"Elizabeth Bishop and the Art of Still Life" is reprinted from *Planets on Tables: Poetry, Still Life and the Turning World* by Bonnie Costello, copyright © 2008 by Cornell University, by permission of Cornell University Press.

In the Frame

Introduction: The Subject of Ekphrasis

Jane Hedley

> Thou, silent form! dost tease us out of thought,
> As doth eternity. . . .
> > —John Keats, "Ode on a Grecian Urn"

EKPHRASIS, THE ACT OF SPEAKING TO, ABOUT, OR FOR A WORK OF visual or plastic art, has drawn considerable attention of late from literary scholars and theorists of visual culture: we are teased *into* thought by a body of poetic writing that tends to leave questions of motive and intention provocatively open to speculation. What do poems see, and what do they seek, in works of visual art—in paintings, sculptures, and photographs? Are there good reasons for claiming that poems by women see differently—that women poets bring a particular set of motives and intentions to their ekphrastic encounters? Several of these essays will argue that this is indeed the case, but the question of gender has not been raised in every essay. An equally important raison d'être for this volume is that ekphrastic poems by women have been largely overlooked in the critical literature on ekphrasis, and this creates a special opportunity for calling attention to how some of our most important twentieth-century poets have experienced the challenge and the lure of ekphrastic writing.[1] Each of the poets these essays discuss, whether she is accosting, admiring, or simply paying close attention to works of art whose "silent" medium is paint or clay or stone, is "speaking out" on behalf of her own aesthetic, political, and/or psychological commitments with particular force and clarity.[2] In writing about someone else's art, she is engaged simultaneously and self-consciously in creation and interpretation, making and viewing, seeing and saying.[3]

> . . . We have surprised him
> At work, but no, he has surprised us
> > As he works.
> > —John Ashbery, "Self-Portrait in a Convex Mirror"

In an essay published in 1992 whose avowed purpose is "to seek a way out of the relentless inscriptions of masculine desire in Western

15

art and art history," Griselda Pollock turns to the paintings of Mary Cassatt for an answer to the question her contemporary, Sigmund Freud, had posed in order to emphasize its unanswerability. Rereading Cassatt's *Woman at the Opera* (fig. 1) with an eye not only to the depiction of its central figure's "claim to the look" but also to the incorporation of an unseen other who is watching her assert that

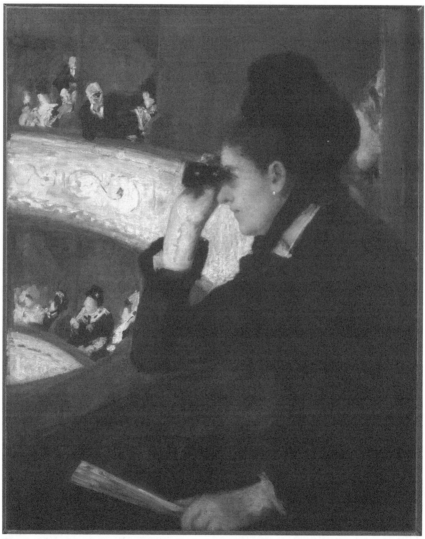

Fig. 1. Mary Stevenson Cassatt, *In the Loge*, 1878, oil on canvas. Boston: Museum of Fine Arts, The Hayden Collection—Charles Henry Hayden Fund. Photograph © Museum of Fine Arts, Boston.

claim, the feminist art historian discovers "a specifically feminine logic" in the spectator's posture the painting offers its viewers.[4] It is as if we shared this woman's box at the opera, positioned too close for a predatory, mastering gaze but invited instead to "embrace and indulge" the gaze *she* directs beyond the space of the painting, toward "a point outside the geometrical field of Western pictorial space" (Pollock, "Gaze and the Look," 123, 124). "The force of [works such as these] can be acknowledged today," Pollock concludes, "because they find an echo of the current struggle of feminism to answer Freud's famous question: 'What do women want?'—'They want their own way'" (ibid., 126).[5]

In her eagerness to "invent ways to speak of, and from, a feminine place" that would lie "outside current . . . ways of seeing art," Pollock has resorted to an ekphrasis, putting into her own words the "passion for women" she discerns in Cassatt's paintings (ibid., 125).[6] Pollock's ekphrasis enables "the force of [Cassatt's] works" to speak out on behalf of women artists, but equally on behalf of spectators who are women and who seek an alternative to the gaze Pollock identifies, at the threshold of the twenty-first century, with "the relentless inscriptions of masculine desire" (ibid.). In this art historian's recourse to ekphrasis we can begin to see why poets resort to it also: to get the image to speak to their own preoccupations, from a temporal distance their questions interrogate and their readings offer to bridge. Made responsive to the poet's or the critic's desire to enter into its original, shaping spirit, the work of art releases its meaning(s) anew—or rather, it releases new meanings, ones the artist herself did not put into words and might not have put into *these* words at all.[7] "We discover," says Pollock, "that the texts we have written are ourselves, caught in the act of peering into history" (ibid.).

The occasion for Pollock's act of peering into history was a museum exhibition of Edgar Degas's paintings and drawings of women. James Heffernan points out that poetic ekphrasis also, for the most part, "springs from the museum, the shrine where all poets worship in a secular age" (Heffernan, *Museum of Words,* 138). In his aptly titled *Museum of Words,* Heffernan explains that whereas "the art historian may elaborately contextualize a work of art, the museum individuates it *for the eye,* sets it off for contemplation or veneration in its own framed and labeled space, presents it to us as a self-sufficient icon" (ibid., 139). At the same time, however, museums are full of information and instructions as to how and why these "self-sufficient" masterpieces are to be venerated. Ekphrastic poetry is often sensitive to the institutional apparatus that is mobilized in and synecdochically signified by the museum, "all the institutions that select, circulate, reproduce, display, and explain works of visual art, all the institutions

that inform and regulate our experience of it—largely by putting it into words" (ibid.).

Is there a subset of "our" experience that is specifically female? Degas thought so: in a series of paintings of female museumgoers he tried, as he explained to his fellow painter Walter Sickert in a statement of intention that has been placed next to one of these paintings in the Boston Museum of Fine Arts, "to give the idea of that bored and respectfully crushed and impressed absence of sensation that women experience in front of paintings." The female museumgoer who is conjured by Degas's words and images is a late nineteenth-century culture vulture: she goes to museums to strike an appreciative pose, to see and be seen. Thirty years later we glimpse her again in T. S. Eliot's "Love Song of J. Alfred Prufrock," talking of Michelangelo in an upper-middle-class drawing room somewhere in London. In one of the poems in Ted Hughes' *Birthday Letters* her more Bohemian counterpart of the 1950s is honeymooning in Paris: she has nicknamed her poet-husband "Aristide Bruant" and is "burbling" with eagerness to sketch "*les toits.*"[8] In the wake of this kind of stereotyping, women poets have not surprisingly taken the initiative to think afresh about both the making of art and the aesthetics and politics of its reception. Several of the poets you will read about in these essays deploy ekphrastic strategies that are, in the words of contributor Barbara Fischer, "keenly attuned to the gendered tensions inherent in acts of looking."

More broadly, however, Pollock's interest in the complex layering of spectatorial gazes is emblematic of an interdisciplinary preoccupation with visual studies and visual culture that has intensified, if possible, since her essay was published in 1992. The term "visual culture" is intended, as W. J. T. Mitchell points out, to convey that vision itself is "learned and cultivated," and hence "deeply involved with human societies, with the ethics and politics, aesthetics and epistemology of seeing and being seen."[9] The nude is not naked, and neither is the eye that worships, delights in, or covets her beauty. As public citizens we are aware as never before of being looked at while we go about our daily business—by hidden cameras in shopping malls, by machines in airports that turn a piece of luggage into a sinister postmodern "still life with fingernail scissors." In our homes we are drenched in consumable images—moving images we can freeze or whose temporal duration we can manipulate, vivid fragments of high culture whose pastness is obtrusive yet meaningless. As we e-mail digitized photos to distant friends, the eyes of Renaissance putti look mischievously up at us from our computer mouse pads. On the door of the refrigerator, next to a postcard of the Acropolis and a rectangular

magnet bearing a miniaturized painting of *Negro Life* by Archibald Motley, we discover a "refrigerator poem" of anonymous origin that reads: "gorgeous beauty is of the girl / we love for the moment." It is probably the work of our twelve-year-old niece, who was just here for dinner; on her way to adulthood she will navigate a postmodern moment in which, it seems, the entire history of Western art is spilling out of the museum onto our desktops and refrigerators.

The impact of this deluge of visual and textual stimuli is registered in many different ways by the poets these essays bring to our attention. In a poem that is obliquely, tacitly ekphrastic, Rita Dove ponders the implications of her three-year-old daughter's reaction to the illustrations in a popular bedtime story. Susan Wheeler's vision of "the consummate poem," which she may herself have written, is that like a collector's box or *Wunderkammer* "it welcomes the quotidian, the frightening, and even the disgusting as well as the rarefied and beautiful." Wheeler's aim, according to Stephen Yenser, is "to epitomize the florabundant energy in which the world's bizarre diversity manifests itself." Rachel Hadas, a poet whose docent mode is diametrically opposed to Wheeler's, is also very much alive to the hypersaturation of our visual environment. A recurrent theme of Hadas's ekphrastic poems is the distractibility that plagues us as art lovers and museumgoers, the difficulty we experience in paying attention well enough to "really see the dragon."

> Even to see what we think we came to look at,
> we need an impulse and an appetite,
> as well as blinders, energy, and patience.
> —Rachel Hadas, "Two Paintings Seen Again"

We know a poetic ekphrasis when we see it, and especially when we see it compellingly executed: Homer's description of Achilles' shield, Keats's "Ode on a Grecian Urn," Auden's "Musée des Beaux Arts" and Ashbery's "Self-Portrait in a Convex Mirror" are exemplary sites of ekphrasis, and this would seem to presage substantial agreement as to what it is and why it should interest us. But "when one looks more closely at the range of definitions on offer," says Ruth Webb in an essay for the journal *Word and Image* that plays off classical against contemporary uses of the term, "one is tempted to ask whether there is in fact a single phenomenon that can usefully be called 'ekphrasis.'"[10] We do not even agree on how to spell the word—whether as a loanword from the Greek, or "domesticated" into English with the latinized spelling "ecphrasis"—and the decision between these two spellings is arguably not inconsequential.[11] In the course of an astringent discussion of modern theorists' tendency to ignore what

Greek rhetoricians used the word to mean, Webb points out that the Greek loanword, "by a sort of etymological magic," can be "seen to bear its meaning inscribed within it."[12] *Phrasis* is "a speaking or telling" and *ek* is a prefix meaning "out" or "off from"—hence *ekphrasis* must be an art of "speaking out," of "telling in full"—or, alternatively, of digression, of "speaking otherwise." From a purely etymological standpoint a variety of readings can be produced, none of which quite gets us to "speaking picture," as Webb points out. John Hollander has opted for domestication in *The Gazer's Spirit*, perhaps because his primary focus is the museum-based lyric of the nineteenth and twentieth century. But his choice also implies disinclination toward the production of definitional rabbits from etymological hats; it is consistent, moreover, with Hollander's decision to eschew "theory" in favor of a more expansive and taxonomically oriented survey of ekphrastic occasions and practices.[13]

According to Hollander, "the earliest ecphrases [*sic*] we have are the descriptions of the shields of Achilles and of Herakles by Homer and Hesiod respectively" (Hollander, *Gazer's Spirit,* 7); what he finds especially interesting about these descriptions is that their presupposed objects are purely imaginary. Hollander has coined the term "notional ekphrasis" for descriptions that invent their visual objects, and as other critics have not been slow to point out, there is a sense in which poetic ekphrasis is always "notional"—always in the business of conjuring up, in the absence of the artwork in question, an arresting image for the mind's eye.[14] In a study that is more theoretically ambitious than Hollander's, James Heffernan also cites the shield of Achilles as paradigmatic, but what interests Heffernan is that Homer's description "invites us to measure the newborn powers of writing itself against those of a much older mode of representation" (Heffernan, *Museum of Words,* 9). To begin the history of ekphrasis with the shield of Achilles is, for Heffernan, to conceive of it as a quintessentially "paragonal" undertaking, one that constructs the relationship between verbal and visual art as antagonism, confrontation, and/or rivalry. Ruth Webb points out, however, that although "certain highly polished and sophisticated descriptions of paintings or artifacts . . . were classified as 'ekphraseis' in antiquity," classical rhetoricians were far from limiting the scope of ekphrasis to works of visual art. Descriptions of persons, of places, and of events such as battles were also called "ekphraseis" if and when such descriptions "appeal[ed] to the mind's eye" (Webb, "*Ekphraseis* Ancient and Modern," 11–12); what was at stake for classical authors was not interart rivalry but descriptive vividness.

Webb finds that the term "ekphrasis" did not begin to be used exclusively for "the poetic description of a pictorial or sculptural work of art" until 1955, in an essay by Leo Spitzer on Keats's "Ode on a Grecian Urn."[15] Jean Hagstrum suggested in 1958 that the term be even more narrowly restricted: he proposed that we reserve it for poems that use what classical rhetoricians called *prosopopoeia* to "[give] voice and language to the otherwise mute art object" (Hagstrum, *Sister Arts*, 18 n. 34). More recent studies have declined to narrow the scope of ekphrasis to this extent, and indeed the definition most favored since 1990 is both broader and more abstract than Spitzer's. "The verbal representation of visual representation" is how both Heffernan, in *Museum of Words*, and Mitchell, in *Picture Theory*, have influentially defined ekphrasis, suggesting thereby that when poets engage in it they are putting representation itself at issue or at stake.[16] Ekphrasis would not, however, be limited to poetry under this broader rubric; as Grant Scott points out, even a painting's title would also count as an ekphrasis.[17] So would the prose of art historians, even though we do not often find them calling upon the work of visual art to disclose its meaning or using prosopopoeia to endow it with speech.

From an art-historical perspective, poetic ekphrasis might well appear to be a dubious enterprise at best, and at worst an exercise in mystification. "Beauty is truth, truth beauty"; "About suffering they were never wrong, the Old Masters": these kinds of assertions shore up the canonical status of the artworks on display in museums, inviting us to regard them as timeless repositories of human wisdom at a moment in the history of art when its practitioners are keen to emphasize the historical contingency of aesthetic and ethical judgments. "Successful ekphrasis," suggests the poet Karl Kirchwey in his essay for this volume, "is predicated upon a perfect receptiveness in the poet-beholder . . . and a strong desire, not even to *conceive* or *interpret* the message of the visual art, but rather to *utter* what the poet feels (so strong will be his or her response) the work of visual art is trying to say." Such perfect receptiveness would involve the poet-beholder in a visionary experience of transcendent immediacy, whereas art historians have become increasingly interested in how the reception of works of art is mediated by social and cultural institutions of various kinds. And yet, as contributor Barbara Fischer points out in *Museum Mediations*, her recently published study of contemporary museum ekphrasis, poets are "interlopers" in the museum; because it is "not their primary institution of canonization . . . they stand at a further remove" (Fischer, *Museum Mediations*, 2). Thus,

many contemporary poets do ekphrasis with a high level of awareness both of "the physical and institutional conditions that frame encounters with art" and of their own necessarily *im*perfect receptiveness. Concerning Ashbery's postmodern meditation on Parmigianino's *Self-Portrait in a Convex Mirror,* Fischer calls attention to a "repeated insistence . . . on the contingency and instability of his approach to this work of the past" (ibid., 83). In the work of many other contemporary poets she finds ekphrasis being used to interrogate "the mediations—the media, processes, and contexts—that enable, structure, and complicate aesthetic experience" (ibid., 51).

Fischer usefully suggests that among the scholars and critics who have tackled ekphrasis over the past half-century there have been "two dominant approaches." The watchword of the first is *ut pictura poesis*—as in painting, so in poetry—a phrase from Horace's *Ars poetica.* Under the aegis of this famous phrase, "the 'sister arts' are [understood to be] reciprocally inspiring."[18] According to the other approach, "which has its roots in [Leonardo] da Vinci's *Paragone,* or competition between the arts, and in G. E. Lessing's insistence on the separate domains of poetry and painting," these "sisters" are actually rivals (Fischer, *Museum Mediations,* 2). It is the second, "paragonal" approach that has been predominant since the 1980s, in books by Wendy Steiner, James Heffernan, Grant Scott, and others. In *Pictures of Romance,* Steiner construes the ekphrastic poet's stance as one of despairing emulation: we have "the literary topos of ekphrasis," she explains, when "a poem declares its aspiration to the eternal poise of the visual arts, and at the same time, as a temporal artwork, demonstrates its inability to achieve it."[19] James Heffernan finds poets aspiring not to *achieve,* but to *overcome* "the eternal poise of the visual arts": "ekphrasis is dynamic and obstetric," he argues, in its drive to "[deliver] *from* the pregnant moment its embryonically narrative impulse" (Heffernan, *Museum of Words,* 5).[20]

W. J. T. Mitchell takes this "paragonal" approach to another level by urging us to recognize that "eternal poise" is not an inherent property of the visual arts, but an idolatrous construct, a fetish. By the same token, "narration, argument, description, exposition, and other so-called 'speech acts' are not medium-specific. . . . [We] can make a promise or threaten or argue metaphysics with a visual sign as eloquently as with an utterance" (Mitchell, *Picture Theory,* 160). Why, then, do both poets and theorists of ekphrasis "make the obvious, practical differences between the media into metaphysical oppositions that seem to control our communicative acts" (ibid., 161)? Mitchell's explanatory hypothesis is that the powerful emotions ekphrastic poetry harbors toward its objects are "subli-

mated versions of our ambivalence about social others."[21] The "alien visual object" can "reveal its difference from the speaker (and the reader)" in the register of historical or cultural distance (as with Keats's Grecian urn), in terms of "alienation between the human and its own commodities" (as in Wallace Stevens's "Anecdote of the Jar"), and in many other ways as well (Mitchell, *Picture Theory*, 181).[22] The one Mitchell spends most of his essay discussing, however, is sexual difference: Keats's urn, he reminds us, is a "still unravish'd bride" (ibid., 170), and he finds "just a hint of the feminine" in the "menacing" barrenness of Stevens's jar (ibid., 168). Indeed, Mitchell remarks, since "visual representations are generally marked as feminine (passive, silent, beautiful)," "the treatment of the ekphrastic image as a female Other is a commonplace in the genre."[23]

Mitchell's theory of ekphrasis looked like a breakthrough to many other critics because, as Grant Scott explains, all the way back to G. E. Lessing "the special *psychology* of ekphrastic encounter" had been largely overlooked—by Leo Spitzer and Murray Krieger, by Hagstrum in *The Sister Arts,* and even by Wendy Steiner in *The Colors of Rhetoric,* her earlier study of modernist interart relations. Mitchell's purpose in "Ekphrasis and the Other" was ostensibly to demystify ekphrasis, but his explanatory hypothesis also raised the stakes of the ekphrastic encounter by locating its motives at the deepest levels of human being. "Mitchell redirects our attention," says Scott, "from the spatial/temporal dynamics of ekphrastic writing to the specific psychology of aesthetic response" (Scott, *Sculpted Word,* 182).[24] His theory offers to account for the "emotionally charged and metaphorical language" not only of ekphrastic poetry but also of "the history of critical discourse on ekphrasis" (ibid., xii). For indeed we do find love, envy, fear, surprise, and other powerful emotions coming into play both in poets' encounters with works of visual art and in scholarly writing about those encounters. Scott finds Murray Krieger, in *Ekphrasis: The Illusion of the Natural Sign,* speaking of his scholarly project in language that makes the subject of ekphrasis itself "sound like the unravished Grecian urn . . . 'maddeningly elusive,' 'endlessly tempting.' "[25] Poet-critic J. D. McClatchy, in his introduction to a collection of poets' essays on painting, assimilates ekphrastic description to poetic lovemaking: "[A] painting," he observes, "is as beguiling as any idealized lip or lash, any fetish."[26]

At the same time, however, Mitchell's version of ekphrasis is one in which men do the hoping and fearing, the looking and speaking. "If ekphrastic poetry has a 'primal scene,' " he suggests, it is to be found in Shelley's poem "On the Medusa of Leonardo da Vinci," since

"Medusa is the perfect prototype for the image as a dangerous female Other who threatens to silence the male voice and fixate his observing eye" (Mitchell, *Picture Theory,* 172). Heffernan concurs with Mitchell in stressing that the "contest" at the heart of ekphrasis "is often powerfully gendered: the expression of a duel between male and female gazes, the voice of male speech striving to control a female image that is both alluring and threatening, of male narrative striving to overcome the impact of beauty poised in space" (Heffernan, *Museum of Words,* 1). That men have historically claimed a monopoly of "the gaze" or "the look" is by now a commonplace in film and media studies, as well as in the history of European painting.[27] Wendy Steiner enlists the work of the art historian Norman Bryson to speak of a "sexual politics of vision" that is presupposed, and often to be found within, Renaissance paintings: "'Woman as Image, Man as Bearer of the Look.'"[28] It is a division of roles that has persisted into the twentieth century, as Mary Ann Caws pointed out in connection with surrealism in 1985.[29] The ease with which other dichotomies can be lined up with this one, so that men are cast as bearers not only of the look but also of speech and narrative, is patent in Heffernan's formulation of what the ekphrastic "contest" involves. But what, then, of poets who are female: why would a woman poet do ekphrastic writing?

The essays in the present volume call attention to a body of work by American women poets whose existence has gone largely unnoticed—in part, perhaps, because "the" ekphrastic encounter has been theorized so persistently in terms of mutually reinforcing binary oppositions that make women unlikely candidates for the subject-position in that encounter. Mitchell ends his essay with an acknowledgment that all of his examples "are dominated, as it happens, by the figures of sexual otherness" (Mitchell, "Ekphrasis and the Other," 717) and ventures to "suspect" that "all this would look quite different . . . if [his] emphasis had been on ekphrastic poetry by women" (Mitchell, *Picture Theory,* 181). Heffernan takes considerable interest in texts whose silenced female protagonists "speak in and through pictures," but the tradition he tracks in *Museum of Words* includes only two poems that are woman-authored, neither of which occasions a reconsideration of his larger claims about the motives and goals of ekphrastic writing. By taking the work of women poets more fully into account, our goal is to expose the limitations of paragonal theories of ekphrasis in favor of a broader, more variegated, and more nuanced account of what poets—or, as Paul Fry puts it, what *poems*—see in pictures.

The task that awaits us is nothing less than the reimagination of
the female subject as an equal partner in aesthetic pleasure.
 —Wendy Steiner, *Venus in Exile*

Is there a "female" aesthetic that yields a distinctive tradition of
ekphrasis? Joanne Feit Diehl's, Paul Fry's, Barbara Fischer's, and Eliz-
abeth Bergmann Loizeaux's essays all raise this question, with all
except Fry taking the position that there is no such thing as "*a* female
aesthetic." Joanne Diehl suggests, however, that "whether or not they
were consciously aware of it, twentieth-century American women po-
ets inherited a tradition of ekphrasis that was deeply gendered."
Writing poetry in the wake of that tradition, their subject positions
were bound, she argues, to be "marked by awareness of . . . the
traditional ekphrastic paradigm." Diehl finds Sylvia Plath aligning
herself simultaneously and interrelationally with the subject and the
object of a traditionally masculine gaze, whereas Elizabeth Bishop
and Jorie Graham have called "the binary of masculine and feminine
itself" into question in order to give ekphrasis different questions to
raise and other kinds of work to do. Diehl's comparison of Plath's,
Bishop's, and Graham's ekphrastic stances points the way toward a
female tradition that, instead of being animated by a single paradigm
or a set of motives that are presumptively gendered female, would
have for its tutelary spirit the "rainbow-bird" of Bishop's late poem
"Sonnet"—"freed . . . from the narrow bevel / of the empty mirror, /
flying wherever it feels like, gay!"

In his essay on the ekphrastic stance of Gjertrud Schnackenberg,
Paul Fry does posit a distinctively female mode of ekphrastic engage-
ment. But unlike other currently popular theories of ekphrasis, Fry's
theory is gender-neutral with respect to the object, the "what," of
ekphrastic writing. Fry broached his theory first in *A Defense of Poetry:
Reflections on the Occasion of Writing* (Stanford, CA: Stanford University
Press, 1995), in an essay entitled "The Torturer's Horse: What Poems
See in Pictures." He begins his essay for the present volume by ex-
plaining why we should prefer his theory of ekphrasis to Mitchell's
and Heffernan's. Insofar as "the object of the literary gaze" is "the
beautiful," it follows that "in the eyes of poetry, visual art is really a
displaced female . . . body." What Fry proposes, as an alternative to
this Kantian "fixation" on the beauty of truth, is a Heideggerian
emphasis on "the material 'there-being' of things." What poems envy
pictures for, Fry argues, is their supposed capacity for sheer "os-
tension"—what Adrienne Rich, in one of her poems, called "pure
annunciations to the eye." And yet he finds that this is not, finally,
what women poets want from works of visual art. Instead, women

poets crave "what is seen to be *absent* from the ostensive moment": a sense of community, of history, of specifically human values in play. Fry's evidence in "The Torturer's Horse" for this bold and sweeping claim consisted of a range of examples from the work of poets as distant and as different from one another as Phillis Wheatley, Elizabeth Bishop, Mary Jo Salter, and Debora Greger. In his essay for the present volume he gives sustained attention to a single poet who has persistently focused on the visual arts with an ambivalence that borders on iconoclasm. In his account of Schnackenberg's repertoire of antiekphrastic devices, Fry demonstrates that binary thinking about how men and women poets differ need not be reductive in the context of a theory that gives women and men equal access to "the eyes of poetry"—that is, to the subject position in an ekphrastic encounter whose objects and whose basis in desire are not already sexualized.

In his essay on Mary Jo Salter, Jonathan Post takes a longer view of ekphrasis, in order to delineate an ekphrastic stance that takes its bearings neither from a paragonal struggle between poetry and painting nor from a primal scene of forbidden knowledge. *Ut pictura poesis:* as Post interprets the famous Horatian dictum, it gestures toward a view of the sister arts that is urbane, genial, and modest. Instead of pitting them against each other as rivals, it allows for the poet to be motivated by a "surge of good feeling" for the visual artist's achievement.[30] Whereas paragonal theories take their bearings from a heroic or "sublime" tradition that espouses "the heroically fraught language of combat," Post locates Salter's ekphrastic poems within a more sociable, domestically inclined tradition whose tutelary spirit is the seventeenth-century parson-poet George Herbert. This is not an exclusively female tradition, any more than the sublime tradition of ekphrasis is an exclusively male preserve. But within this Horatian or Herbertian tradition activities, interests, and emotions that are stereotypically female are accorded greater scope and visibility, and hence by implication greater importance and value, than in the heretofore canonical tradition of ekphrasis. Herbert's poetry, Post explains, was foundational not only for Salter but also for Elizabeth Bishop: in their poems "what is visually entrancing invites vivid description, even homage by imitation, a kind of love." We are not far off here from religious worship—and indeed, before there were museums, churches were where the art of painting flourished, in the service of a divinely authorized interpenetration of word and image.

Mary Ann Caws is a feminist scholar of interart relations who for forty years has been inviting the readers of her many books to pay close attention to the use and abuse of women's bodies in the art and

poetry of the avant-garde. To counter the kinds of visual images that offer to give their viewers pleasure at women's expense, Caws has stressed the importance of finding images that women themselves can unreservedly celebrate. Resistance is important, but so are discussion and dialogue: our "will to discussion . . . turns us from consumer and consumed to creator and life-giver. . . ."[31] Caws's essay for this volume on the poetry of Grace Schulman is drenched in the atmosphere of the museums where the poet and the critic have spent the years of a lifelong friendship discussing art with each other. "To share in the poetic and the painterly with a friend," she writes, "is about as joyful an experience as I have known." Ostension is the theme of Caws's account of ekphrasis as much as it is of Fry's, but when Caws speaks of "looking with a firstness only paintings can teach," she is turning not to Heidegger but to Duns Scotus for a religiously based conception of the "thisness" and "there-being" of things. "God lives in the detail" is the first (and last) line of one of the poems she discusses.

To be sure, this kind of "iconophilia" carries its own risks and challenges in our cultural moment: to expose oneself in an act of unreserved admiration is to risk embarrassment and court sentimentality. And yet not to confess to the religious stakes of the ekphrastic encounter is to risk having one's description of the work of art seem undermotivated, fetishistic perhaps, but in any case pointlessly meticulous. The resilience and optimism of Schulman's ekphrastic sensibility are well served by Caws's willingness to speak of ultimate matters simply and openly. "It is in no way that within them there are not terrible things," she explains in relation to the ekphrasis of a painting by the Jewish artist Chaim Soutine; but Schulman has also sought out the "hidden boldness" of the *Young Woman Drawing*, by Marie-Denise Villers. Speaking *with* this painting in concert with her friend, Caws observes that "God and his light of creation, the dove and his gift, are in no way greater than this creative will of a human so gifted with desire."[32]

> We pass this way
> once, so choose one thing and look and then
> look back.
> —Rachel Hadas, "Two Paintings Seen Again"

During the second half of the twentieth century the production of museum-based ekphrastic lyrics became "nothing less than a boom," according to James Heffernan, and in the United States a particular set of catalysts can be adduced. After the end of World War II, Americans revisited Europe's museums and contributed American dollars

to their restoration with a heightened sense of the preciousness—
and precariousness—of their European cultural heritage.[33] The po-
ets among these postwar visitors to Europe shared a formalist orienta-
tion that was auspicious toward the project of writing about the mas-
terpieces they encountered. For Richard Wilbur, Anthony Hecht,
James Merrill, and other poets of that postwar generation, artworks
in museums were visual icons whose apparent self-containment
spoke to an aesthetic of the verbal icon that prospered under the
aegis of the New Criticism. In the university writing programs where,
from the 1950s onward, would-be poets increasingly went to learn
their craft, ekphrasis became a standard writing exercise. One of the
poems Sylvia Plath wrote as a student at Smith College in the 1950s
self-enjoins the fledgling poet to "Suspend this day, so singularly
designed, / Like a rare Calder mobile in your mind": Plath would go
on to sketch "les toits," but also to produce a significant body of
ekphrastic poetry.[34] Ekphrasis also formed a crucial part of Jorie
Graham's poetic apprenticeship, in the 1970s: as Willard Spiegelman
points out in his essay for the present volume, many of Graham's
early poems are exercises in "framing" and in self-willed limitation.
During the 1980s and 1990s museums themselves contributed to the
boom in ekphrastic writing by commissioning anthologies from poets
with established reputations. Such museums included the Tate Gal-
lery in 1986, the Art Institute of Chicago in 1994, the Museum of Art
at the University of Michigan in 1997, and the Yale University Art
Gallery in 2001.[35] "A museum-sponsored anthology, with its implicit
homage to consecrated works of high art, and its traffic in cultural
cachet, is on the whole a conservative proposition," Fischer observes
in *Museum Mediations* (18). She finds, however, that in these an-
thologies "charisma is only half the story"; "critiques of the museum
. . . are no less predictable in a collection of late-twentieth-century
writings from an academic milieu" (ibid., 19).

Elizabeth Bergmann Loizeaux calls attention to a dissident tradi-
tion of ekphrastic writing in the work of certain women poets that
extends further back. During the first half of the twentieth century,
she finds Gertrude Stein, H.D., and Marianne Moore deploying
ekphrasis as part of a wider effort "to change the perceived gender
dynamics of seeing-and-saying."[36] All three poets were working, she
suggests, from the premise that "the patterns of power and value
implicit in [the dominant tradition] can be exposed . . . resisted and
rewritten." And yet she stresses that they were working independently
of one another, calling on very different strategies and techniques. In
an essay that plays off Moore's ekphrastic stance against that of

Adrienne Rich, Loizeaux argues that the art of looking Moore cultivated in museum-based poems was for her "a way of practicing justice." Self-consciously "nonpredatory," Moore's approach was one that declined to "master the image by establishing a particular view of it"; instead she "multiplies points of view, unfixing authority." In this way Moore's ekphrastic tactics foreshadow those of the postmodern poets Barbara Fischer writes about in her essay for the present volume, who deploy multiple speakers within a single poem.

For Moore, according to Loizeaux, "selection of object also mattered": she was drawn to objects that "didn't settle comfortably into their places in museums." And, indeed, a number of women poets have looked for their ekphrastic objects outside the museum or in its most neglected corners, seeking out works of art and venues for its appreciation that are eccentric, aleatory, unexpected. In "Bird, Weasel, Fountain," Rachel Hadas looks at objects that are poorly displayed, "not well painted," "badly lit," whose challenge for the viewer is "overdetermined" by their lowly or marginal status. Rita Dove's "Venus of Willendorf" is set in a small village in the Swiss Alps whose only tourist attraction is a replica of the prehistoric statue that is supposed to have been uncovered there. The ekphrastic sites in Mary Jo Salter's poems include a basement where a mother's portrait of her son has lain unfinished, and a street in Florence where Botticelli's Venus is reborn in chalks that will not outlast a shower of rain. These poems of Salter's raise a question that tends to get foreclosed by museum ekphrasis but may be especially salient for artists who are women: the question of "what to make of an unfinished thing."

> Mirror, mirror, on the wall . . .
> —Grimm brothers, "Snow White"

Portraiture is a genre of painting that raises important issues for women because of having been used, throughout its history, to capture its subjects' likeness for presentation to the society at large. Does a portrait reveal or does it confer identity? Does it show us who its subject really is, or does its legibility derive from the way in which she or he has been induced to pose? Portraits encourage us to suppose that we can "find the mind's construction in the face"; do they also collude in processes of objectification and stereotyping, and in a general tendency to overvalue physical appearance? Both Wynn Thomas's and Stephen Burt's essays are concerned with these kinds of questions. Burt's essay follows the poet C. D. Wright and the photographer Deborah Luster into a women's prison in Louisiana whose

inmates' prior experiences with the camera were mostly associated with surveillance and social control: the mug shot, the driver's license. Thomas's essay on Lucie Brock-Broido follows her into the hospital room of her dear friend Lucy Grealy, whose badly disfigured face brought her intimately to grips with the "male deformation by beauty of female identity." Deborah Luster wanted to give the subjects of her photographic portraits an opportunity to "choose what face they show the world"; in her photographic ekphrases Wright furthers this project while at the same time questioning its premise. Can someone who has never been incarcerated speak *for* a group of women whose self-awareness has been crucially altered by their prison experience? In Wright's poems, according to Burt, an aesthetic question that haunts the genre of ekphrastic poetry (with its mandate, in the words of poet-contributor Karl Kirchwey, "to utter what the work of visual art is trying to say") is thus reframed as an ethical question of considerable urgency. Brock-Broido's project is one that, according to Thomas, has been "central to female art and feminist arthistory over recent decades": the attempt "to overwrite male representations of women with female self-portraiture." But instead of attempting to replace a self that is "subject to a male artist's imagination" with a truer, more authentic self, Brock-Broido, like Cindy Sherman and other contemporary visual artists, has been attracted to a "performative, antiessentializing model of subjectivity."

Fools and Crows, Terri Witek's first book of poems, was hailed by her fellow poet Mark Jarman in 2002 as a collection that "takes the ancient discipline of ekphrasis to a new level of intensity."[37] Her second volume, *The Carnal World* (2006), has Terri's portrait on its cover, one of a series of portraits Gary Bolding painted of her in 2000–2001. Witek's account of her experience as a painter's model is the centerpiece of an essay that considers the imbrication of gender and genre from a number of unexpected angles. "It seemed logical to write ekphrastically about the experience," she explains, and yet she found herself unable to do so. Her difficulty should not surprise us: Wendy Steiner has argued, in *Venus in Exile,* that "perhaps the most central problem for women artists" at the present time "is how to manage the symbolic identities of subject and object suddenly merged in them."[38] And yet Witek's essay is itself an ekphrastic meditation of an unusual kind: it captures the experience of being captured on canvas from a position of enforced passivity and stillness that turns out to be richly conducive to reflection about the "ordinary magic" of a painter's process.

But something new is on the way, a new preciosity
In the wind. Can you stand it,
Francesco?
 —John Ashbery, "Self-Portrait in a Convex Mirror"

As John Hollander points out in *The Gazer's Spirit,* ekphrastic poems take up a wide range of stances toward paintings, statues, urns, and other visual objects: "[T]hese include addressing the image, making it speak, speaking of it interpretively, meditating on the moment of viewing it, and so forth" (4). Each of these stances is characterized by specific rhetorical tactics and tropological strategies whose deployment calls attention to the whys and wherefores, the nuances and subterfuges, of voicing and of verbal figuration. What are the relative advantages of speaking *to, about,* or *for* the work of visual art? Each mode of address will put the ekphrastic "subject" or "speaker" in a different relationship not only with the ekphrastic object, but also with readers whose access to its meanings or techniques of representation or to a certain conception of its importance the poem has offered to mediate. The gamut of possible third-person stances runs from W. H. Auden's impersonal and boldly authoritative pronouncement to a docent's mode that is more self-effacing and deferential, like Schulman's, Hadas's, and Salter's,[39] or to one that is self-consciously idiosyncratic and opinionated, like Lucie Brock-Broido's or Gjertrud Schnackenberg's. Abandoning the fiction of "a unified lyric voice," Anne Carson, Cole Swensen, and Susan Wheeler use multiple speakers within a single poem—"a technique," says Barbara Fischer, "that unsettles the ekphrastic occasion by introducing more viewpoints than that of a single gazer."

Apostrophe, which enables us to speak directly *to* the work of art, is a high-profile tactic not only because it is, according to Paul de Man, Jonathan Culler, and others, the very figure of voice or of poethood, but also because the relationship it sets up between the subject and the object of ekphrasis is confrontational, intimate, and/or possessive. Apostrophe calls attention to the ekphrastic object's inherent wordlessness by implying that its silence is willful, or could be given up in response to entreaty, or that the poet knows what the ekphrastic object really means to say. Rachel Hadas suggests in her first-person essay that apostrophe is "surely the essential ekphrastic trope," and yet finds herself tending to avoid or to skirt the "instant intimacy" of this figure in favor of more indirect and "nonconfrontational" tactics of various kinds. In the photographic ekphrases of C. D. Wright, in contrast, Stephen Burt finds "the 'O' through which poems acknowledge human persons" being boldly used to invoke women's genera-

tive powers—the vagina as origin of the universe—and also the "O" of a camera lens. As Willard Spiegelman points out in his essay on Jorie Graham, questions are another staple of ekphrastic writing: "If simple . . . unvarnished 'description' demands or implies declarative sentences, then one means of complicating a response to pictures is to pose questions about or to them." To think of the different kinds of rhetorical questions that are possible, ranging from *aporia* (a performance of deliberating with oneself) to *epiplexis* (the question that chides or expresses grief) to *anacoenosis* (the form of questioning favored by Graham, which asks the reader to form a judgment), is to become aware of the extent to which rhetorical devices have ethical and political implications.[40] They are used to claim authority; they establish (and if clumsily used may weaken) credibility; they serve to expose or conceal the poet's stake in the ekphrastic encounter; and they offer to involve the poem's readers in the interpretive process.

To attribute speech to the work of art or someone depicted within it is the most radical move an ekphrastic poet can make: a generous gift or a more or less hostile takeover, depending on the spirit in which it is used. A good example of the latter is a poem by Adrienne Rich, inspired by Edwin Romanzo Elmer's *Mourning Picture,* in which it is not the artist himself who is made to speak—though he is the one whose gaze confronts us most directly from within the painting—but the daughter for whom he is in mourning. "I am Effie, you were my dream," Rich has her say to the world she is prophetically reclaiming for herself. *Mourning Picture,* discussed in this volume by both Kirchwey and Loizeaux, points the way toward a feminist intervention in the history of Western art that the rhetorical strategy of "envoicing" puts poets in an especially good position to make. If, with the art historian Griselda Pollock, they are inclined to think of that history in terms of "relentless inscriptions of masculine desire," then instead of creating new spaces of representation for women to occupy they can choose to inhabit already existing works subversively, with rereadings that are critical and/or revisionary.[41] In a particularly interesting instance of this strategy that is discussed by Barbara Fischer, Kathleen Fraser uses "mesostic" wordplay to give her poem's female speaker, a circus performer in one of Degas's paintings, the means of beginning to come into possession of a voice and a will of her own from within the very language that affirms her compliance with an already scripted performance.

In an ekphrastic series by Anne Carson that Fischer also discusses, the poet enters into each depicted scene from an Edward Hopper painting by way of the consciousness of one of its inhabitants in order to arouse, but then frustrate, our avidity for the kind of clichéd

"confessional" anecdote the painting's scenario seems to call for. Narration is one of the most important resources a poet can bring to the ekphrastic encounter: Heffernan cites it as the principal means by which the visual image is brought to life. In "Hopper: *Confessions,*" Carson has used envoicing parodically to suggest that the women in Hopper's paintings have been taken hostage by scenarios for which stereotypical backstories are all too easy to furnish. C. D. Wright's photographic ekphrases give us yet another way to think of ekphrasis as envoicing: she and Luster have sought to use both words and images "antipanoptically" to recover the prerogative of each of their incarcerated subjects to decide for herself how she will "face" the world. Luster's photographs "let inmates make and show faces, or even save face"; Wright's poems "attribute voices to [those faces], and match or respect those voices with her own speech."

At its simplest and least ambitious, ekphrasis equals description. But as Wynn Thomas reminds us in his essay on Lucie Brock-Broido, even a poem that refers to an already existing painting is reinventing what it describes. The poet can have recourse to schemes and tropes and wordplay, the resources specific to her verbal medium, either in a spirit of homage to the visual object's own devices of representation or in rivalry with them. Rachel Hadas discovers, in an ekphrasis of Botticelli's *Mars and Venus,* that the entire painting is a "landscape of V-ness";[42] Salter begins her ekphrasis of Nicolas Maes's *Young Girl Peeling Apples* with the assertion "It's all an elaborate pun," since the young girl peeling apples is herself "the apple of [the artist's] eye." A poet's descriptive resources include the physical shape of the poem itself: Salter's ekphrasis of the young girl peeling apples, as Jonathan Post points out, is a single, long, unpeeling sentence.[43] A poem may augment the image's powers of description by drawing on other dimensions of sensory experience: "The air is fresh and cold," writes Elizabeth Bishop of a painted landscape that triggers a sense memory of her Nova Scotia childhood. "Sensation and memory, crucial attributes of human subjectivity, are thus read into, as they are extrapolated from, the painting," as Joanne Diehl observes.

As Diehl's observation implies, the relationship between poetry and painting is potentially a two-way transaction between descriptive media that can enter into and borrow from each other's protocols of representation. Bishop was a poet who also liked to draw and sketch. Bonnie Costello suggests that in her drawings and watercolor sketches "one can find the style and manner of her poetry," but the relationship cuts both ways: *as a poet,* Bishop can also be said to have practiced an "art of still life." "Still-life moments" in Bishop's poems are those in which "objects are arranged and scrutinized for their aesthetic and

sensuous pleasure and their silent cultural significance." Bishop has created such moments in her poems, Costello suggests, "not only . . . to elevate the ordinary, but to read the everyday as the domain in which the purposes of culture (such as economics, sexuality, politics) are conveyed or resisted."

As not only Costello but also Diehl and Post have emphasized, Bishop's ekphrastic practice is one in which painting and poetry are mutually supportive—"as in . . . so is." In the warier, more ambivalent ekphrases of Gjertrud Schnackenberg, Lucie Brock-Broido, and Rita Dove we find poems holding visual art at a distance, trope becoming apotrope at a moment's notice. Paul Fry finds Schnackenberg using a whole array of "antiekphrastic" devices "each of which erases, distorts, or reconstructs the observed image." Brock-Broido turns to ekphrasis in search of an "art of displacement" that may shield her from unbearable loss: her "mannered stylistics," suggests Wynn Thomas, are those of a belated, self-ironizing Lady of Shalott, seeking the "safe enchantment . . . of her most dangerous emotions." Rita Dove has also turned to ekphrasis in search of an art of displacement: Jane Hedley's essay finds Dove citing racially inflected visual images from both high and popular culture in order to acknowledge and inhabit, yet also ward off and hold at a distance, the psychological, social, and political meanings with which they are invested.

In his essay on Louise Glück, Nick Halpern takes note of a "hidden ethical agenda" that is often to be found in discussions of poetry's capacity for description and for visualization, "a kind of piety for atheists—humility before the object, with Elizabeth Bishop as the patron saint." Glück will have no truck with this kind of deference, and Halpern rejects, on her behalf, the notion that there is a kind of mental health in seeing like Bishop—or like Charles Darwin, who was *her* patron saint. Glück studied painting and considered becoming a painter, but when she writes about paintings and photographs her stance is one of resistance, contradiction, or correction, of turning away or refusing to look up—in short, of "opposing [herself] to the declared desires of others." Glück's relationship to the visual arts is thus as inhospitable as possible to the project of ekphrasis—of representing, entering into, speaking for, or even merely *describing* a painting or a photograph. Especially in her early poetry she is "a hunger artist when it comes to other people's perspectives": they disgust her; she refuses them. Halpern's essay invites us to be compelled and persuaded by the rigorous austerity of Glück's antiekphrastic stance. It is a stance that would be easy to pathologize: Halpern entertains but rejects that possibility, choosing instead to

put Glück in dialogue with a series of other writers, among them
Bishop and Gerard Manley Hopkins, who have been more willing to
trust the visible world.

> The words are only speculation
> (From the Latin *speculum*, mirror)
> —John Ashbery, "Self-Portrait in a Convex Mirror"

John Ashbery looked into Parmigianino's self-portrait, and "set
himself / With great art to copy all that he saw in the glass"; by the
time he had finished, the painter's self-portrait had become his own.
In dialogue with Ashbery's "Self-Portrait" in "The Debtor in the Con-
vex Mirror," Susan Wheeler has produced a comparably self-reflexive
meditation on indebtedness as the ground and condition not only of
ekphrasis but of the artistic enterprise itself, more broadly con-
sidered: as the poet-critic Stephen Yenser observes, Wheeler's poem
"is all a mesh and mass of indebtedness." Her poem's preoccupation
with indebtedness speaks to one of ekphrastic poetry's crucial givens:
in basing itself upon a prior work of art, the poem has incurred a debt
that it seeks to repay with interest.

In Ashbery's and Wheeler's poems a self-reflexive dimension is
especially apparent, but any poet who engages in ekphrasis, to the
extent that she is re-presenting another work of art or borrowing its
protocols, will be using the ekphrastic occasion as a kind of theater or
laboratory in which to test her own aesthetic commitments. "In the
mannered stylistics of painting," suggests Wynn Thomas, Lucie
Brock-Broido has found "a valuable model for considering the pur-
pose and function of poetic forms." In Gjertrud Schnackenberg's
ekphrasis Paul Fry calls attention to the presence of "a running com-
mentary on Yeats's 'Byzantium' "; in Debora Greger's ekphrasis of an
ekphrasis, Karl Kirchwey finds her taking on the dual role of "active
interpreter" and "still-unravished bride." Jorie Graham "observes and
responds to paintings," says Willard Spiegelman, "then moves beyond
them and into herself." Even the most antiekphrastic stance conceiv-
able, even Glück's refusal to look up, is a stance that is full of informa-
tion about her own desires and purposes. By the same token, "to see
how Wright uses photography is not just to see her poetic goals,"
according to Stephen Burt; "it is also to see how her style . . . realizes
those goals, what she, and nobody else, has done with poems."

The essays collected here will thus be worth reading not only for
their engagement with the motives and tactics of poetic ekphrasis,
but also for the profiles they give us of each poet's engagement with
the resources of her own artistic medium. What does she want as a
poet, and how does she see herself? In essaying to answer this ques-

tion on behalf of these poets, each of our contributors has also, inevitably, exposed his or her own predilections and commitments. Each essay is thus also "speculative" in a double sense: as scholars, critics, and/or fellow poets, we ourselves take yet another step along the chain of provocation and response.

NOTES

1. My co-editors, Nick Halpern and Willard Spiegelman, were crucially involved in framing the issues addressed in this introductory essay, and their advice during the process of revision, at the level of both structure and language, was unfailingly trenchant and tactful. When we first began to put this volume together, we could find only four single-figure essays on women poets' ekphrastic writing: one on Barbara Guest and three on Sylvia Plath (which will be cited here in due course). In the notes to her essay for this volume, Elizabeth Bergmann Loizeaux cites a few more recently published pieces. John Hollander offers readings of a few poems by women in his "Gallery" of poems and paintings in *The Gazer's Spirit;* Paul Fry raises the question of what women poets want from their ekphrastic encounters in *A Defense of Poetry.* The implications of other critics' neglect of women poets will be discussed below. Two of our contributors, Barbara Fischer and Elizabeth Loizeaux, have by now published books that go some way toward redressing this neglect.

2. Etymologically, the word "ekphrasis" is derived from the Greek *ekphradzein,* which is usually construed to mean "speak out" or "tell in full." Cf. Jean Hagstrum, *The Sister Arts: The Tradition of Pictorialism and English Poetry from Dryden to Gray* (Chicago: University of Chicago Press, 1958), 18 n. 34, hereafter cited in the text; John Hollander, "The Gazer's Spirit: Romantic and Later Poetry on Painting and Sculpture," in *The Romantics and Us: Essays on Literature and Culture,* ed. Gene W. Ruoff (New Brunswick, NJ: Rutgers University Press, 1990), 130; and esp. James A. W. Heffernan, *Museum of Words: The Poetics of Ekphrasis from Homer to Ashbery* (Chicago: University of Chicago Press, 1993), 191 n. 2, hereafter cited in the text. For Ruth Webb's critique of this approach to defining the term, see pp. 19ff.

3. Cf. Jas Elsner, "Seeing and Saying: A Psycho-Analytic Account of Ekphrasis," *Helios* 31 (2004): 157–85.

4. Griselda Pollock, "The Gaze and the Look: Women with Binoculars—A Question of Difference," in *Dealing with Degas: Representations of Women and the Politics of Vision,* ed. Richard Kendall and Griselda Pollock (London: Pandora, 1992), 106–30. Hereafter cited in the text. Whereas the male spectator depicted within the painting has his opera glasses trained on its central figure from a loge on the other side of the opera house, "the place we the viewers are invited to share" is that of the companion whose presence, Pollock suggests, is "a logical necessity," an unseen but "necessary guarantee of [her] respectability" (ibid., 123).

5. In *Reclaiming Female Agency: Feminist Art History after Postmodernism* (Berkeley and Los Angeles: University of California Press, 2005), its editors, Norma Broude and Mary Garrard, "look back to a period of politically engaged feminist writing that spans nearly a quarter century" (vii). Two earlier collections of essays edited by Broude and Garrard for the University of California Press have titles that evoke the beginning and middle of that twenty-five-year time span: *Feminism and Art History: Questioning the Litany* in 1982, followed ten years later by *The Expanding Discourse: Feminism and Art History.* In England, *Old Mistresses: Women, Art and*

Ideology, ed. Roszika Parker and Griselda Pollock, was published by Routledge in 1981.

6. Pollock acknowledges having learned what it is that women want from a children's version of "Sir Gawain and the Loathly Lady," where one of King Arthur's knights must lose his life or guess the right answer to the question, "What do women most desire?" ("Gaze and the Look," 130 n. 42). Pollock's ekphrasis is thus citational, referring to a centuries-old text of anonymous origin where feminism's "current struggle" is already scripted.

7. Cassatt might have been surprised, for instance, by Pollock's suggestion as to where her painting's protagonist is directing her so purposeful look. A more obvious inference, given the painting's title, would be that she is watching the opera!

8. Ted Hughes, "Your Paris," in *Birthday Letters* (New York: Farrar, Straus and Giroux, 1998), 36.

9. W. J. T. Mitchell, "Showing Seeing: A Critique of Visual Culture," in *Art History, Aesthetics, Visual Studies,* ed. Michael Anne Holly and Keith Moxey (Williamstown, MA: Sterling and Francine Clark Institute, 2002 [dist. Yale University Press]), 232.

10. Ruth Webb, "*Ekphrasis* Ancient and Modern: The Invention of a Genre," *Word and Image* 15, no. 1 (January–March 1999): 7. Hereafter cited in the text. Should ekphrasis be classified as a topos, a rhetorical "situation" or device, a mode, a trope, or a genre of writing? Some scholars have found it expedient to keep their options open; thus, for example, in *The Sculpted Word: Keats, Ekphrasis and the Visual Arts* (Hanover, NH: University Press of New England, 1994), hereafter cited in the text, Grant F. Scott calls it a trope, a genre, and a topos within the space of two sentences (xi). Heffernan argues that ekphrasis is not a genre, "because it lacks the distinguishing formal features we find in such traditional genres as epic, dramatic, and lyric" (ibid., 194 n. 20); he seeks in this way to invoke a tradition going back to Homer that includes ekphrastic set-pieces embedded in longer works of both prose and poetry. The tradition that concerns us in this volume is that of the freestanding ekphrastic lyric, which emerged as a distinct subgenre in English and American poetry during the nineteenth century. Alastair Fowler pertinently suggests, in "The Formation of Genres in the Renaissance and After," *New Literary History* 34, no. 2 (Spring 2003), that genres "differentiate, more or less systematically, a combination of features" that "may include . . . favorite rhetorical figures . . . favorite subjects and typical themes" (190). Of ekphrastic poetry's favorite rhetorical figures we will have more to say later in this introduction.

11. "Domesticating" is John Hollander's word for the decision to depart from his own prior usage in favor of the latinized spelling: see *The Gazer's Spirit: Poems Speaking to Silent Works of Art* (Chicago: University of Chicago Press, 1995), 349 n. 1. Henceforth cited in the text.

12. Webb exaggerates this tendency, perhaps. Hagstrum, Hollander, and Scott each point out that what the Greek rhetoricians taught under the rubric of "ekphrasis" was "the skill to create set descriptions, intended to bring visual reality before the mind's eye by means of words" (Hagstrum, *Sister Arts,* 29; cf. Hollander, *Gazer's Spirit,* 5, Scott, *Sculpted Word,* 10).

13. Hollander begins his book as follows: "*The Gazer's Spirit* is not a theoretical study of ekphrasis. It is rather a book that takes the reader on walks through a notional gallery, hung both with images and with poems addressing those images. Whether, in each case, the poem should be thought of as hanging across from, below, alongside of, inscribed in, helping to frame, or even turning away from the picture or piece of sculpture in question, the reader will decide" (Hollander, *Gazer's Spirit,* xi).

14. "All ekphrasis is notional, and seeks to create a specific image that is to be found only in the text as its 'resident alien.'" W. J. T. Mitchell, *Picture Theory: Essays on Verbal and Visual Representation* (Chicago: University of Chicago Press, 1994), 157 n. 19. Henceforth cited in the text. Cf. Grant Scott, who finds that "Romantic ekphrasis represents a nostalgic attempt to recapture the power of Hephaistus by creating the artwork anew in the verbal imagination of the poet" (*Sculpted Word,* 18). In the present volume, cf. especially Wynn Thomas's essay on Lucy Brock-Broido.

15. Leo Spitzer, "The 'Ode on a Grecian Urn,' or Content vs. Metagrammar," *Comparative Literature* 7 (1955): 203–25. Webb points out that in Gotthold Lessing's *Laocoön,* a nineteenth-century discussion of poetry's difference from painting that was often cited in twentieth-century discussions of ekphrasis, the term itself never appears (Webb, "*Ekphrasis* Ancient and Modern," 10).

16. See Heffernan, *Museum of Words,* 3; and Mitchell, *Picture Theory,* 151–52. Heffernan suggested this definition first in "Ekphrasis and Representation," *New Literary History* 22 (1991): 297–316. Peter Wagner, in his introduction to *Icons— Texts—Iconotexts: Essays on Ekphrasis and Intermediality* (New York: Walter de Gruyter, 1996), observes that it is the definition "most experts now seem to accept" (14). Barbara Fischer argues in *Museum Mediations: Reframing Ekphrasis in Contemporary American Poetry* (New York: Routledge, 2006), hereafter cited in the text, that our definition of ekphrasis needs to be more capacious to allow for poems that address *nonrepresentational* works of visual art, as well as poems that do not "'represent' their subjects at all, riffing off their visual sources more tangentially or interrogatively" (2).

17. Scott's inclination "is to stress the more specifically aesthetic elements in the definition of ekphrasis, a creative process that involves making verbal *art* from visual *art*" (*Sculpted Word,* 1). But the question of titles is well worth mentioning, since a title's "verbal representation" of the work has often (though not always) been provided by the visual artist, who could thereby be said to have set the ekphrastic process going. From this perspective, verbal representation is already implicit in the visual or sculptural work itself.

18. Jean Hagstrum argues that Horace's phrase, in its original context, means only "as sometimes in painting, so occasionally in poetry"; it has acquired the force of a prescription ("Let a poem be like a painting") only through being cited out of context (cf. Hagstrum, *Sister Arts,* 9). The first chapter of *The Sister Arts* includes a brief survey of what several important classical thinkers contributed to a "pictorialist" view of the aims of poetry and rhetoric.

19. Wendy Steiner, *Pictures of Romance: Form Against Context in Painting and Literature* (Chicago: University of Chicago Press, 1988), 122.

20. "Pregnant moment" is G. E. Lessing's phrase: both he and Steiner are thinking of the visual paradox that is endemic to Renaissance action painting. Heffernan's propensity for a gendered account of ekphrasis is conspicuous here; neither Steiner nor Lessing has used the pregnancy metaphor to "feminize" visual art.

21. This quotation is from W. J. T. Mitchell, "Ekphrasis and the Other," *South Atlantic Quarterly* 91, no. 3 (Summer 1992), 702, hereafter cited in the text. (A revised version of the essay that expands and clarifies, without essentially changing, its argument was included in *Picture Theory* two years later.) The original essay will be cited by its title for any wording that appears only there.

22. The registers of "otherness" that interest Mitchell are those that are politically as well as psychologically consequential. Cf. Scott, *Sculpted Word,* xii: "In this sense, ekphrasis is more enticing by far than Lessing's time-space conundrums would suggest, because it is political."

23. The wording of the first part of this quotation is from the original essay, where both the passages quoted in this sentence appear on 705; in *Picture Theory,* the second passage appears verbatim on 168.

24. Scott cites Mary Ann Caws as having called this a "'crucially undervalued' aspect of ekphrasis" in 1989 (Scott, 181–82, n. 4). Cf. Caws, *The Art of Interference: Stressed Readings in Verbal and Visual Texts* (Princeton, NJ: Princeton University Press, 1989), 240. Elizabeth Loizeaux, in *Twentieth-Century Poetry and the Visual Arts* (New York: Columbia University Press, forthcoming), takes hold of Mitchell's essay somewhat differently: for Loizeaux, "the power of Mitchell's argument lies in his perception of the inherently social nature of ekphrasis."

25. Scott, *Sculpted Word,* xiii; Murray Krieger, *Ekphrasis: The Illusion of the Natural Sign* (Baltimore: Johns Hopkins University Press, 1992), 1. Krieger's 1967 essay, "The Ekphrastic Principle and the Still Movement of Poetry; or *Laokoön* Revisited," hailed by Mitchell as "the single most influential statement on ekphrasis in American criticism" (*Picture Theory,* 153 n. 8), is included as an appendix in the book-length study cited by Scott. Mitchell cites Lessing's *Laocoön* as a "classic expression of ekphrastic fear" (cf. *Picture Theory,* 154–55).

26. J. D. McClatchy, *Poets on Painters: Essays on the Art of Painting by Twentieth-Century Poets* (Berkeley and Los Angeles: University of California Press), xiii. Notably, however, the heterosexual bias of Mitchell's paradigm is not apparent in McClatchy's remarks.

27. Hollander remarks that "the fashionable use of 'gaze' in critical studies of film and photography, as well as of the painting of the eighteenth and nineteenth centuries, seems to have come, perhaps via Georges Bataille and Jacques Lacan, from Sartre's pages on *le regard* in *L'etre et le néant,*" but notes that *le regard* was originally rendered into English by Hazel Barnes, in her 1956 translation, as "the look" (Hollander, *Gazer's Spirit,* 351 n. 10).

28. "This division of roles," Steiner suggests (*Pictures of Romance,* 46), "is akin to that in courtly romance, where the lady first appears to her love as a disembodied dream image, a portrait, or a figure seen 'from afar.'" In her more recent polemic on behalf of beauty, Steiner points out that "in traditional myths of aesthetic creation, such as Pygmalion and Galatea," it is a male artist whose love for his own work of art brings it to life as a beautiful woman who can breathe and speak and return his love. Steiner, *Venus in Exile: The Rejection of Beauty in Twentieth-Century Art* (New York: Free Press, 2001), 8–9.

29. Mary Ann Caws, "Ladies Shot and Painted: Female Embodiment in Surrealist Art," in *The Female Body in Western Culture: Contemporary Perspectives* (Cambridge, MA: Harvard University Press, 1985), republished as chapter 9 of *The Art of Interference.* In *Ways of Seeing* (London: BBC/Penguin, 1972; New York: Viking, 1973), John Berger explains the logic of this division of roles with copious illustrations from the history of Western art.

30. It was in the Renaissance, says Hagstrum, that *ut pictura poesis* began to be cited out of context as a directive for the poet (see n. 18 above); at that point it did become associated with "paragonal" rivalry. But the reason why it became such an important dictum for the Renaissance was the revival of naturalism, and hence of *enargeia,*—that is, of an ancient (pre-Christian) desire "to approximate in verbal art the beauty and vivacity of the real world" (Hagstrum, *Sister Arts,* 65).

31. Caws, "Ladies Shot and Painted," 134; this passage is also cited by Sarah Lundquist, "Reverence and Resistance: Barbara Guest, Ekphrasis, and the Female Gaze," *Contemporary Literature* 38, no. 2 (Summer 1997): 283.

32. Lundquist, "Reverence and Resistance," 286 suggests that Guest's poems "add an alternative" to the claim that ekphrastic poetry speaks "about, to and for paintings": Guest's ekphrastic poems "speak *with* the paintings" (emphasis added). Lundquist cites Caws at this point for her welcome emphasis on celebration, resistance, and dialogue.

33. The Hague convention of 1954 affirmed that "damage to cultural property belonging to any people whatsoever means damage to the cultural heritage of all mankind" (http://portal.unesco.org). Anthony Hecht and Richard Wilbur went to Europe first as soldiers, but returned as tourists after the war.

34. Plath's ekphrastic poetry and her "painterliness" as a poet have been discussed by Leonard Scigaj, "The Painterly Plath That Nobody Knows," *Centennial Review* 32, no. 3 (1948): 220–49; Jane Hedley, "Sylvia Plath's Ekphrastic Poetry," *Raritan* 20, no. 4 (Spring 2001): 37–73; and Sherry Lutz Zivley, "Sylvia Plath's Transformations of Modernist Paintings," *College Literature* 29, no. 3 (Summer 2002): 35–56.

35. This list is from Fischer, *Museum Mediations,* 18. Elizabeth Bergmann Loizeaux also calls attention in "Ekphrasis and Textual Consciousness," *Word and Image* 15, no. 1 (January–March 1999), 80, to how museums "have become not just the sites of ekphrasis, but commissioners and/or publishers of ekphrasis."

36. Cf. also Catherine Paul, *Poetry in the Museums of Modernism: Yeats, Pound, Moore, Stein* (Ann Arbor: University of Michigan Press, 2002).

37. Terri Witek, *Fools and Crows* (Alexandria, VA.: Orchises Press, 2003). Jarman's assessment is on the back cover.

38. Steiner, *Venus in Exile,* 138.

39. Cf. Hollander, *Gazer's Spirit,* 7: "In the presence of a work of Art, Poetry seldom makes the manifest claim that its own further removal gives it a greater authority, and its usual rhetorical stance is awed deference. But just such a claim is often latent."

40. These terms and definitions are cited from Gideon Burton's taxonomy of rhetorical questions in *Silva rhetoricae,* an online rhetoric based at Brigham Young University (http://humanities.byu.edu/rhetoric/silva.htm).

41. For a good example of a revisionary intervention of this kind by an art historian, see Anna C. Chave, "New Encounters with *Les Demoiselles D'Avignon:* Gender, Race, and the Origins of Cubism," in Broude and Garrard, *Reclaiming Female Agency,* 301–24.

42. Hadas does not discuss this particular poem in her first-person essay for this volume; interested readers may find it, along with a reproduction of Botticelli's painting, in Hollander's "gallery" of poetic ekphrases (cf. Hollander, *Gazer's Spirit,* 344–46).

43. Museum ekphrases always tend to have an iconic dimension, to the extent that the poem is framing its object and/or offering to break the frame: John Ashbery's "Self-Portrait in a Convex Mirror" is paradigmatic in this regard.

I

A Female Tradition?

All three of the essays in this part broach the question of whether there is a distinctively female tradition of ekphrasis. If there is, they suggest, it has arisen in reaction to a dominant tradition that poets who are women have found inhospitable or uncongenial. "The strongest women poets," suggests Joanne Feit Diehl in an essay that plays off Sylvia Plath, Elizabeth Bishop, and Jorie Graham against one another, have ventured beyond "a tradition of ekphrasis that was deeply gendered." In so doing, Diehl suggests, they open up the possibility that a "female-identified ekphrasis" may acquire the capacity to throw off the paralysis that shadows that tradition. Barbara Fischer calls attention to the work of three postmodern poets who have undermined, resisted, and/or proffered alternatives to a traditional paradigm that has persistently thematized "female erotic otherness." Cole Swensen, Kathleen Fraser, and Anne Carson stage interart encounters that are distinctively postmodern in their awareness of the museum itself as a venue for both traditional and countertraditional stances.

Paul Fry, whose theory of ekphrasis was first put forward in *A Defense of Poetry* in 2005, takes the position that there is a transhistorical difference in ekphrastic sensibility between poets who are women and poets who are men. In his essay for this volume he uses the antiekphrastic stance of Gjertrud Schnackenberg to extend and complicate his earlier claims about what women poets "see in pictures."

Toward a Theory of Ekphrasis:
The Female Tradition

Joanne Feit Diehl

WHETHER OR NOT THEY WERE CONSCIOUSLY AWARE OF IT, TWENTI-
eth-century American women poets inherited a tradition of ekphrasis
that was deeply gendered. This legacy envisions a paradigm in which
the viewer is identified as male and the object of the gaze as female.
In response, the poems of Sylvia Plath, Elizabeth Bishop, and Jorie
Graham offer distinct configurations of the relation between poetic
speaker and object viewed. For Plath, speaker and object are identi-
fied with the contested Romantic self; for Bishop, the erasure of
heterosexuality frees the speaker to return to sensation and history in
order to recalibrate the relative values of poetry and visual art; for
Graham, gender, in the example I have chosen, recedes as she ven-
triloquizes male voices and privileges the powers of the philosophic
mind as verbal strategy comes to the fore.

The dynamic of the earlier, dominant model of ekphrasis depends
upon what W. J. T. Mitchell understands as a heterosexual paradigm:
"female otherness," he writes, "is an overdetermined feature in a
genre that tends to describe an object of visual pleasure and fascina-
tion from a masculine perspective, often to an audience understood
to be masculine as well."[1] Indeed, from the beginnings of our literary
culture, ekphrasis has been predicated upon a psychological model
wherein, to quote Joshua Scodel, "ekphrastic objects are normally
treated as compensatory substitutes for the unfulfilled desire for a
female Other. . . . The ekphrastic object registers both the woman
that the poet cannot capture in poetry and the possibility of another,
beneficent relationship between a poet and his male audience."[2]
This triangular relationship, which is reminiscent of the more gen-
eral pattern that Eve Kosovsky Sedgwick has identified as a homoso-
cial model of male engagement, does, nevertheless, contain within it
two alternative scenarios. In the first, put forth by W. J. T. Mitchell
and Grant Fraser Scott, "ekphrasis is a mode of writing in which the
male poet ambivalently responds to an image typically viewed as

female: an image that excites both 'ekphrastic hope'—the desire for union—and the 'ekphrastic fear' of being silenced, petrified, and thus unmanned by the Medusan 'other.'"[3] Bracketing the Medusa theory as the master trope of ekphrasis by characterizing it as just one "strand in the fabric of ekphrasis," James Heffernan asserts that upon occasion the sight viewed by the "ekphrastic spectator propels the viewer to action."[4] Nevertheless, in both versions the heterosexual paradigm of male viewer and female object remains constant. *Confronting such a tradition, what might the woman poet who wishes to engage in ekphrasis do?* Each of the poets I have chosen to discuss presents a different version of ekphrastic writing that responds in its own way to the gendered paradigm that precedes her. Keeping in mind the need for caution when discussing an engendered poetics, I invoke "female subjectivity" as a category that is marked by awareness of the woman poet's specific position in the traditional ekphrastic paradigm while allowing for the scope of individual difference.

For Plath such subjectivity involves placing the woman at the center of the ekphrastic paradigm as both observer and object observed. While Plath wrote at least nine poems that allude to specific, identifiable artworks early in her career (most on assignment for *ArtNews*), these tend to be rather conventional in their relation to the visual representations they evoke. They deploy descriptive techniques and fantasy material called forth by the artistic sources to meditate on color, form, and myth. What interests me, however, is the depiction of a more fundamental relation articulated by a number of poems— that between the viewer and the representational power of self-reflection, the representation of the mirror image. It is this relation of self and reflection that thematizes the problematics of Plath's attitudes toward ekphrasis. If we agree with James Heffernan that "the mirror is the most powerful and enduring of all figures for both verbal and visual representation,"[5] then an examination of the mirror in Plath's poetry may reveal much about Plathian subjectivity vis-à-vis her relation to ekphrastic tradition, herself, and the world.

In Plath's poem "Mirror," the viewer of the visual representation is no longer male but female; the relation between viewer and viewed is that between the self and an uncanny version of the viewer, but interestingly the speaker of the poem is neither the viewer nor the viewed, but the male-identified presence of the mirror.[6] As the poem reveals what the gazer in the mirror witnesses and her growing horror before that image, we are reminded of the inevitability of the passage of time. Whereas in traditional ekphrasis a major distinction appears between the stasis of the visual object and the temporal realm of the verbal artifact, here it is the revelatory glance into the mirror reflect-

ing the passage of time that is itself caught in its verbal representation. The relationship between viewer and viewed is, of course, based upon physical appearance, and its alteration results in a lamentation that registers the fear of aging. Thus, the viewer sustains a narcissistic relation between herself and the eye of the mirror, "that little god."

Writing from the point of view of the mirror, Plath states, "I am silver and exact." Escaping the mirror's "truthful" gaze, the viewer turns to "candles or the moon"—kinder because softer sources of light. As the mirror is significant for the viewer, so the woman signifies the coming of dawn to the mirror. Returning to the mirror's visual representation of the passage of time, the poem closes by articulating the despair the viewer literally *faces:* "In me she has drowned a young girl, and in me an old woman / Rises toward her day after day, like a terrible fish." Out of the depths of reflection comes the image that signifies the "horrors" of aging and its inevitability.

In "Mirror," then, the female self, seeing her image reflected in a visual object, is confronted with a relationship that ends in the painful reflection of narcissistic objectification. The verbal representation of this mutually dependent relationship, spoken in the deceptively innocent, present-tense voice that emanates from the mirror, site of identification, conjures up a scenario fraught with the dangers of such narcissistic doubling. Plath's poetics, as I have argued elsewhere, evolves from the Romantic tradition.[7] Here Plath reinscribes that tradition's objectification of the feminine, but with a difference, for she lends the objectified female "other" a subjectivity of her own. Desire lies at the heart of Plath's writing, a desire that critiques as it eroticizes the ekphrastic relationship she inherits.

To Plath the relation between subject and object constitutes a form of control as she seeks simultaneously to preserve both her subject position and the object being described. Paradigmatic of this relationship is "In Plaster," which presents an evolutionary unfolding of an autoerotic situation.[8] It may seem strange to call this an ekphrastic poem, but "In Plaster" provides a poetic articulation of a visual representation—only, here the visual representation is three-dimensional and has an overtly healing character. Although this medicinal purpose is primary, aesthetic qualities do enter into the poem as the cast ages and its color turns. Without violating the boundaries of identification, "In Plaster" may be read, I would suggest, as an ekphrastic poem to the extent that it depicts a molded form that resembles sculpture.

This identity is important, because it enables us to see the typical relationship between Plath's imagination and the visual representations that lie beyond it. The cast that the speaker inhabits is, of

course, fitted to the speaker's body, so that inside and outside remain in intimate contact with each other. The cast as visual object gives way to tactile description—one of the key distinctions of Plathian ekphrasis, wherein self and other are often fused or in danger of merging yet fight off the need to merge. The speaker in many of Plath's poems articulates the "consciousness" or "feelings" of the visualized or experiential other. Mitchell's rhetorical question is apposite here, acquiring resonance for Plathian poetics: "Suppose the 'other' spoke for herself, told her own story, attempting an ekphrasis of the self?"[9] In the dialogic structure of "In Plaster" this is exactly what Plath accomplishes; for although she does not speak directly from the viewpoint of the cast, she does let us know how the cast feels, its motives and desires. The symbiotic relationship of cast and person underscores liminality as the emotions of one and then the other shift:

> At the beginning I hated her, she had no personality—
> She lay in bed with me like a dead body
> And I was scared, because she was shaped just the way I was . . .
>
> . . . I couldn't understand her stupid behavior!
> When I hit her she held still, like a true pacifist.
> Then I realized what she wanted was for me to love her:
> She began to warm up, and I saw her advantages.[10]

In the poem's closing stanzas, tension builds as the cast, according to its occupant, wants to leave her—and the competition between the two develops into a life-and-death struggle. The self triumphs over the plaster cast, leaving it to "perish with emptiness then . . ."

To call this poem ekphrastic and say that it exemplifies Plath's relation to this tradition suggests that, for her, surfaces are crucial: the self, in its relation to objects, projects itself into them only to be threatened by their abrading qualities. Endowed with feelings of competition and deep ambivalence, Plath's ekphrastic poems reenact fundamental themes of infant-mother ambivalence, preoedipal paradigms of attachment and rejection, and identification of infant with mother only to seek to cut off these aspects of the self. Both "Mirror" and "In Plaster" recount the history of a relationship between viewer and viewed or inhabitant and inhabited. It is this historicity, its very relationality, that characterizes the distinctively female, gendered nature of Plathian ekphrasis. In "Mirror," the voice of the poem itself reflects the viewer's own reflections as she peers into it in a visual echolalia that comments on itself. "In Plaster" provides a similar play of identities, as the cast that has assumed the

shape of the body it covers nevertheless establishes a difference that originates in similarity. The interrelation intrinsic to the dynamics of these poems operates more generally in all of Plath's later instances of ekphrasis. To sum up, when, in Plath, the other tells her own story, the listener hears a dynamic tale that bespeaks the troubled, conflictual tensions that surround Plath's understanding of her own identity.

Unlike Plath, Bishop calls into question the binary of masculine and feminine itself; gender for her constitutes a variable position as a poem's speaker assumes a masculine or a female voice. The implication of such gender switching for the poet's relation to the art object is that issues relating to gender raise questions about identity and the assumption of various poetic guises to visualize representation. For a poet known for her visual accuracy, this repositioning of an engendered point of view may cause a problematic relation between speaker and object (recall, to name just two examples, "The Monument" and "The Gentleman of Shallott"). But in the first example I have chosen Bishop evades the problematic question of gender. That she names this work "Poem" speaks to its emblematic, aesthetic importance. Thus to read it keeping in mind the absence of gender identification allows us to focus on the direct, deeply personal response the speaker achieves examining her great-uncle's painting. "Sonnet," my second example, speaks to the possibility of escaping from the entrapment of a prescriptive, binary system that demands balance. While for Plath the subjective voice speaks for a distinctly heterosexual position, for Bishop the "self" constitutes a break from the traditional, engendered identifications of poet and visual object. Bishop's poetics reencodes the subject/object opposition and thereby calls into question the paradigm of heterosexuality that marks the dominant tradition of ekphrasis.

"Poem," Bishop's most explicitly ekphrastic composition, could not be further in tone from Plath's work.[11] Bishop's poem is a deliberately provisional, anecdotal response to an extremely small painting by her great-uncle, a poem that hides its vast ambition behind the guise of the casual.[12] For the poem takes as its subject nothing less than an appraisal of what verbal and visual art can accomplish.

As part of this appraisal, "Poem" introduces not only historical subjectivity but human perception into the viewer's experience of the painting. The poem opens,

> About the size of an old-style dollar bill,
> American or Canadian,
> mostly the same whites, gray greens, and steel grays

—this little painting (a sketch for a larger one?)
has never earned any money in its life.
Useless and free, it has spent seventy years
as a minor family relic
handed along collaterally to owners
who looked at it sometimes, or didn't bother to.

Spoken in an approximating, minimalist language, this description points to the painting's lack of commodity value, which is supplanted by its capacity to sustain human connections. The last line, with its "or," a characteristic Bishopian equivocation, attests to the picture's dependence on the owners for its acquisition of meaning. In the poem's second part, the speaker moves back and forth between an acknowledgment of the illusion of the real created by the painting and a commentary on painterly technique. After identifying the landscape's site as Nova Scotia, the viewer's gaze moves to the details of the painting. "In the foreground," Bishop writes, "a water meadow with some tiny cows, / two brushstrokes each but confidently cows. . . ." In these lines and those that follow, the speaker moves between drawing attention to the painting's composition and to the reality it represents, raising questions about the status of representation itself. Elsewhere the speaker describes what would be felt, not seen, in the landscape: "The air is fresh and cold; cold early spring / clear as gray glass. . . ." This recording of perception brings the scene alive by emphasizing sensation. The written work of art supersedes the visual image because the poem can extrapolate to all aspects of the sensate individual's feelings rather than be restricted to the suggestive realm of the entirely visual. In one of the several moments of humor in the poem, the viewer's spontaneous response to what she sees courts confusion: "A specklike bird is flying to the left. / Or is it a flyspeck looking like a bird?"

In the poem's third section, the viewer identifies the specific scene represented by the picture. And while she cannot recall the name of the farmer whose barn backs onto the meadow depicted, she nevertheless underscores a theme that predominates from here to the poem's close, that of the passage of time melding with the preservation of it through memory: "Those particular geese and cows," Bishop notes, "are naturally before my time." By specifying the animate objects of representation and their existence in the fleeting past, the poet brings them to life while distancing the speaker from them. Continuing to interpolate words from her aunt, who has given her the painting, Bishop gives the painting's provenance, a history that emphasizes kinship, thereby accentuating the artifact's role in preserving collateral, familial relationships. It is the painting that ties

her to her great-uncle George. Combining themes of representation, illusion, and memory, Bishop writes,

> Our visions coincided—'visions' is
> too serious a word—our looks, two looks:
> art 'copying from life' and life itself,
> life and the memory of it so compressed
> they've turned into each other. Which is which?
> Life and the memory of it cramped,
> dim, but how live, how touching in detail
> —the little that we get for free,
> the little of our earthly trust. Not much.

The poem closes with a description of the scene that returns us to a living, historical presence observed by the attentive speaker:

> the munching cows,
> the iris, crisp and shivering, the water
> still standing from spring freshets,
> the yet-to-be dismantled elms, the geese.

This vision of ongoing life, caught in the midst of things, nevertheless registers a loss (the yet-to-be), which hints at a future knowledge subsequently known by the current viewer. Thus, the poem, in its final moments, invests the painting with a temporal aspect that would ordinarily be absent from visual representation. Sensation and memory, crucial attributes of human subjectivity, are thus read into, as they are extrapolated from, the painting. Freed from the explicit categorization of gender identity, the speaker here makes herself known relationally, with the painting a key element in preserving family memory.

In a short poem that treats the division and unity of the individual and ends with the word "gay," Bishop, at the end of her life, addresses a theme she had earlier tackled in those poems that deal with image, representation, and reflection as a way of addressing questions relating to ontological instability, self-division, and self-knowledge. I quote the poem in its entirety not to privilege the poem's final word, "gay," but to demonstrate Bishop's desire to break out of a balancing act necessary to maintain the evenness of a level and enter into a freedom that produces a new kind of joy:

> Caught—the bubble
> in the spirit-level,
> a creature divided;
> and the compass needle

> wobbling and wavering,
> undecided.
> Freed—the broken
> thermometer's mercury
> running away;
> and the rainbow-bird
> from the narrow bevel
> of the empty mirror,
> flying wherever
> it feels like, gay![13]

Escaping from the now empty mirror, the bubble is freed from its captivity. Once "a creature divided," it now flies "wherever / it feels like, gay!" Herein may lie the secret of Bishop's own escape from the conventional heterosexual ekphrastic paradigm. Having evaded, through her own homosexuality, the confines of an explicitly patriarchally derived cultural identification, Bishop herself is free to return to fundamental questions of time, memory, and representation—questions that have for so long haunted the tradition of a male-gendered ekphrasis.

In our own time, Jorie Graham stands out as writing most persuasively on subjects related to the visual arts. This cosmopolitan and philosophic voice goes further than either Plath or Bishop in assuming a stance that at times veers sharply from an identification with a specific gender. Proceeding associatively in a mode of almost oneiric subjectivity, Graham may move from visual image to contemplation and back again with an imaginative expansiveness of astonishing scope. Given her strong identification with female subjects (poems of mother and child, for example), we can read poems where no allusion to the female voice appears as an alternative and deliberate choice. I, therefore, do not mean to suggest that Graham's relation to representation is always by way of ungendering her voice; rather, I choose to consider a strikingly successful example of a poem about a painting where the voices we hear are masculine voices (Hopkins and Pascal), and no woman speaks. In what follows, I suggest the stance the speaker takes toward a visual object endowed with special meaning: the Magritte painting of Pascal's coat.

In "Le Manteau de Pascal," Graham opens speaking from the point of view of Pascal. From here the poem moves like a fantasia, employing frequent repetition of images and entire lines to create a mimetic narrative that, as Bonnie Costello has suggested, itself resembles a woven narrative.[14] The coat initially acquires value through the woman who made it: "It is a fine admixture. / The woman who threw the threads in the two directions, headlong, / has made, skillfully,

something dark-true . . ."[15] Graham then introduces a simile that compares the making of the coat to a natural scene: "as the evening calls the birds up into the branches of the shaven hedgerows / to twitter bodily / a makeshift coat—the boxelder cut back stringently by the owner / that more might grow next year, and thicker, you know— . . ." After starting another verse paragraph that opens "I have a coat I am wearing," dealing with human action, Graham draws us back to the visual field: "You do understand, don't you, by looking?"[16] The coat "floats in illustration / of what was once believed, and thus was visible— / (all things believed are visible)—." As if waiting to be inhabited, the coat offers "hovering empty arms, an open throat, / a place where a heart may beat if it wishes, / pockets that hang awaiting the sandy whirr of a small secret, / folds where the legs could be, with their kneeling mechanism, /. . . this form, built so perfectly to mantle the body . . ."

By emphasizing the making of the coat and its uses, what it feels like to inhabit the coat, Graham, like Bishop, draws us subjectively closer to the object while simultaneously insisting on its distance from us. She achieves this effect by, on the one hand, making us aware of the generally acknowledged usefulness of the coat, and, on the other, by emphasizing its singularity. Description of the coat is interrupted by a different kind of discourse: words of Gerard Manley Hopkins writing in his journal. Hopkins writes of oak trees, emphasizing the formal systems of their appearance. A sense of intense scrutiny and wonder prefaces the sudden declaration, "It was this night I believe but possibly the next that I saw clearly the impossibility of staying in the Church of England."[17] For both Pascal and Hopkins, issues of faith take precedence over all other subjects. Graham, by citing this passage, ventriloquizing the poet's voice, draws out the similarity between the two men. Later, extracts from Pascal's journal and imagined words from the coat appear, preparing us for the close of the poem, an extraordinary tour de force, as almost every line repeats a former one. This Whitmanian, choral climax echoing the words, "I will vanish, others will come here." from earlier in the poem, registers the coat's existential importance: it provides us access to the mind of Pascal, as well as his hesitations and eventual faith in God, the "proof" of which was sewn into his pocket, unread, by his sister.[18]

Graham thus uses ekphrasis to write a philosophic, allusive poem that investigates issues of faith and poetic mimesis (the repetition of the poem reflecting the weave of the coat). Gender, if present at all, is here by exclusion, an avoidance of sexuality in favor of faith. As Helen Vendler has remarked, "In enlarging her scope to include

the metaphysical questions of necessity, intentionality, human self-definition, and cultural inscription, Graham, like other philosophical poets, reminds us that human beings have, in addition to an erotic, domestic, and ethical life, a life of speculative thought."[19]

If Graham has explicitly elided the role of gender in this poem and elsewhere, she has done so in the face of a Romantic tradition that conceptualizes the ekphrastic paradigm as heavily gendered, not just in the ways mentioned so far in this essay, but in the even more dramatic "primal scene," as Mitchell calls it, when the Medusan powers of the ekphrastic object threaten to paralyze and silence the male viewer. Writing of Shelley's manuscript poem, "On The Medusa of Leonardo Da Vinci in the Florentine Gallery," Mitchell notes:

> If ekphrastic poetry has a "primal scene," this is it. Shelley's Medusa is not given any ventriloquist's lines. She exerts and reverses the power of the ekphrastic gaze, portrayed as herself gazing, her look raking over the world, perhaps even capable of looking back at the poet. Medusa is the image that turns the tables on the spectator and turns the spectator into an image: she must be seen through the mediation of mirrors (Perseus' shield) or paintings or descriptions. If she were actually beheld by the poet, he could not speak or write; if the poet's ekphrastic hopes were fulfilled, the reader would be similarly transfixed, unable to read or hear, but perhaps to be imprinted with alien lineaments, the features of Medusa herself, the monstrous other projected onto the self. . . . Medusa is the perfect prototype for the image as a dangerous female other who threatens to silence the poet's voice and fixate his observing eye. Both the utopian desire of ekphrasis (that the beautiful image be present to the observer) and its counterdesire or resistance (the fear of paralysis and muteness in the face of the powerful image) are expressed here.[20]

Mitchell takes us back to the mirror, which now has the efficacious capacity, through its powers of reflection, to protect the masculine viewer from the direct, Medusan gaze. For the woman poet, however, Medusan power might take on a different meaning, as with female identification may come an inoculation that protects the woman from the petrifying capacities of the female phallus. Escaping the psychodynamics of Medusa and her masculine viewer, the female subject may discover through the revised sexual drama in which she plays a crucial part a relationship that fortifies rather than subdues her. Thus, protected from the gaze of the Medusa, the strongest women poets find themselves free to venture beyond such a heterosexually inscribed paradigm, thereby erasing and surpassing the inherent limitations implicit in the heteronormative patterns of the ekphrastic tradition.

To the extent that the woman poet can rid herself of the burden of speaking to or for the semiotic "other," a female-gendered ekphrasis acquires its own trajectory. The tradition of a female ekphrasis continues to deepen, and with it a shift from the exclusive identification of the masculine viewer with the gaze. When the woman poet assumes the role of the witness and tells what she sees, she may speak from many positions, only three of which I have touched on here. But from whatever angle the female viewer approaches the semiotic object, she does so marked with a difference inscribed by her sexuality, a difference that has wide-ranging implications for the poet and her readers.

The poems of Plath, Bishop, and Graham offer distinct configurations of the relation between poetic speaker and object viewed. For Plath, speaker and object are identified with the contested Romantic self; for Bishop, the erasure of heterosexuality frees the speaker to return to sensation and history, the relative values of poetry and visual art; for Graham, gender, in the example I have chose, recedes, along with an individualized poetic stance, as the powers of the philosophic mind and the verbal imagination come to the fore.

But the story would not be complete if we ignored a third, crucial factor that I can only touch upon here: the effects this female-inflected, alternative ekphrastic tradition might have on its readers. For, if the poetic speaker is female and the reader is a woman, they potentially might establish a relationship that would emphasize links between speaking subject and reader. Or, if the speaker is female and the reader male, the Medusa effect might adhere to the poet so that the reader would feel simultaneously paralyzed and empowered. Whatever the configurations (and there are many), the female-to-female model of reading may itself offer an alternative to the paradigm of male poet and male-identified reader, as the female viewer comes into contact with a female-identified representation. Consequently, the female poet might form a link on a continuum where the reader comes into contact with the ekphrastic process freed from the fear associated with male dread of the Medusan object, thus achieving a more direct contact with the ekphrastic process itself. Beyond the fear of this process, a woman writer may construct for her reader a poetics that takes on the lineaments of unfettered desire.

Thus a female-identified ekphrasis may acquire the capacity to throw off the paralysis that in part undergirds the masculine version. When she does so, the reader recognizes a voice that need not sacrifice vitality to acquire the gift of poetic power. We can provisionally sketch the beginnings of a distinctive ekphrastic tradition grounded in a female aesthetic that offers us access to texts that signify nothing

short of another way to read. It seems fair to say that such an alternative model both evades the patriarchal associations of a male-gendered ekphrasis and puts in its place a paradigm that may have pragmatic value for all of us who continue to read and admire the ekphrastic poem.

NOTES

I would like to thank the English Department at the University of California, Davis, for its support in helping to defray the costs of permission to use copyrighted materials.

1. W. J. T. Mitchell, *Picture Theory* (Chicago: University of Chicago Press, 1994), 168.

2. Quoted in Mitchell, 165, from correspondence with Joshua Scodel.

3. This is James A. Heffernan's summary in *Museum of Words: The Poetics of Ekphrasis from Homer to Ashbery* (Chicago: University of Chicago Press, 1993), 108.

4. Ibid., 109.

5. Heffernan, *Museum of Words,* 176.

6. See Sylvia Plath, "Mirror," in *The Collected Poems,* ed. Ted Hughes (New York: Harper & Row, 1981), 173 for the complete text.

7. See Joanne Feit Diehl, *Women Poets and the American Sublime* (Bloomington: Indiana University Press, 1990), 155 and passim.

8. Sylvia Plath, *The Collected Poems,* 158.

9. Mitchell, *Picture Theory,* 184.

10. Sylvia Plath, *The Collected Poems,* 158.

11. Elizabeth Bishop, "Poem," in *The Complete Poems* (New York: Farrar, Straus, Giroux, 1986), 176.

12. For illuminating discussions of "Poem," see Langdon Hammer, "Useless Concentration: Life and Work in Elizabeth Bishop's Letters and Poems," *American Literary History* 9, no. 1 (1997): 162–80, particularly 174–76; and Bonnie Costello, *Elizabeth Bishop: Questions of Mastery* (Cambridge, MA.: Harvard University Press, 1991), 226–33.

13. Elizabeth Bishop, "Sonnet," in *The Complete Poems* (New York: Farrar Straus, Giroux), 192.

14. See Bonnie Costello, "A Review of *The Errancy,*" *Boston Review,* October/November 1997: 49–50.

15. Jorie Graham, "Le Manteau de Pascal," in *The Errancy* (New York: Ecco Press, 1997), 64.

16. Ibid., 65.

17. Ibid., 67.

18. Ibid., 70.

19. Helen Vendler, *Soul Says: On Recent Poetry* (Cambridge, MA: Belknap Press of Harvard University Press, 1995), 242.

20. W. J. T. Mitchell, *Picture Theory,* 172.

The Lamplit Answer?: Gjertrud Schnackenberg's Antiekphrases

Paul H. Fry

In "The Torturer's Horse: What Poems See in Pictures," I claimed that poems find in pictures and other visual representations an enviable freedom from the sometimes irksome compulsion to make sense of things.[1] In saying this about pictures, poems are of course misreading visual signs, which are no more at liberty to stop making sense than verbal signs. Yet ekphrastic poems do, nonetheless, with obvious moral ambivalence, see painting highlighting the moment of *insignificance* in phenomenal perception: "unsignificantly / off the coast / there was / a splash quite unnoticed" (W. C. Williams, "The Fall of Icarus"); "The unfeeling armor of old time" (Wordsworth, "Peele Castle": in Sir George Beaumont's painting the rectangular castle seems a kind of anticanvas, dark on light, within the canvas). It is the larger argument of the book in which "The Torturer's Horse" appeared that "poetry" (literature, literariness) at all times harbors the longing to say that things *just are.* To say, that is, how astonishing their just being there is, rather than to say, as of course it must, that things are interesting because they have differential identities as objects of epistemology, ideology, or desire. When this craving for sheer "ostension" is overt, as frequently it is in the later nineteenth-century ekphrases of Rossetti, Swinburne, and Pater, it evokes languor, lassitude, the Hour of Pan, and indifference (i.e., implicitly, in-difference). I claim that whereas a resistance to predication, a craving for sheer ostension, is never not present in literariness transhistorically considered, it becomes a dominant theme of ekphrastic poetry.

Or rather, this envy of painting's in-difference becomes a dominant theme in ekphrastic poetry by *men.* In women's ekphrastic poetry, as I tried to demonstrate in "The Torturer's Horse" with reference to poems by Phillis Wheatley, Anna Seward, Elizabeth Bishop, Mary Jo Salter, and Debora Greger, we more often find a recoil from in-difference on behalf of some form of sympathy with otherness. In

returning to this theme now in the work of Gjertrud Schnackenberg, I find her poetry raising an issue I had not seriously considered before, in ekphrasis written either by men or by women. Schnackenberg's poetry shows that ekphrasis may be so disappointed by what it sees, or fails to see, that it takes an iconoclastic turn.

The belief—ostensibly a matter of common sense—that for better or worse the raison d'être of verbal and visual art alike is *aesthetic* has been the rock on which virtually all thinking about the arts has foundered since Modernism and the New Criticism set the paradigm in place. For theorists of ekphrasis including Murray Krieger, W. J. T. Mitchell, and James Heffernan, the object of the literary gaze, an object that writing aims to seduce for its own purposes, is the "beautiful."[2] This object has been gendered feminine ever since commentators first noticed the eroticized metaphors for the beautiful in the writings of Addison and Burke (Mitchell finds these in Lessing as well).[3] The moment of aesthetic judgment in Kant, our most important theorist of "the beautiful," cannot be "disinterested," because the sexual or acquisitive desire for the beautiful can never be neutralized.[4] This claim in itself would suggest that women's ekphrases must certainly resist the genre's sexism, if not necessarily its capitalism; but gender-inflected theories of ekphrasis typically do not pursue the matter in that way. This is not surprising, since for theory it can scarcely be a question of men and women (who are not genders, only sexes), but becomes a question rather of the logic of an appropriative relationship in which one is chiefly speaking of poetry's designs on painting, not men's designs on women. That is the avenue explored by Mitchell especially, starting with his *Iconology*.

This fixation on the aesthetic, whether in celebration or critique, has repressed the *ontological* (or better, the *ontic*) in reflections on the function of poetry for most of the twentieth century. If in the eyes of poetry visual art is really a displaced female or otherwise eroticized body, a desirable form, then poetry's own aspiration must be as iconic as the New Critics told us it was, appropriating for itself what John Crowe Ransom called "the world's body." I do not wish to argue that this sort of aspiration is absent, or has no role to play, in the self-conception of poetry. It should be obvious, though, that placing an exclusive emphasis on it leads to the conclusion that art owes its very existence to its potency as a psychoanalytic or cultural fetish.

The basis of ekphrasis in desire seems to me unquestionable. The question remains, however: desire for what? I suggest that what poems see (and envy) in pictures is not beauty or knowledge but being. What I mean by "being" is the material, somatic, embodied "there-being" of things (as Heidegger would call it), which resembles

the Kantian sense of the aesthetic only in possessing the kind of self-sufficiency, or indifference to the gaze, that gives the vocabularies of sexual and cultural politics their somewhat misleading plausibility.[5] The desire that paintings awaken is a desire for the absence of desire, for an escape from the turmoil of desire's rationalizations—which is to say, of signification. For women writing ekphrastic poetry, however, as I said unguardedly in 1995 yet still believe, what is more often aroused is a desire for what is seen to be *absent* from the "ostensive" moment in painting. In turning now to Schnackenberg's ekphrases I hope to show that this desire need not linger in poignancy, but can also assume a dazzlingly virtuoso negativity.

Poets writing in the postwar era acquired their polish not just from MFA workshops but from college classes in English literature, where they found themselves exposed to literary criticism and also to literary theory. They learned thereby that even though in their own milieu they were likely to prefer book reviewing to academic criticism, there was nevertheless a difference between reviewing and criticism that could not be ignored. They learned, in short, that whatever a reviewer's or poet's preferences may have been, in the eyes of criticism a poem was a verbal icon. They internalized, thus, the lesson about which ekphrastic theory is still debating the pros and cons. They learned about the Metaphysical Poets: little worlds made cunningly and little rooms (*stanzas*) in sonnets. They learned that the gold of Byzantine tesserae forms the magnificent singing school of "the mature" Yeats.[6] No wonder, then, that the workshops and English classes alike inspired a "new formalism" in the period during which Gjertrud Schnackenberg's first published poems were being written.[7] *Portraits and Elegies* (1982) begins with an epigraph from Yeats decrying slovenly poems as "extravagance of breath" ("Vacillation"), and even the title poem in the more recent *A Gilded Lapse of Time* (1992) takes, or rather experiments with the possibility of taking, its inspiration from the Byzantine mosaics of Ravenna. Her memorable way with a line and with poetic endings she owes chiefly to Lowell—who had long been contriving to relax his forms but whose instinct for the high-voltage line never lessened—but her emphasis on craft was of the moment, if not the movement.

Yet from the very beginning there is a complex self-irony, even self-mockery, in Schnackenberg's formalism, and there is no better way to see how it works than to study her earliest ekphrastic passage. The first elegy of the series for her father in *Portraits and Elegies*, "Nightfishing," sees the relation between representation and reality as a kind of whorl or nautilus. The remembered twirling boat merges with the twirl of

the clock hands. The moon dropping over the lake merges with the moon on the clock. The lake itself becomes the growing abyss of time marked by the clock hands, "pushing me, oarless, from the shore of you."[8] In this poem the memory of night fishing with her father, now three days dead, is framed by an ekphrasis of the clock face. That an ekphrasis is in progress (has she been reading Krieger?) is pointedly signaled by the verb in the first line, which lends itself to the title of the book: "The kitchen's old-fashioned planter's clock portrays . . ." (*PE*, 1). What the clock face portrays is a "happy" process world, the reassuring cycle of the planting seasons, the forward progress of time contained by the timelessness of recurrence, just as the verbal icon is supposed to contain time like a "happy, happy" well-wrought Grecian urn. But the poet is *not* happy, even with the comfortably prosaic formalism of the clock, and insists on the bad faith of this household image. A clock is a clock, human and melancholy enough to know that it marks time rather than constraining it; hence it "covers its face with its long, thin hands" (ibid.).

It is as though Schnackenberg had begun her career with a pronouncement: No aesthetic moment can be a lie against time, hence there is no use looking for it in the visual arts. To be sure, the constraint of time and the transcendence of time are two separate matters, and Schnackenberg's persisting interest in the latter motivates her continued focus on the visual arts, especially those that aspire to a Yeatsian permanence. But before turning to the possibility of transcendence in her early ekphrases, let me touch briefly on the question (returning to it more fully in my concluding remarks on *The Crux of Radiance*) whether there is any trace of an "ostensive" interest in a poem like "Nightfishing," and whether as a woman Schnackenberg turns away from it. Very faintly such an interest can be discerned, faintly because it is only an allusion to a topos and because it is displaced from the ekphrastic frame of the poem to the remembered event—from the representation of a representation to the representation of a past present. Schnackenberg writes of the lake experience, addressing her father: "You stop the oars, mid-air. We twirl and float," like a world rotating in space (*PE*, 2). Here she alludes to an eighteenth-century topos in elegies for father figures, Collins's "Elegy for the Death of James Thomson," and Wordsworth's youthful "Remembrance of Collins" (a kind of first poem for him), poems in which the silence of "the dashing oar" suspended while boating on the Thames is a shared motif. This is a genre scene, hence in a sense what John Hollander would call a "notional ekphrasis."[9] These oars, as in the boat-stealing episode of *The Prelude*, represent the recurrence of meter, the suspension of which suspends time. This

is the moment of being that men writing poems try to borrow from visual art, and Schnackenberg wants none of it. The true and only oars propelling us forward, she says, are the hands of the clock, over which neither poet nor painter have control: "Clock hands sweep by it all, they twirl around, / Pushing me, oarless, from the shore of you" (*PE*, 2). So much for form, says this formally intricate poem; but so much also for the thereness of things, even and especially those addressed as "you." For the woman poet confronting art, there is neither escape from human loss, nor consolation for it.

Unless, perhaps, one looks for the transcendence rather than the containment of time. In pursuit of this possibility one finds in Schnackenberg a running commentary on Yeats's Byzantium, often cruelly parodied in delicious rhyme, as when describing the walls of the mad Ludwig in Neuschwanstein ("Bavaria"):

> Romanticism's last hysteria
> Of Niebelungen murals golden-iced
> Along the Hall of Song, the King with Christ
> Floating in gold above Bavaria
>
> (*PE*, 7)

The lunatic king, who anticipates the half-mad Tiberius uncertain about his godhead in *The Crux of Radiance,* will soon enough be "floating face down on the lake" (*PE*, 8). There is a fascination with gold everywhere in Schnackenberg's work, not Donne's gold to airy thinness beat but Yeats's firmer stuff: the "stiff gold tails" of the letters spelling "*Steinway*" on her father's piano ("Intermezzo," in *PE*, 3), the "gold rope in a knot" around the waist of a figure in Gérard David's *La Vierge et les Saintes* to whose identity we must return ("The Living Room," in *PE*, 37), the "Blizzard-sprinkled flakes of gold" that "Gleam," fixed in place, "from small interiors" in "Advent Calendar,"[10] and everywhere, of course, in the aptly entitled "Gilded Lapse [or apse] of Time."

Yet all this gold remains somehow incidental, especially in the later work that stresses the crumbling and pulverization of monuments, including the golden ones. Schnackenberg gathers also from Yeats, in this case from the great ekphrasis "Lapis Lazuli," that transcendence may lurk not in the perfection of art but in its flaws. Many of Schnackenberg's miniature ekphrases are about porcelain, and one senses that Yeats's lapis is mediated by Merrill's "Willoware Cup,"[11] as when, in the brilliant *Imaginary Prisons* (an apt description for the aesthetic moment of ekphrasis), another mad grandee appears. He is upset because his published article claiming that the world is made of unbreakable porcelain ("'The Paradigm of Glass Unbreakable'") is dis-

proved by a flaw in the china plate he stares at (*LA*, 30–31). Still, there is a kind of hope for this madman, who is surely a metaphysical wit steeped in the ekphrastic faith of the New Critics and the unrevised "Paradigm" of their critics. With patience he may come to understand that permanence rests in the flaw itself. He swears "a vow to stare"

> Until the fragile web of laws breaking
> The tragic glaze apart come to appear
> To be the laws by which it's held together.
>
> (*LA*, 31–32)

This is the "state of life so tickle" controlled by Spenser's Mutability, calling for faith in the principle—or that there is a principle—behind change. It is not to be confused with the permanence-in-recurrence theme rejected by Schnackenberg through the ekphrastic strategy of "Nightfishing." In dialectical terms, the flaw in the work of art—here the worm-spun and worm-eaten silk of ancient vestments—brings into consciousness, as negation, the concept of flawlessness:

> We cannot learn first hand
> The bleakness of the craft
>
> With which God made the world,
> We cannot recount the legend that,
> When they met face to face, both
> God and the worm laughed.[12]

From this concept Schnackenberg finds hope, or hopes that her Lutheran father found hope, in the print of the fifth scene in the "Battle of Hastings" sequence of the Bayeux tapestries, hanging in the historian's campus office ("'There are no dead,'" in *PE*, 18–19). It is the imperfection of the image that gives it life; she imagines the women employed in the stitchery, "too busy talking to repair / The small mistakes," to which the centuries have added "the blind white moth / And grinning worm that spiraled through the cloth." But this very crudeness is a vitality, and has allowed Walter Schnackenberg to read the panel, aided by the interwoven text and by the "medieval" element of narrative development within the scene, as the defiant moment in which William of Normandy proclaims that death shall have no dominion, and to identify with this typological resurrection—at least until the last line:

> There William of Normandy remounts his horse
> A fourth time, four times desperate to drive

Off rumors of his death. His sword is drawn,
He swivels and lifts his visor up and roars,
Look at me well! For I am still alive!
Your glasses, lying on the desk, look on.

(*PE*, 19)

A grim cenotaph for "the gazer's spirit" (Shelley, "On the Medusa"), uncanny in their survival of their wearer, like Fitzgerald's "eyes of T. J. Eckleburg," the glasses declare that if vision is to be improved, it must become artificial. Hope, certainly, but hardly reassurance. Schnackenberg is not prepared to say merely that we see through a glass darkly. That view would be too transparent. For her, recurrently in *A Gilded Lapse of Time* (see, e.g., *GL*, 69, 74, 82, 83), we stand in front of a wall, by no means always a frescoed wall. It is typically in decay—its flaw—and that may afford us tiny chinks to see through, or in any case "pinhole pricks" to guide us, in keeping with the practice of Piero della Francesca ("The Resurrection," in *GL*, 83).

Is there an element of gendering in any of these views? Perhaps it can be found in the degree of iconoclasm, or mistrust at the very least, in Schnackenberg's treatment of visual images. This could be read, admittedly, as a gendered self-distancing from a male aesthetic, but I see it as disappointment with the aesthetic as such, which has both a "male" and a "female" component. Were she proffering a women's aesthetic, the argument might go as follows: When she takes up the gaze from a male point of view—something more than one reviewer thinks she does too readily[13]—she sees the emptiness, the blurring of signs, in pictures, and the uncanniness of negation in them: "The family portraits blindly stare, / All haunted by each other's likenesses" ("Darwin in 1881," in *PE*, 21). But the aged Darwin's consciousness sees the whole world, not just pictures, as a kind of Waste Land (note her sustained allusion in this poem to Eliot's "Game of Chess"). Hence the aesthetic poverty of male rationalism here portrayed somehow points toward the Ash Wednesday and Four Quartets, respectively, of "Supernatural Love" (*LA*, 81–83) and *Gilded Lapse* (including *Crux of Radiance* and the ode to Mandelstam), as female epiphanies induced by sympathy.

I have just suggested, though, that these later poems see through a wall obscurely. Bolstered perhaps by her interest in philosophy, Schnackenberg's ekphrases to an amazing extent refuse to look at the images in front of them while using these undescribed images as a springboard for her empathetic entry into "other minds." Most notable here is "The Dream of Constantine" in the *Crux of Radiance* sequence, subtitled "Piero della Francesca" to let us know she really has that fresco in mind. It is one of Piero's best known, and certainly

invites hermeneutic description. And yet, in a poem of five pages Schnackenberg evokes the picture just once, not to describe Constantine lying asleep in the tent (in this Legend of the True Cross series, Constantine is said typologically to recall the dying Adam in the first fresco), but rather to describe, even in this moment, what is not in the picture: "You awaken, in a tent on the field of battle" (*GL*, 90). This is not in the picture she has evoked, but in the dream of the other mind it suggests (encouraged, to be sure, by the title), and the aftermath of that dream. Her ekphrasis does not describe the picture but accompanies it, as a supplement of sympathetic understanding.

This poem brings into full view what is characteristic of Schnackenberg's ekphrases: they are about what is not there in the pictures. A good example is "The Self-Portrait of Ivan Generalic" (*LA*, 13–14). Generalic's picture *Self-portrait* (fig. 2), painted by the Serbo-Croatian folk artist in the year of his wife's death (1972), portrays the bowed,

Fig. 2. Ivan Generalic, *Self-portrait*, 1975, oil on glass. Zagreb: The Croatian Museum of Naïve Art.

shaven head of the painter (a mourning custom) against a solid backdrop of blue violet as vivid as black light. Most of Schnackenberg's poem describes the rich barnyard, landscape, and village imagery of Generalic's typical, Brueghelesque paintings, as though that imagery were in *this* painting, suggesting that no imagery can now suffice; yet for her the painting is haunted, given a phantom density, by the poignancy of what is not in it. Toward the end of the poem Schnackenberg does give us first a discontentedly religion-filtered sense of the black light in the painting ("I take it up with Him whose evening streaks / The violet flash of Christ beyond the fence, / As tears make purple clouds of Bible ink" [*PE*, 13]), and then a grim sense of the world deserted not just by imagery but by meaning: "our windows darken into squares / Of night, from which you've vanished, window squares // Like Bibles closed forever, squares of black" (*PE*, 14). This poem, though spoken by the male painter, is shaped by the female refusal to wish for insignificance. Whether either Generalic or Schnackenberg were struck by the resemblance of this head to that of Max Schreck in Friedrich Murnau's *Nosferatu* is impossible to say, but it is clear enough that for both of them he is, precisely, the Undead.

Despite her continuous interest in confronting works of art, Schnackenberg's oeuvre to date offers only one sustained ekphrastic description that addresses the details of the work confronted, yet that very ekphrasis involves a feint that confirms rather than qualifies my claim that she typically describes what is not there. A poem called "Living Room" (*PE*, 37–38) begins with what seems to be a sustained description of a painting in the Rouen Musée des Beaux-Arts by Gérard David called *Virgo inter Virgines,* or *La Vierge et les Saintes* (fig. 3). The Virgin, says Schnackenberg, "is perfectly dressed, / Silk sleeves, green velvet gown, and jeweled cap; / Waves cascade down her back. . . . / And round her waist a gold rope in a knot," and she holds a Book of Hours in her lap (*PE*, 37). Most of this is a meticulously accurate description of one of the women in the picture, but *it is not the Virgin Mary.* Mary is seated in the center wearing a dark, drab gown, not holding a Book of Hours, symbolizing the cyclicity of the temporal world (as does the kitchen clock in "Nightfishing"), but rather holding the Child, who in turn is holding a round bunch of grapes, eucharistic symbols of the fulfilled, redeemed world. The person actually described is one of the "companionable blessed" to the right. It is she who holds the Book of Hours, only it seems rather to be an illuminated book (a text, that is: temporality without cyclicity) and certainly does not show any of the landscape-with-peasants imagery that Schnackenberg enthusiastically describes as though it were there. (Possibly this scene is in the pages attributed to David in a

Fig. 3. Gérard David, *La Vierge et les Saintes*, 1509, oil on wood. Rouen, France: Musée des Beaux-Arts. Photo Credit: Réunion des Musées Nationaux/Art Resource, NY.

Book of Hours said also to be in the possession of the Rouen museum.) No one "touches her wedding ring" (ibid.). How could any *virgo* do that other than the *Virgo*—who is indeed wearing a wedding ring, as is the woman described? One must conclude that purity, or the question of what a "sainte" is, can only be understood metaphorically, as a transference of what is not there to what is, and not in the more literal, iconographically communicated mode of theology. If your model is—for example—the baker's wife, you ask her to take her ring off or you do not paint it, and it is only after the reader-viewer has grasped these complexities that a possibility dawns: the identical waves of hair cascading down the back of both figures suggests that the Virgin and the woman actually described were painted from the same model.

But with this difference: whereas it is indeed the Virgin whose "eyes are tolerant, / Dull with fulfillment" (*PE*, 37), like the grapes held by the Child (note that this is precisely the languor of the male ekphrastic moment featured repeatedly in Rossetti and turned away from here via Schnackenberg's turn from this central figure), the eyes of the woman to the right are open, and point us right out of the picture. She gazes down on Schnackenberg playing the piano, and "enjoys / Bach in Heaven" (ibid.). The poem as a whole is not an ekphrasis but a *paragone*, and its featured sister-arts rivalry is not painting versus poetry but painting and poetry versus music, with the palm awarded unequivocally to music, which alone transcends time

and space.[14] The last "sainte" in the poem—not excluding Schnack-enberg herself—is Mrs. Bach, Anna Magdalyn (two names from the life of Christ), "the first on earth" to hear her husband's heavenly music (*PE*, 38). One of Gérard David's specialties is "musician an-gels." They are in a great many of his Virgin-with-attendants scenes, and there are two of them here. What one is tempted to call Schnack-enberg's elaborate joke about displaced reference (this is not a pipe: a virgin is not a virgin, the painter and his models listen to music, the poet plays music) must have this thought as its punch line: represen-tation as such transfigures all things, leaving music to make even "Paradise a figuring of air" (ibid.: poem's last words). After all, how can it be, in a scene depicting the Virgin and Child, that "the compa-nionable blessed" are "in Heaven" (*PE*, 37)? Yet for Schnackenberg it is not focally a Virgin and Child; the absent center in her description is not even the Virgin, who is at least mentioned in passing, but the Child, who is replaced by a book. Something has been spirited into place that is out of place, just as this poem has been spirited into the sequence of historically receding vignettes concerning inhabitants of the poet's residence, 19 Hadley Street, placed between 1858 and 1843 ("The End of the World"), yet anachronistically anchored in a historical, domestic present ("We've hung David's. . . .")[15] which its homage to music nonetheless dissolves, together with history itself. This is not so much the longing for insignificance as the achieve-ment of it, but only through an extraordinarily complex chain of redirected relays.

One of Schnackenberg's most interesting virtuoso performances throughout her work is the displacement of ekphrasis away from itself in a surprising number of directions.[16] To watch this perfor-mance, on a miniature scale I shall imitate the taxonomic approach of Hollander's introduction to *The Gazer's Spirit,* though delineating different subcategories. Rather than "a verbal representation of a visual representation" (the definition is Heffernan's),[17] Schnacken-berg offers the following array of variants, each of which erases, dis-torts, or reconstructs the observed image. First there is the ekphrasis of ekphrasis, which takes two forms. It may be a description of some-one else's description of an image, as in the notes to "Annuncia-tion"—"The ambitious building activities of Herod the Great . . . are described by Josephus" (*GL*, 136)—or "Angels Grieving over the Dead Christ": "The title is from a description of the Thessalonikan epitaphios in *Byzantium,* by Paul Hetherington and Werner Forman" (*GL*, 137). Or it may represent language *as* an image or natural sign, as in the ascription of symbolic and anthropomorphic qualities to letters of the alphabet à la Kipling's *Just So Stories* in *The Throne of*

Labdacus.[18] Then there is the evocation of painting not as one sees it oneself but as one imagines another to see it: "Or were you," she asks her dead father whom she remembers having been "abstracted" on a walk, "with Van Gogh beneath the moon / With candles in his hatband, painting stars / Like singed hairs spinning in a candle flame?" ("Walking Home," in *PE*, 5).

Then again there are "gallery" or "museum" ekphrases that seem to be about only one picture but are actually a composite of many, sometimes not even identifiable pictures but simply a genre. Hollander calls this kind of poem a "capriccio."[19] "Rome" (*PE*, 15) may be about the catacomb of a particular church with its diabolical frescoes and mannerist crucifix, but it need not be. *Kremlin of Smoke* describes the imagery embroidered on a particular kind of carpet slipper worn both by Chopin and his teacher (see "Chopin's Apartment," in *LA*, 8; the note on 84 refers us to a biography of Chopin, so this example is also an ekphrasis of an ekphrasis). The title *Imaginary Prisons* is borrowed from Piranesi's proto-Escherian architectural fantasias, evoked en bloc and only in passing by Schnackenberg. The poem includes among its prisoners "the painter," who dreams of painting (he does not paint them) "utopian waterways" whose bridges between palaces are "dolphin-leaps" that may be Venetian, but which in context bear a closer notional relation to the mazes of Piranesi (*LA*, 35).

Yet another kind of displaced ekphrasis, or antiekphrasis, insists with Keats's "Ode on a Grecian Urn" on the impenetrability, the inaccessible otherness, of images:

> Their wedding photograph keeps under glass,
> A young couple cutting their wedding cake.
> Next to the photo sits a crystal bowl
> Of water and white rocks where angelfish
> Keep rising to a surface they can't break.
> ("Elizabeth and Eban, 1940," in *PE*, 31)

Just so, in "The Paperweight" (*PE*, 43), which is Schnackenberg's "Grecian Urn" with some of Stevens's "Snow Man" worked in, the poet observes a domestic scene in the snow under the toy's glass hemisphere, and learns "from this scene. . . what / It is to stand apart." "Beyond our touch, / Beyond our lives, they laugh, and drink their tea," just as "our" own winter scene may be observed at a comparable distance by some unknown, invisible consciousness that cannot penetrate *our*—other—minds. Then there is the motif of the politically or socially anachronistic, "precious" *locus amoenus*, filtered through the sensibility of Watteau or Fragonard to adorn porcelain

or ornamental hangings. This faery land forlorn appears most nota-
bly in *Monument in Utopia*, where the opening notional image of a
czarist estate with swans, willow park, statues, and ponds is a remote,
irrelevant dream to Mandelstam under Stalin, "A door pushed shut
in the Iron Age" (*GL*, 95). Or again, the image of the world is dis-
placed by the map of it, as in Schnackenberg's homage to Steven-
son's "Land of Counterpane," "Thanksgiving Day Upstairs" (*PE*, 36),
where the invalid's bed is "a thousand square miles / Of valleys,
meadows," made vivid by an atlas with "a map / Of North America."
Add to these the fond critiques of illusionism in the trompe l'oeil and
tableau vivant moments of *Kremlin of Smoke* (*LA*, 5, 6), the grim inex-
orability of objects that must be read as signs of the future, an im-
prisoning fate made visible ("Like words locked up in pencils, webs in
spiders, / Like flames imprisoned in the match tip's sulphur," in
Imaginary Prisons, in *LA*, 39)[20], together with the fleetingness of the
miniekphrasis ("Paper Cities," in *LA*, 62; "Advent Calendar," in *LA*,
78–80), and the variety of angles from which Schnackenberg's am-
bivalent iconoclasm can be viewed is more or less sketched in.

There is little or no ekphrasis—after the notional, frivolously irrel-
evant ekphrasis of the opening lines mentioned above—in the final
third of *Gilded Lapse*, the tribute to Mandelstam called *A Monument in
Utopia*, and there are no artworks to describe in *The Throne of Lab-
dacus*. Whatever Schnackenberg may write in the future, as of this
moment the splendid sequence called *The Crux of Radiance* (*GL*, 45–
87), to my mind a more successful poem than the touristic, Dante-
inspired struggle to see the stars—of the church of San Vitale!—that
precedes it,[21] can be read, in conclusion, as a farewell to ekphrasis.
Her focus must surely be the titular radiant cross, which is, one may
be tempted to say, the image that burns away all images. But a "crux"
is also an interpretive impasse or crisis, one that sustains the "lapse"
of the previous poem. This poem sequence, a gesture toward fresco
sequences like Piero's, frames the life of Jesus without touching on it,
moving directly from the Annunciation to the corpse, the Resurrec-
tion, and its inspiration of Constantine, just as her approach to
ekphrasis surrounds the pictorial subject or abjures it without touch-
ing on it. There can be no living icon. Tiberius knew this, for ex-
ample (in "Tiberius Learns of the Resurrection"), and in his am-
bivalence about his own deification he forbade the distribution of
statues and busts of himself as a god (*GL*, 138, note to "Tiberius
Learns. . . ."). Our alienation from images even of the divine in
death, the theme of the ekphrasis on Mantegna's famously discon-
certing *Christ Dead*, is reinforced by Schnackenberg's characteristic
exclusion of the crux. In this case she leaves out the two homely

mourners next to the body in the picture, who are there to enact the viewer's possible *participation mystique:* "You," by contrast, "may only rest your forehead / On the ancient mortarwork / That holds you back from him" (*GL,* 69). "You" the spectator are unable even to "put your eye / To a chasm in the wall."

The other three actual ekphrastic moments in the sequence, every poem of which is given a title that could be assigned to a painting, concern two Pieros (with a passing glimpse of his *Triumph of the Duke of Urbino*): *The Dream of Constantine* discussed above and, on two occasions, *The Resurrection,* with its triumphal image of the banner-bearing Christ about to spring aloft from the tomb. For a variety of reasons the centurions guarding the tomb are all distracted at this moment. One of them is asleep, and it is on this figure, the "Soldier Asleep at the Tomb," that Schnackenberg predictably concentrates (*GL,* 54–62). Male ekphrasis would see in this sleeper the gift of release from the arduous guardianship of the truth; Schnackenberg sees in him the impossibility of witnessing the representation of the miraculous. Her return to this picture, "The Resurrection," commends Piero, now old and blind, for the *imitatio Christi* of his devotion to art. Having been led up to his picture, Piero stretches out his hand to Christ. Yet what he finally sees, in his blindness, is what he never painted: Christ in Schnackenberg's account, not in the picture, stretches out "death's unraveled, pitiful bandages" to the sightless viewer (*GL,* 86), like Keats stretching out his macabre "living hand." It is a failed synecdoche in which what binds the wounds alone remains, and does not redeem them—a synecdoche for death, not life.

There is a hopeful composite symbol in "Supernatural Love" at the end of *The Lamplit Answer*—the answer in question being the etymology of the word "carnation" traced by her father at the lamplit dictionary stand. In this poem the ekphrasis of a child's embroidery is "incarnated" by the blood of her pricked finger (*LA,* 83).[22] By contrast, and more characteristic even of the exuberant poems in *The Lamplit Answer,* the angels at the end of *The Crux of Radiance* tell the Constantine who hoped to be victorious *in hoc signo* that light can be shed on nothing visible: "no lamps are lit in the cities your armies enter" (*GL,* 91).

No images allowed, then, or in any case no images visible, not even the radiant cross itself; yet it is hard to say why this is so when reading a poet whose keen responsiveness to art in all its forms is so clearly evident. Ekphrastic matters aside, Schnackenberg's poetry is haunted by Gerontion's "We would see a sign," without ever giving a clear sense of whether such a vision has been, on some occasion, vouch-

safed to her. Whether the poet remains on a darkling plain or chides those of little faith for *needing* a sign is not wholly clear, at least to me, and seems to depend on the striking variety of moods her poetry evokes. This variety is largely absent from *The Throne of Labdacus*—her most recent poem—in which the god Apollo himself remains in the dark, leaving little that counts as knowledge or faith except a fatality so obscure that it makes Hardy's seem reassuring. This grim sense of occluded design is, if anything, gendered male; or in any case it is usually men, or male characters, whom the literature of both sexes shows insisting on the darkness of the dark. This is why the frequent variants on ekphrasis in Schnackenberg's work should not be ignored in assessing her stance as a poet, and why one hopes that her future work will return to ekphrasis. Many of her gloomiest messages come from pictures, either from their opacity or their inadequacy, and she cannot rest content with what grandstanding male ekphrases—equally stark in outlook—enviously discern in pictures as the peace of meaninglessness. For her, meaninglessness can never be peace, and with this self-awareness to guide her she frames, alongside pictures, her own glimpses of hope and sympathy.

NOTES

1. Paul Fry, "The Torturer's Horse: What Poems See in Pictures," in *A Defense of Poetry: Reflections on the Occasion of Writing* (Stanford, CA: Stanford University Press, 1995), 70–87.

2. Murray Krieger, "*Ekphrasis* and the Still Movement of Poetry," in *Ekphrasis: The Illusion of the Natural Sign* (Baltimore: Johns Hopkins University Press, 1991), 263–88; James A. W. Heffernan, *Museum of Words: The Poetics of Ekphrasis from Homer to Ashbery* (Chicago: University of Chicago Press, 1993); W. J. T. Mitchell, *Iconology: Image, Text, Ideology* (Chicago: University of Chicago Press, 1986); Mitchell, "Ekphrasis and the Other," in *Picture Theory: Essays on Verbal and Visual Representation* (Chicago: University of Chicago Press, 1994), 151–81.

3. Mitchell, "Ekphrasis and the Other," 155.

4. Immanuel Kant, *The Critique of Judgment*, trans. J. H. Bernard (New York: Hafner, 1972).

5. Martin Heidegger, "The Origin of the Work of Art," in *Poetry, Language, Thought*, trans. Albert Hofstadter (New York: Harper & Row, 1971), 15–86.

6. Schnackenberg's learning is evident, especially in the classics, patristic literature, and philosophy. But I suspect her knowledge of criticism too goes beyond what she may have picked up at Mount Holyoke. For the relevance of Yeats, see Daniel McGuiness, "*A Gilded Lapse of Time*," *Antioch Review* 51 (1993): 656; and Dorothy Barresi, "Seeing Divine," *Parnassus* 18, no. 2–19, no. 1 (1993): 299.

7. See Dana Gioia, "Can Poetry Matter?" http://www.danagioia.net/essays/ecpm.htm, (repr. from *Atlantic Monthly*, May 1991); and Paul Lake, "Return to Metaphor: From Deep Imagist to New Formalist," in *New Expansive Poetry: Theory, Criticism, History*, ed. R. S. Gwynn (Ashland, OR: Story Line Press, 1999), 138–39.

8. Gjertrud Schnackenberg, *Portraits and Elegies* (Boston: David R. Godine, 1982), 2. Hereafter referred to in the text as *PE*.

9. John Hollander, *The Gazer's Spirit: Poems Speaking to Silent Works of Art* (Chicago: University of Chicago Press, 1995), 7ff.

10. Schnackenberg, "Advent Calendar," in *The Lamplit Answer* (New York: Farrar, Straus and Giroux, 1985), 78. Hereafter referred to in the text as *LA*.

11. Note the "patterns painted on white dinnerplates, // Blue willow-trees, blue, half-hidden estates" in "Thanksgiving Day Downstairs, 1858" (Schnackenberg, *Portraits and Elegies*, 35).

12. Schnackenberg, "Angels Grieving over the Dead Christ," in *A Gilded Lapse of Time* (New York: Farrar, Straus and Giroux, 1992), 68. Hereafter cited in the text as *GL*.

13. See esp. Sandra Gilbert, review of *The Lamplit Answer*, by Gjertrud Schnackenberg, *Poetry* 147 (1985–86): 163–67; and Christian Wiman, "Short Reviews," *Poetry* 179, no. 2 (November 2001): 91–92. Gilbert makes cutting comparisons with Felicia Hemans and Laetitia Langdon (review, 164), while Wiman, who is bored with the recent poems that are "almost exclusively about works of art or dead artists" ("Short Reviews," 92), remarks that Schnackenberg defers too easily to male authority (ibid., 91).

14. In a companion volume on women poets' descriptions of music, Schnackenberg would be at least equally prominent. One guesses that music matters more to her personally than painting does.

15. "The Living Room" begins: "We've hung David's *La Vierge et les Saintes* / Near the piano" (*Portraits and Elegies*, 37).

16. "[O]r even turning away from" the picture, writes Hollander in describing the variety of things ekphrasis can do (*Gazer's Spirit*, xi).

17. Heffernan, *Museum of Words*, 3.

18. Gjertrud Schnackenberg, *The Throne of Labdacus* (New York: Farrar, Straus and Giroux, 2000), 47–64. The *Throne of Labdacus* is a book-length poem rehearsing the fortunes of Oedipus, and in this section Schnackenberg reveals an interesting debt to the essay by Lévi-Strauss called "The Structural Study of Myth" in *Structural Anthropology*, trans. Claire Jacobson and Brooke Schoepf (New York: Basic Books, 1963), 206–31. In Schnackenberg's "The Alphabet Enters Greece," there appear the lines: "Before *Lambda* appeared like a lame man / Leaning on a stick, λ" (*Throne of Labdacus*, 49). Lévi-Strauss ascribes the letter "λ" in the names Labdacus and Laius to the "difficulty in walking straight" made manifest in the hamstrung Oedipus, and I suspect his decidedly out-of-the-way insight to have inspired Schnackenberg's reflections on the alphabet. "In this telling, time is synchronous," Ruth Fainlight points out in her review of the poem. Fainlight, "Touching the String," *Times Literary Supplement*, February 8, 2002, 25.

19. Hollander, *Gazer's Spirit*, 41.

20. Here we touch upon what many reviewers take to be her central theme. See, e.g., Adam Kirsch, "All Eyes on the Snow Globe," *New York Times Book Review*, October 29, 2000, 29.

21. Schnackenberg, *A Gilded Lapse of Time*, pt. 1, 3–41. Cf. Richard Tillinghast, "The Everyday and the Transcendent," *Michigan Quarterly* 32 (1993): 488.

22. In his excellent review article, Daniel Mendelsohn sees "Supernatural Love" as "a Janus figure in Schnackenberg's work," aided by the fact that she chose this as the title for her collected volume (2000), and in keeping with his sense that *Gilded Lapse* (all three parts of the volume together) is a "religious epic." Mendelsohn, "Breaking Out," *New York Review of Books*, March 29, 2001, 39, 38. Religiocentric, undoubtedly,

but faith seems elusive. Roseanna Warren, too, speaks of "the gilded lapses or rifts in time through which revelation gleams," and "just barely-open apertures to transcendence." Warren, "Visitations," *New Republic,* September 13, 1993, 37, 39. In contrast, Glyn Maxwell thinks that the faith of "Supernatural Love" may be sadly outgrown, and writes of "Schnackenberg's primary scene of a child gazing into light from shadow." Maxwell, "Things Done on Earth," *New Republic,* November 12, 2001, 56. I take my term "exuberance" from Stephen Yenser, who thinks that in recent times a "poetry of exuberance is written mostly by women." Yenser, "Poetry in Review," *Yale Review* 81 (January 1993): 164. I would not agree with William Logan, finally, that the ekphrases of *Crux of Radiance* "take their tone" from the indifference theme of Auden's "Musee des Beaux Arts." Logan, "Angels, Voyeurs and Cooks," *New York Times Book Review,* November 15, 1992, 15.

Noisy Brides, Suspicious Kisses: Revising Ravishment in Experimental Ekphrasis by Women

Barbara Fischer

WHEN CRITICS ARGUE THAT EKPHRASIS IMPLIES AN EROTIC EX-change, especially an exchange energized by male desire to ravish the female body, they tend to couch their claims in careful layers of critical metaphor and analogy. W. J. T. Mitchell explains that "the ekphrastic image *as* a female other is a commonplace in the genre" and then argues that "the voyeuristic, masturbatory fondling of the ekphrastic image is *a kind of mental rape*."[1] James Heffernan, who also stresses the connections of ekphrasis to rape, describes pictures that "break through the silence in which they, *like women,* are traditionally bound."[2] Katy Aisenberg, in her book *Ravishing Images,* claims that ekphrastic poets speak for images "*in the rhetoric of* possession, subordination, violence. . . ."[3] As my emphases on the distancing and tempering gestures in these quotations indicate, the matter of ekphrastic ravishment is presented not as a species of actual violence, of course, but as a critical trope, a way of talking about representations of power and desire. Interart encounters, in these accounts, seem to reproduce a hierarchical structure of dominance—male over female, text over image—in which "male" aligns with text, speaking, and beholding subject, and "female" with image, silence, and art object. Ekphrasis, the argument goes, unfolds along the rhetorical trajectory of erotic consummation, or romantic desire, or sexual aggression, carrying ideological weight but signifying violence only at several representational removes. There need not be an actual woman in the picture: ekphrasis evinces a masculine yearning for a "still unravished bride of quietness" while looking at, say, an urn.

Anne Carson, in one poem about a frustrated male artist, succinctly mocks this kind of slippage between woman-as-desired-object and object:

I hunger for Anna.
Passing a cubicle I saw a painting of her
and removed it to my room,
feverishly.
It proved to be a still life
of apricots and aqua minerale.[4]

Much to the disappointment of the desiring gazer, the object of desire turns out to be an arrangement of inanimate objects, a "feverish" projection. No matter how suggestive or voluptuously rendered, those apricots are still not a real body—they are not even an overt representation of a real body. Critics of ekphrasis, I contend, are prone to a similar confusion. By projecting a gendered power dynamic onto ekphrasis itself—onto the process of writing poetry in response to an artwork, and onto the results of that process—they overgeneralize this paradigm and risk overlooking the specific objects that ekphrasis may approach. In some cases, poets are not looking with rapacious gazes at all, but *at* rapacious gazes. Rather than treating the ekphrastic image *as* a female other, some poets address images that in fact *depict* female others in problematic ways, depictions that have complex effects on their ekphrastic perspectives and interpretations. This essay considers the work of three contemporary poets who turn to art that lays bare the theme of female erotic otherness. This thematic focus, while certainly not the only way that poets can confront the traditionally gendered paradigm for ekphrasis, constitutes one kind of intervention, one set of counterexamples. In recent ekphrastic work, Kathleen Fraser, Anne Carson, and Cole Swensen challenge the critical commonplace of ekphrasis-as-ravishment by inverting it: they demonstrate that ekphrasis can expose and interrogate the objectification of women rather than duplicate it.

In "La La at the Cirque Fernando, Paris" (1988), Fraser employs an innovative mode of wordplay to dramatize the issues of possession and exploitation that underpin Edgar Degas's 1879 painting of a showgirl. Carson's sequence "Hopper: *Confessions*" (2000) assembles a collage of fragmentary ekphrases that both invite and rebuke the impulse to "confess" the erotic liaisons implied in Edward Hopper's paintings. Cole Swensen's "Triage" (1999) frames an ekphrasis of Rodin's *The Kiss* in the context of its museum environs and alongside several other examples of eroticized looking.

There are significant differences in these poets' styles and techniques, as well as in the poetic and political motives that underlie their different brands of experimentalism, but all three reenvision ekphrasis in the context of postmodern poetics and reflect the heterogeneity of that practice in late twentieth-century American writ-

ing. All three use modes of verbal collage and juxtaposition to run interference in the circuitry of ekphrastic desire: their arrays of fragments record interruptions and distractions, cross-references and cross-purposes. All three employ multiple speakers instead of a single, unified lyric voice, a technique that unsettles the ekphrastic occasion by introducing more viewpoints than that of a single gazer. Moreover, they all produce sequences rather than self-contained ekphrastic lyrics, opening the arena of the ekphrastic poem to a wider periphery of verbal-visual play. In these ways, I will show, they instigate discomfort with the erotic assumptions of the ekphrastic occasion, and offer revisionary readings of male artists' portraits of female subjects.

"TONGUE-TIED STILL": FRASER ON DEGAS

"La La at the Cirque Fernando, Paris," a poem in twelve parts, presents a layered meditation on Degas's painting of a female circus performer hanging from the ceiling by her mouth (fig. 4). In Fraser's telling, La La's performance is both striptease and freak show, an erotic spectacle enabled by "a rubber bit with narrow troughs / for teeth" (*il cuore : the heart*, 161).[5] Fraser uses ekphrastic procedures of description and narration to evoke her fictional account from the viewpoint of first victimizer, then victim, shifting the manner in which the story is voiced to complicate the ways ekphrasis invites collusion or solidarity with each party. Vivid details from the painting ("papaya ceilings," "a pulley, a ship's long rope," "cut-out boots laced high over tights") accompany an imagined backstory of La La's impoverished early life in Avranches. Fraser then presents Fernando's seduction and exploitation of La La, whom he plies with liquor so she is willing to perform the painful stunt and "pull silky things / between her legs . . ." (ibid., 160). The poem seems at first to be dramatizing a classic ekphrastic motive, presenting a scenario that exemplifies James Heffernan's generalization of the ekphrastic encounter as "the voice of male speech striving to control a female image that is both alluring and threatening."[6] Yet the poem proceeds to undermine this attempt at control: Fraser brackets Fernando's voice and allows La La to speak against her role as the centerpiece of an erotic spectacle.

To represent this resistance, Fraser employs an experimental verbal tactic. As she explains in a note on the poem's genesis, the text is built around a "matrix" of words from La La's history (including

Fig. 4. Hilaire-Germain-Edgar Degas, *Miss La La at the Cirque Fernando*, 1879, oil on canvas. London, © The National Gallery.

"do," "ring," "try," "rise," "calmed," and "edge"), words that she re-
cycled from draft versions of the poem to suggest a new account of La
La's germinal attempt to speak for herself. Like other postmodern
poets who employ "mesostics" to generate new verbal possibilities (an
"acrostic" in which the capitalized source text appears midword or
midline), Fraser relies on an aleatory procedure that foregrounds the
potentialities of the language itself.[7] The poem, Fraser explains,

> discovered its final matrix of words inside the existing partial draft of the
> poem, arising initially from a typo . . . in which the D of the second
> syllable of FernanDo had been accidentally capitalized. La La's grid of
> words was *then* constructed from the second parts of other two-syllable
> words, searched out in the already existing text; La La's private matrix
> thus evolves from her own fragmented story—that of a young circus
> performer, learning to hang by her teeth from a ring. Within minutes the
> matrix appeared, revealing a core lexicon or set of word clues needed by
> La La in order for her to come into possession of her own voice and her
> autonomy from "the boss." (*il cuore : the heart,* 196)

Fraser explains that her compositional process, which relies on
chance typographical errors, helped liberate new verbal possibilities
that she sees as emblematic of La La's attempt to speak for herself.[8]
This postmodern emphasis on the mechanics of writing is, for Fraser,
part of a larger feminist language practice, an exploration of the ways
language can be an effective means to female autonomy and self-
possession.[9] In this poem, the "matrix" of words catalyzes counterten-
sions in the story of La La's plight, suggesting that the ekphrastic
process has sparked not only description and narration, but a recon-
figuration, at the level of the signifier, of the meanings that process
has produced.

Throughout the poem, Fraser shakes words loose from her ek-
phrastic descriptions to explore the troubling implications of Degas's
vision of this woman's theatrical feat. When La La says, for example,
"I could be whirRing / in air & / disappear. . . ." (*il cuore : the heart,*
163) the capitalized R dislodges the word "ring," which reappears as
"a ring the size of a wrist"—the device that is at once her lifeline and
her implement of torture. Juxtaposed with first-person observations
like these, Fernando's coercive voice is blunt: "Shut your eyes, / bite
down hard on this / and I'll show you Paris" (ibid.). Presenting
Fernando's words in quotation marks within La La's monologue,
Fraser is able to do two things at once: give voice to a female image,
and expose the way the picture hinges on a woman's objectification:

Fernando's talk and Pernod doubles me over
and I'm down. . . .

.

"Named her La La, bought her
white gauze, yellow ribbon and
sent her off to the dressmaker for
a seethrough circus suit & a full-length cape
to drop over it . . . or drop to the floor.

"She crosses her ankles when she hangs there
like a bat (a little blind),
twirling

and twirling. Thought

 —Who'd be interested in a naïve counTry girl
 just hanging-on with her teeth,
 as if hanging by her neck?—
I'll tell you who."

 (*il cuore : the heart*, 162)

La La articulates what happens to her, and then overhears Fernando's dehumanizing boast. He lays claim to her identity by naming and costuming her, scripts her erotic performance, and then likens her to an animal. When the bald fact of her action—"hanging-on with her teeth"—is spoken in the context of his assurance of commercial success, the grim violence of the spectacle is apparent. Fernando's comparison "as if hanging by her neck" suggests an almost murderous intent. Only the capitalized T in "counTry," which yields the word "try" in La La's revisionary matrix, suggests a miniscule interruption of his crass reverie—a hint of a way out, of effort and exertion.

La La's own speaking parts show that while she complies with Fernando's instructions, her aspirations and longings quickly break down under the strain of the act:

 My mouth took
 the bit in it. Each time
 Fernando turned the handle
 he told me to soar like an angel
 arching. Going up,
 I could see
 me spinning from his hand,
 taut rope, jawed-down

> cells jabbering
> rubber bracket bit
> & face lifted frown. . . .
>
> (*il cuore : the heart,* 162)

Her experience changes quickly from one of self-consciousness and
vertigo ("I could see / me spinning") to intense discomfort, as the
heavy alliteration of *b* sounds suggests ("jabbering / rubber bracket
bit"). La La's confusion is enacted in the syntax: a complete sentence
presents Fernando's command that she transcend her earthbound
body, as the line break on "angel" emphasizes, but once she goes
"up," the language fragments into tense monosyllables and dis-
jointed phrases. To manage her feat, La La finds that she must with-
draw to an imagined interior: "In pain (neck and arms), / but bind-
ing myself / with Fernando's words I sink down / between ice and
lightning, go inside / of inside (echo & over)" (ibid., 164). Enduring
physical pain, she is quite literally "binding [herself]" in "Fernando's
words"—male speech that controls a female image indeed. His
words make her act possible, but they are also the source of her
suffering, and Fraser makes clear that she reads La La's compliance
as a sexual subordination: "(In my dream his cock rises high / with
the two-holed snout of a pig. . . .)" (ibid., 165). In graphic terms,
Fraser presents her character's plight as a struggle not only against
male speech but also against male physical and sexual force.

Fraser encapsulates La La's erotic objectification, and gestures
toward the locus classicus of ekphrastic ravishment, when she has
Fernando refer to her as "a kind of bride for a kind of price" (ibid.,
165): La La is an already ravished bride, and her ravisher trades on
her losses. Nonetheless, the poem proceeds to allow La La to talk
back:

> For strength of molars chewed bark and raw cashews.
> But tongue-tied still,
> tied down in empty air
> with ribbons, yellow, see-through gauze,
> (no silky things, no furs)
> and more than anything their eyes,
> almost always surpRise
> when no fall comes.
>
> Fernando's instructions are always
> to drop the cape
> just as he cranks me up.

(But it's only a cape.)
Inside of inside
I will never drop.

<div align="right">(il cuore : the heart, 166)</div>

La La demystifies the feat by explaining her physical training for it, eliding the "I" who chews but underscoring her own strength and resilience. She may be "tongue-tied still"—quite literally bound at the mouth in the apparatus of her act—but the poem offers a version of the circumstances from her point of view. In her perception, the most important part of the experience ("more than anything") is her awareness of her impact on the reaction of the spectators. The text preserves her ability to "Rise" from the "surpRise" of the spectators who fix her in their gazes (getting a "Rise" out of them and Fernando too), and stresses her ability to defy their expectation that she will fall. The sensationalism of the spectacle is countered by the "rising" speech of the female figure as protagonist, not object.

Fraser's ekphrasis, blending description and dramatic monologue with wordplay, suggests that the figure of La La represents both erotic victimization and resistance to it. Reinstating the first-person pronoun, La La's vow—"I will never drop"—sounds at once naive and resolute, pathetic and defiant. The poem ends with a "Coda" that rewrites the first matrix of error-generated words as an array of possibility, the last row of which is "now need speech" (il cuore : the heart, 168). The poem's concluding words thus suggest the immediacy and urgency of La La's attempt to come into "possession of her own voice." The attempt is a tentative one, an imagined future of speech yet to come, but it is proffered as a gesture of empowerment. The speaking voice that resonates from this ekphrasis is not a male voice driven to violate, but a feminine voice piecing together the linguistic terms of her incipient resistance to that violation.

"A DIFFICULT WOMAN": CARSON ON HOPPER

In "Hopper: *Confessions*," a ten-part series in *Men in the Off Hours* (2000), Carson constructs a collage of fragmentary responses to Edward Hopper's eroticized scenarios. The women in the paintings she addresses are in compromised positions—perched nervously on the edge of a bed in *Western Motel* (1957), standing in a clingy dress at a filing cabinet in *Office at Night* (1940), naked on all fours in *Evening Wind* (1921). They are less obviously victimized than La La, but they are in their different ways silenced "others"—women who appear in

the light of what one critic calls "that deep sensualism . . . which contributes to the masculine strength of [Hopper's] art."[10] Carson's poems interrogate the nature of this sensualism by considering the implications of Hopper's statement, which she takes as an epigraph, that his paintings "[do] not tell an obvious anecdote, because none is intended." The anecdotes may not be "obvious," but the paintings cannot help but suggest seduction scenes, illicit rendezvous, and regretful mornings after. One speaker questions the woman in the painting *Eleven a.m.,* who sits naked in an armchair looking out a window: "Your sins do you confess them?" The woman offers no explanation for why she is undressed in the middle of the day: "No I keep them." Through dialogues like these, Carson's poem unfolds as part "true confessions"—wry takes on a sensationalized genre—and part meditation on the paradoxical "still movement"[11] of Hopper's visual narratives: each section concludes with a quotation from Augustine's ruminations on time and eternity in book 11 of *Confessions.* By juxtaposing vivid perceptions, partial narratives, and cryptic pronouncements, Carson both entertains and undercuts the prurience that inheres in attempts to "confess" the stories of male desire these paintings tell.

The first section of the poem addresses a painting that so strongly invites narrative that the project of telling its story has become a cliché—Hopper's famous *Nighthawks:*[12]

> I wanted to run away with you tonight
> but you are a difficult woman
> the rules of you—
>
>
>
> On a street black as widows
> with nothing to confess
> our distances found us
>
> (*Men in the Off Hours,* 50)[13]

Beginning with the voice of the man seated at the counter, but then indicating that there is "nothing to confess," Carson takes her ekphrastic narrative quickly into a rhetorical cul-de-sac, stalling the rendezvous. Without the impetus to relate his sins, the quasi-Augustinian plot of self-dramatization through confession cannot move forward. The section ends with an inversion of the first stanza, the final line exactly repeating the first, a formal symmetry that suggests the "difficult woman" has refused to cooperate with what the male speaker "wanted" and derailed the plot of "running away." Desire has been deferred, not intensified but turned back on itself. Carson makes a similar move in an allusion to Duchamp's *The Bride Stripped*

Bare by Her Bachelors in her next book, *The Beauty of the Husband* (2001): "What is being delayed? / Marriage I guess."[14] In both of these instances, Carson points out the charged anticipation of consummation that ekphrasis provokes, but defuses the erotic, confessional plot with a humorous shrug.

Against the stalled narrative of *Nighthawks*, Carson then poses brief glimpses of the female figures in Hopper's paintings as static objects, evoking them through tight verbal mosaics such as this description of *Automat*, a 1927 painting of a downcast, well-dressed woman seated alone:

> Night work
> neon milk
> powdered
> silk
> Girl de luxe
>
> (*Men in the Off Hours*, 51)

Here, the rhymes and minimalist lineation focus attention on the female figure as fixed in the visual field—"de luxe" suggests both "of light" and prettied up in the ironic "luxury" of her fashionable attire. The sketch invites the question of what kind of "night work" the woman was doing, but offers no speculation. Similarly, in the section "Western Motel," Carson brings into focus the uneasiness of the woman in the 1957 painting of that title (fig. 5), but does not imagine the story of her predicament:

> Pink bedspreads you say
> are not pleasing to you
> yet you sit very straight
> till the pictures are through.
> Two suitcases watch you like dogs.
>
> (*Men in the Off Hours*, 54)

The question of where the woman is going, or what she is leaving, is not addressed. Carson's ekphrasis exposes instead the palpable discomfort of being watched—the woman is under the intense gaze of the person making "pictures," as well as under the scrutiny of the speaker who addresses her repeatedly with an accusatory "you." The chiming quatrain has a tone of false cheer: the woman may be able to express her displeasure about the bedspread, but she cannot escape the surveillance she is under, as the disturbing image of the suitcases as vigilant dogs, repeated three times in the poem, makes apparent. Carson perhaps chose to address this painting instead of *Hotel Room*

Fig. 5. Edward Hopper, *Western Motel*, 1957, oil on canvas. Yale University Art Gallery, bequest of Stephen Carlton Clark, B. A. 1903.

(1931), which treats the same subject (including the two suitcases), because it makes her point without melodrama. It is easy to read *Hotel Room* as a dehumanizing erotic fantasy—a woman slumps despondently over a letter, wearing a girdle but no panties—but *Western Motel* is all the more troubling for the woman's dignity. Carson's ekphrasis tells no titillating story but still accounts for the woman's apparent defeat: "You seem to know / the road ends here" (ibid., 54).

In turning to Hopper, Carson addresses a male perspective on feminine objecthood, and her ekphrases complicate the erotic dynamics of that viewpoint. Thus far her sequence has been a space for interrogation, a field on which to reexamine the paintings' implications in relation to a confessional impulse. She ends her sequence with a coup: in "The Glove of Time by Edward Hopper," she names the artist in her subtitle, but only to highlight her lie—as Kevin McNeilly observes, no such painting exists.[15] Concluding with a notional ekphrasis, but telling her readers outright that it is an actual ekphrasis,[16] Carson undercuts the project of "confessing" the "sins" of the paintings by framing the process in outright fabrication. Whether we are irritated or amused, Carson has underscored the inherently fictive nature of an ekphrastic, or confessional, "telling in full":[17]

> She walks through the door.
> She takes off her glove.
> Does she turn her head.
> Does she cross her leg.
> That is a question.
> Who is speaking.
> Also a question.
> All I can say is
> I see no evidence of another glove.
>
> (*Men in the Off Hours*, 59)

The declarative sentences that ostensibly narrate the imaginary painting's "story" quickly break down into unpunctuated interrogatives. With teasing reference to a woman disrobing (taking off a glove) and posing (turning a head, crossing a leg), Carson reminds us of the instability of attempts to tell the sexy stories of visual works. She foregrounds the uncertain identity of the speaker-gazer ("who is speaking"), and admits interpretive defeat: "I see no evidence of another glove." The observation takes us back to "Automat," where such a statement would make sense, suggesting that "The Glove of Time" is a reimagining of that scene, a blurring of it in Carson's imagination that she retitles for her own purposes. This figure, in the notional ekphrasis, "likes to dress in formal attire / despite the stains" (*Men in the Off Hours*, 59). The unconfessed "sins" of "Automat" become the new figure's willful refusal to cooperate with the terms of the ekphrastic "interrogation" to which she is subject and in which she is posed.

The section and the sequence conclude with Carson's characteristic brand of postmodern referentiality, tacking on a reference to Jean-Luc Godard's 1987 film *King Lear*. Musing on the missing "evidence" of the glove in the nonexistent painting, Carson mentions that "a good evening glove" was described as "'shot in the back' / (as Godard said of his *King Lear*)" (*Men in the Off Hours*, 60). She puns on "shot" as means of murder and film composition, leading us to chase after a red herring, but then circles back to summarize what is at stake when the female body appears as "other." The final image of the poem focuses the theme of a male gaze that strives, violently, to silence and control female bodies: "Listening to his daughters Lear / hoped to see their entire bodies / stretched out across their voices / like white kid" (ibid.). The poem has given us multiple glimpses of women's bodies "stretched" in the tension of a controlling male gaze, "their voices" fixed in projections of male desire. Elliptical, tangential, and deliberately elusive, Carson's collage of ekphrastic imagery,

explication, dialogue, and citation constitutes an exploration of the effects of those gendered projections.

"KISSED ONCE OR TWICE": SWENSEN ON RODIN

"Triage," one of several ekphrastic triptychs in *Try* (1999), raises with its title the possibility of injury: what wounds are being assessed and prioritized, and what intervention will they require? In this poem, as in much of her work, Swensen addresses artworks from a kaleido-scopic viewpoint, a shifting and fragmenting array of observations about visual works.[18] In "To Writewithize," a 2001 essay in *American Letters and Commentary*, Swensen proposes new directions for ekphras-tic poetry by issuing a challenge to write "with eyes"—"as in 'to hybridize,' 'to harmonize,' 'to ionize.'"[19] The essay summarizes a key strategy in Swensen's poetics: the creation of layered responses to visual media in which "eyes" double as the "I"s of a volatile subjec-tivity. Juxtaposition and digression allow Swensen, as they do Carson and Fraser, to present multiple perspectives and intermix head-on and sidelong glances. When her subject is the depiction of women as objects of desire, she worries over odd and counterintuitive angles, interrogating the overlapping complicities and resistances implied in looking at and interpreting representations of erotic intensity.

The first section of the poem, "Éventail," alludes to an egregious example of a painterly depiction of female erotic otherness, but quickly looks away. The title invokes Gauguin's *Jeune Fille à L'Éven-tail* (1902), in which a young Polynesian woman, her white gown dropped to her waist, holds a feather fan so that it covers one breast (fig. 6). In a disjunctive paragraph, Swensen strings together details that suggest quick glances at this picture—"unobstructed furl," "the unphalanged hand," "veins arranged as a single sheet"—but she does not engage directly with the painting and its provocative gesture. Rather than describe or ventriloquize this image of a woman who appears as both passive and sexually available, Swensen shifts to "FAN: LANDSCAPE AFTER CÉZANNE, *Paul Gauguin, 1885*," as if walking away from a disturbing picture in a gallery and fixing on another with augmented anxiety:

> It's the season in the shape,
> the curve that comes down
> to the brow and borrowed
> from an orient and drowned.

(*Try*, 73)[20]

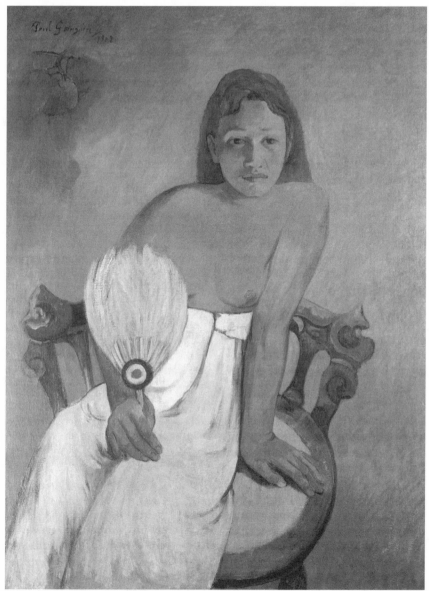

Fig. 6. Paul Gauguin, *Jeune Fille à L'Éventail*, 1902, oil on canvas. The Bridgeman Art Library, © Museum Folkwang, Essen, Germany.

With perception colored by the previous painting, this landscape itself seems to evoke a body—a "curve" and "brow" that are tightly enmeshed with the exterior "season" and "shape," as the purring consonance and internal rhymes stress (down / brow / drowned). If this poem suggests any comment on Gauguin's orientalism or his objectification of exotic women, it is oblique at best. Instead, Swensen's tactic is to set up resonant glances, a mood of unease but heightened alertness.

In the second section of the poem, titled "Auguste Rodin, THE KISS, 1886–98," Swensen turns to an image of erotic communion that is one of the most clichéd portraits of heterosexual desire in Western art. A woman hangs from the neck of a man who is squarely upright: it is an image, in one critic's terms, that has become a "luminous symbol of love and of the twofold tenderness of man the protector and woman stirred to the depths of her being."[21] In his critique of this image's cultural weight, Phillip Brian Harper argues that "[w]hat is, perhaps, most familiar in this assessment is the positing of the male figure as imperturbably stolid (in his protectiveness) even as he acts upon the female in such a way that she, by contrast, is utterly moved."[22] Swensen begins by taking a long road around these implications, de-eroticizing the work with scholarly objectivity:

> Taking them from the unfinished *Gates of Hell,* he executed three in marble
> each nine feet tall, identical and entwined
> in two bodies that break down to a
> single point that lips. . . .
>
> (*Try,* 74)

She reminds us immediately that these lovers are taken out of context: they are part of an ongoing larger work in which the erotic pose is not a "luminous symbol of love" but an emblem of damnation. Using the word "lips" as a verb introduces a stumble, a moment of awkwardness where we tend to see only swoon. *The Kiss,* Swensen points out, immortalizes an intense "single point" of erotic contact, but it is also a fragment from an unfinished work, a provisional pose.

Swensen reframes this ekphrastic occasion in the process of the artwork's making and in its institutional setting. As she describes them, Rodin's lovers do not embrace alone; instead, they are copies, objects that function in a complex system of display and appreciation:

> . . . The three
> aligned on a diagonal in a basement of the Gare d'Orsay.
> They barely fit. Enumerate and yet

at no point could a viewer stand and catch
the echo of a single image splayed but other angles intervene.

<div align="right">(Try, 74)</div>

The speaker has perhaps gone behind the scenes, gaining access to
the basement of the museum where the works of art are not pre-
sented for display.[23] She identifies the space by its former role as the
"Gare d'Orsay" rather than the "Musée d'Orsay," taking us out of
museum reverie and into the realm of workaday comings and goings.
Noticing that the sculptures "barely fit" in their storage area, Swen-
sen draws attention to a museum convention we normally overlook:
the presentation of artworks with ample blank space around them.
Seeing them outside of this arena and without the aura of aesthetic
veneration it promotes, the speaker discovers that understanding
these artworks requires the viewer to stand in multiple positions,
count ("enumerate"), and listen ("catch / the echo"). The observa-
tion is a brief ars poetica: in this as in other works, Swensen's frag-
mented ekphrastic point of view allows for acts of looking in which
"other angles intervene." This revolving ekphrastic perspective is not
devoid of feeling; on the contrary, it sparks this lyrical meditation:

Give me your hands; they are cold to the touch and not
one but all and if nothing new under the sun we say slightly stunned
 who then
who, carved from the same score and different are
and a single lip
from four seals the refraction.

<div align="right">(Try, 74)</div>

Here the ekphrastic occasion initiates a mode of intimate address, a
command to a lover, "Give me your hands." After the bodily percep-
tion of hands "cold to the touch," the syntax softens into a loose,
elongated line that evokes the mood of being "slightly stunned."
Internal rhyme (sun/stunned; your/score/four) intensifies the sen-
sory immediacy. Swensen presents this intimate "angle" in the midst
of a more calculating interrogation, suggesting that ekphrasis entails
an interplay of analytical distance and sensual force.

"Triage" then concludes with an equally abrupt shift to another
scene of kissing. A prose paragraph, "Even" tells a contemporary
anecdote in the idiom of overheard conversation:

This happened to a friend of mine, a very bright man, and it really did
happen this way: he met a woman at a café or some equally casual place,
and they'd hit it off, had gone out three or four times, and had gotten

rather close, some warm embraces, kissed once or twice, and were getting
nearer and nearer to a physical intimacy, so one day she said, there's
something I think I should tell you; I have no left hand.

(*Try,* 75)

In this unnerving narrative, the speaker insists on the truthfulness of
an account that smacks of urban myth, but the story still provokes
questioning—how could a person not notice a physical deformity
after several meetings, even after having "kissed once or twice"? Fol-
lowing the two ekphrastic sections of the poem, this anecdote causes
unease, relating an incident in which a misperception interrupts the
path toward sexual consummation. This time, a woman who is an
object of erotic desire (as well as a desirer herself) halts the man's
advances and calls attention to a bodily fact his gaze has missed.
Punning on the French word for "fan" that titles the poem's first
section, "Even" suggests both equal terms and settling the score. With
this weird story, Swensen disturbs the erotic trajectory implied in the
ekphrastic exchange.

Swensen's "triage" has sorted through various responses to the
predicament of the female figure as an image of erotic otherness,
though her poem is ultimately inconclusive, a space for interrogation
rather than a direct challenge. The objectification of Gauguin's sit-
ter, the iconicity of Rodin's lovers, and the emotional-erotic dis-
connect of a contemporary couple circulate in an atmosphere of
unresolved tension and ambiguity. This poem, like many others in
Swensen's oeuvre, represents an effort to write ekphrasis in a new way
by presenting the meanings of artworks as complexly interrelated
with many associations and perceptions—personal, interrelational,
historical, and art-historical. Swensen explains that traditional ek-
phrasis "accentuates the separation between the writer and the object
of art. The writer not only remains mentally outside the visual piece,
but often physically in opposition to it, i.e. standing across from it, in
a kind of face-off, in a gallery or museum."[24] Instead, she admires
poems "that don't look at art so much as live with it. The . . . differ-
ence here is not in the verb, but in the preposition. There's a side-by-
side, a walking-along-with, at their basis."[25] Her own ekphrastic work
likewise emphasizes contact and contiguity—it is peripatetic and ac-
cumulative, quizzical rather than oppositional. In Keats's classic Ro-
mantic ekphrasis, the speaker laments, "Bold Lover, never, never
canst thou kiss." In "Triage," Swensen sees kisses and tells—not
about desire anticipated and endlessly deferred, not about an iso-
lated and aggrandized encounter, but about erotic meanings as they
unfold in multiple contexts and under proximate scrutiny.

The three poems I have discussed in this essay offer a set of counterexamples to the theory that ekphrasis follows a trajectory of rapacious, heterosexual male desire. Rather than reduplicating a structure of male desire for female erotic otherness, these poems expose and interrogate the implications of artistic representations of that very dynamic. Many ekphrastic poems, past and present, do indeed document poetic attempts at seizure of an image, poetic graspings at elusive objects of desire. Many poems about artworks trope the frustrated longings of a verbal art for visual presence as a kind of erotic yearning in which the players are figured as male and female. But these conventions are not intrinsic mechanisms of the genre. To argue that a violent and gendered struggle is fundamental to ekphrasis is to deny the possibility of fluctuation within or resistance to that paradigm as it appears thematically in art and poetry both—a possibility that these three poets fully exploit. Fraser's openly feminist challenge to a male artist's portrait of a woman, Carson's ludic manipulation of another's erotic stagings, and Swensen's assemblage of ambivalent responses to several other male visions all suggest innovative possibilities for ekphrasis that are unconstrained by formulaic assumptions about gendered tensions between visual and verbal media. These poets approach ekphrasis as a vital space for perceiving, interpreting, and rethinking artistic representations of erotic experience, and their revisionary readings document the insights and pleasures of that practice.

NOTES

1. W. J. T. Mitchell, "Ekphrasis and the Other," in *Picture Theory: Essays on Verbal and Visual Representation* (Chicago: University of Chicago Press, 1994), 168–69.

2. James A. W. Heffernan, *Museum of Words: The Poetics of Ekphrasis from Homer to Ashbery* (Chicago: University of Chicago Press, 1994), 6.

3. Katy Aisenberg, *Ravishing Images: Ekphrasis in the Poetry and Prose of William Wordsworth, W. H. Auden and Philip Larkin* (New York: Peter Lang, 1995), 1.

4. Anne Carson, "Canicula di Anna," in *Plainwater* [1995] (New York: Vintage, 2000), 53.

5. Kathleen Fraser, "La La at the Cirque Fernando, Paris," in *il cuore : the heart; Selected Poems 1970–1995* (Hanover, NH: Wesleyan University Press, dist. University Press of New England, 1997), 158–68. References to this poem will be indicated by page numbers in the text.

6. Heffernan, *Museum of Words*, 1.

7. For discussions of "mesostics" and other uses of chance operations and source texts in postmodern poetry, see Marjorie Perloff's chapters on John Cage and Steve McCaffery in *Poetry On & Off the Page* (Evanston, IL: Northwestern University Press, 1998), and *Radical Artifice* (Chicago: University of Chicago Press, 1991).

8. Fraser's emphasis on "error" as a way to liberate poetic possibilities pervades her ekphrastic work. In "Giotto: ARENA," for example (*il cuore : the heart*, 119–37),

she dwells on the "errors" that inhere in efforts to read artworks and texts, and suggests that various "corruptions" in texts on Giotto by Vasari, Dante, and Ruskin enable reilluminations of Giotto's meanings.

9. For a helpful statement of Fraser's feminist poetics, see her essay "Translating the Unspeakable: Visual Poetics, as Projected through Olson's 'Field' into Current Female Writing Practice," in *Moving Borders: Three Decades of Innovative Writing by Women*, ed. Mary Margaret Sloan (Jersey City, NJ: Talisman, 1998), 642–54. See also her interview with Cynthia Hogue, in *Contemporary Literature* 39, no. 1 (1998): 1–26.

10. Lloyd Goodrich, *Edward Hopper* (New York: Harry N. Abrams, 1993), 105.

11. For a seminal account of ekphrasis as a paradoxical "still movement"—a narrativizing and temporalizing of visual stasis, and a stilling of verbal-temporal movement—see Murray Krieger, *Ekphrasis: The Illusion of the Natural Sign* (Baltimore: Johns Hopkins University Press, 1992).

12. See, for example, Joyce Carol Oates's short story about the painting in *Transforming Vision: Writers on Art*, ed. Edward Hirsch (Chicago: Art Institute, 1994).

13. Anne Carson, "Hopper: *Confessions*," in *Men in the Off Hours* (New York: Knopf, 2000), 49–60. References to this poem will be indicated by page numbers in the text.

14. Anne Carson, *The Beauty of the Husband* (New York: Knopf, 2001), 5.

15. Kevin McNeilly, "Five Fairly Short Talks on Anne Carson," *Canadian Literature* 176 (Spring 2003): 9.

16. For a discussion of Carson's dissimulation in her poetics more generally, see ibid., 6–11.

17. Carson is not the only poet to have employed this ekphrastic strategy recently. Richard Howard, in *Trappings* (New York: Turtle Point Press, 1999), also creates an unannounced notional ekphrasis when he imagines an "obscene" painting by Magritte in "Family Values V" (33–37).

18. Even more so than Fraser and Carson, both of whom have written many poems about the visual arts, Swensen has produced an ekphrastic oeuvre. *Try* (1999) addresses a dizzying range of artists, including Giotto, Orcagna, Benvenuto, Mantegna, Bellini, Tintoretto, Bosch, Memling, Rodin, and Olivier Debré. *Such Rich Hour* (2001) is an extended meditation on the *Très Riches Heures du Duc de Berry*. *Goest* (2004) is framed in sequences on Cy Twombly's sculptures.

19. Cole Swensen, "To Writewithize," *American Letters & Commentary* 13 (2001): 122–27.

20. Cole Swensen, "Triage," in *Try* (Iowa City: University of Iowa Press, 1999), 73–75. References to this poem will be indicated by page numbers in the text.

21. Champigneulle, quoted in Phillip Brian Harper, *Private Affairs: Critical Ventures in the Culture of Social Relations* (New York: New York University Press, 1999), 2.

22. Harper, *Private Affairs*, 2.

23. In *Museum Mediations: Reframing Ekphrasis in Contemporary American Poetry* (New York: Routledge, 2006), I argue that the museum setting, when it is foregrounded in an ekphrastic poem, often signals a crucial node of questioning and critique. Swensen, like other poets who demonstrate an acute "peripheral vision," employs museum-conscious ekphrasis as a space for interrogation, a way to mediate the often competing demands of aesthetic perception and critical appraisal.

24. Swensen, "To Writewithize," 123.

25. Ibid.

II
The Poet Speaks

When we asked Karl Kirchwey and Rachel Hadas to speculate about how gender might be at stake in the impulse to write about works of visual art, their initial response was one of bemusement. Looking back at her own ekphrastic poems to see what common themes would emerge, Hadas found that "on the whole [those themes] are gender-neutral." Kirchwey argues that "the urgency with which *all* poets engage with works of art . . . is essentially genderless," though he finds women poets engaging, very often, with paintings that thematize their relationship as women both to society and to art. Yet Kirchwey and Hadas do differ, in ways that Hadas suspects are gender-related, in their description and modeling of ekphrastic engagement. In striking contrast with *his* depiction of a posture of "perfect receptiveness" are the vicissitudes and contingencies of reception to which *her* poems bear witness. For Hadas, encounters with works of visual art are impure, untidy, and full of distractions. The blistered heel, the voice of the docent in the next room, the ghostly presence of a dead friend with whom earlier visits to the same museum were shared—all these intimations of our bodiliness, our sociability, and, finally, our mortality are part and parcel of the ekphrastic encounter and of its human significance.

Women Look at Women: Prophecy and Retrospect in Six Ekphrastic Poems

Karl Kirchwey

It is tempting, but incorrect, to see ekphrastic poetry as motivated by *envy*, on the poet's part, of the immediacy of communication available to the visual arts. Instead, it seems to me that the motive for its creation is *awe* and a sense of urgency in communicating the message that the poet finds implicit, if not explicit, in the work of sculpture, painting, or architecture. Successful ekphrasis is predicated upon a perfect receptiveness in the poet-beholder, an openness to sensation and impression, and a strong desire, not even to *conceive* or *interpret* the message of the visual art, but rather to *utter* what the poet feels (so strong will be his or her response) the work of visual art is trying to say. I believe this to be the case even in a poem such as John Keats's "Ode On a Grecian Urn," which seems to speak not *for* but *to* a work of art, and in which the discrepancy between the perfection of the world represented in visual art and the imperfection of the world of the beholder can only be expressed as anguish. To some extent the poet-beholder has no *choice* in this process, for he feels, as a moral imperative, the need to speak for the work of art. The words spoken by Rilke's headless archaic torso, after all, are "You must change your life."

The nature of the message contained in the work of art will, of course, vary according to the work—and indeed, according to the beholder. Emma Lazarus sees the "Mother of Exiles" when she looks at the Statue of Liberty; Ambrose Bierce sees a mob-capped revolutionary; Robert Lowell sees a jaded American party girl, and the Native American writer Adrian C. Louis sees a mechanized emblem of the genocide of an indigenous people. But it is frequently the case in ekphrasis that the *pastness* of the art considered allows the poet an opportunity for personal, social, or cultural criticism, a vantage point from which, not only to understand the past as it may bear upon the present, but to formulate objectives and ideals for the future. The urgency of the act of articulation that is ekphrasis may be particularly,

93

and understandably, acute when the poet-beholder belongs to a traditionally disenfranchised group.

One important function of ekphrasis for contemporary women poets, therefore, has been to perform a kind of social prophecy and retrospect, exploring the relations and prospects for women as artists, as lovers and spouses, and as parents. A stanza from Adrienne Rich's poem "Love in the Museum," from her second book, *The Diamond Cutters and Other Poems* (1955), contemplates some of these roles. In its first three stanzas, the poem describes imaginary composites (rather than single identifiable paintings) by Velázquez, Boucher, and Vermeer, each one featuring a woman. It begins:

> Now will you stand for me, in this cool light,
> Infanta reared in ancient etiquette,
> A point-lace queen of manners. At your feet
> The doll-like royal dog demurely set
> Upon a chequered floor of black and white. . . .[1]

The "love" referred to in the poem's title is not only that which might animate the lives of the women represented; it is that felt by the (female) viewer toward these female subjects, who "stand for" (i.e., represent, substitute for) the viewer even as the viewer literally stands before the paintings in the gallery. The lives depicted in these paintings are lives that the viewer can try on as if they were her own. They are lives bound, not only by painterly conventions, but also by the formal decorum of Rich's five-line stanzas and *ababa* rhyme scheme. The details of Rich's poem have a varnished and static beauty against which the speaker of the poem rebels in the last stanza:

> But art requires a distance: let me be
> Always the connoisseur of your perfection.
> Stay where the spaces of the gallery
> Flow calm between your pose and my inspection,
> Lest one imperfect gesture make demands
> As troubling as the touch of human hands.
> (*Collected Early Poems*, 113)

It is the dissatisfactions of such "perfection" (which the poem does not quite imply is the result of the depiction of females by male artists) that the last stanza acknowledges. While asserting the necessity of a "distance" between art and life, the speaker of the poem—the female viewer of the paintings—in fact rejects that distance, choosing instead the "troubling . . . touch of human hands." By its very decorous-

ness, the poem amounts to an ultimatum by the speaker to *herself* to expand the compass of her emotional experience. The poem thereby answers the question that is not asked (no question mark) in its first sentence—"Now will you stand for me. . . ."—with a no, or replaces that question with a strong assertion ("Now you *will* stand for me"), and rejects a posture of passive connoisseurship for a life of direct sensual engagement: whatever the poem prophesies for art, it will be accomplished through the body. The poem's speaker has found her way to this assertion or epiphany *by means of* the imaginary paintings she actually contemplates.

A different example of a poet seeking to take her bearings for life by means of the contemplation of art is provided by Debora Greger's poem "The British Museum," in her book *God* (2001). The voice here, less contained by form than Rich's, is emotionally cooler, too:

> It was just a Roman translation, too flowery,
> of some long-lost Greek,
> but still I stood in front of the vase
> Keats had stood before,
> waiting to feel what he felt then,
> or later, on paper—
> I wasn't particular. I wasn't
>
> even a scholar, heartbroken,
> forced to admit, at least in a footnote,
> that she couldn't prove
> on which vase, exactly, Keats had seen
> *that heifer lowing at the skies.*
> And what green altar, O mysterious priest?
> Where was the sacrifice?[2]

Greger's poem neatly reverses the traditional gendering by which a male viewer contemplates a female subject, though her ultimate interest is not in the genders of viewer *or* subject. Here a female poet is *both* the active interpreter and the passive "still unravished bride of quietness" who wants only to feel what the poet before her once felt in contemplating an object (the poem, really, not the urn) that is gendered male. Greger even admits the impossibility of being sure of *which* Grecian urn Keats was contemplating. Greger subtitles her poem "The Portland Vase," but several different candidates have been suggested as the object of Keats's attention (there is a drawing in Keats's hand of the Sosibios Vase, which is in the Musée Napoléon), and indeed Keats's poem may provide an example of what John Hollander refers to as "unassessable actual ekphrasis."[3]

The incorporation of italicized lines from Keats's poem through-
out Greger's might suggest that the poem should be interpreted, not
as a meditation on gender, but as an attempt to appropriate some of
her predecessor's lyric power. Greger is "waiting to feel what he felt
then, / or later, on paper—" which suggests that for her, as for Keats,
the epiphany may have come in the museum or it may have come
later, in the writing down. And yet Greger's own "belatedness," in
writing after Keats, does not quite seem to be the point of the poem
either. The prophecy contained in this poem amounts to a recapitu-
lation (from the vantage point of posterity) of Keats's life from the
moment he wrote the ode about the urn. What interests Greger
most, therefore, is making explicit a biographical "reading" of the
urn that is implicit in Keats's poem, and that draws an analogy be-
tween the symptoms and pathology of tuberculosis and those of love:

> A milky goddess held a milk-white snake
> almost to her breast—
> was this what she wanted Keats to see?
> He'd read medicine—
> when the lungs wasted with each bloody breath,
> the barber-surgeon was sent for,
> who ministered the blessed leech.
>
> (Greger, *God*, 34)

The application of biography to poetry, in Greger's poem, is a process
largely independent of gender, though the "milky goddess" with her
snake (morphing into an early nineteenth-century doctor with his
leech) is close, in her visual attitude, to Cleopatra and her asp, as if
the vase itself, or what was depicted on it, were a symbol, not of
immortality, but of mortality: "*A burning forehead, / and a parching
tongue*—he knew the symptoms, / and wrote them off / to lovesick-
ness a few months longer" (ibid., 35).

The poem speculates about, but does not successfully reproduce,
Keats's "feeling." With the benefit of hindsight, it is able to reproduce
the course of his life. By means of a deep sympathy with the poet's
life, Greger's poem attempts to learn how to "read" both a poem and
the work of art that inspired the poem. Indeed, Greger's poem repre-
sents a kind of "secondary" ekphrasis: a poem responding to a poem
responding to a work of art. But Greger's poem contains no final
Rilkean crisis and challenge, like that presented to Rich's speaker by
the troubling touch of human hands. Whereas the speaker at the end
of Rich's "Love in the Museum" is galvanized by the disjunction
between art and life, the speaker at the end of Greger's poem is still
"waiting to feel," *knowing* that, without living Keats's biography, she

Pier Celestino Gilardi, *A Visit to the Gallery*, 1877, oil on canvas. University of Michigan Museum of Art, bequest of Henry C. Lewis, 1895.94.

Edwin Romanzo Elmer, *Mourning Picture*, 1890, oil on canvas. Northampton, Massachusetts: Smith College Museum of Art.

Helen Frankenthaler, *Sunset Corner*, 1969, acrylic on canvas. University of Michigan Museum of Art, museum purchase 1973/1.813.

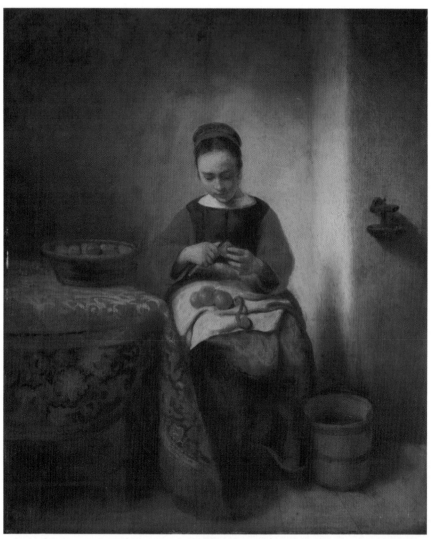

Nicolas Maes, *Young Girl Peeling Apples*, ca. 1655, oil on wood. Metropolitan Museum of Art, bequest of Benjamin Altman, 1913 (14.40.612). Image © The Metropolitan Museum of Art.

cannot feel as he felt. Indeed, the speaker in Greger's poem has been (narratively) eclipsed at the end of the poem by the facts of Keats's life.

A poem by Molly Peacock entitled "Girl and Friends View Naked Goddess" and subtitled "After Gilardi's *A Visit to the Gallery*" was written for the University of Michigan Museum of Art's fiftieth anniversary (1997). It begins, like Rich's poem, by contemplating painted female figures, but draws conclusions and makes prophecies applicable, not to the life of the poet-viewer (as Rich does; as Greger is unable to do), but to the lives of the women depicted in the painting. The visual situation of this 1877 Italian academic painting by Pier Celestino Gilardi is quite complex: a trio of well-dressed young nineteenth-century women contemplate the frontal view of a nude classical female sculpture whose back is to the viewer of the painting (see color insert). The front of the classical statue is, however, dimly reflected in a pier glass behind the girls, like the face of the goddess in the mirror in Velázquez's *Rokeby Venus*. A fourth well-dressed young woman stands to the right of the statue, looking not at it but at her trio of friends. Thus it may be she, as much as the statue, who is the object of the three young women's attention. Apparently speaking for the young woman who stands apart, the poem begins:

> She'd rather be nude, she'd rather be dressed,
> rather cover up her bum and breasts.
> If she dropped her clothes would she look like *this?*
> A sculpted goddess, bare as an almond?
> Her girlfriends' buzz about those goddess tits,
> though the shy one stares straight ahead—stunned
> to see what she might become. What might
> the goddess become if she could untighten
> her gaze and be part of her watchers' scene?[4]

The immediacy of Rich's second-person address is here sacrificed for a third-person voice, and the precision of Rich's rhymes and the formality of her voice are traded for something more casual. Peacock's poem is a double sonnet and an additional concluding couplet with a scheme of imperfect rhymes, as on "dressed" and "breasts," "*this*" and "tits," and so on. On the one hand, the poem seems overtly to question both the motives of male artists and the male-dictated social order. Peacock the female poet—herself a connoisseur of Eros, as demonstrated elsewhere in her poetry—contemplates four females contemplating a sculpture of a female. Beyond such perspectival play, beyond myth and history (the story of Pygmalion and Galatea; Pliny's account of the man who fell in love with the statue of

Cnidean Aphrodite and tried to make love to it),[5] the poem is a
meditation on social freedom and empowerment, as the young
women contemplate their probable future roles in society and the
possible sources of their power over males:

> Ruffled, laced, stockinged and corseted,
> this girl's dying to shed it all; a sheen
> of longing on her face asks, "Can't I be rid
> of my stays?" But the object she'd become
> would have to stay in the hall alone
>
> in the clammy gloom of every Roman night. . . .
> (Peacock, *Visit to the Gallery*, 27)

Unlike the poems by Rich and Greger, there seem to be no immedi-
ate stakes here for the poem's speaker in the outcomes she imagines
for the figures in the painting, and, indeed, our conviction of the
speaker's emotional involvement in the poem is dependent upon
our accepting the rhetoric of prayer or invocation that develops in
the second sonnet, referring to the young ladies: "May they dress up
daily, may their servants stir / hot washtubs of bloody cotton strips to
insure / they won't bleed on their taffetas. May they laugh / at a man
inserting his soul in a sculpture" (ibid.).

The poem seems to speak *both* for the young women who are
spectators *and* for the goddess of the statue herself. This renders its
social criticism somewhat opaque, as does an apparent sympathy for
the bourgeois comforts already enjoyed by the young women, and
the language of sexual penetration that takes over from approxi-
mately the seventh line of the second sonnet and blends with the
imagery of menstruation. The gossip among friends, the servants, the
taffetas: discarding these is not a serious possibility. Between the
loneliness of the work of art (the "nude") and the confinement of
social decorum, the poem asks, can there not be a posture of physi-
cal unselfconsciousness? (Perhaps this is the "naked.") The poem
does wish to avoid the consequences of the usual male gaze upon
undressed female flesh. But the wish expressed in the poem's last
sentence—"may her [i.e., the nude female statue's] observers be
creatures"—seems ambiguous. Perhaps it urges that the young
women now looking at the statue find satisfaction in a life as "crea-
tures," a life of fulfillment and pride in the female body, but not
merely as sexual objects for male delectation. Alternatively, if the
"her" referred to in the last line is one of the young women depicted,
then the speaker of the poem seems to wish upon the *painting's*
beholders, either that they should view the young women with

creaturely sympathy, or else that, like Dionysus's pirates transformed to dolphins, they should become mere "creatures." Neither the prophecy nor the prayer being made by the poem is altogether clear, though the poet-beholder's desire to derive such a prophecy or a prayer from the painting seems unmistakable.

A later poem by Adrienne Rich (included in her 1966 book *Necessities of Life*) discovers an extraordinary narrative perspective by which to contemplate the likely course of female experience. "Mourning Picture," which is also the title of the painting it describes (see color insert), includes the following headnote: "*The picture was painted by Edwin Romanzo Elmer (1850–1923) as a memorial to his daughter Effie. In the poem, it is the dead girl who speaks.*"[6]

One of the forms of ekphrasis identified by John Hollander is making the image itself speak (Hollander, *Gazer's Spirit*, 4), and that is the form chosen by Adrienne Rich here. A young girl rendered doubly powerless—by childhood and by death—is empowered to speak. Part of what makes Elmer's painting unsettling, apart from its proto-photorealistic quality, is that it does *not* leave anything out. It seems to combine aspects of landscape (that of Elmer's western Massachusetts), still life (the family's house; the child's toys and pet), and portraiture. Conventional funerary art might choose to depict either the grieving parents or the deceased child; but depicting *both*, in simultaneous narrative space and time, violates the single greatest reality of death, which is separation.

Effie's voice is so flat as to be prosaic, but she appropriates the mimetic and narrative initiatives her father, as a painter, has kept up until now:

> This was our world.
> I could remake each shaft of grass
> feeling its rasp on my fingers,
> draw out the map of every lilac leaf
> or the net of veins on my father's
> grief-tranced hand.
>
> (Rich, *Collected Early Poems*, 230)

Indeed, her father exercises those initiatives elsewhere, over her mother, for one. Another of Elmer's paintings, like this one in the Smith College Museum of Art, depicts the mother at the spinning wheel, providing Rich with a vital metaphor: "I tell you, the thread that bound us lies / faint as a web in the dew. / Should I make you, world, again, / . . . / and leave *this* out? I am Effie, you were my dream" (ibid., 231).

Effie feels compelled to speak (Rich feels compelled to speak for her), because something *has* after all been left out of the painting, something unrepresentable: the bond of love. Is Effie challenging her parents (or the viewer) to look harder at the painting and find this "thread," too, faintly depicted there? Effie's monologue is *both* prophecy and retrospect. Just as the child is in the foreground of the painting, so the painting's reality seems to depend upon her perception of the living world. The poem's last line asserts that the material world in all of its beauty exists only as a function of living human perception. We usually think of the adage "life is a dream" as applying to those who are alive; the ingenuity of Rich's poem is to speak it in the voice of someone who is dead.

The iconic relation between a parent and a child is also the subject of "The Pietà, Rhenish, 14th C., The Cloisters," a poem from Mona Van Duyn's appropriately entitled book *To See, To Take* (1970). Van Duyn's poem, off-rhymed couplets grouped in quatrains, is marvelous in part for its ventriloquism—it allows both figures in the pietà to "speak," so that the monologue of Rich's Effie is replaced by a dialogue—and also for its fidelity to the sheer *homeliness* (to a contemporary eye) of the art it describes:

> He stares upward at a monstrous face,
> as broad as his chest, as long as he is
> from the top of his head to his heart. All her
> feeling and fleshiness is there.[7]

Van Duyn's poem goes far beyond any reductive and predictable manifesto of gender grievances against traditional religious art (passive Virgin, active Gabriel, active Christ Child, etc.). Instead, it chronicles, in plastic terms, the universal progress of human grief:

> To see her
> is to understand that into the blast
> of his agony she turned, full-faced,
>
> and the face began to melt and ache,
> the brows running down from their high arc
> to the cheekbone, the features falling toward the chin,
> leaving the huge forehead unlined, open,
>
> until, having felt all it could feel,
> her face numbed and began to congeal
> into this.
>
> (Van Duyn, *If It Be Not I*, 103–4)

But also, and with infinite delicacy, it comprehends the specific intimacy between a mother and the son who predeceases her. Here it is the dead Christ who speaks, not without some irony, to Mary:

> "Willingly I dried
> out of consciousness and turned to the slight
> husk you hold on your knee, but let
>
> an innocent, smaller love of a son
> hold me, let not my first stone
> be the heart of this great, grotesque mother.
> Oh God, look what we've done to each other."
>
> (ibid., 104)

She has brought him into the world only to die, and he, participating in the ambivalence, or even the aversion, of the viewer confronting the statue, has reduced his mother to ugliness. Of course, he is the Lamb of God, and willingly he has "dried" (not, as we might expect, "died") into the husk on his mother's lap. He is without sin, but nonetheless hopes not to cast the first stone of calling his mother "grotesque" or stonyhearted for the grief he has caused her, grief that has reduced her heart to a stone. He longs for an "innocent," rather than a tragic, maternal love.

Mary next points out to the dead Christ the implausibility of his having believed love was unbounded, "pure possibility" when he came through the "bloody straits" of her body to arrive in the world. She is "gross and virginal," her body inflated, not with his incestuous seed, but with his notion of love. She returns the favor of his aversion toward her—she finds his dead body "an ugly / cold corrugation"—and confronts the intolerable choice of all who have grieved, between the dead weight of the body and the desolate weightlessness of absence. The poem seems to take a physical, quasi-sexual bond between Mother and Son as an inevitability ("the handsome male load of your whole / body"), although the gender difference seems less important than the yearning for oneness between two separate beings. Like the late *Annunciation* of Caravaggio (1609) in which Mary greets the angel's news with all the weariness of which human mortality is capable, Van Duyn's Mary is stricken by mortality. The miracle of Easter morning is still light years away, for her, whether her dead son is "unmanned spirit" (that is, a spirit unoccupied) or "unfleshed man," because man, *or* woman, has no existence outside of the flesh, whatever the Son's hopes were for love as "pure possibility."

Mary's crisis of faith, in Van Duyn's poem, is *ours,* preoccupied as

we are with the homely tangibility of the plastic arts. Much of the poem is phrased in the conditional ("if he could see / as we are forced to see"), and it imputes to the figures in the pietà a disillusionment and a knowledge that only belongs, properly, to those who like St. Paul are born "out of due time," after the historicity of the Christian mystery is long past:

> It is a face that, if he could see
> as we are forced to see, and if he
> knew, as we cannot help but know, that
> his dead, dangling, featureless, granite
>
> feet would again have to touch the ground,
> would make him go mad. . . .
>
> (Van Duyn, *If It Be Not I*, 103)

The prophecy spoken by the two figures in Van Duyn's pietà is therefore simultaneously a retrospect for the readers of her poem and the viewers of the statue.

A further instance of ekphrasis-as-prophecy with particular reference to the relations between a parent and a child is provided by a poem of Linda Gregerson's entitled "Bleedthrough," included in Gregerson's 1996 volume *The Woman Who Died in Her Sleep*. Gregerson bases her poem upon Helen Frankenthaler's *Sunset Corner*, a 1969 abstract expressionist tableau of acrylic washes, in which a bloodred color predominates (see color insert). Since the painting is abstract, the poet enjoys considerable imaginative and interpretative freedom:

> 1.
> As when, in bright daylight, she closes
> her eyes
> but doesn't turn her face away,
>
> or—this is more like it—closes her eyes
> *in order*
> to take the brightness in,
>
> and the sun-struck coursing of blood through the
> lids
> becomes an exorbitant field to which
>
> there is
> no outside,
> this first plague of being-in-place, this stain

of chemical proneness, leaves so little
room
for argument. You'd think

the natural ground of seeing when we see
no object
but the self were rage.[8]

 These tercets modulate without much syntactic pause through the
four sections of the poem; in fact, the sections seem rather arbitrarily
determined. The tradition in Renaissance Italian religious painting
of the "sacred conversation"—a series of eye lines connecting the
Virgin, the Christ Child, the painting's donor (featured in the paint-
ing), and the painting's spectator—is here fulfilled in a nonrepre-
sentational setting and recast as a four-way "sacred conversation"
between a mother who is also a poet, her nine-year-old daughter, the
painter, and the reader. The "she" referred to in the poem's first line
is presumably the daughter. What is described is the effect of looking
at the world through closed eyelids; in bright light, this results in just
the blood-tinged wash that Frankenthaler's painting depicts. Greger-
son understands this simple bodily experiment in its broadest terms,
however: "to take the brightness in" is to understand the world in
terms of the body, and the poem is concerned, in part, with whether
there are any *other* terms in which the world can be understood. In
the poem's first section, too, the limitations of such perception are
clearly apprehended: "there is / no outside," when the world is seen
this way through the body (because everything is literally "inside");
there is, for example, no equivalent to the edge of a canvas. And yet
the phrase "chemical proneness" suggests a sort of hormonal vulner-
ability—in its simplest terms, the poem is about menarche—and
"seeing red" in this way, seeing "no object / but the self," results in
"rage" at human limitation.
 To these ambivalences of experience are added the poet's ambiva-
lences of interpretation: the interjection "this is more like it" in the
first section suggests that the poem is only approximate in pinpoint-
ing what it is trying to say, and that it will be continuously self-revising.
In the poem's second section, what parallels the daughter's fear of
the mother's scorching anger (expressed in the medium of burned
food: the mother is a careless cook, and the threat of anorexia or
bulimia hovers in the domestic air) is the poet's fear of the reader's
disapproval. Hence the daughter makes a "penitent reparation" (the
second word understood not only in its sense of "repairing" but also
of "returning"), but the poet asks "Do you like / me, reader? / Do

you like me sorry now?" as if the only functional relationship between writer and reader were an apologetic or penitent one (Gregerson, *The Woman Who Died in Her Sleep,* 62). Yet what remains in the reader's mind is the "terrible be- // seeching shape" of the daughter's face and upper body, as she tries to find a posture with which to confront the world. Gregerson's enjambments can seem willful unless we understand a pun intended between "-seeching" and "seeking"; the enjambment of "this im- // partible estate" seems to cancel out, by its negative (im = in = not) prefix, the vulnerability by which something might otherwise be "imparted" by the daughter to the mother or by the poet to the reader.

"It seemed like / Mars / to me when I was young," writes Gregerson, of the world of the female body, of menstruation (ibid.). She means it seemed strange and alien to her life, but of course Mars is the (blood) red planet, and also the god of war and strife. The "four fleshed walls / of love" that symbolize that female body are not only domestic stability (the poem does not quite resolve its own ambivalence about the "glib suburban pavement" suggested by the coziness of Frankenthaler's title, *Sunset Corner*) but also perhaps that *Frauenzimmer* that Freud identified in German colloquial speech as the contemptuous tag for the female as a mere sexual object or "housing" for the male.[9] In the poem's third section, the speaker suggests that even her mother, who, like the poet or the painter "can turn the most un- // likely raw materials to gladness," could find no better expression for menstruation than "the curse" (ibid., 63). The assertion is that, in spite of the modern cosmeticizing of the body's monthly process, the authenticity of the experience is to be recognized in the fact that the body still "seethes and cramps." Likewise, the artist is not delivered from mortal existence *by* metaphor, but only by the "leverage" she can find *upon* metaphor, and for the painter, such "leverage" is a kind of manual labor. In any case, language and metaphor together only reassert the life of the body they might otherwise transcend, as when "we say // that the surfeited pigment 'bleeds'" (ibid.). In this sense, every "counter-argument" (i.e., counter*metaphor*), every effort to establish a margin between life (the body) and art, such as "the four- / fold / margin she's stretched the canvas to com- // prehend," cancels itself out, simultaneously "undoes itself" (ibid., 64).

The daughter—she of the bodily games, of looking at light through closed lids, of "composing" her face and shoulders—arrives in the poem's final section at a new game, and asserts that she can tell the difference between morning and evening light, not only in the world but also in the world of the museum (i.e., in paintings such as Fran-

kenthaler's). The daughter "blazons her facility" as if she were, not a mere interpreter of light, but the source of light itself (ibid.). So the poem delivers us to a particular gallery and a particular painting, where it seems to suggest that Frankenthaler's cozy title after all represents "an act of wit" by which to control "the vaults of fire" that are the true subject of her painting. The poem has considered every metaphor, whether of writing or of painting, as a misreading of the natural world; and yet it wonders at its end ("I've loved this grief too well") whether mortality is not the only lesson to be learned from life and art (ibid.). The bandages and rags of "the curse" yield a sensual beauty, in their washing (changing colors, smell of iron), which rhymes with what Frankenthaler discovered on her canvas; if art does not, finally, transcend life, it is at least "the stain that's last to go" (ibid., 65). Gregerson's poem, like Peacock's, resolves itself at last in prayer, and its tenderness toward the daughter's vulnerability is exquisite and unambiguous: "the young / girl's hands / —she's just pubescent—ache // with cold" beautifully balances naked skin with a contrary and Ovidian sense of "pubescent" as "covered" or "clothed" (ibid.).

Six poems can hardly represent the entire field of ekphrasis by contemporary women poets. And yet, as these poems make clear, ekphrasis has provided women poets with a genre alive with possibilities and not at all burdened with the historical prerogatives of male perception. On the contrary, the urgency with which *all* poets engage with works of visual art—all poets who are susceptible to the visual, that is—is essentially genderless, though the human subjects of works of visual art (including the mostly female subjects considered here) may lead women poets to unique conclusions. Ekphrastic poems have provided a means by which women writers have been able both to scrutinize the past relationship of women to society and to art and to speculate about future possibilities.

NOTES

1. Adrienne Rich, "Love in the Museum," in *Collected Early Poems, 1950–1970* (New York: Norton, 1993), 113. This edition of *Collected Early Poems* is hereafter referred to in the text.

2. Debora Greger, "The British Museum," in *God* (New York: Penguin Books, 2001), 34. Hereafter referred to in the text.

3. John Hollander, *The Gazer's Spirit: Poems Speaking to Silent Works of Art* (Chicago: University of Chicago Press, 1995), 34ff. Hereafter referred to in the text.

4. Molly Peacock, "Girl and Friends View Naked Goddess," in *A Visit to the Gallery*, ed. Richard Tillinghast (Ann Arbor: University of Michigan Press, 1997), 26–27.

5. Pliny the Elder (Caius Plinius Secundus), *Natural History,* trans. D. E. Eichholz, Loeb Classical Library, vol. 10 (Cambridge, MA: Harvard University Press, 1962), 36.4.21.

6. Adrienne Rich, "Mourning Picture," in *Collected Early Poems,* 230–31. The head-note itself, however, has been quoted from *Necessities of Life: Poems, 1962–1965* (New York: Norton, 1966), 72. In *Collected Early Poems* the headnote simply reads: "The picture is by Edwin Romanzo Elmer, 1850–1923" (230).

7. Mona Van Duyn, "The Pietà, Rhenish, 14th C., The Cloisters," in *If It Be Not I: Collected Poems, 1959–1982* (New York: Alfred A. Knopf, 1993), 103. Hereafter referred to in the text.

8. Linda Gregerson, "Bleedthrough," in *The Woman Who Died in Her Sleep* (New York: Houghton Mifflin, 1996), 61, hereafter cited in the text. The poem's entire first section has been quoted.

9. Sigmund Freud, *The Interpretation of Dreams,* trans. James Strachey (New York: Avon Books, 1965), 248, 389nn.

To Really See the Dragon

Rachel Hadas

Many of my poems emerge from preoccupations that look clear only in hindsight. Subliminal, subterranean, subtext—a lot goes on beneath the surface. My poetic vein is a buried stream that occasionally froths into view aboveground—occasionally and unpredictably, but also, alas, over a period of years quite repetitiously. Thus when I look back at a body of work I have written over a longish period of time, I rarely fail to be struck by the insistent recurrence of a theme or idea, a feeling or question, I may not have been aware of at the time I was writing. More disciplined and economical poets are, I imagine, far more purposeful when they set out to write, oh, an ekphrastic poem. I admire such canniness, but it is not for me. The poems I plan to write are those I never finish, while those I do write often rehash themes that have engaged me in earlier poems I have by now forgotten that I ever wrote.

This is how I account for the fact that the eleven ekphrastic poems I happened to write between roughly 1993 and 2004 overlap a good deal. (A list of all eleven is provided at the end of this essay.) Since these poems share not only certain preoccupations but also strategies for approaching them, to discuss all of them here would, as well as taking too much space, involve a good deal of redundancy. Rather I have chosen to focus on four of my ekphrastic poems: "Two Paintings Seen Again," "Homage to Winslow Homer," "Mayday at the Frick," and "Bird, Weasel, Fountain."[1]

Before turning to these poems, it seems worthwhile to set out a central notion all my ekphrastic poems worry like a dog with a bone. This idea is that art solicits or demands and also rewards our attention, at the same time that our unregenerate bodies and spirits make paying attention difficult. Lacking leisure or patience, we are often tempted to turn away; yet despite steamed-up glasses, a blistered heel, or a nudging neighbor, we are also pulled back toward the art. When we do establish some kind of connection with whatever it is we see, a sense of recognition or acknowledgment, possibly mutual, can result.

Not only are these themes well-worn; it seems to me that on the whole they are gender-neutral. Many of them turn up in that proof-text of ekphrastic poetry, the "Ode on a Grecian Urn," where Keats addresses both the silence of the urn and its essential if inscrutable benignity.[2] The unheroic physicality of peering over someone else's shoulder, of being distracted by a dog's footsteps in a gallery or a tour guide's spiel (experiences that figure in my poems "Two Paintings Seen Again," "Courbet," and "Greek Gold," respectively)—Keats doesn't include these humble annoyances in his poem, but they are surely not peculiar to art lovers who happen to be women.

What seems more likely to be distinctively female is the emotional tenor of at least some of my ekphrastic poems. Jane Hedley observes in her introduction that since the early nineties "paragonal" theories of ekphrasis have been in the ascendancy—theories, that is, that cast the poet-beholder of a painting or a work of sculpture as the rival or antagonist of the artist. But the predominant mood I sense in my own ekphrastic poems is something more like a wistful inclination toward fellowship—a leaning toward the artwork, even as the body wants to turn away or sit down or go out for a breath of fresh air.

And now down to business. My title is taken from my poem "Two Paintings Seen Again."

I. *Saint George and the Dragon*

It needs a second visit
and taking off my glasses
to wipe them and approaching

again (sighs, shoulders, toes)
to really see the dragon on its back,
four paws, soles up, in air,

all its green scales sparkling like gems,
its duller anus clearly visible.
Despite the lance thrust halfway down its throat,

the dragon shows no sign of pain;
only the violent twisting of its body
signals distress. To note

the precise expression of the saint
standing musing over his green prey
will need another look.

II. *Petrus Christus "Pietà"*

It takes a second visit
to really see the woman on the left
from beneath the folds of whose starched white kerchief

strands of hair meander to her shoulders,
gleaming red and gold, but secondary
to the tiny focused face,

soft yet severe, which is bent to the urgent need
of the moment: hold up that cloth
which, sagging like a hammock,

supports the drooping body.
It's hard to pierce the fog
of numbness and indifference and distraction.

Even to see what we think we came to look at,
we need an impulse and an appetite,
as well as blinders, energy, and patience.

Persistence, too, and courage.
We pass through this way once,
so why not try to look at everything

if only on the run? We pass this way
once, so choose one thing and look and then
look back. Risk desiring to return.

But it occurs to me that just as apt a title, also lifted from this poem, might be "It Takes a Second Visit." To really see the dragon, or the woman, or any detail in a work of art requires what life does not always afford us: another chance. To be sure, the process of really seeing is also helped by writing about what it is one sees—a fact of ekphrastic poetry that seems almost too obvious to need pointing out. Writing down what one sees not only forces the viewer to focus and to make choices, but facilitates remembering the dragon's green scales or the woman's red and gold hair.

Yet another obvious point about ekphrastic poetry—a point I have rarely seen made—is that even first-person poems almost never depict the writer with her notebook in the gallery or museum. But why shouldn't the crucial "second visit" consist of consulting one's notes about what one saw in the museum? In "Two Paintings," it is

not clear that an actual second visit ever took place—all that is said is that such a visit is needed—though the detailed description implies that yes, the speaker returned.

"Two Paintings" ends by spelling out the requirements for "really seeing" what we came to see:

> Even to see what we think we came to look at,
> we need an impulse and an appetite,
> as well as blinders, energy, and patience.
>
> Persistence, too, and courage.

Lacking such energy and patience, the hapless viewer may come to resemble the depicted dead Christ in having a "drooping body," and unlike him will not be supported by the faithful but will have to cope on her own with nudging neighbors and steamed-up glasses.

Dualistic to the end, "Two Paintings" closes with the opposite conclusions that can be drawn from the fact that "we pass through this way once":

> so why not try to look at everything
>
> if only on the run? We pass this way
> once, so choose one thing and look and then
> look back. Risk desiring to return.

That notion of return keeps returning, explicitly or implicitly, in my other ekphrastic poems, and perhaps in all poems that simply by virtue of being about works of art necessarily revisit them.

When I visit museums, I am often nonplussed and ambivalent at overhearing tour guides explain the paintings to groups of viewers. On the one hand, what they say can be informative and helpful; on the other hand, it can seem obvious and pedestrian; and on the third hand, it leaves out so much. Now the act of recalling and resaying what (attention summoned, spectacles polished) one sees in the work of art is what I think of as the docent's mode. Almost all my ekphrastic poems incorporate a portion of docent-speak; but almost all are also restless or uncomfortable with the limitations of such discourse. This is not to claim that such discomfort then necessarily becomes the focal point of the poem; nevertheless, at some point the formal framework of observation or commentary gives way to a very different mood or mode. Consider "Homage to Winslow Homer":

Wringing out her heavy woolen skirt,
a tall girl with one dripping flaxen pigtail
stands, head tilted to clear
the water from an ear.
Not too far beyond her on the beach,
six, seven, eight small boys—they form a troop—
splash, boast, shriek, leap, skip stones.
Beyond them, it's just possible to spy
clusters of little girls in twos and threes
sitting, heads together, on the sand.
Or else, still grouped, some stand,
stockings off and ankle-deep in water.
One holds a doll;
one points out to another
the pink and glossy inside of a shell.
The pale cool noon lighting a northern summer
glazes it all, sails on the horizon, dancing water.

Wait. Since the girls are turned away, and small,
part of the background of this painting, how
can I be so sure what they are doing?
I have been there.
I know.

The poem begins in docent mode, impersonally saying what it sees. But by lines 5 and 6 the viewer is straying from the central scene; and by the time we get to "it's just possible to spy," we're past what a docent would probably point out. This sense of straying beyond some boundary of fact or decorum is underscored by the codalike second stanza, which introduces in quick succession an imperative ("wait") and the first-person pronoun, as well as the destabilizing interrogative. The uncertainty articulated in the second stanza makes us wonder just how reliable that docent's voice ever was: can we believe what we are told? What about the subjectivity of the observer?

Rereading "Homage to Winslow Homer," I am struck by two things. First, the first person is so delayed here; presumably the "I" has been speaking all along, so it is surprising that it waits till so near the end to come out into the open. Second, the poem contrives to avoid what is surely the essential ekphrastic trope, apostrophe, while never moving too far from an apostrophic mood. Rather than directly addressing the painting, or the girl in the painting, the poem describes, interprets, and in a sense endows her, not only with the voice, but, as we learn, also with the experience of the viewer ("I have been there. I know."). In the process of addressing certain social innuendoes in

the painting rather than the painting directly, the poem might be said to shift the artist's concern here from such technicalities as light on water to the more social matters of the different ways in which girls and boys play on a beach. As a matter of fact, we know from other paintings such as *Snap the Whip* that Homer was indeed interested in children's play.

The longest poem of the four I deal with here is "Mayday at the Frick." Like "Two Paintings Seen Again," only much more specifically, "Mayday" evokes the physical conditions of a museum visit, going so far as to specify which museum and when. We begin outside, in a line of people waiting for the Frick Collection to open:

> Sundays the doors don't open until one,
> so tourists wait outside in mild spring rain.

Is the speaker to be located among these tourists? A few lines down, we learn that—presumably unlike most of the tourists—she has knowledge of "a few perennials . . . inside"; she is someone who has been to the Frick before and knows what awaits.

> The patient, glossily umbrellaed queue
> curls round the corner to Fifth Avenue,
> confident a few perennials
> serenely wait inside: gaunt Cardinals;
> a sturdy, swarthy blacksmith bending over
> his sooty anvil; a beribboned lover
> chasing his lady through espaliered greenery;
> a horseman pensive against twilit scenery.
> Saint Francis in his stony landscape stands
> transfigured, spreading wide his wounded hands.

By the end of this stanza, we have made our way into the gallery and seen many famous paintings; expectation has blended into experience.

The second stanza, while it moves away from the human figure, gives us a lot more information about the (very fleshly) speaker:

> The human image isn't everywhere.
> In a small dim side-room there appear
> a jewel-encrusted, flashlight-sized salt cellar,
> a massive goblet, and a matching salver;
> triptychs, enamels, crucifixes, glass.
> Every object closely studied has
> not only its own history but a vision,

the artist's rendering of some occasion
that we may never know, but sense, being human,
carrying human baggage. I'm a woman
who just this morning got her period
and now suspects her skirt is stained with blood,
and thus, constrained to keep her raincoat on,
sweats as she moves from room to humid room—
moreover in new shoes, so she can feel
a juicy blister ripening on her heel.
Blood, canvas, blister, silver, sweat, and paint,
a ruined skirt and an ecstatic saint:
none of these incongruities afflicts
my power of seeing. What I see is fixed
all the more firmly, set inside my brain
indelibly, as dried blood leaves a stain.

A few lines into this, the identity of the speaker is inescapably pres-
ent: the first appearance of "I" coincides with the announcement
that I am a woman who just got her period. (How many ekphrastic
poems mention menstruation? Someone else's research topic.)[3] The
menstruating speaker is uncomfortable: too warm, wearing a raincoat
in a humid room, and with a blistered heel. Nevertheless, her "power
of seeing" is not affected by the "human baggage" she carries. In-
deed, since the artists have had and had had their own human bag-
gage even in the creation of a salt cellar or a reliquary, who better to
study their works than a living, breathing, sweating, bleeding fellow
human being? Memory fixes the sights offered by the artworks as
"indelibly as dried blood leaves a stain," and possibly all the more
indelibly because of the physical process being undergone by the
museumgoer.

Then, in the next stanza, in an unusual ekphrastic move, "Mayday"
glances briefly, almost conversationally, outdoors again to the season
and temperature, before turning to what Robert Frost might have
called the connection between inner and outer weather.

We have survived the umpteenth winter storm.
It's Mayday, and it's drizzling, but it's warm.
In Central Park the tulips are in bloom.
I also stretch and quicken toward the sun.

Back inside the Frick, the social circumstances of this occasion now
come to the fore. Just as the line of tourists gave way to the single
speaker with her raincoat and blistered heel, so she now turns out to
be accompanied—in fact, doubly accompanied.

For here in the museum I'm not alone
but blessed with a kind companion,
a woman more or less my age, whose eyes
linger on whatever draws my gaze
and vice versa. We seem to pace and pause
and look, speak, laugh obedient to laws—
strong laws, strange ones. A beloved ghost
accompanies us—the brother whom she lost,
who left the world of triptychs, tulips, snow
forever—can it be two years ago?

The dead man who has brought these two women together now—
lightly, briefly—serves as their guide before disappearing. He may be
the rare docent who actually teaches the visitor to see "with a differ-
ent eye."

Her brother and my friend. I see him stand
between us, gesturing with careful hand
at exquisite details we might have missed . . .
He vanishes. It's useless to insist
he stay. We move past Chinese porcelains,
French enamels, statuettes in bronze.
The portraits that look gravely down at us—
were the faces always lined with loss
or do I see them with a different eye?

Not only does the beloved ghost vanish; the hour in the museum is
itself precious, threatened, evanescent. Art rescues us from time;
leaving this refuge means rejoining the hurried world of "ordinary
women," or indeed mortals.

We've reached the door. It's time to say goodbye.
Once separated, we'll resume our lives
as ordinary women, mothers, wives,
moving through the seasons' gallery
often too rushed to take in what we see.

The poem closes (outdoors again now) with a tribute to the dear
dead docent, whose spirit seems likely to haunt places where art is to
be found.

The rain's evaporated. Hugs; we part.
The man whose face is stamped on either heart,
whose intermittent presence I won't name—
I cannot see him now. But just the same,

he's somewhere near here if he is at all.
Loving what art has made perpetual,
he knew his beauty might be doomed to fade,
but not what skillful human hands had made.

Once again, I am struck by how narrowly this poem skirts apostrophe, a trope to which it is clearly attracted. The instant intimacy of speaking to a stranger, the risky "Thou still-unravished bride" mode, is here softened to a more indirect ploy. The narrative (for "Mayday" is probably as close to a narrative as my ekphrastic poems ever get) meanders along, moving from outdoors to inside the building, then through the Frick collection, pausing in the meantime to note the physical travails of the speaker before doubling casually back to check on the season and the weather, then again moving inside and turning to the companion whose brother (the speaker's friend and the presiding if unseen spirit of "Mayday at the Frick") has furnished the occasion the poem commemorates . . . As apostrophes (or indeed elegies) go, this one is notably indirect, nonconfrontational, associative, digressive. Are not some of those words often applied to the ways women operate in conversations and in relationships?

The last of the poems I want to discuss here echoes the previous three in ways I warned of earlier. Like "Homage to Winslow Homer" and "Mayday at the Frick," "Bird, Weasel, Fountain" does some fancy footwork around the notion of apostrophe. Like "Two Paintings Seen Again," "Bird, Weasel" is about, among other things, the difficulty of looking, of seeing. The painted bird, the stuffed weasel, and the fountain in Riverside Park are challenging in ways that are overdetermined; even though the viewer/speaker here seems less distracted and more eager than the museumgoer in "Two Paintings," bird, weasel, and fountain are all "hard to see."

> Seuss-like with its tufted yellow topknot
> and roosting in a histrionic landscape—
> snowcapped purple mountains, orange sunset—
> the oddly crested bird in one of the paintings
> upstairs in the Roerich Museum
> stopped me on my last visit. Recognition
> passed between us. I remembered it;
> it seemed to have been awaiting my return.
>
> Mounted by Balch of Lunenberg, the weasel,
> wearing winter white, and with a mouse
> eloquently dangling from its jaws,
> takes my measure from its pedestal

low in a glass case in an exceptionally
dim corner of the Fairbanks Museum
and says quite plainly, though its mouth is full,
We'll know each other when you come again.

Solemn in their pre-Raphaelite grace;
alert and sympathetic, though reserved;
ready to meet the gaze of anyone
who passes by, the figures in the fountain
at Riverside Park and 116th Street
hold out their shallow goblets, mildly offer
the thirsty wayfarer a drink of water
and silently invite her to return.

The bird is not well painted, and the weasel
is badly lit. The fountain's low relief,
eroded by familiarity,
is hard to see—they all are—
without an effort. All three are too proud
and patient to call *Here I am—remember?*
Given attention, I have things to say
to you, as you to me, if you return.

Rereading the poem and pausing to consider why these three enti-
ties are so resistant to the viewer's gaze, I come up with two ideas.
First, each is a detail, part of a much larger picture, in a way not
precisely true of a framed painting hanging in a museum. The bird is
a small part of a painting; the weasel only one object in a crowded
and dim glass case; the fountain is easily trumped by the trees and
people in its vicinity. And second—another idea that has come up
before—writing about these three things is a way to rescue them: to
re-remember them, refix them in the mind's eye, apprehend them
freshly.

Thus reapprehended, bird, weasel, and fountain gain the energy
to turn the apostrophic tables on the observer—or almost. "Too
proud and patient to call" out, all three nonetheless at the very least
enact the phenomenon Gerard Manley Hopkins, an exceptional ob-
server, noted in an 1871 journal entry: "What you look hard at seems
to look hard at you."[4] Even if the painted bird, the stuffed weasel, and
the stone fountain do not quite make the leap from gaze to utter-
ance, they all seem on the verge of apostrophizing the viewer.

And cannot this trembling on the brink of speech be said to charac-
terize anything, not to mention any person, we look at hard enough?
Hopkins's pregnant insight, which oddly enough I came across in an
essay about Dallas by Willard Spiegelman before encountering it

again in a splendid recent selection of Hopkins's poems and prose, was not known to me when I wrote any of my ekphrastic poems.[5] Nevertheless, it might serve as an epigraph for them all, back to the little green dragon of "Two Paintings."

Bird, weasel, and fountain are on the brink of speech, but my poem winds up by putting words in their mouths. And what I have them say is this: *"Given attention, I have things to say / to you, as you to me, if you return."* If you return: it takes a second visit to really see . . . or perhaps, in this case, to really hear. We are back to the notion of ekphrasis as focusing attention by compelling one kind of return or another, even if the return is in memory.

Art as figure, art as ground; art as what pulls and pushes us, as what we leave and return to . . . Manifestly, for me, when it comes to looking at art, poetry is the tool I use to sharpen my attention. In "Against Interpretation" the late Susan Sontag wrote: "All the conditions of modern life—its material plenitude, its sheer crowdedness—conjoin to dull our sensory faculties. . . . What is important now is to recover our senses. We must learn to *see* more, to *hear* more, to *feel* more."[6] That was written in 1964, a period that from our vantage point in 2008 looks serenely uncluttered, tranquil, silent: No cell phones!

And yet the truth is surely that art has always had to struggle for our attention. Whether women, with our natural tendency toward multitasking, are more prone to distraction than men, or simply more candid in owning up to it, is a question I leave others to debate. Male or female, our humanity involves knowledge of our mortality: in looking at art, what to do with the fact that, as I put it in "Two Paintings," "We pass through this way once"?

Finally, a fragment from John Ashbery's ekphrastic masterpiece, "Self-Portrait in a Convex Mirror," slides into my mind: "The balloon pops, the attention—Turns dully away."[7] Indeed it does. But what arrests that turn, or at any rate records it, is not the painting but the poem.

EKPHRASTIC POEMS BY RACHEL HADAS

"Bird, Weasel, Fountain." In *The River of Forgetfulness,* 20–21. Cincinnati, OH: WordTech Communications, 2006.

"Courbet Revisited." In *The River of Forgetfulness,* 30. Cincinnati, OH: WordTech Communications, 2006.

"Four Lives, Stirring." In *The Empty Bed,* 81–82. Middletown, CT: Wesleyan University Press, 1995.

"Greek Gold." In *Halfway Down the Hall,* Middletown, CT: Wesleyan
 University Press, 1998.
"Homage to Winslow Homer." In *Indelible,* 67. Middletown, CT:
 Wesleyan University Press, 2001.
"Mars and Venus."[8] In *The Empty Bed,* 79–80. Middletown, CT:
 Wesleyan University Press, 1998.
"Mayday at the Frick." In *Halfway Down the Hall,* 15–16. Middletown,
 CT: Wesleyan University Press, 1998.
"Neolithic Figurine, Spetses Archaeological Museum." In *The River of
 Forgetfulness,* 117. Cincinnati, OH: WordTech Communications,
 2006.
"Recognition" (unpublished).
"The Red House." In *The Empty Bed,* 84–85. Middletown, CT: Wes-
 leyan University Press, 1998.
"Two Paintings Seen Again." In *Laws,* 36–37. Lincoln, NE: Zoo Press,
 2004.

NOTES

I would like to thank my intern, Kaitlyn Elisabet Bonsell, for invaluable help with editorial matters relating to this essay.

1. Whenever a poem of my own is quoted, publication information can be found at the end of the essay in the list "Ekphrastic Poems by Rachel Hadas."

2. John Keats, "Ode on a Grecian Urn," in *The Poems of John Keats,* ed. Jack Stillinger (Cambridge, MA: Harvard University Press, 1978), 372–73.

3. *Editors' note:* Linda Gregerson's "Bleedthrough," one of the poems Karl Kirchwey discusses in his essay for this volume, is such a poem as well.

4. Gerard Manley Hopkins, *Mortal Beauty, God's Grace: Major Poems and Spiritual Writings of Gerard Manley Hopkins,* ed. John F. Thornhill and Susan B. Varenne (New York: Vintage Books, 2003), 70.

5. Willard Spiegelman, "Dallas On (and Off) My Mind," *Parnassus: Poetry in Review* 28 (2004): 372.

6. Susan Sontag, "Against Interpretation," in *Against Interpretation and Other Essays* (New York: Farrar, Straus and Giroux), 13–14.

7. John Ashbery, "Self-Portrait in a Convex Mirror," in *Selected Poems* (New York: Viking, 1985), 190.

8. Reprinted and discussed by John Hollander in "The Gallery," in *The Gazer's Spirit* (Chicago: University of Chicago Press, 1995), 334–38.

III

Forefathers and Foremothers

THE FIRST ESSAY IN THIS PART RETURNS US TO THE QUESTION OF whether there can be said to be a female ekphrastic tradition. Elizabeth Bergmann Loizeaux says yes, in her preamble to an essay on the feminist ekphrastics of Marianne Moore and Adrienne Rich. Alongside the dominant tradition of museum-based ekphrastic lyric Loizeaux calls attention to a dissident tradition whose premise is that "the patterns of power and value implicit in [the dominant tradition] can be exposed . . . resisted and rewritten." Moore and Rich have set out to do this, as she demonstrates, in strikingly different ways.

In her essay on Elizabeth Bishop's "art of still life," Bonnie Costello broadens the parameters of ekphrasis to encompass poems whose techniques of description are painterly. Still life, according to the art historian Norman Bryson, "belongs to what is culturally defined as feminine space"; Costello shows Bishop reclaiming the "overlooked" spaces of domestic life with an eye more attuned to class than to gender, and often with a disquieting sense of her own outsider status.

In his essay on Mary Jo Salter, Jonathan Post uncovers a "Horatian" tradition of ekphrasis that represents a clear alternative to the "sublime" tradition that has received more attention to date. Within this alternative tradition activities, interests, and emotions that are stereotypically female are accorded greater scope and visibility, and hence by implication greater importance and value, than in the heretofore canonical tradition. Among the objects of Salter's ekphrastic attentions are refrigerator magnets and a mother's unfinished portrait of her son; she shares with Bishop an interest in domestic spaces and with Moore an affinity for objects that, in Loizeaux's words, "might not be considered 'art.'"

Women Looking: The Feminist Ekphrasis of Marianne Moore and Adrienne Rich

Elizabeth Bergmann Loizeaux

IN HIS INFLUENTIAL ESSAY, "EKPHRASIS AND THE OTHER," W. J. T. Mitchell attributes our fascination with poetic ekphrasis to its inherently social dynamics. The "verbal representation of visual representation" draws critics and poets alike, Mitchell suggests, because in staging the interaction between poet and work of art, word and image, it enacts the negotiation of the self with a whole host of "others."[1] The negotiation is often competitive and charged by the gendered underpinnings of ideas about the nature of words and images. Citing the long history in Western discourse of identifying time and language as male, and space and picture as female, Mitchell notes that "the treatment of the ekphrastic image as a female other is commonplace in the genre."[2] From Keats's rounded urn, that "still unravish'd bride of quietness,"[3] through Rossetti's enthroned brides and William Carlos Williams's "Portrait of a Lady," practitioners of ekphrasis have worked the trope of the active male poet gazing on the silent, passive, female image, and having his verbal way with her.

If ekphrasis has operated in the gendered ways Mitchell describes —and I think it has, much of the time—then one would expect it to be inhospitable ground for women, especially in the twentieth century when women were presumably more conscious of such dynamics and might be expected to be more wary of entering into them. Certainly feminist literary criticism and art history have pointed out the powerful association between looking and the exercise of specifically male power. Luce Irigaray's argument that western ocularcentrism perpetuates a phallocentric culture makes looking a suspect activity, especially for a woman.[4] And yet, when one reconsiders the history of ekphrasis, it is clear women have practiced it all along, from the Greeks through Joanna Baillie to Christina Rossetti, Elizabeth Barrett Browning, and Michael Field, and *especially* in the twentieth century: Marianne Moore, Mina Loy, Gwendolyn Brooks, Elizabeth Bishop, Adrienne Rich, Sylvia Plath, Anne Sexton, Rosanna Warren, Jorie

121

Graham, Rita Dove, Eavan Boland, and Maya Angelou, among others.[5] Have these women simply accepted—knowingly or not—the options Laura Mulvey famously set out for female spectators: to "take the place of the male or to accept the position of male-created seductive passivity"?[6]

As a way of beginning to sketch out a tradition of female ekphrasis, I would like to turn to that strain of modern ekphrasis by women that recognizes a sexually charged male tradition of looking and challenges its gendered dynamics. We can call this "feminist ekphrasis." In the 1980s, while feminist film critics debated the dynamics of female spectatorship, the art historian Griselda Pollock entertained the "possibility that texts made by women can produce different positions within this sexual politics of looking."[7] Feminist ekphrasis anticipates such works and participates in it; it recognizes that a woman's place as viewer is established within, beside, or in the face of a male-dominated culture, but that the patterns of power and value implicit in a tradition of male artists and viewers can be exposed, used, resisted, and rewritten. Feminist ekphrasis can and has been written by men—Irving Feldman's " 'Portrait de Femme,' After Picasso" (1965), on one of Picasso's portraits of Dora Maar, might be considered an example—but it has tended to be written by women who have found in ekphrasis, especially in the twentieth century, a rich field for charting, exploring, and asserting different relationships to the world.

As central figures in twentieth-century feminism and American feminist poetry, Moore and Rich must feature prominently in any attempt to define a feminist ekphrasis. They are among the twentieth century's most important poets and have used ekphrasis to write some of their finest poems, though Rich has not been thought of before as an ekphrastic poet and Moore's ekphrastic innovations have not been considered as such. The differences in their ideas about negotiating gender barriers yielded dramatically different ekphrastic practices that, together, suggest the range of feminist ekphrastic practices and the various ways the genre has been transformed under the pressure of feminist awareness. The importance of ekphrasis to both Moore and Rich further suggests how this seemingly minor and most aesthetic subgenre of the lyric has functioned as a significant means of feminist argument and intervention.

MARIANNE MOORE'S ETHICAL EKPHRASIS

"Almost every poem Moore wrote involved a picture or art object at some stage of composition," notes Bonnie Costello.[8] Herself an avid

sketcher who had thought of becoming an artist, Moore loved mu-
seums at a time when New York City's great art galleries were being
founded: the Metropolitan had opened in 1880, seven years before
her birth; MoMA would open in 1929, the Whitney in 1930.[9] (The
last two were founded by women, signaling the entry of female collec-
tors into what had been, until then, exclusively male territory.) The
dynamics of looking, and the pleasures and problems it presents to
those who would say what they see, are at the very core of Marianne
Moore's poetics. When she wrote on a basilisk or a glacier, Moore
exercised a kind of submerged ekphrasis, often working from photo-
graphs of her subjects. Her explicit ekphrases, such as "No Swan So
Fine," "Nine Nectarines," and "An Egyptian Pulled Glass Bottle in the
Shape of a Fish," raise to the surface of the poem the issues and a
mode of inquiry always implicit.

The kind of looking Moore set herself to practice engaged both the
long tradition of sight as the avenue to truth and the positive moral
value that it implied. Looking carefully, steadily, particularly, was, for
Moore, a way of practicing justice. Moral scrupulosity required disci-
plined observation. It was no easy matter. As she says in a line in
"England" that itself stretches one's capacity for attention as it con-
tinues and continues across the page: "To have misapprehended the
matter is to have confessed that one has not looked far enough."[10]
She well understood that intense observation had its dark aspect.
"The desire to see good things is in itself good when not degraded by
inquisitiveness or predatoriness," she observed.[11] She knew that
women could be predatory, and that men were not so inevitably.

Cristanne Miller's nuanced analysis of Moore's feminist poetic is
suggestive here. Moore's poetry, she argues, "is implicitly . . . feminist
in its manipulation of received truths about identity and authority
and yet . . . is more apt to strive for a non-gendered or multiply gen-
dered positioning than for . . . the kind of simple oppositionality (us/
them, female/male, black/white) that characterizes much openly
political poetry."[12] The implications for thinking about Moore's use
of ekphrasis are clear. Moore's poetic seeks to subvert the oppositions
inscribed in the very ekphrastic situation itself as the poet encounters
the "semiotic other" of the visual sign.[13] Or, rather, Moore seeks to
confound and unseat the dynamics by which otherness is met as
opposition, by which word engages image as inevitably "rival" and
"alien."[14] Ekphrasis could be understood as "a literary mode that
turns on the antagonism—the commonly gendered antagonism—
between verbal and visual representation,"[15] but it need not be. As a
genre that encourages the play of many kinds of difference figured in
that between word and image (quick/still, living/dead, mortal/
eternal, present/past, mind/body), ekphrasis was various and capa-

cious enough for Moore's inquiring, perspicacious imagination. At the same time, its strain of gendered *paragone* kept active in her poetic field the model of looking that her own work sought to revise.[16]

A product of a first-wave feminism—bred in Eastern women's colleges, steeped in a belief in the gender-neutrality of the professions, and dedicated to showing that women could do what men could— Moore came of age at a time when women were making headway in what might be called the "viewing professions," among them the sciences, anthropology, and art history. Developing an ability to observe objectively and precisely was associated with advancing the cause of women's rights. Moore took courses in biology and studied writing at Bryn Mawr with the remarkable pioneering art historian Georgiana King, a friend of Gertrude and Leo Stein, who taught her students to "speak to the picture"[17] and hung pages of Alfred Stieglitz's *Camera Work* around her room. Moore visited Stieglitz's gallery, 291, in 1915 and saw the "straight photography" he and Paul Strand were pioneering as a means of breaking the bonds of artistic possessiveness. The importance they assigned to the selection of subject, rather than manipulation of the negative, carried over into Moore's ekphrastic practice, as we will see.

Observation

Observations (1924), Moore's first authorized volume, full of ekphrases, initiates her lifelong exploration of nonpredatory looking. "Sea Unicorns and Land Unicorns" exemplifies the discipline and its difficulties. This is a notional ekphrasis whose details are gathered from a number of artifacts depicting "SEA UNICORNS AND LAND UNICORNS // With their respective lions" (line 1)—including the famous fifteenth-century tapestries at the Cluny (fig. 7) and the Cloisters, and paintings of the Virgin Mary.[18] In this poem Moore describes the depiction of a fabulous world where those "by nature much opposed" are twinned in "strange fraternity" and "unanimity" (lines 22, 37, 24). So described, her subject echoes the conventional ekphrastic situation in which she finds herself in writing this poem— word and image, poet and artist, "by nature much opposed"—but she refuses to accept that *paragone* is their necessary relation, imagining instead the possibility of reciprocal exchange:

> You have remarked this fourfold combination of strange
> animals,
> upon embroideries,
> enwrought with "polished garlands" of agreeing indiffer-
> ence— . . .
> This is a strange fraternity—these sea lions and land lions,

Fig. 7. *Smell,* from the Lady and the Unicorn tapestry series, the motto of which is "A mon seul desir." Woven in Brussels after Parisian design for Jean le Viste, burgher of Paris, 1480–90. Paris: Musée national du Moyen Age-Thermes de Cluny. Photo Credit: Erich Lessing / Art Resource, NY.

land unicorns and sea unicorns:
the lion civilly rampant,
tame and concessive like the long-tailed bear of Ecuador—
the lion standing up against this screen of woven air
which is the forest:
the unicorn also, on its hind legs in reciprocity.

(lines 27–29, 37–43)

Explicitly in the poem Moore uses this fourfold combination to counter, wittily and cannily, the rapacity that characterized Europe's discovery of the New World by the explorers and "cartographers of 1539" (line 5) who brought pictures and pieces of these strange animals home. For Moore, colonial hegemony, collection, and visual appropriation expressed the same need to possess. As Costello observes, the oppositions of sea and land unicorns and of unicorns and their accompanying lions "represent an ideal of dynamic reciprocity held out for the beholder."[19] They constitute a model by which Moore would instruct the conduct of our relations to others of all kinds—a model of exploration, of observation, and of ekphrasis.

The gendered underpinnings of Moore's instruction are highlighted by the poem's resolving image of the unicorn, who is "'impossible to take alive'" (line 66), and the virgin, who alone can tame him, depicted in many medieval and early modern representations. Unlike the dogs and the male hunters in the tapestries at the Cloisters, the virgin is "inoffensive like itself— / as curiously wild and gentle." The unicorn "approaches eagerly; / until engrossed by what appears of this strange enemy, / upon the map, 'upon her lap,' / its 'mild wild head doth lie'" (lines 79–82). The sexual charge of this final image reimagines the gendered dynamic between man and nature exposed earlier in the poem when the rapacious "voyager" despoils the sea unicorn to obtain its horn (lines 10–12). The gentle harmony of virgin and unicorn rewrites those gendered relations between beholder and beheld so often described in terms of violence, sex, and rape. "We need," Moore said in 1929, quoting a passage from *The New Image* by Claude Bragdon, "'the feminine ideal . . . the compassional' not 'the forceful.'"[20] Her virgin becomes the ideal type of the observer-explorer, implicitly instructing Moore's own ekphrastic looking.

Despite the liberating possibilities the poem's final, attractive image hold up for us, the word Moore uses and does not shy away from is "tame": the unicorn can be "tamed only by a lady inoffensive like itself" (line 67). It raises one of the thorniest problems for her: how to avoid what she understood could be the arrogance of the civilized eye, no matter how inoffensive it tries to be. How was it possible to look upon anything without following the impulse of "human nature" to "stand in the middle of a thing"—as she put the case thirty pages earlier in *Observations* in "A Grave."[21] In "Sea Unicorns and Land Unicorns," Moore sounds the alarm for women as well as for men: the will to conquer and possess characterizes not only the men who ravage the New World, but the poem's other virgin, Queen Elizabeth, who paid "a hundred thousand pounds" for the horn of the sea unicorn (line 12). In embodying an ideal of open, wild,

curious, respectful regard for the other, the virgin suggests an alternate way of exercising power in the world. Yet, in taming the unicorn and bringing it into her civilized realm, she remains importantly related to Queen Elizabeth. Moore thus opens up the central ethical problem of ekphrasis: to look and to record one's looking is inevitably to set the scene in relation to oneself. "Tell Me, Tell Me," Moore says in the late poem of that title, "where might there be a refuge for me / from egocentricity."[22]

"Sea Unicorns and Land Unicorns" itself suggests strategies for mitigating the egocentric and acquisitive in all relations. If ekphrasis conventionally masters the image by establishing a particular view of it, Moore multiplies points of view, unfixing authority. By incorporating quotations—from Spenser, Violet Wilson, J. A. Symonds, an anonymous medieval poem, and Charles Cotton—Moore diffuses the controlling power of the ekphrastic viewer, dispersing it across history and gender as well as across descriptive languages. Moore also does not stand and stare at one thing too long. Though she may return again and again to an object, she looks obliquely, favors the fleeting glance rather than the fixing gaze, the gallery rather than the single work of art. Her ekphrases are rarely based on one picture. "An Egyptian Pulled Glass Bottle in the Shape of a Fish," for example, derives not only from a bottle from Tel el Amarna, but from two sculptures by Icelandic artist Einer Jonsson.[23] In "Sea Unicorns and Land Unicorns," images from one tapestry blend into those from another; a quick look at Leonardo's *St. Jerome* interrupts a description of a tapestry's pack of dogs; "an old celestial map," a painting of the Virgin Mary, and an image from a tapestry appear in quick succession. Such radical intertextuality is both the height of ekphrastic arrogance (the word rearranging the image at will, disrespecting its boundaries) and its opposite (an effort to respect integrity by not trying to possess the whole, by not saying "here it is").

Selection of object also mattered. Moore's ekphrastic objects most often come from museums; they are emblems of the very possessive urge she sought to rid herself of. But she liked objects that did not settle comfortably into their places in museums; she liked, especially, those that might not be considered "art," or that come trailing evidence of a previous, domestic, life: Chinese plates, a glass bottle, a pair of candlesticks, a patch-box, a carriage from Sweden, a six-foot painted wooden organ in the shape of a tiger devouring a man, tapestries, embroideries. Hanging in museums, the tapestries from which Moore draws evoke domestic craft and use, while reminding Moore of the strength of the desire to possess and display that brought them to that place.

Silence

Late in her life, Moore would return to writing on a tapestry, and again would choose one featuring a central, instructive female. Based on a Franco-Flemish tapestry in the Burrell Collection at the Glasgow Art Gallery and Museum (fig. 8), which Moore knew from a postcard, "Charity Overcoming Envy" (1963) continues Moore's strategy of multiplying points of view via quotations from various sources, but it proposes an even more radical response to the dilemma of the observing "I" than "Sea Unicorns and Land Unicorns."[24]

Fig. 8. *Charity Overcoming Envy,* 15th c. Glasgow City Council, The Burrell Collection.

From the start of the poem she refuses to speak for/of the tapestry with the kind of authority the ekphrastic tradition grants her. With the poem's title and subtitle naming the work, the date, the country of origin, and the collection like a good museum label, the speaker seems about to take up the role of ekphrastic docent that poets like Yeats and Auden had so effortlessly assumed to instruct us about the old masters or how to read the "lineaments" of portraits. But Moore immediately deflects that authority by asking our leave to speak, then offering to tell us not anything about the history of art or about the fineness of the artifact or even about the human lessons depicted, but a homey "story":

> Have you time for a story
> (depicted in tapestry)?
>
> (lines 1–2)[25]

The presumptions of museum culture are fondly, firmly tweaked.

The story she gives us—what *she* sees on the tapestry—is neither the conventional story of virtue defeating vice, nor the cryptic story offered by the inscription on the tapestry itself, which might be translated as: "The grief of the envious soul born of a goat is near. His joying is from evil things like a dog. But the elephant does not know this and Charity beats down this evil."[26] Instead, Moore parodies the gendered ekphrastic situation: the tapestry she sees is a scene of looking and saying, a scene of ekphrasis. Envy personifies that major motive of ekphrastic *paragone:* the perception that the image does it better than the word, has more signifying power—indeed, is worth a thousand words. Envy "looks up at the elephant" (line 14) on which Charity rides, and, like the ekphrastic poet, he talks and talks, cajoling, calling for pity, trying to wheedle and beg in a bid to master the situation, prove some power, or at least save his skin:

> He is saying, "O Charity, pity me, Deity!
> O pitiless Destiny,
> what will become of me,
> maimed by Charity—*Caritas*—sword unsheathed
> over me yet? Blood stains my cheek. I am hurt."
> In chest armor over chain mail, a steel shirt
> to the knee, he repeats, "I am hurt."
>
> (lines 16–22)

Like Moore the ekphrastic poet who calls on other texts, he calls to his aid the word *Caritas* displayed on the tapestry, thus pointing up the text Moore's counters. The poem is thoroughly self-reflexive as Moore presents a parody of herself via Envy, and works to retrain the possessive impulses of her word-making.

Charity, as conventional female object of the gaze, is silent. She says nothing. But, of course, it is the silent female who has the power; she, not Envy, holds the phallic sword. This is the revenge of the image, what Mitchell suggests the male viewer fears. And yet, in Moore's story, though Charity holds the sword and occupies the superior position, she neither acts nor speaks. Moore might have used two of the most prevalent devices of ekphrasis to give this silent female image the power of action and speech: prosopopoeia to en-voice her, and narrative to liberate her from the frozen, preg-nant moment. Instead, Moore turns the supposed liability of the silent, "passive" female image into a strength. While composing the poem, Moore recorded in a notebook: "Charity has a problem—how to preserve itself and to learn patience, the . . . mastery is from within."[27] That is Moore's problem, too. Moore recognizes that for Charity to act and speak would be for her simply to invert the power dynamic of Envy's desire to possess and dominate. Mastery is cer-tainly required ("The problem is mastered" in the end, we are told [line 26]), but not the mastery of either male Envy or female Charity over the other. The mastery must be over the impulse to master. Female Charity must stay her hand. Restraint in speech (and action) is here a sign of patience, and of expertise, that other sense of mas-tery.[28] For Moore, Charity's still silence is the sign of actively chosen restraint, not of constraint placed upon her, and certainly not of anything inherent in her nature as female.

The situation Moore sees depicted on the tapestry echoes one of Moore's own ekphrastic strategies used here and elsewhere in her poetry. She had difficulty finishing the poem. She recorded one ending in her diary, but a month later wrote that she "had a problem with the poem and [would] not try to solve it":[29] "the Gordian knot need not be cut" (line 29). Silence, Moore concluded, could be a telling option in response to the image. The gendered dynamics of ekphrasis that depend on a conventionally male word responding to a female image, language filling silence with speech, need not be played out to the end. Moore need not take on the mantle of Alex-ander the Great come to claim Asia by untangling the knot. Like Charity who does not lower her sword on Envy, but with her other hand holds his hand (the knot at the center of the image), Moore can simply leave potential as potential. The silence of Moore's Char-ity and Moore's silence about Charity are as powerful as the talk.

For Moore, egocentricity could never be eradicated without erad-icating the self; speech must always organize the world around the speaking subject. But there were ways of indicating a desire to let the other be, and to enact that as far as possible. Declining the single

speaking subject of ekphrasis who seeks to possess the image for poetic use through such strategies as description and narrative, Moore's feminist ekphrasis multiplies the speaking subject and its objects, chooses objects less challenging to the desire to possess, and recognizes silence not as defeat by the image but as an option of response to the image. Reciprocity, as far as it is possible to enact in language, is the ideal she holds up for the relation between viewer and viewed, an ideal her ekphrastic poems enabled her to both talk about and test.

ADRIENNE RICH'S EKPHRASTIC POWER

Across the divide of the 1950s, it was difficult for the second wave of American feminism to see in Marianne Moore much to suggest a way forward, or even a fruitful way back. In search of a female literary tradition that might guide and sustain her, Adrienne Rich famously recorded her bitter disappointment: "I discovered that the woman poet most admired at the time (by men) was Marianne Moore, who was maidenly, elegant, intellectual, discreet."[30] Impersonality and reticence hardly seemed the marks of a feminist; indeed, they seemed, historically, to have played right into the oppressors' hands. Rich, Plath, Sexton, and others spoke out in their poems in ways that would have been unthinkable to Moore. And they did so in ekphrasis, using the opportunities the ekphrastic situation offered and rewriting its strategies to explore issues of female identity in unapologetically performative, self-mirroring, and self-revealing ways. Like Moore, Rich understood sight as a ground for rewriting "the received truths about identity and authority,"[31] but Rich attacked them by renouncing the optimistic, failed assumption of gender equality in favor of outspoken accusations of inequality and deliberate efforts to wrest from the male gaze the power inscribed in the gendered workings of ekphrasis.

Rich couched her feminist program in terms of sight, most famously as "re-vision." From the beginning, ekphrasis featured as a tool in her feminist cause. In the foreword to *On Lies, Secrets, and Silence* (1979) in which "When We Dead Awaken: Writing as Revision" (1971) was collected, Rich called upon women "to look afresh at, and then to describe for ourselves, the frescoes of the Ice Age, the nudes of 'high art,' the Minoan seals and figurines," along with "the moon-landscape embossed with the booted print of a male foot, the microscopic virus, the scarred and tortured body of the planet Earth."[32] "The old masters, the old sources, / haven't a clue what we're about,

/ shivering here in the half-dark 'sixties," she had declared in 1969 in a retort to the authoritative voice of the most famous ekphrasis of the twentieth century.[33] Rich argued for engaged, active reanalysis of what women see, and she urged women to recover what had been overlooked by the male viewers of the past. Her aim was not so much to change the power dynamics of looking itself, as Moore did, but to train the eye to select and understand what it saw differently. Rich's viewing is more actively analytical than Moore's, and more driven by a desire to effect specific social and political change. In her ek-phrases, Rich aims to put power into the hands of viewing women.

Rich published her first volume, *A Change of World* (1951), some twelve years before Betty Friedan's *The Feminine Mystique* galvanized the movement; but already in it, as the title suggests, are the rum-blings of the revolution. The poems display what Susan Van Dyne calls "the particular strengths of a frequently ambivalent poetic stance"[34] that spoke of the painful struggle of coming to feminist consciousness. Some of them, among her best poems, are ekphrases. They make clear that "the main concerns of the later mature work" are not just "adumbrated" in this early work, as critics have argued,[35] but are already being explored in complex, nuanced ways and often more movingly than in the later programmatic poems on which her reputation as a feminist poet rests.

Women's History / Women as Historians

In her search for foremothers, Rich helped pioneer the feminist movement's crucial recovery of the effaced history of women. Her poems are full of the lives of exemplary women brought out of the back room of history, many of them artists: Paula Becker, Clara West-hoff, Emily Carr, Mary Jane Colter, and others. By 1979, when Elaine Showalter called on literary critics to "focus" "on the newly visible world of female culture" uncovered by a decade of work by feminist historians, anthropologists, psychologists, and sociologists,[36] Rich had already grasped the importance of seeing women not as isolated heroic individuals, but as part of a female subculture that might be constituted as a women's tradition.

In the poems, Rich turned to art for historical evidence of women's lives, and, importantly, to ekphrasis as a mode of historical re-vision. "Mathilde in Normandy," on the Bayeux tapestry, is her first foray into writing women's history.[37] Using ekphrasis to gain access to the past, Rich links herself to the modern male ekphrastic practice of such poets as Yeats and Lowell, but where they see a male line connecting the present, however uncertainly, to the past of Sato and Colonel

Shaw, she would recover a female line. With "Design in Living Colors" and the much-anthologized "Aunt Jennifer's Tigers," "Mathilde in Normandy" forms a trio of ekphrases in *A Change of World* that puts stitched and woven images to feminist ends.

As a major means of ekphrasis, description simultaneously pays homage to the image and appropriates it by orchestrating the selection, arrangement, and interpretation of its details. Opening "Mathilde in Normandy" by detailing the image, Rich turns this conventional tool of ekphrasis to powerful use in feminist historiography: naming and describing anew, she makes women's past accomplishments, previously unremarked by history, present and available as example. The poem builds on the legend that, while their men sought "harsher hunting on the opposite coast" (line 16), William the Conqueror's wife, Queen Mathilde, and her ladies embroidered the tapestry depicting William's invasion of England and his defeat of King Harold.[38] It is a monumental achievement: a continuous narrative worked in colored wool on unbleached linen 231 feet long and 19.5 inches wide. Displayed in the bishop of Bayeux's palace (now a museum) since shortly after the French Revolution, the tapestry may originally have adorned a church where William's subjects, both literate and illiterate, read on it his great deeds. Like *Charity Overcoming Envy*, this tapestry itself is a verbal/visual field with embroidered labels describing and dating the events depicted: for example, "Here King Harold addresses his faithful ones," "Where Harold took an oath to Duke William," and "Here King Harold was killed."[39] Like Moore's "story," Rich's opening description might be considered a responding re-vision of the labels:

> From the archaic ships the green and red
> Invaders woven in their colored hosts
> Descend to conquer. Here is the threaded headland,
> The warp and woof of a tideless beach, the flight,
> Recounted by slow shuttles, of swift arrows,
> And the outlandish attitudes of death
> In the stitched soldiery.
>
> (lines 1–7)

By constantly reminding us of the crafted artifact, Rich raises to consciousness the fact that history is made rather than simply reported, and that it is made, here, by women. Choosing as ekphrastic object a tapestry that still serves as a historical document enables Rich to assert not just the lasting achievement of the women's fine needlework, but their roles as important historians, a role she simultaneously takes on herself in writing the poem.

While the static stillness of the work of art conspires with its literal silence to code it as ideally feminine in so much ekphrasis, Rich taps the ekphrastic trope of art's endurance (the other sense of "still") to proclaim the durability of female accomplishment.[40] Using ekphrastic deictics, she invokes the work of art's presence as evidence. "That this," she says,

> should prove
> More than the personal episode, more than all
> The little lives sketched on the teeming loom
> Was then withheld from you; self-conscious history
> That writes deliberate footnotes to its action
> Was not of your young epoch.
>
> (lines 7–12)

While the men are dead and gone, the women's work lives on. Such enduring accomplishment is set implicitly against the fleeting and invisible domestic work of women in postwar America, prescribed by a conception of "female life," as Rich described it, "with its attention to small chores, errands, work that others constantly undo, small children's constant needs."[41]

At the same time, Rich uses the ekphrastic occasion to point out that the historical importance of that accomplishment was "withheld" from the women. She puts to historical use what would become a crucial insight of Kate Millet's *Sexual Politics* (1970): that patriarchy's denigration of women's worth is so pervasive that women internalize it as natural.[42] Mathilde and the court ladies did not even think to write "self-conscious history" or "deliberate footnotes." Following the recuperative program she later prescribed "for reading between the lines, watching closely for symbolic arrangements, decoding difficult and complex messages left for us by women of the past,"[43] Rich spins the narrative out beyond what is visible on the tapestry, as so much ekphrasis does, to bring to light the story the women could not tell themselves, the story of the challenge they faced and overcame in their work:

> Say what you will, anxiety there too
> Played havoc with the skein, and the knots came
> When fingers' occupation and mind's attention
> Grew too divergent
>
> (lines 21–24)

Capturing the tension of anxiety in the echoing vowels and internal rhymes, Rich rewrites the history of wars to tell the stories of the

women who stayed at home. Her words correct what she sees as the limitations of the image to tell the whole story.

Between the lines of the tapestry Rich also reads a tradition of female community:

> For a pastime
> The patient handiwork of long-sleeved ladies
> Was esteemed proper . . .
> Yours was a time when women sat at home
> To the pleasing minor airs of lute and hautbois,
> While the bright sun on the expensive threads
> Glowed in the long windless afternoons.
>
> (lines 12–14, 17–20)

While irony registers and resists the prescriptions that enforced such community and such reduced expectations, the warm direct address and the natural imagery suggest a utopian cooperative sisterhood, stretching across time, that was to become a central feature of American feminists' efforts in the 1970s to challenge competitive individualism. Whether Rich apprehended in 1951 the exclusiveness of her vision, as she later would under the pressure of international politics, multiculturalism, and growing class consciousness, is uncertain—"expensive threads" suggests she has an inkling—but Rich's commitment to a constantly evolving vision of sisterhood is displayed in her immediate correction of the nostalgic, utopian vision of Mathilde and the women: "anxiety there too played havoc," as it did with Rich's more self-conscious contemporary sisters.

Connoisseur of Perfection

In "Love in the Museum" (*The Diamond Cutters*, 1955), Rich rewrites the ekphrastic situation, anticipating the debate in feminist art history and film theory about how women find pleasure in looking at images of women. This is a poem of complex, shifting gender identities and relations. Written soon after her marriage, before the birth of the first of her three sons, years before she began to write frankly of lesbian sexuality in *Twenty-one Love Poems* (1976), "Love in the Museum" achingly reenacts the male objectification of the female. "Now will you stand for me, in this cool light, / Infanta reared in ancient etiquette," Rich begins, posing the beloved in a series of attitudes and dress that mirror famous paintings: "a Louis' mistress, by Boucher" or "in a bodice by Vermeer" (lines 1–2, 6, 12).[44] The speaker is not specifically gendered. If we read it as male, as in Rich's many other male-persona poems, Rich plays a feminist riff on Keats's "Grecian

Urn." Rather than the accumulating fear of unfulfilled desire Keats's "never, never" records even as he celebrates its eternity, this speaker fears the moment *cannot* be fixed. He staves off fulfillment, defers, pleading lest perfection slip away,

> let me be
> Always the connoisseur of your perfection.
> Stay where the spaces of the gallery
> Flow calm between your pose and my inspection,
> Lest one imperfect gesture make demands
> As troubling as the touch of human hands.
>
> (lines 16–21)

We might think of Rich here, viewing through a man, as performing what Laura Mulvey calls transvestitism, identifying by necessity with the masculine spectator for whom images of women are made.[45] But rather than acceding to the conditions of such spectatorship, the poem suggests that the tradition of stilling the woman in art, sustaining the desire for the child-bride ("Infanta"), mistress ("Louis' mistress"), and domestic muse ("Vermeer"), is a fantasy. That women will not stay on the walls, at least not for long, is the feminist hope held in the balance with the poem's genuine regret that such images cannot be timeless and immutable. If, however, the speaker is female, we might read "Love in the Museum" as a lesbian love poem. Rich tries on the gaze of female sexual desire, savoring its pleasures, feeling its tenuousness, before admitting and acknowledging the touch that will destroy.

The poem's first line, "Now will you stand for me . . . ," opens up the question of representation by signifying identity as well as objectification: will these images represent, "stand for," the poet/speaker? A woman looks at a woman. Ekphrasis becomes a way of exploring issues of female identity, of what will stand for women, and what women will and will not stand for. The ekphrastic dynamic represents not the play of difference, but the play of similarity, unseating the very terms of antagonistic dualism on which Rich believes patriarchal culture is founded.

When We Dead Awaken

While in "Love in the Museum" Rich tried on the role of observing artist, in "Mourning Picture" she speaks from the other side, for/as the image, deploying prosopopeia as a tool of political liberation. In so doing she rejects Moore's refusal to speak for another, but she

does so on equally ethical grounds. The woman poet, said Rich, "is endowed to speak for those who do not have the gift of language, or to see for those who—for whatever reasons—are less conscious of what they are living through."[46] The ekphrastic trope of the still, dead, frozen image provided the perfect figure for the silenced victims of patriarchy, some of whom Rich would work to awaken through the regenerative power of her language. This would become a standard technique in feminist ekphrasis of the second half of the century as a way of envoicing women silenced in an image.

The prosopopeia of "Mourning Picture" arises from second-wave feminism's insight that patriarchy works with the cooperation of those it oppresses, an insight already suggested by the tenuous obedience of the posed in "Love in the Museum." Published in *Necessities of Life* (1966) the same year NOW was founded, "Mourning Picture," on Edwin Romanzo Elmer's painting of himself, his wife, and his dead daughter, Effie (see color insert), reconfigures the terms on which images, even images already made, appear. "In the poem, it is the dead girl who speaks," the headnote tells us.[47] Doubly silenced by the picture and by death, she rises up, one of the dead awakening to feminist consciousness as Shelley feared the female image might, and not only speaks, but does so to claim her own role in the making of her image. She refuses to be complicit in the view of her and of death that the painting depicts.

In the poem, Effie observes her grieving parents across the space that occupies the center of the painting and signifies the gap between death and life, a position that replicates Rich's (and our) own position, gazing on the work of art:

> They have carried the mahogany chair and the cane rocker
> out under the lilac bush,
> and my father and mother darkly sit there, in black clothes.
> Our clapboard house stands fast on its hill,
> my doll lies in her wicker pram
> gazing at western Massachusetts.
>
> (lines 1–6)[48]

Baldly asserting the pastness of this image, dismissing the picture's presence, Effie declares "This was our world," then goes on to claim her ability to remake that world and to rival her father: "I could remake each shaft of grass," she says (lines 7–8). Indeed, the second verse-paragraph suggests she *is* the maker of the scene she/we see; the dream of her life as it was "condenses" in an ekphrastic description:

> Under the dull green of the lilacs, out in the light
> carving each spoke of the pram, the turned porch-pillars,
> under high early-summer clouds,
> I am Effie, visible and invisible,
> remembering and remembered.
>
> (lines 16–20)

As the memory ("remembered") that inspired her father and as the "remembering" re-creator of these word images of her gone world, she is doubly the maker of this image.

The assertion of female creativity is reinforced by Effie's description of how her mother responds to grief:

> Mute and rigid with loss my mother
> will ride the train to Baptist Corner,
> the silk-spool will run bare.
> I tell you, the thread that bound us lies
> faint as a web in the dew.
>
> (lines 23–27)

If the picture already provides evidence of how the father responds (by painting a picture), Rich recovers the elided story of Effie's mother by using the conventional narrativizing impulse of ekphrasis.

Denying the very foundation of her father's memorial, Effie tells the truth the living do not wish to hear: that the silk thread of memory is faint as a web, that the spool will run bare. This is a devastating truth for any dead child to tell her grieving parents. Brutal though it may be, it indicates the way of Rich's feminist future. As a truth told by the living (Rich) to/for the dead (depicted in the picture) and to us, it is the painful hope of those who need past ways of being to "run bare." In the end, "Mourning Picture" rejects Elmer's elegiac relation to the past. A family drama like many midcentury poems by women, it is an antielegy that refuses to mourn the loss of a family founded on the gender relations implied in the picture. The daughter will not, the voice asserts, die off like the mother, nor will she tell the lie about memory that her father's memorial embodies: "Should I make you, world, again, . . . and leave *this* out?" she asks (lines 28, 32). Fully awakened, she declares her old life past: "I am Effie, you were my dream" (line 32).

Like Moore, whose tapestries are recalled by Rich's metaphor of thread and spool, Rich participates in efforts to stop what she called "the dismissal of the traditional work of women as nonwork, of our art as mere 'decoration' or 'craft' or 'scribbling.'"[49] Mourning pictures were popular nineteenth-century forms of memorial, some-

times painted, often worked in embroidery.[50] The poem's image of
memory as a silk thread may evoke the embroidered mourning pic-
ture, worked most often by women. Thus, the invisible ghost of such a
memorial (what the mother might have made, running out her spool
of silk thread) seems to lie behind the father's painted, visible memo-
rial. Unlike the Bayeux tapestry, it is unrecoverable, truly lost, if it was
ever there, a further comment on history's effacement of women.

In "Transcendental Etude" (1975) Rich imagined a woman who

> quietly walked away
> from the argument and jargon in a room
> and sitting down in the kitchen, began turning in her lap
> bits of yarn, calico and velvet scraps . . .
> pulling the tenets of a life together
> with no mere will to mastery[51]

The vision of quiet, separate work is almost Marianne Moore's
(though Moore would cast an ironic eye on such idealization); but in
actual poetic practice, Rich often *does* display the "will to mastery"
that she and Moore would agree must be repudiated. Even in "Love
in the Museum," the relationship described between artist and
model, viewer and viewed, lover and beloved, depends on a domi-
nant figure who gives directions. Rich said, "Poetry is above all
a concentration of the *power* of language, which is the power of
our ultimate relationship to everything in the universe."[52] Though
she turned frequently to works of art in her poems, running be-
neath them is a wariness of images, a suspicion that they seduce, that
they tell lies that must be brought within bounds by the power of
language.

Rich's uses of ekphrasis for feminist ends is finally a less radical
revision of the genre than Moore's, but a more politically effective
one. With irony and indirection, Moore instructs men and women
alike to establish relationships to images and to others of all kinds on
less possessive grounds, and she works to enact the kind of viewing
she has in mind in her poems, always keeping before her her own
liability to the faults she would eliminate in others. To look and
to speak is *already* to possess, she knows. Her view is flexible, self-
conscious, never comfortable in fixed positions, and slippery in ways
that make it of questionable use for political purpose. Rich vests her
hope in women, turning the old gender dynamics on their heads
without essentially altering them, asking *women* to use the power of
looking and saying to expose patriarchal structures, and to use the
knowledge so gained to remake their lives. Ekphrasis suited Rich's
needs precisely because it could stage the exercise of power. Though

Moore hoped little and Rich much for the social efficacy of poetry, Moore understood what Rich would assume: that ekphrasis offered a means of re-vision.

The feminist ekphrasis of Rich and Moore makes clear that the workings of canonical ekphrasis would look different were women practitioners written into the account. At the least, the history of ekphrasis encompasses more than a century of poems that subvert, rewrite, and use for feminist ends the idea of a mastering male gazer and a feminized work of art. One might go on from Rich and Moore to consider how modern feminist ekphrasis would look were Elizabeth Bishop's quiet, unsettled looking and describing seen in relation to them; or one might trace a line from Joanna Baillie's ekphrasis of domestic objects through Eavan Boland's. And what happens when Jorie Graham is figured in, or the experimental poetics of, say, Cole Swensen, or ekphrasis arising from collaboration between women poets (Katherine Bradley and Edith Cooper writing as Michael Field) or between women poets and artists (Barbara Guest with a number of artists, C. D. Wright's recent work with photographer Deborah Luster)? If what Michael Baxandall has said is true—that "we explain pictures only in so far as we have considered them under some verbal description or specification"[53]—then ekphrasis, broadly considered, is the paradigmatic act in a culture of images. As we turn ever more decisively into that culture, it is important that we take the fullest measures of our traditions of seeing and saying. Writing women into the history of ekphrasis is a step toward encompassing the variety and possibilities of those traditions on which future practices will be founded.

NOTES

For an extended version of this essay, including greater detail about the sources of the poems' images, see my *Twentieth-Century Poetry and the Visual Arts* (Cambridge: Cambridge University Press, 2008). Thanks to Cameron Bushnell, whose unpublished paper suggested a way into Moore; to Ted Leinwand and Marsha Bryant, for their close readings of a draft of this essay; and to my research assistant, Natalie Prizel, for her excellent work and unfailing good humor.

1. W. J. T. Mitchell, *Picture Theory: Essays on Verbal and Visual Representation* (Chicago: University of Chicago Press, 1994), 152.

2. Ibid., 168.

3. *The Poems of John Keats,* ed. Jack Stillinger (Cambridge, MA: Harvard University Press, 1978), 372.

4. See Cathryn Vasseleu's argument that Irigaray's position is more complicated and not as hostile to sight as others, notably Martin Jay, perceive. Vasseleu, "Illuminating Passion: Irigaray's Transfiguration of Night," in *Vision in Context: Historical*

and Contemporary Perspectives on Sight, ed. Teresa Brennan and Martin Jay (New York: Routledge, 1996), 127–37. See Martin Jay, *Downcast Eyes: The Denigration of Vision in Twentieth-Century French Thought* (Berkeley and Los Angeles: University of California Press, 1993). For an excellent overview of the role of vision in Western thought, see Evelyn Fox Keller and Christine R. Grontkowski, "The Mind's Eye," in *Feminism and Science,* ed. Evelyn Fox Keller and Helen E. Longino (Oxford: Oxford University Press, 1996), 187–202.

5. Discussions of particular women poets' ekphrastic practices are accumulating. See, e.g., Kristin Bluemel, "The Dangers of Eccentricity: Stevie Smith's Doodles and Poetry," *Mosaic* 31, no. 3 (September, 1998): 111–32; Jane Hedley, "Sylvia Plath's Ekphrastic Poetry," *Raritan* 20, no. 4 (2001): 37–73; Donna K. Hollenberg, " 'History as I desired it': Ekphrasis as Postmodern Witness in Denise Levertov's Late Poetry," *Modernism/Modernity* 10, no. 3 (2003): 519–37; Sherry Lutz Zivley, "Sylvia Plath's Transformations of Modernist Paintings," *College Literature* 29, no. 3 (Summer 2002): 35–56; and, especially, Sarah Lundquist, "Reverence and Resistance: Barbara Guest, Ekphrasis, and the Female Gaze," *Contemporary Literature* 38, no. 2 (Summer 1997): 260–86. For a brief account of the importance of the sister arts analogy (and the use of ekphrasis) to nineteenth-century feminism, see Michele Martinez, "Women Poets and the Sister Arts in Nineteenth-Century England," *Victorian Poetry* 41, no. 4 (Winter 2003): 621–28.

6. Linda Nochlin, *Women, Art, and Power* (New York: Harper, 1988), 30.

7. Griselda Pollock, *Vision and Difference: Femininity, Feminism and Histories of Art* (London: Routledge, 1988), 85.

8. Bonnie Costello, *Marianne Moore: Imaginary Possessions* (Cambridge, MA: Harvard University Press, 1981), 192.

9. For the importance of museum culture to Moore and other moderns, see Catherine Paul, *Poetry in the Museums of Modernism: Yeats, Pound, Moore, Stein* (Ann Arbor: University of Michigan Press, 2002). On the role of the visual arts in Moore's poems, see Costello, *Marianne Moore;* Linda Leavell, *Marianne Moore and the Visual Arts: Prismatic Color* (Baton Rouge: Louisiana State University Press, 1995); and Elisabeth Joyce, *Cultural Critique and Abstraction: Marianne Moore and the Avant-garde* (Lewisburg, PA: Bucknell University Press, 1998).

10. Revised version, as it appears in *The Complete Poems of Marianne Moore* (New York: Macmillan, 1981), 47.

11. Marianne Moore, *The Complete Prose of Marianne Moore,* ed. Patricia C. Willis (New York: Viking, 1986), 215.

12. Cristanne Miller, *Marianne Moore: Questions of Authority* (Cambridge, MA: Harvard University Press, 1995), ix.

13. Mitchell, *Picture Theory,* 156.

14. Ibid.

15. James A.W. Heffernan, *Museum of Words: The Poetics of Ekphrasis from Homer to Ashbery* (Chicago: University of Chicago Press, 1993), 7.

16. Though working largely independently and in different ways, Gertrude Stein and H.D. were engaged in a similar reimagining of sight (in part through ekphrasis), suggesting that Moore belongs to a wider effort by Modernist women poets to change the perceived gender dynamics of seeing-and-saying. See Margaret Dickie, "The Maternal Gaze: Women Modernists and Poetic Authority," in *Alternative Identities: The Self in Literature, History, Theory,* ed. Linda Marie Brooks (New York: Garland, 1995), 221–44; and Paul's discussion of Stein (*Poetry in the Museums of Modernism,* 200–203). Though none have placed Moore in the ekphrastic tradition, many critics have explored Moore's efforts to undermine conventional, gendered attitudes to-

ward the world, especially the natural world. See, esp., Jeanne Heuving, *Omissions Are Not Accidents: Gender in the Art of Marianne Moore* (Detroit: Wayne State University Press, 1992). For a discussion of how Moore's "use of Chinese painting theory and philosophy [and Chinese art] . . . enabled her to explore alternatives . . . to western ways of narrating visual experience," see Cynthia Stamy, *Marianne Moore and China: Orientalism and a Writing of America* (Oxford: Oxford University Press, 1999), vii.

17. Susanna Terrell Saunders, "Georgiana Goddard King (1871–1939): Educator and Pioneer in Medieval Spanish Art," in *Women as Interpreters of the Visual Arts, 1820–1979,* ed. Claire Richter Sherman with Adele M. Holcomb (Westport, CT: Greenwood Press, 1981), 218.

18. Marianne Moore, "Sea Unicorns and Land Unicorns," in *Becoming Marianne Moore: The Early Poems, 1907–1924,* ed. Robin G. Schulze (Berkeley and Los Angeles: University of California Press, 2002), 133–35. Further references will be indicated by line numbers in the text. The poem also draws on Elizabethan maps, Leonardo's *St. Jerome,* and ekphrastic descriptions of the "embroideries" adorning Queen Elizabeth's dresses. Moore's notes point us to Violet A. Wilson's *Queen Elizabeth's Maids of Honour and Ladies of the Privy Chamber* (London: John Lane, 1922). For two of the fourfold combination, those described in lines 39–43, we can turn to the Cluny tapestries, three of which depict the lion and unicorn on their hind legs. The pursuit of the unicorn by the dogs is depicted in the famous *Hunt of the Unicorn* series at the Metropolitan Museum (The Cloisters). The final image of the unicorn tamed by the lady is a notional tapestry.

19. Costello, *Marianne Moore,* 154.

20. Moore, *Complete Prose,* 218.

21. Moore, *Becoming Marianne Moore,* 102.

22. Moore, *Complete Poems,* 231.

23. Costello, *Marianne Moore,* 200.

24. The colored postcard was given to her in January 1962 by Laurence Scott. She sent to the museum for more postcards, and also got two booklets. As Patricia Willis notes ("'Charity Overcoming Envy,'" *Marianne Moore Newsletter* 3 [1979]: 2–6), one of them, the *Scottish Art Review,* displays the tapestry on the cover and contains an article on it by William Wells that provides the quotations (some altered) in Moore's poem, and the phrase ("chest armour over chain mail") altered and not in quotations. "Chain-armour" is Wells's phrase. Wells also provides another important phrase not in quotation marks: "the problem is mastered." The problem to which Wells refers is "the problem of representing three-dimensional space." Wells, "Two Tapestries in the Burrell Collection," *Scottish Art Review* 6, no. 3 (1957): 29. Three-dimensional space does not interest Moore; the issue of mastery does.

25. Moore, *The Poems of Marianne Moore,* ed. Grace Schulman (New York: Viking, 2003), 335. Further references will be indicated by line numbers in the text.

26. The scroll reads *Ividi dolor animi cepru peris est proximi—gaudens eius de malis/ut canis—sed hoc elephas nescit vincit et hoc nephas caritas fraceri.* Thanks to Judith Hallett, Gregory Staley, and Jeffrey Hammond for help with the translation. I have not been able to discover whether Moore read a translation elsewhere, but she probably had enough Latin to get the drift of this difficult passage.

27. Willis, "'Charity Overcoming Envy,'" 5.

28. Elisabeth Joyce suggested this sense of "master" to me. Private correspondence, November 2002.

29. Willis, "'Charity Overcoming Envy,'" 6.

30. Adrienne Rich, "When We Dead Awaken: Writing as Revision" (1971), in *On Lies, Secrets, and Silence: Selected Prose, 1966–1978* (New York: Norton, 1979), 39.

31. Miller, *Marianne Moore*, iv.

32. Rich, "Foreword: On History, Passivity, Illiteracy, Violence, and Women's Culture," in *On Lies, Secrets, and Silence: Selected Prose, 1966–1978* (New York: Norton, 1979), 14–15.

33. Adrienne Rich, "In the Evening," in *Collected Early Poems, 1950–1970* (New York: Norton, 1993), 287.

34. Susan Van Dyne, "The Mirrored Vision of Adrienne Rich," *Modern Poetry Studies* 8 (1978): 146.

35. Albert Gelpi, "Adrienne Rich: The Poetics of Change," in *Adrienne Rich's Poetry and Prose*, ed. Barbara Charlesworth Gelpi and Albert Gelpi, rev. ed. (New York: Norton, 1993), 283.

36. Elaine Showalter, "Towards a Feminist Poetics," in *Women Writing and Writing about Women*, ed. Mary Jacobus (New York: Barnes and Noble, 1979), 28.

37. Adrienne Rich, "Mathilde in Normandy," in *Collected Early Poems*, 29. Further references will be indicated by line numbers in the text. For a discussion of this poem in the context of Rich's recovery of women's history, see Marianne Whelchel, "Mining the 'Earth-Deposits': Women's History in Adrienne Rich's Poetry," in *Reading Adrienne Rich: Reviews and Re-visions, 1951–1981*, ed. Jane Roberta Cooper (Ann Arbor: University of Michigan Press, 1984), 52–53.

38. Historians now believe the tapestry was commissioned by Odo, the bishop of Bayeux and half brother of William, and produced by the famous embroidery works in Winchester, England. Lynn Harry Nelson, www.ku.edu/Kansas/medieval/108/lectures/bayeux_tapestry.html.

39. Ibis Communications, "Invasion of England, 1066," www.eyewitnesstohistory.com/bayeux.htm.

40. For an extended discussion of ekphrastic stillness, in both senses, as the central "principle" of all literature, see Murray Krieger, *Ekphrasis: The Illusion of the Natural Sign* (Baltimore: Johns Hopkins University Press, 1992).

41. Rich, "When We Dead Awaken," 43.

42. Kate Millet, *Sexual Politics* (Garden City, NY: Doubleday, 1970), 54–58.

43. Rich, "Foreword," 14–15.

44. Adrienne Rich, "Love in the Museum," in *Collected Early Poems, 1950–1970* (New York: Norton, 1993), 113. Further references will be indicated by line numbers in the text.

45. Laura Mulvey, *Visual and Other Pleasures* (Bloomington: Indiana University Press, 1989), 32–33.

46. Adrienne Rich, "Vesuvius at Home: The Power of Emily Dickinson" (1975), in *On Lies, Secrets, and Silence: Selected Prose, 1966–1978* (New York: Norton, 1979), 181.

47. In *Collected Early Poems* the poem is missing part of its original headnote, which has therefore been cited from *Necessities of Life: Poems, 1962–1965* (New York: Norton, 1966), 72. Cf. Karl Kirchwey, "Women Look at Women," 99 and 106 n. 6 in the present volume.

48. Adrienne Rich, "Mourning Picture," in *Collected Early Poems, 1950–1970* (New York: Norton, 1993), 230–31. Further references will be indicated by line numbers in the text.

49. Adrienne Rich, "Motherhood: The Contemporary Emergency and the Quantum Leap" (1978), in *On Lies, Secrets, and Silence*, 263.

50. *Folk Art in America: A Living Tradition: Selections from the Abby Aldrich Rockefeller Folk Art Collection, Williamsburg, Virginia* (Atlanta: High Art Museum, 1974), 37–41.

51. Adrienne Rich, "Transcendental Etude," in *The Dream of a Common Language: Poems, 1974–1977* (New York: Norton, 1978), 76, 77.

52. Rich, "Power and Danger: Works of a Common Woman" (1977), in *On Lies, Secrets and Silence,* 248.

53. Michael Baxandall, *Patterns of Intention: On the Historical Explanation of Pictures* (New Haven, CT: Yale University Press, 1985), 1.

Elizabeth Bishop and the Art of Still Life

Bonnie Costello

WHEN ELIZABETH BISHOP TOOK OUT HER WATERCOLORS AND INKS, as she tended to do throughout her itinerant life, it was often to capture some small-scale arrangement of objects—a liver-spotted croton leaf, a star cactus, a simple but graceful wildflower cluster, wreaths in a cemetery. Often the subject was a domestic interior, not home but a hotel room, a ship's cabin, a hearth with no walls around it. Bishop's eye was drawn to anything on a table—an oil lamp, a candelabra, tea laid for one, a scraggly bouquet of daisies in a paint bucket. This attention to proximate objects is hardly surprising in a poet who values useless concentration, and the emphasis on domestic interiors reflects her long meditation on "home." In her simple ink drawings and watercolor sketches, often unfinished but always enchanting, one can find the style and matter of her poetry. A richly colored image of pansies beside a pile of books on a checkered tablecloth conveys her instinctive association of word and image (fig. 9).[1] Bishop's words become visible in odd angles of vision, the play with scale, the emotional language of colors, an affection for the humble. And as with her poetry, her paintings sometimes represent a world, and a point of view, anomalous to the viewer and yet intimate.

Red Stove and Flowers, for instance, is a marvelous bit of folk art in which the "Magic"-brand stove topped with pots of black beans and white rice is placed on the same visual plane and in the same scale alongside white and red flowers bursting from a crude pitcher (fig. 10).[2] Presumably in this deliberately "naive" image the flowers are meant to be in the foreground, sized to indicate their relative proximity in comparison to the background stove. But without the perspective lines the effect tips toward a psychological and emotional equivalence: aesthetic delight holds its place beside necessity. As if by "magic"—and painted in a Brazilian environment that favored the occult—norms of proportion and scale disappear and the stove and flowers fit equally on the picture plane and in the mind. The black background (common in Dutch and Spanish still life), which is hardly even a wall, establishes closeness; we cannot distance ourselves

Fig. 9. Elizabeth Bishop, *Pansies*, 1960. © Farrar, Straus and Giroux, US / Carcanet Press, UK.

Fig. 10. Elizabeth Bishop, *Red Stove and Flowers*, 1955. © Farrar, Straus and Giroux, US / Carcanet Press, UK.

from this space, strange as it is. The wooden floor becomes a wooden table and the two items become intimate gifts offered to the addressee: "May the future's happy hours bring you beans and rice and flowers." Like the painting, the syntax of the greeting puts the objects in parity, and we adjust our perception.

Rather than isolating the object in poetic space, Bishop often presents objects arranged in shallow, intimate spaces. She liked to study people, and herself, through their things, removing her gaze from human purpose and labor to the objects in which they leave their trace. Her penchant for the domestic still life and the culture of the table gives her an affinity with the Dutch tradition, but while Dutch still life attends to the surfaces of things, Bishop's poetry probes objects for the cultural and psychological knowledge they might contain. From wild cliffs and coasts she returned repeatedly to more local, habitable orders of "fish and bread and tea."[3] And while she often treats these objects with familiar nearness and even myopic detail, she conveys at the same time the sense of an outsider, even an ethnographer.

Bishop does not take up the subject matter of still life directly as a matter for formal experimentation, as does Wallace Stevens, William Carlos Williams, or Marianne Moore, studying pears, animating a pot of flowers, emblematizing a dish of nectarines. But one finds within Bishop's portraits, domestic scenes, and travel narratives still-life moments in which objects are arranged and scrutinized for their aesthetic and sensuous pleasure and their silent cultural significance. In a manner characteristic of still life, Bishop frequently foregrounds objects, suspending human activity. A begonia set on a doily, a scarlet fish in a frying pan, a wasp's nest on a pharmacy shelf, an iron teakettle on a stove—these images belong to stories and even, indirectly, to history. But Bishop removes these structures and narratives to the background and lets objects speak in the language of material culture.

Norman Bryson identifies the matter of still life as "the life of the table, of the household interior, of the basic creaturely acts of eating and drinking, of the artifacts which surround the subject in her or his domestic space, of the everyday world of routine and repetition, at a level of existence where events are not at all the large-scale, momentous events of History, but the small-scale, trivial, forgettable acts of bodily survival and self-maintenance."[4] But Bishop's imagery, the peripheral stuff that she brings into focus, tells us something important that we could never see full-face. The hand-hewn clogs in "Questions of Travel" are the trace of Dutch presence in Brazil (*Complete Poems*, 94); the "arctics and overcoats, lamps and magazines" in "In the

Waiting Room" are things absent from the world depicted in *National Geographic*, but they seem, in an estranged gaze, just as "unlikely" (*Complete Poems,* 159–61). This is the trivial, ephemeral, entropic stuff of still life that art historians label "rhopography," and Bishop's eye lights on it not only in order to elevate the ordinary, but also to read the everyday as the domain in which the purposes of culture (such as economics, sexuality, politics) are conveyed or resisted.

Bishop knows that while we may want materiality to precede culture, to be the ground of ideas and the anchor of identity, we inevitably experience things within culture, within semiotic and ideological structures. Still life often suppresses the work of culture as it displays the goods of culture. These arrangements seem given rather than made. And indeed, while things are never things in themselves, yet they are never fully of us either. The table is the primary site of material culture for the art of still life: even more than the hearth, it is the sign of home, the site of conversion from nature to culture, raw to cooked. The table is the sign, too, of consumption and display, the two sides of cultural desire, the shelf being a related, prior site. In these relatively shallow spaces (compared to the landscapes Bishop describes) local orders become defined in relation to material flux. Things bespeak the culture that produces them, its relationship to nature, and the place of individuals within that culture. But they retain an alien aspect, an otherness.

In the seventeenth-century Dutch world, many still lifes celebrated an affluent, bourgeois existence and the national confidence of a productive culture able to import goods from distant places, a culture proud of its secular learning but, as Simon Schama has shown, also anxious about its spiritual health.[5] Bishop greatly admired and imitated the Dutch art of describing, but the cultures she represents are very different. And unlike the Dutch, Bishop often looks as an outsider at cultural positions different from her own and reflects, implicitly, on the ethics and politics of this outsider gaze. Still life in her poems thus offers a refracted mirror, in which we see ourselves reflected, as well as the very different world to which these displays bear witness.

When Bishop's poetry represents worlds very different in class and region from that of her audience, a tension arises between the insights of social justice and aesthetic pleasure. Bishop's imagination is drawn to the aesthetic impulse within poor and working-class life; she discovers the affective power of the minimal or tattered object. Indeed, their poverty is part of the beauty of these arrangements for her, a relief from the excesses of first-world affluence. At the same time, one is moved to pity the hardship these inhabitants endure and

to see their arrangements in terms of the broader political and social environment. Some of her descriptions recall American trompe l'oeil artists of the nineteenth century, especially John Peto, whose rack painting, *Poor Man's Store* (with its faded reds, greens, and blues) anticipates the beautiful melancholy of her Key West images.

Bishop's prose description of the Key West barbershop window in which she first saw a painting by the Cuban folk artist Gregorio Valdes is itself a kind of rack painting: "The picture leaned against a cardboard advertisement for Eagle Whiskey, among other window decorations of red-and-green crepe-paper rosettes and streamers left over from Christmas and the announcement of an operetta at the Cuban school—all covered with dust and fly spots and littered with termites' wings."[6] Do the ornaments and luxuries of culture here evoke a *vanitas* (the still life tradition that reminds us, through symbols of time and erosion, of our mortality)? This society has little for sale and can afford even less. But the colorful barbershop window frames a culture that refuses to be defined by necessity, that may escape into drink ("Eagle Whiskey") but may also embellish its dark world with rosettes and operettas.

It is less pathetic than the house of the more affluent white woman in "Faustina, or Rock Roses" whose visitor, the narrator of the poem, is embarrassed "not by nakedness, / though perhaps by its reverse," not by proximity to nature but by the effort to deny it in the all-white still life exhibit of "talcum powder, / the pills, the cans of 'cream'" that promise to ward off mortality. But we are reminded even more of the vanity of human wishes by her pathetic display, her "clutter of trophies" (*Complete Poems*, 72–74). An unambiguous *vanitas,* the poem reminds us of the entropy to which all culture is subject, even for those socially designated masters, like the white woman who employs Faustina. Clearly this little study in white is racially as well as psychologically inscribed, set as it is in chiaroscuro with a "black / coincident conundrum" (ibid., 73). (The poem becomes for a moment a grotesque parody of Manet's *Olympia* as the black maid "exhibits" the objects to the reclining white figure, proffering pills now; Manet's bouquet is transferred by Bishop to the speaking guest with her rock roses.) There is no sense of home or hospitality in that morbid environment, tense with race and class hierarchies trumped by mortality.

Bishop's still lifes can display, then, poverty amid riches or riches amid poverty. It is a difficult ethical balance that she would struggle with throughout her work—the balance of "pity" (think how often the word arises in "Questions of Travel" and how ambiguous its referent [*Complete Poems*, 93–94]) and pleasure. As Margaret Preston has

observed, there are "so many tables of still life in modern paintings
. . . because they are really laboratory tables on which aesthetic prob-
lems can be isolated."[7] But for Bishop these are also ethical prob-
lems. How can we appreciate the aesthetic of the primitive without
sentimentalizing the minimal, and limited, conditions that give rise
to it? How can we recognize distinctive regional traditions without
stereotyping their exemplars? Bishop represented a broader trend in
American culture of the thirties when she turned her attention to
rural and folk cultures in contrast to the sterile excesses of urban and
dominant cultures. Yet many readers criticize Bishop's early poetry,
and even some of her Brazil portraits, for falling into stereotypes
despite their appreciation of regional cultures. Camille Roman, for
instance, remarks: "In poems like 'Jerónimo's House' and 'Cootchie'
she represents the complex multicultural race- and class-oppressed
local cultures of Key West and in this respect refuses to follow the
dominant cultural tendency of the era to ignore the existence of
difference. However, she also domesticates and/or primitivizes racial
difference and 'otherness,' reifying her own privilege and repro-
ducing the era's stereotypes."[8] By examining Bishop's descriptions
of domestic objects within these regional cultures we can see how
she negotiates this problem of cultural difference and aesthetic
attraction.[9]

"Jerónimo's House" (*Complete Poems*, 34) was inspired by Bishop's
observations of the Cuban émigrés in Key West. Her letters suggest a
particular model: "Down the street is a very small cottage I can look
right into, and the only furniture it contains beside a bed and chair is
an enormous French horn, painted silver, leaning against the wall,
and hanging over it a pith helmet, also painted silver."[10] The poem is
similarly an inventory of the Cuban's belongings—almost like a Peto
or Harnet rack painting. Bishop brings the distant near in this small,
shallow space through references to the radio and to the émigré's
cultural and political past—with the suggestion here of an aspiration
lost to the ravages not just of hurricanes but of political history itself.
But under the artifice of Jerónimo's voice one hears Bishop both
universalizing his condition (we are all living in frail shelters from the
hurricane) and identifying with it personally (she likes this minimal
aesthetic; she shares the desire for display). In particular, Bishop
exposes the scene of writing so that his near distances become her
own. In "Jerónimo's House" the shallow, primitive space of the
Cuban's dwelling becomes intercepted with "writing-paper / lines of
light," and the window in which she gazes into his home becomes a
mirror, his center-table her desk. The "wasp nest" home of chewed-
up paper glued with spit recurs in "Santarém" as a figure for the

poem (*Collected Poems*, 186). One might criticize this move as a meta-phoric appropriation of Jerónimo's actual historical suffering. But the poem manages to retain Jerónimo's particularity while inhabiting his abode. The result is a linking of the poet and her subject that neither subverts nor presumes full knowledge of the Other.

The mixture of festivity and *vanitas* further complicates our reading of "Jerónimo's House." He celebrates life even in the poorest conditions, and finds aesthetic abundance within spare circumstances. But as the poem delights in visual display and vibrant color, it highlights the precariousness and transience of this domestic order, the proximity of luxury to necessity, thus adding a note of melancholy. What complex relationship to this display does Bishop create for her relatively affluent, Northern audience? What role does the still life of the minimal play in a culture marked by excesses of number and scale? Does the scene in Jerónimo's house claim an imaginary, spiritual economy within a spare material economy? Does the poem therefore objectify Jerónimo and his household, making them available for the metaphorical and aesthetic contemplation of the better-endowed reader? Yet for Bishop the material economy is never forgotten.

We do not see Jerónimo, who creates this order—but we hear him (or, rather, his voice is constructed by the poet), and his contemplation of the order he has created is different from our own. The Roman word for still life, *xenia*, means both "host" and "guest," and he is both host and guest of this scene—audience, that is, to his own theater. But we are also his guests, audience, through Bishop, to his performance. We are aware immediately of the vibrant color—scarlets, pinks, greens, blues, aluminum—and the baroque variety of shape as well: ferns, French horns, looping Christmas decorations, woven wickerwork and latticework on the veranda (an aural echo in the flamenco music). As so often in the still-life tradition, all the senses are suggested within the visual field—smell and taste from the food, sound from the radio—adding to the feeling of abundance. Jerónimo's rhetoric denotes his pride and pleasure in the order he has created: his "fairy palace" "endowed" with spiritual worth by himself as ruler, though materially poor and minute. Miniaturization makes this whole house, not just its contents, part of a still life—with its "little / center table" (*Complete Poems*, 34).

This ornate and vibrant variety, addressed to the imagination, does not dispel the material poverty of the "perishable / clapboards," or the general impermanence of the paper materials, that mark the thin border between this home and the chaos of the weather, the hurricane. The attention to number throughout the poem contrasts this

domestic scene to an aesthetic of abundance—how many of us can enumerate our belongings? Here four chairs, ten beads, two palm-leaf fans, four pink tissue-paper roses, one fried fish. (A fish for how large a family? one wonders; since he mentions only the "smallest baby," we infer several others in this three-room house.) These are spare numbers against the "lottery numbers" and their dream of quick affluence (the same force of chance, in contrast to feeble, man-made order, that brings the more likely hurricane).

The lineation of the poem reinforces the insubstantiality of the scene, but at the same time allows the eye to register each item, connected by "and . . . and . . . and." Why did Bishop choose to set this poem in double columns (as she did not, say, for "Night City" [*Complete Poems*, 167–68], which also has very short lines)? The single page seems important to the sense of a finite space. The poem stresses the proximity of the culture of the table to the disorganized and even threatening presence of nature—the sense of the raw strong here within the cooked. The house, as Jerónimo tells us, is a kind of "wasps' nest," an ad hoc "affair" of "chewed-up paper / glued with spit." The decorations retain their origin in nature—the ferns planted in sponges, the palm-leaf fans. The little allowance for decoration at Christmas becomes the ornament that must sustain the occupants throughout the year. Jerónimo makes a space at Christmas for decoration, but not for the Christ Child; the real child, the baby, is the important one. Yet even here, display and aesthetic pleasure, not just necessity and use value, order the objects.

How are we to feel about this display? John Peto's rack paintings sometimes include a sign: "Important information inside." What kind of information is this poem alluding to with its display of objects? Certainly the objects are marked in an ethnic sense. The vibrant coloring and love of ornament seem to be part of a Southern baroque style that Bishop, like Stevens, contrasts to a more muted (grays and greens), colder Northern culture. Like many still lifes, this one evokes music, first with "an old French horn" repainted with aluminum paint, then with "flamencos" coming from the radio. The flavors evoked in the images again clearly provide a contrast to the familiar diet of the Northern poet. Here we find a "scarlet sauce" for the classic still-life fish—it has been dressed, most likely, in red chili sauce. Jerónimo's house is clearly that of an émigré, his possessions registering his frail tie to his origins. Objects are not universal or objective; they are ethnically coded, and Bishop celebrates this ethnic distinction even as distinctions of class and political oppression mark the difficult conditions of Jerónimo's dwelling.

We can read these images for their political pathos. Here is poor Jerónimo, barely getting by in Key West, pathetically celebrating the Cuban struggle against Spain in the parade for José Martí.[11] Martí is a symbol not only of Cuba, but of exile and of poetry as well. And Jerónimo is his heir. How liberated is he? He will be moving soon (unable to pay the rent?). Yet Bishop is clearly attracted to this ad hoc, primitive aesthetic with its proximity to nature. She is attracted not as an insider but as an outsider—coming from the world of excess in New York City and its hubristic "fantastic triumph"[12] over nature. Bishop seems to align her art with Jerónimo's. But in doing so she acknowledges the limit of her knowledge, turning the poem away from ethnic description and toward metaphor. The poem draws attention to its own making in relation to the order Jerónimo has made—the "writing paper / lines of light" remind us that all of this display rests upon the poem itself, ephemeral as the chewed-up paper house. Poetry itself is something ad hoc, a papier-maché of the past. But if one direction of the poem is toward "rhopography" (the display of the stuff of life, what is ephemeral, trashy, and everyday), another is clearly toward "megalography" (the conversion of poor materials to numinous riches). The poem seems to hover between these impulses, between rhopography and megalography, between economics and imagination, between Jerónimo's world and Bishop's, between the shabbiness of John Peto and elegance of Joseph Cornell.

The paternal Jerónimo presides over his own private world (emasculated though he may be within the economic and colonial structure of the wider culture). But still life belongs to what is culturally defined as feminine space.[13] It belongs to the realm of the domestic, of nurture, of the table, of rest, of nature converted to culture, as opposed to the masculine realm of the road, of the outdoors, of work and war, of movement and stress, of animal impulse. "Filling Station" (*Complete Poems*, 127–28) pursues the structure of this "dazzling dialectic"[14] in the idea of family. The poem recalls Walker Evans's tableaus of American life along the roads of the South. More concretely, Bishop may have seen Evans's photographs of small rural establishments that served as both home and business—the isolated barbershops and lonely gas stations backed by invisible private lives. Evans's compositional use of advertising signs comes to mind as Bishop's speaker reads off the "Esso — so — so — so" on the oilcans at the end of the poem; in Evans's interiors, as in Bishop's, American aspirations are mirrored back in awful but somehow resilient and even cheerful conditions of dwelling. The speaker, coming from the

road, is marked by voice and attitude as different from her subjects; she is more sophisticated and more urban than they. She approaches a male tableau (father and sons handling fuel pumps) with anxiety. The "saucy" (sexual) father and sons in their "monkey suits" are not yet human. They must be "civilized" by the feminine principle (with her "sauces"?). But as the speaker's gaze shifts toward the porch and the world of still life, the "disturbance" is calmed. The animal element (now benignly embodied as a dog in a chair) is made "comfy." Bishop stresses that the domestic space is not an independent realm; the wickerwork is "grease impregnated," but sexuality has become familial. The demotic still-life scene on the porch offers a "note of color" *within* this study in grays and blacks.

> Some comic books provide
> the only note of color—
> of certain color. They lie
> upon a big dim doily
> draping a taboret
> (part of the set), beside
> a big hirsute begonia.
>
> (*Complete Poems*, 127)

The combination of books and flowers is a topos of still-life arrangement, but here we have comic books in place of august bound volumes; instead of an elegant floral arrangement we have a "big hirsute begonia." "Hirsute" means "hairy," reminding us of the hairy males who live there. (The feminine "doily" drapes like a skirt; on it "lie" the fictional comic books.) The conversion of nature to culture is provisional and by definition artificial. The decorative element seems indeed "extraneous" and a little ridiculous. Yet this is an affirmation of *both* the comic spirit and the aesthetic impulse for calming the animal in us and offering respite from the anxious drive of technology. Bishop here, in this generic portrait of Middle America, confirms Constance Rourke's observation that humor is an element of national character. Is the comedy of the poem condescending to the people who live at the filling station? Perhaps at first. But the speaker-beholder is drawn to this aesthetic arrangement, "dim" though it may be; she (we suspect a female beholder from the knowledge of the embroidered "marguerites") interrogates the arrangement, but also recognizes and enjoys it, becoming an insider, overcoming the high/low distinction of cultural pleasures. The speaker pauses to note detail—the parentheses in the poem ("part of the set") providing a typographical equivalent to the stillness of still life, the arrangement suspended from the forward movement of travel. She forgets the

road in the theater of the still life. The language of the speaker mirrors the still-life incongruities, introducing words like "taboret" and "hirsute" (like the baroque elements of Jerónimo's house) into the colloquial world of comfy and saucy, rhyming "oily" with "doily." The still-life moment here performs a calming function: the aesthetic principle quiets the "high-strung" life of the road.

The final stanza of the poem highlights two fundamental features of still life: the absence of agency and the intransitivity of the image. Still life, Bryson argues, is the world minus its narrative, or the world minus its capacity for generating narrative interest.[15] But Bishop's poem awakens just this interest. "Somebody embroidered the doily." The poem shifts to the present tense, as if to merge the static "still moment" of still life and the continuous present of life: "Somebody / arranges the rows of cans" (somebody *still* does). Ultimately the poem evokes a third, transcendent temporality: "somebody loves us all" (*Complete Poems*, 128). The last two stanzas of "Filling Station" evoke temporal paradoxes in a way characteristic of ekphrasis. If still life, a spatial art, suppresses narrative, the verbal art awakens it. The comic books visually provide a note of color, but who provides the comic books? The verbal here does not compete with the visual but complements it. We see this particularly in the end of the poem, where the verbal and visual coincide in the oilcans lined up to read "Esso — so — so — so." Here is a still life moment suggestive of Jasper Johns or Andy Warhol, whose word-images recall us to the layering of representation. The prompt may be advertising, the visual text scrawled with brand names, but Bishop's "so — so — so" reminds us also of the way poetry converts instrumental language to pleasurable sound. If we must leave the domestic world of still life and return to the world of "high-strung automobiles," we can be fueled, at least, by the aesthetic order.

"Things hurry away from their names" in Joseph Cornell's boxes, in Marcel Duchamp's ready-mades, in Claes Oldenburg's pop art, and also in some of Bishop's still lifes.[16] If hers is poetry of the everyday, she is also concerned with transfigurations of the commonplace. And as with the contemporary art of the object, Bishop's transfigurations often involve uncanny disruptions of scale. But her aim is not Dada subversiveness or private metaphysics. We might consider "12 O'Clock News" (*Collected Poems*, 174–75) as a vocational still life (the philosopher's study, the artist's studio, the geographer's desk, the musician's chamber) in this mode.

Whereas some of the poems I have discussed bring the distant culture near, this poem presses out from the personal. Bishop de-familiarizes the artist's materials in order both to achieve an eth-

nographer's distance from her own work, and also, conversely, to bring her own scene of writing into contact with distant political realities. In "12 O'Clock News" she describes her writing desk but expands it to the scale of landscape while at the same time insisting on the nearness of the objects. On the left margin she provides, in italics, an inventory; to the right of each item, a prose block converts the item to a feature in a landscape. Without a fixed perspective or vanishing point, we cannot orient ourselves in this space. By describing the objects of her creative activity—typewriter, ink-bottle, and typewriter eraser—as features of a third-world war zone, she suggests the turmoil of the creative mind from the point of view of a hegemonic, rational mind. The voice of the news broadcast (which echoes the voice of wartime bureaucracy) displaces the lyric voice. Rhetorical stance and point of view line up as the "tiny principality" is seen from the angle of aerial reconnaissance, yet the intimate perspective of the writer remains implicit (*Complete Poems,* 174). Bishop liberates objects from their quotidian, functional meaning and consequently releases the dream work of the personal and social psyche. The "superior vantage point" of the news report thus exposes the numen of objects (ink-bottle in particular) even while it dissociates itself from spiritual affect (ibid., 175). Bishop's personification of the typewriter eraser produces the reverse effect of Claes Oldenburg's sculpture *The Typewriter Eraser,* now in front of the National Gallery of Art in Washington. Bishop's typewriter eraser as "a unicyclist-courier" and "native" of the land of creativity lies in a fallen, pathetic state, defeated by the forces of normative reality (ibid.). Oldenburg, in contrast, gives us a perky monument to the bureaucratic mind, an anachronism of cold-war technology, absurd in a postmodern, computer culture.

In "12 O'Clock News," as in many of the poems of *Geography III,* Bishop resists a steady, dichotomous calibration of objects (small converted to large), instead unsettling the scale of large and small several times over—for by what size is the world of the psyche measured? As she says of the typewriter eraser turned native insurgent, "Alive, he would have been small, but undoubtedly proud and erect, with the thick, bristling black hair typical of the indigenes" (ibid.). Several standards of measure—physical, spiritual, political—are at play here. As a personified object the typewriter eraser has been transformed by the poet from something hand-sized to something human-sized; but the "superior vantage point" of the rationalist diminishes the cyclist figure as a racial subaltern, putting the human back into the state's gigantic, invisible hand. This still life stands at the juncture of the personal and the public, the near and the distant.

As an image of objects in an intimate, personal space, it points toward the world of the individual; as an image of vocational objects, it points toward the social position of the artist, which itself resembles the position of indigenous societies under the scrutiny of a hegemonic power. The poem refuses to stabilize the relationship of tenor and vehicle; it protests an imperialist war (Bishop returned to and finished the poem during the Vietnam War) even as it surveys the private war of the imagination.

The scene of writing surfaces often in Bishop's poems, whether as figure or as ground. In "The Bight" the desk appears implicitly at the end of the poem (as the table is implicit from the pun in the title), where metaphor gradually shifts the scale from landscape to still life and the "little white boats" in the Key West harbor are "torn-open, unanswered letters" (*Complete Poems,* 60). In all Bishop's still-life gestures we see her attraction to "untidy activity" over prim, static orders, but in "The Bight" she implies that disorder is linked to the absence of a key to all correspondences. As Rosemary Lloyd observes, "Often and increasingly so in modernist works, the still life objects convey a sense of messiness, of disorder, of chaos impinging on a world from which theological certainties were being eroded."[17] In "The Bight" the untidiness is "awful but cheerful" (ibid., 61), but in "12 O'Clock News" the disorder is the result of war rather than of neglect.

The ambiguity of this poem arises at every level, and at every level has bearing on the play of proximity and distance. "12 O'Clock News" is a prose poem. What is a prose poem? The generic hybridity underscores a fusion of animate and inanimate objects, such as the "*gooseneck lamp*" (ibid., 174). Does the italicized catalogue of objects on the left margin designate a foreground? A gloss on the right-margin text? A heading or title (yet put to the side, not the top), a relation of metaphor? The list of things on the left seems voiceless as compared to the marked public voice of the newscaster/bureaucrat on the right. Is it twelve o'clock here in the scene of writing or there in the war-torn country? (The hour itself is an ambiguous threshold between p.m. and a.m.) We are given descriptions through a radio correspondent while the poem is set in an entirely different site. Dislocation, defamiliarization, difficulty of seeing, and ambiguity of what we are seeing—these are trademarks of Bishop's work, however living in detail. The "plain" is anything but plain. We are never just "here" or "there," in metaphoric structures or in life.

These dualities are compounded rather than relieved as we try to enter the world described in the prose blocks. The problem is not simply in the white space between items and descriptions or in the landscape's metaphoric relationship to the desk (expansion of scale

and distance, thematic implications of the analogy). Within the description itself, "visibility is poor" (ibid., 174). For example, whereas identification is straightforward enough in the left-hand inventory, labeling is problematic throughout the right-hand prose. "Our aerial reconnaissance reports the discovery of a large rectangular 'field,' hitherto unknown to us, obviously man-made. It is dark-speckled. An airstrip? A cemetery?" (ibid.). The embedded metaphors dislodge the established adjustment of scale and perspective: the "typewriter," enlarged to an "escarpment," is then metaphorically reduced to fish scales. The voice of the narrator also reduces what the poet has expanded: while the desk has become a geographic region, it is a "tiny principality" (ibid.). The "typewriter eraser," enlarged to a fallen "unicyclist-courier," is judged in life to have been "small, but undoubtedly proud and erect" (ibid., 175). Problems of seeing and interpretation in fact mark every paragraph, and much is said to be "undisclosed," as if there were some superior position of knowledge from which the speaker is quoting. From her desk Bishop shatters the presumptions of knowing the other even as she insists that the other is we.

In most of the poems we have examined so far the space of still life affirms the domestic world, defending a human scale of order and comfort against larger forces that threaten the individual. Still life is based on the culture of the table (whether for food or for work), that site of transmission from public to personal space and conversion of raw to cooked.[18] But Bishop's art of the everyday includes the surrealism of everyday life. The art of the object, subjected to animation, peculiar lighting, shifts of scale and perspective, and incongruous metaphor, is central to the uncanny affect. Despite its Pieter de Hooch–like calm impersonality, "Sestina" creates a sense of the uncanny as the eye scans discrete objects of various textures—iron kettle and stove, the bread, book, bird, and tea. Containers do not hold things and surfaces yield to a menacing intentionality of ideas in things. The sestina's repetitions may be likened to the obsessive circling of trauma. While the description of childhood memory seems timeless, as a scene of Bishop's childhood it would be the years of World War I, an era of public as well as private turmoil; the almanac says "time to plant tears" (*Complete Poems*, 124). In a reversal of still life, dead things come alive, but only to remind us of death.

Bishop evokes the mood of *vanitas*, that element (marked in skulls, broken jars, torn papers, butterflies, books, and candles) in several poems that tells us that all our provisions are conditional and that material wealth is not equivalent to spiritual health. Bishop works both ends of this *vanitas* association. In "First Death in Nova Scotia"

the dead become associated with consumption and food (death is caught in a structure of desire); here the culture of the table repulses the beholder. In "Going to the Bakery," set in Brazil, food becomes associated with death and disease (desire is repulsed by knowledge of the economic decay). In both poems still life becomes a way of exploring large social and ontological questions on a personal scale.

"First Death in Nova Scotia" (*Complete Poems,* 125–26) describes a "lay[ing] out," a wake, but the morbid display suggests still life's imagery of a feast and alludes to its structure of desire. The bird on the table is not a pheasant or a turkey but a "stuffed loon"; the table on which it rests has become a winter landscape, a "frozen lake." The coffin itself "was a little frosted cake," and the whole scene suggests a starved desire: the loon caressable but uncaressed, eyeing the little cakelike coffin as if wishing to consume it. Lurking in the poem too, since the scene is described from a child's point of view, are fairy-tale fears of adults eating children. (Did Uncle Arthur kill not only the bird but also young Arthur himself? Has Arthur also been stuffed by the taxidermist for heroic display?)

Still-life painting often involves the depiction of several modes of being—natural and artificial, animate and inanimate, representational and "real"—on the same plane. This becomes a source of confusion for the beholder in "First Death" as she struggles to understand the various layers of presence and absence in the scene in relation to human mortality. The chromographs, "Edward, Prince of Wales, / with Princess Alexandra, / and King George with Queen Mary" (ibid., 125), signify the colonial presence (Nova Scotia was still part of the United Kingdom). They place the larger world (a world at war in the time of the poem's scene) into this small space (with its own silent history of violence). The speaker longs for narrative transformation—Arthur has been invited to join the royal couples presiding in the photograph—but agency is interrupted (Jack Frost has dropped the brush), and all the figures are frozen in a still-life moment (ibid., 126).

"Going to the Bakery" (*Complete Poems,* 151–52) presents another form of *vanitas,* from the Southern region of Bishop's experience, and the opposite perversion of the still-life image. This time the scene is not home but the street—the world of the market and its window displays. Food-stall images are common in Dutch still life, mirroring a predomestic stage of material culture. In these images facts of labor and economic exchange disappear and we see only a limitless supply of goods, as if there for the taking. But in Bishop's "Going to the Bakery" the goods can never become part of a nurturing domestic reality, even for the beholder who can afford to purchase them. The

hunger surrounding the plenitude contaminates it, shocking bourgeois complacency. Sight becomes infected with the truth of a troubled economy in which everything is rationed and adulterated. As with many of Bishop's poems, her unique perspectives trouble the surface and expose truths suppressed in familiar angles:

> the round cakes look about to faint—
> each turns up a glazed white eye.
> The gooey tarts are red and sore.
>
> (*Complete Poems*, 151)

This grotesque bakery-as-hospital-ward is seen in moonlight—but such is also the light of the imagination, exposing certain truths within the everyday. Bishop's surrealism leads not to the fantastic, but to the real—to the dysfunctional and inhumane conditions of society. Rosemary Lloyd notes that the poem's "deliberately trivialized fixed form" helps to "underpin the ugliness of modern mass-produced food."[19] In the monotonous jingle, "buy, buy, what shall I buy?" we also hear the mood of *vanitas* (ibid.).

We cannot leave the subject of still life in Bishop's work without examining its relation to memory, both personal and cultural. What Benjamin called "the mysterious power of memory—the power to generate nearness" is a key element of Bishop's imagination, and still life is often the agent of this work of memory.[20] Still life stands against time and flux; it is inherently memorial. The objects of still life are souvenirs signifying lost (or imagined) contexts of origin. In this way, again, still life both suppresses and evokes narrative. Memory is, of course, a problematic mental process in Bishop, defining the continuity of self, but linked inevitably to both pain and nostalgia. Removed from time and place, souvenirs represent desire's always-future past. Crusoe at the end of "Crusoe in England" surveys the archived objects from his island days with a hopeless sense that their numen cannot be retrieved (*Complete Poems*, 166). They fail as still life, presenting neither order nor nostalgic value, but only waste.[21] Finally, Bishop's imagination breaks with still life where it leaves depiction and becomes exhibition. Objects belong to flux; if objects are invested with human meaning, they do not ultimately belong to us: the mother's watch and the lost door key of "One Art," like all material things, "are filled with the intent to be lost" (ibid., 178). They may be archived (the poem draws links to all the poems in *Geography III* and earlier), put in a box like a villanelle itself, labeled and arranged as a guide to memory, but we cannot hold them in our gaze for long. The sequential nature of poetry, for all its repetitions, reminds us of this fact.

Yet the archival imagination persists in Bishop's late poetry. Though the art of still life must yield to the art of losing, the souvenir is not without value altogether. As Bishop returns at the very end of her life to remember Nova Scotia and Brazil, she is more willing to acknowledge the pleasures of memory without nostalgic longing. The great-uncle's painting in "Poem" is a "family relic," not metaphysical but alive with impacted temporalities (*Complete Poems*, 176). The Santarém of the poem of the same name (1978), etched in the blue and gold of memory, is a fictive Eden, if an embattled and demotic one. She cannot stop there, but the poet finds a souvenir, something she sees in another display:

> In the blue pharmacy the pharmacist
> had hung an empty wasps' nest from a shelf:
> small, exquisite, clean matte white,
> and hard as stucco. I admired it
> so much he gave it to me.
>
> (*Complete Poems*, 186)

What is there to admire? By asking us as readers to interpret the object, she causes it to speak and makes us value it with her. Obviously this object—homely, ephemeral—has associations for Bishop with the town's charming church ("Cathedral, rather" [ibid., 185]). The wasps' nest is a miniature version of an already modest, perishable architecture (subject to lightning). (The house is treated as a still life.) It resonates, too, with Jerónimo's home, that "fairy palace . . . my gray wasps' nest" and thus with poetry itself, that "chewed-up paper glued with spit" which houses the sting of life (*Complete Poems*, 34). Like all Bishop's houses, this image is full of ambivalence. Gaston Bachelard writes of the nest as a key image in the poetics of interiority.[22] But the wasps' nest is in some sense a center of pain; the source of pain, the pain itself has fled, leaving something "hard" but hollow. (The blue pharmacy and the nest on the shelf suggest Joseph Cornell and alchemy; her translation of Paz's tribute to Cornell was not far off.) These things are not of museum quality but take their place in the personal archive of memory, and the public archive of poetic emblems. Bishop knows this souvenir has no inherent value and has little more chance against the ravages of time than it did in nature. Her fellow traveler Mr. Swan, a romantic attuned to a sublime scale, who "wanted to see the Amazon before he died," asks "what's that ugly thing?" (*Complete Poems*, 187). But if he gets the last word in the poem, his view does not prevail. It simply marks the limits of the speaker's power over things.

The generic affinities with still life and poetry are too strong. The keeping of poetry, like the keeping of still life, does not denote mastery over material things, let alone over landscapes. Both remove objects from experience and reconfigure them in an artificial space. But they mark out an environment—shallower than landscape, but more intimate, more human—in which the material world is arranged and encoded for the individual beholder.

NOTES

This essay is reprinted, with minor changes, from *Planets on Tables: Poetry, Still Life and the Turning World* (Ithaca, NY: Cornell University Press, 2008), where it appears as chapter 3.

1. Elizabeth Bishop, *Exchanging Hats: Elizabeth Bishop's Paintings,* ed. William Benton (New York: Farrar, Straus and Giroux, 1996), 75.

2. Ibid., 67.

3. Elizabeth Bishop, "The Moose," in *The Complete Poems, 1927–1979* (New York: Farrar, Straus and Giroux, 1983), 169. This edition of *Complete Poems* is hereafter cited in the text.

4. Norman Bryson, *Looking at the Overlooked: Four Essays on Still Life Painting* (Cambridge, MA: Harvard University Press, 1990), 14.

5. Simon Schama, *The Embarrassment of Riches: An Interpretation of Dutch Culture in the Golden Age* (New York: Alfred A. Knopf, 1987).

6. Elizabeth Bishop, *The Complete Prose,* ed. Robert Giroux (New York: Farrar, Straus and Giroux, 1984), 51.

7. Quoted in Rosemary Lloyd, *Shimmering in a Transformed Light: Writing the Still Life* (Ithaca, NY: Cornell University Press, 2005), 6.

8. Camille Roman, *Elizabeth Bishop's World War II—Cold War View* (New York: Routledge, 2001), 51.

9. Walter Benjamin associated folk art with kitsch: "Art teaches us to look into objects. Folk art and kitsch allow us to look outward from within objects." Bishop's artful poetry incorporates folk art and so allows us to look both ways, avoiding kitsch. Walter Benjamin, *Selected Writings, Vol. 2: 1927–1934,* ed. Michael Jennings (Cambridge, MA: Harvard University Press, 1999), 279.

10. Elizabeth Bishop, *One Art: Letters,* ed. Robert Giroux (New York: Farrar, Straus and Giroux, 1994), 68.

11. "The apostle of Cuba," Martí was a poet and statesman banished from his native Cuba for activities that protested Spanish colonialism. While he was devoted to Cuba's freedom, then, his life was a wandering one as he roamed the United States, Europe, and Latin America seeking support for his cause. Indeed, in 1892 he gathered Key West's fragmented Cuban exile community into the Cuban Revolutionary Party, the movement that led to the establishment of a free Cuba in 1902, just seven years after his death. He died on Cuban soil only minutes after his first ride into battle. His collected writings in seventy-three volumes commenced publication in 1936, just as Bishop was living in Key West.

12. Elizabeth Bishop, "From the Country to the City," in *The Complete Poems, 1927–1979* (New York: Farrar, Straus and Giroux, 1983) 13.

13. Bryson, *Looking at the Overlooked,* 136–78.

14. Ibid., 185.

15. Ibid., 60–61.

16. Elizabeth Bishop, "Objects and Apparitions," in *The Complete Poems, 1927–1979* (New York: Farrar, Straus and Giroux, 1983), 275. Joseph Cornell is the poem's dedicatee.

17. Lloyd, *Shimmering*, xiii.

18. Bryson, *Looking at the Overlooked*, 29.

19. Lloyd, *Shimmering*, 13.

20. Benjamin, *Selected Writings, Vol. 2*, 248.

21. Writing at the same time as Bishop, Robert Harbison's remarks on museums echo Crusoe's lament: "The act of museumifying takes an object out of use and immobilizes it in a secluded atticlike environment among nothing but more objects, another space made up of pieces. If a museum is first of all a place of things, its two extremes are the graveyard and a department store, things entombed or up for sale, and its life naturally ghost life." And later: "In order to enter, an object must die." Robert Harbison, *Eccentric Spaces: A Voyage Through Real and Imaginary Worlds* (New York: Ecco Press, 1977), 140, 147.

22. Gaston Bachelard, *The Poetics of Space* (1958; rpt., Boston: Beacon Press, 1969), 90–104.

Ekphrasis and the Fabric of the Familiar in Mary Jo Salter's Poetry

Jonathan F. S. Post

IT IS NOT QUITE TRUE THAT IF YOU CROSSED ELIZABETH BISHOP WITH John Ashbery, you could then number Mary Jo Salter among their painterly offspring, but this improbable fancy does underscore, at once, both her deep attraction to the visual, in its many shapes and manifestations, and her quirky, uneven footing in two strands of contemporary American verse associated with ekphrastic poetry in particular. One, of a more domestic order, might be said to travel through Bishop. It typically includes the objet trouvé or the odd family heirloom, like the painting, "about the size of an old-style dollar bill," done by her "Uncle George," that Bishop so patiently and lovingly describes in her celebrated *ars poetica* called "Poem." A carefully composed modesty is a condition of its imagined being: *ut pictura poesis*—"as in painting, so in poetry." In English, the tutelary spirit for this Horatian figure is George Herbert (a foundational poet for Bishop), whose following lines from "The Temper" also form the epigraph to Salter's first book of poetry, *Henry Purcell in Japan* (1985):

> How should I praise Thee, Lord! How should my rhymes
> Gladly engrave Thy love in steel
> If, what my soul doth feel sometimes,
> My soul might ever feel![1]

As Herbert's reference to engraved rhymes indicates, this is a poetry that aspires to a perfect fusion of form and praise; but—and the balancing turn is both inevitable and crucial to what Seamus Heaney calls Herbert's "daylight sanity and vigour"[2]—it also willingly acknowledges, and appreciably accepts, smaller artistic victories as part of the limited conditions of living in this world. This more mundane Herbert, the artful master of parables and plain speaking, who is not the Albrecht Dürer of Renaissance devotional poetry seeking to write rhymes engraved in steel, still lives with modern and contemporary

164

poets like Bishop and Salter, even if, with Dickinson and Larkin, they sometimes "cheat"—the word is Bishop's[3]—on his theology.

A second tradition, orchestrated in part by scholarly and theoretical pursuits, harks back to Homer and the famous depiction of Achilles' shield in book 18 of the *Iliad*. More readily associated, as epic generally is, with the sublime, this version of the visual descends through a number of Western canonical texts often bearing dynastic or imperial themes, and includes the likes of Virgil and Shakespeare, but its urgencies can be felt as well of late in Anthony Hecht's "The Venetian Vespers," Richard Howard's "Giovanni da Fiesole on the Sublime, or Fra Angelico's 'Last Judgment,'" and Jorie Graham's *The End of Beauty*.

Again, betraying its epic roots, the relationship between poetry and painting in this tradition is often characterized by critics not as one of Horatian geniality ("as in . . . so is") but in the heroically fraught language of combat ("as in . . . so isn't"). As initially set forth in Leonardo's High Renaissance concept of the *paragone*, painter is pitted against poet (to say nothing about the poor laboring sculptor). And within the field of modern studies, written in the aftermath of Lessing's famous distinction between the two art forms (one being spatial, the other temporal), and fueled more generally by Harold Bloom's agonistic theories of influence, an eminent picture theorist like W. J. T. Mitchell can ultimately conclude that, "like Stevens's jar, Achilles' shield illustrates the imperial ambitions of ekphrasis to take 'dominion everywhere.'"[4] Although one might have thought James Heffernan saw the situation differently—he proposed a potentially elastic definition of ekphrasis as simply "the verbal representation of visual representation" in his influential *Museum of Words: The Poetics of Ekphrasis from Homer to Ashbery* (1993)[5]—his study actually supplies a *Laocoön*-like finishing touch to the paragonal struggle between poetry and painting. Ekphrasis remains the arena of large predicaments and statements: the founding of empires, mythic rape, matters of Truth and Beauty, a postmodern age finding its convex image in a deflected "mannerist" other, but not necessarily a place of much joy or pleasure. Simply looking, if there ever was such an occasion, is pointedly not the point.

Mary Jo Salter is clearly attracted to some of these larger themes. The sublime itself comes up as a topic in "Art Lesson," from *Sunday Skaters* (1994), as she muses over the question, "Why has Iceland no Tiepolo?" on her way to offering a funny shaggy dog story with a local, Frostian answer: "When you have to watch your footing, you don't look up."[6] Likewise she addresses, explicitly, matters of beauty in the same collection in "Boulevard du Montparnasse" (*Sunday Skaters*, 5),

while trips to the Louvre and visits to Venice put her in some elevated company: Titian, the mosaics of St. Mark's. She is often moved, too, by what she sees, although she instinctively shies away from a rhetoric of unimpeded emotional "transport." Meditating on a Titian *Entombment,* for instance, as part of a sequence of poems called "The Jewel of the World" in *A Kiss in Space* (1999), she can enter into the religious drama of the scene as one who knows the story and can sympathize with the characters: "Held still by his ring / of mourners in a winding-sheet, his weight / is nearly more than anyone can bear." But her passion lies elsewhere in the poem, as becomes radiantly clear near the end:

> The story hangs from his suspended frame
> only because we know it; have seen him rise
> in other galleries, stepping from each tomb
>
> as if from a refreshing bath.
> Prolific Titian lovingly stroked more
> farewells like these in light and shadow,
> Christ's head at the right, then at the left;
> one ends up at the Louvre, two at the Prado,
> the world abloom with entombments.[7]

What's "refreshing" here, it should be said, is simply the surge of good feeling by the poet for the artist. As we step over that final enjambment into the last stanza, we enter into a world bright with possibility. "Prolific Titian" emerging in name, as if fresh from a bath, too, stroking his way through painting after painting, is indeed a nice touch, as is the sonic connection made through all those *l*'s until we arrive at the last line, giddy with internal rhymes as well: "the world abloom with entombments." The happenstance of artistic creation, as Aristotle understood, is itself a kind of miracle, a bloom—one at the Louvre, two at the Prado—and also the sense that artistic love, not church commissions or a system of patronage, lay behind these strokes, although they probably did, too. Yes, a nice touch (literally), not a formula: Christ's head at the right, then at the left—the intimacy of the artist for his, or her, subject.

One of the pleasures of Salter's ekphrastic poetry is the obvious joy she takes in celebrating the accomplishment of other artists ("How should I praise Thee, Lord!"): for thinking a Titian to be a "Jewel" and risking the cliché; or for depicting, in delicate detail, the exquisite fan painting by the late seventeenth-century Chinese court artist Li Shih-Cho in a poem called "Late Spring" from *Unfinished Painting* (1989), and in shaping her stanzas in fanlike imitation to

match.[8] Her verse has often been seen as a product of time spent in distant lands, but it might be more accurate to think of Salter, like Shakespeare's Rosalind, as possessing a traveler's wooing eye, somehow both innocent and educated, praising and appraising the sights—those latter interlocking attributes being part of her maternal inheritance, as we shall see. Poem after poem verifies the old equation between ekphrasis and *enargeia*. What is visually entrancing invites vivid description, even homage by imitation—a kind of love. The Eros of the eye links painter and poet, even if the objects to which they are "drawn" must, by nature, differ.[9]

Salter's most notable experiments with ekphrasis, however, are not usually prompted by high art, although the sequel on Titian's "massive *Pietà*," now in the Accademia in Venice, is a studiously engaging look at the master's late style in his last painting.[10] (The poem also reflects Salter's interest in viewing the work not as a final example of Titian's "*paragone* with Michelangelo," often noted by art historians,[11] but as a family narrative embedded in the creation of this pearl of "great value.") Rather, they belong, as even the Titian poems tend, to the less exalted world of the domestic and the down-to-earth—even the concrete, it should be said. If there is "a certain parasitism" involved in writing about "existing works of art," as some poets have felt,[12] the worry might be said to shrink with the scale of the work itself.

Indeed, if the last quarter of a century has witnessed an explosion of interest in local ekphrases of all sorts, Salter makes acute use of some of the poetic fallout. In *A Kiss in Space,* she crafts, for instance, a homemade "Magnet" poem of her own in response to Alfred Corn's "Self-Portrait with Refrigerator Magnets," in her case of one "on the door of the fridge" bearing "Essence-of-kid" in the "fingerpainted imprint" of a daughter's hand.[13] (The cozy diction tells us of her willingness to sound like a sentimental "mom.") Still in the house, so to speak, and in the same volume, "Home Movies: A Sort of Ode" shows her enduring a father's attempt to turn his "camera to subjects more / artistic or universal." Her own preference is for viewing reruns that capture incidentally scribbled signs of the personal as she rediscovers ("And look") a "Grecian / urn of sorts" in a stoneware kitchen bowl (*A Kiss in Space,* 20–21). "Of sorts" initiates the slide from the high Romantic ode, continued in her Bishop-like inclination (spelled out in Bishop's "Poem") for "looks" over "vision."

Salter likewise enjoys playing loopy games with familiar household items: videos, in a villanelle on her husband's recursive desire to watch Myrna Loy reruns ("Video Blues," in *A Kiss in Space,* 14); and a collage, which gets blended into "college" in "Collage" (*A Kiss in*

Space, 69–71). For more serious musings, nearly every volume includes poems on photos and family snapshots—the most ambitious being the three-part sequence "In the Guesthouse," from *Open Shutters* (2003).[14] But a sense of loss, of temporality and change, of the ephemeral associated with "art"—however defined—shadows most of her ekphrases (as, indeed, her poetry more generally, as her best reviewers note). As with her recent poem in the *American Scholar* on Bernini's bust of Costanza Bonarelli (Autumn 2004), they are products of the mutable, material world as seen by a mutable, aging, keen-sighted "I" or "eye"—to allude to a pun exposed and explored in her little "baroque" marvel on the hidden mysteries contained in the four-letter name "Liam" (reminiscent of Herbert's "Jesu"), again from *A Kiss in Space* (79).

Still, if a wide-angle survey of ekphrasis in Salter points to the subject's ubiquity as a sign of our visually saturated times and selves—ekphrasis might not be imperially ambitious, just everywhere possible—only a close-up view can reveal the special, nuanced hold the topic has in her poetry. I am thinking, in particular, of her book of poems bearing the explicitly ekphrastic title *Unfinished Painting* and, more specifically, of the unlikely pair of answering ekphrases, "The Rebirth of Venus" and "Unfinished Painting," which frame the opening sequence of poems also bearing the same title as the 1989 book. Both poems pay homage to unknown "artists," which is part of their attraction. Titian, we know, will survive just fine without an ekphrasis, even if his monumental *Pietà* was finished not by his hand but (in an irony that Salter savors) by the hand of a student of his, Palma il Giovane. But not so with these two otherwise potentially forgotten works. Their status as unfinished ephemera provides the occasion and the need for the poetry they inspire—indeed, their incompleteness calls out for a different hand in kind, as it were. And both remind us of the root meaning of "amateur," as someone who attempts something out of love, again like the poet, who is enlisting poetry's ancient Orphic claim to rescue them from obscurity for no other apparent reason than affection. (Salter's formalism, like Herbert's, allows plenty of sentiment.) But an unlikely pair of poems, nonetheless (as are "L'Allegro" and "Il Penseroso"), for one describes a humble street artist, "here, in the sun," indefatigably copying in chalk Botticelli's familiar figure of Venus, even under the threat of rain, while the other unveils a portrait of the poet's mother, whose unfinished painting of her son forms the shadowy subject of the poet's elegiac musings.

I am not sure whether Salter intended "The Rebirth of Venus" as a riposte of sorts to Ashbery's fiendishly slippery sestina, "The Painter,"

but, anchored in alternate rhyming quatrains, her lowly street artist stands (kneels, rather) altogether free of the frustrations and indignities that plague Ashbery's aspiring *artist*. There is no adequate way to represent this poem, except in full:

> He's knelt to fish her face up from the sidewalk
> all morning, and at last some shoppers gather
> to see it drawn—wide-eyed, and dry as chalk—
> whole from the sea of dreams. It's she. None other
>
> than the other one who's copied in the book
> he copies from, that woman men divined
> ages before a painter let them look
> into the eyes their eyes had had in mind.
>
> Love's called him too, today, though she has taught
> him in her beauty to love best
> the one who first had formed her from a thought.
> One square of pavement, like a headstone (lest
>
> anyone mistake where credit lies),
> reads BOTTICELLI, but the long-closed dates
> suggest, instead, a view of centuries
> coming unbracketed, as if the gates
>
> might swing wide to admit, here, in the sun,
> one humble man into the pantheon
> older and more exalted than her own.
> Slow gods of Art, late into afternoon,
>
> let there be light: a few of us drop the wish
> into his glinting coinbox like a well,
> remembering the forecast. Yet he won't rush
> her finish, though it means she'll have no shell
>
> to harbor in; it's clear enough the rain
> will swamp her like a tide, and lion-hearted
> he'll set off, black umbrella sprung again,
> envisioning faces where the streets have parted.[15]

From the opening description of him in a posture that fuses reverence and hard work to the concluding heartfelt but humorous prayer of encouragement by one artist for another, the poem forms, as Anthony Hecht has argued, a joyous response to Plato's criticism of art as "an inferior imitation of the ideal."[16] Here is copying galore, "wide-eyed," concentrated, exuberant; poet depicting artist depict-

ing Botticelli depicting the Idea of beauty, but in a more intricately artful order that keeps attention focused on the material beauty being looked at and copied—indeed, highlighted—by the poet's copying out that most familiar of prayers from Genesis in an effort to see this act of creation to its conclusion: "late into afternoon / let there be light."

For all its play with reflection and resemblance, however, the poem does not dissolve into a postmodern hall of ever-receding mirrors. What stands out, in fact, like a silhouette in allegorical clothing, is the old-fashioned dedication of this lionhearted craftsman to his calling. He performs out in the open, in front of others; he is at home with a centuries-old subject. Indeed, indifferent to daily time, he makes love slowly and carefully to his own creation ("Yet he won't rush / her finish"), even if it means leaving her vulnerable to bad weather. There will be others, in time, because the gates of the past are open to him, and so, too, are the avenues of the future. Citing his principal source in caps, this unnamed "he" is, it must be said, firmly part of a well-traveled male line.

If we see his mastery as a glimmering reflection of his gender, as I am suggesting, in no way, however, does Salter allow it to tarnish our—or her—view of his merits, which are deserving of a place in the pantheon. But it does throw into dramatic relief the shift in focus toward the maternal artist in "Unfinished Painting," and it hints, too, why this poet, who is also female, is particularly drawn to ekphrases as both a family inheritance and a means to explore, at a slight distance, artistic matters of both immediate and broad artistic concern to her. In an essay that appeared in the *New Republic* (March 4, 1991) called "A Poem of One's Own," Salter reflected extensively on the paradoxes of being a "woman poet," and at one point, recalling the allusion to Virginia Woolf in her title, remarked: "[T]he means by which most men writers throughout history have discovered how to speak self-lessly of the broadly human, the universal, the spiritual is through selfishly shutting themselves off from domestic distractions."[17] Her street artist in "The Rebirth of Venus" is a version of this male writer. (What could be more broadly universal than Botticelli's *Venus,* in this case chalked out in public with no thought but for the task?) And her mother in "Unfinished Painting" is an example of the selfless "other." She is the woman whose work does not get beyond the home.

"Unfinished Painting" is not a polemic but a pensive descent into the tender burden of "domestic distractions." As an ekphrasis gener-ated by a forgotten object—in this case, a painting found in the basement—it is one of several that show the lasting influence of

Bishop, a crucial female model for Salter, but a poet who, unlike Salter, always resisted the limiting adjective "woman" before the noun. (Dickinson, of course, is the other.) Acutely aware of this difference and of belonging to a later moment in history, Salter concluded her essay, in fact, by declaring, as a sign of artistic freedom, her wish to "see the word 'woman' in italics in some poems, and in parentheses in others, and we won't read it at all in others," and the comment has proven to be accurate with regard to her own poetry ("A Poem of One's Own," 34).

"Unfinished Painting" we might consider to be an example of woman in parenthesis (in several senses), just as her ekphrasis, "Young Girl Peeling Apples," to be discussed shortly, is an instance of woman in italics, and "The Rebirth of Venus"—notwithstanding its title—perhaps not at all about woman, except as imagined by man. The difference is mainly one of subject emphasis, since all Salter's poems are manifestly artful—indeed, few more so than "Young Girl." In the case of "Unfinished Painting," Salter foregrounds the matter of her mother's painting, of course. A copy even appears on the original book jacket. The poem is also one of several notable examples in her oeuvre of an ekphrasis serving as an emblem poem. ("Poppies," from *Sunday Skaters,* is another, again involving memories associated with her mother.) Its formal strategy is to turn the descriptive act of ekphrasis in the first two stanzas into an extended meditation that gradually reveals a mother's domestic habits and character. Her partially completed painting thus serves as the complex emblem of her certain love for her son and her own uncertainty over the place of painting in her life.

The crux of the poem, then, is what to *make* of an unfinished thing. Here is its richly burnished beginning:

> Dark son, whose face once shone like this,
> oiled from well within the skin
> of canvas, and whose liquid eyes
> were brown as rootbeer underneath
> a crewcut's crown, just washed,
>
> his body's gone unfinished now
> more than thirty years—blank tent
> of bathrobe like a choirboy's surplice
> over the cassock's stroke of color,
> a red pajama collar.

<div align="right">(Unfinished Painting, 20)</div>

In deference to her slighter subject, Salter has reduced the line by a foot (or two feet in the case of the last line) from the pentameter of "The Rebirth of Venus," and in place of a repeating pattern of regular end-rhyme quatrains, she has chosen a more idiosyncratic mix of internal and imperfect harmonics (son/shone; within/skin; brown/crown; color/collar). The sharp, finished, defining edge of "art" is not what this poem, or her mother's painting, are about. Rather, in diction as plain and luminous as the dawn, Salter describes the stir of emotions, the lyrical blend and blur of domestic life and love, that underlies a mother's impulse to paint:

> Drawn as if it might reveal
> the dotted hills of Rome, a drape
> behind him opens on a wall
> she'd painted with a roller once.
> Everything made at home—
>
> she made the drapes, she made the boy,
> and then, pure joy, remade him in
> a pose to bear his mother's hope:
> the deep, three-quarter gaze; the tome
> he fingers like a pope.
>
> Is this the History of Art
> he marks her place in, or—wait—
> that illustrated Brothers Grimm
> she'd inscribed for him, his name enclosed
> within it like a heart?

The few perfect rhymes, like "hope" and "pope," speak to a mother's dressed-up wish to tailor a son's future, just as the distant echoes of "home" and "tome," then "Art" and "heart," point to the gulf between the interior life of domestic desire and the hard choices that would need to be made if she were to win a place in Gombrich or Janson.

That conflict, of course, lies at the heart of the poem, but Salter will not rush the poem's finish. "Hard to sort out . . ." she goes on to say, with the telltale, trailing ellipses leaving the matter deliberately open to speculation at this point:

> . . . She rarely put
> the final touch on anything
> when he was young. It seems that bringing
> the real boy up had taken time
> away from painting him

(no crime); she also failed to think
of him—back then her only child—
as truly done, and one child only,
but marvelled as he altered like
 the light she painted by.

With its fine mesh of Frost and Bishop, its New England-sounding
country wisdom amid crafted pauses and parenthetical asides, she
portrays the complex mix of domestic distractions that kept the
mother from ever finishing the painting. These admit, as well, to
inherent impediments in portraying a changing subject—the grow-
ing boy—in a temporally fixed mode, and yet not to frustration on
the mother's part, who sees the child's growth as a marvel of chang-
ing light. Salter is infinitely generous, it seems, in her reflections "(no
crime)," and only gradually do we arrive at the real answer. In re-
sponse to what we can only call the higher laws of time and poetry,
her thinking quietly insists on completing itself:

. . . Like, too, the image he's retained
of the sun in her, now set,
her eyes that took him back, and in,
squinting as he squirmed, appraising,
 praising him again,

so that, when sifting through her basement
stacked with a dozen such false starts,
and lifting this one, lighter than
he thought it ought to be, to frame
 and hang in his apartment,

he saw in his flushed face how she'd
re-created there what rose
and fell in hers: the confidence
she forfeited each time she dared
 think of an audience.

Who (she must have asked) *would care?*
He does: that finished head conveys
still to him how, sought in a crowd,
a loved one stands apart—he's taller,
 comes in a different shade.

Salter's mother has none of the street artist's worldly confidence, it
need hardly be said. And yet what can look like defeat from one
perspective—yet one more example from the past of a "false start"—

can assume the face of victory from another, as the last stanza makes clear in the shift to the present tense. The son who now stands apart in a crowd does so because of what the partially completed portrait, the "finished head," signifies about a mother's love. Nicely caught by Salter in the play on "light," this picture catches the son's attention for being "lighter than / he thought it ought to be." And the poem catches ours for the same reason: in the radiant way it transforms the image of the "dark son" at the outset into a "different shade" by the end. That final classicizing touch suggests, paradoxically, not just the son's special coloration and character but their source as well in the shadow that is his no longer living, yet still present, mother. We might also regard so nuanced an appraisal as part of a mother's wider artistic legacy in a "female 'tradition'—however wobbly and uneven it is—," as Salter ruefully notes in "A Poem of One's Own" (31), a legacy now reconceived and continued by the poet in a different medium. Such subtly shaded praise is one way for a daughter to claim a place for both beyond the parenthesis of the unfinished, as the title of the poem, amplified into the book's title, with a copy of the painting on the cover, pointedly declares.

Salter's most perfectly finished ekphrasis is not, however, the one to her mother, but a poem whose making might be said to replicate the sense of "pure joy" the mother experienced in painting the boy to fit the shape of her hopes. "Young Girl Peeling Apples," from *Sunday Skaters,* is a rare instance in Salter's visually rich verse of a pure, or classic, ekphrasis, by which I mean a poem that is completely dedicated to describing a specific painting, indicated in the poem's title, with the painter's name—in this case, that of the seventeenth-century Dutch artist Nicolaes Maes—figuring parenthetically, in catalog fashion, as the poem's subtitle. The painting, moreover, can be viewed by the interested general reader, since the original is in the Metropolitan Museum of Art, even if Maes is not a major name and therefore remains something of a poet's find. The title also spells out Salter's continued interest in exploring the female domestic subject, but in this case, as we discover, by shifting focus away from the household distractions that impede perfection to appraising the layered acts of concentration that uniquely link subject, artist, and poet.

In fact, to look at Maes's painting (see color insert) in light of another from the same genre popular in Dutch art of the period— say, Gabriel Metsu's *The Apple-Peeler,* from the late 1650s, in the Louvre (fig. 11)—is to recognize the particular force behind Salter's claim in "A Poem of One's Own" (34) that every work of art "is unique." For if Metsu's woman is likewise busy peeling an apple, both her brandished knife and outward stare (to say nothing of the

Fig. 11. Gabriel Metsu, *The Apple-Peeler*, oil on wood. Paris: Musée du Louvre. Photo: Arnaude / J. Schormans. Photo Credit: Réunion des Musées Nationaux / Art Resource, NY.

dead rabbit awkwardly displayed on the table) are completely antithetical to the aura of warm, supreme quiet and inward focus that Maes creates and that Salter is drawn to "copy." What could be more unique, we might ask, with Herbert in mind, than a poem written in the shape of the thing it would commemorate? Only a poem, Salter suggests, that further reflects, through its syntax, the process of concentrated thinking that the young girl's actions seem to embody. A single, lengthy, suspended sentence, the poem is a chal-

lenge to quote and like the painting, get the finely crafted lineation
accurate:

> It's all
> an elaborate pun:
> the red peel of ribbon
> twisted tightly about the bun
> at the crown of her apple-
>
> round head;
> the ribbon coming loose in the real
> apple-peel she allows to dangle
> from her lifted hand; the table
> on which a basket of red
>
> apples
> waits to be turned into more
> white-fleshed apples in a water-
> filled pail on the floor;
> her apron that fills and falls
>
> empty,
> a lapful of apples piling on
> like the apron itself, the napkin,
> the hems of her skirts—each a skin
> layered over her heart, just as he
>
> who has
> painted her at her knife
> paints the brush that puts life
> in her, apple of his eye: if
> there's anything on earth but this
>
> unbroken
> concentration, this spiral
> of making while unmaking while
> the world goes round, neither the girl
> nor he has yet looked up, or spoken.[18]

There is so much to appreciate here that we hardly notice that the
poet says nothing about some of the picture's other striking stylistic
attributes: the dramatic play of light and darkness, for instance, that
helps to identify Maes as a student of Rembrandt (the kind of sharp
luminescence to which Salter immediately attends in her early poem
in *Henry Purcell in Japan* on Vermeer's *Officer and Laughing Girl*[19]), or
the intricate double design in the oriental carpet on the table, which

was popular in domestic scenes of the period and which must have cost the painter many hours of labor to produce. To widen the frame to include these effects might readily blur the poem's focus on concentration itself, elegantly realized in the slow, stanza-by-stanza unfurling of sensuous imagery. It would also more certainly obscure the poem's play with color—what I want to call the politics and poetics of pigmentation.

So much depends in this poem, not on "a red wheel / barrow," but on "the red peel of ribbon," that it is difficult to read "Young Girl Peeling Apples" without thinking of Williams—soon we will arrive at "white-fleshed apples in a water- / filled pail on the floor," rather than "rain / water / beside the white / chickens"—especially in light of Salter's confession in "A Poem of One's Own" that the male trio of double Ws (William Wordsworth, Walt Whitman, and William Carlos Williams) are overrepresented in the canon and have "at times bored me nearly to tears" ("A Poem of One's Own," 32). As one of the editors of the *Norton Anthology of Poetry,* Salter might be especially prone to feeling their combined masculine weight, but she also understood that "the problem with taking men poets down a peg . . . is that it's awfully hard to do so with discernment" (ibid.).[20]

"Young Girl Peeling Apples" is nothing if not discerning, and if Williams is being recalled here, it is in the service of illustrating another kind of poetics altogether, one that originates in the female domestic household and yet is also more extensively and richly metaphoric—more Herbertian or Dickinsonian. "It's all / an elaborate pun." The immediately expansive opening might almost serve, in fact, as a Dickinsonian article of poetic faith according to Salter, given her knowledgeable slant on this hometown poet, whose mantle she wore for many years as "Emily Dickinson Senior Lecturer in the Humanities" at Mt. Holyoke[21]—one that receives a further, more explicitly feminine/feminist, twist or spiral in the figure of the young girl at the originating center of picture and poem. How much more interesting it is to see what "she" is *doing,* the poem suggests, than it is to be presented with a wheelbarrow next to chickens—"she" being the young girl and the poet. How much more interesting it is to think, further on, of the artist drawn to the young girl out of affection, painting her (the "apple of his eye"); to be made aware, furthermore, of "this spiral / of making" and of the poet's share in it, looking at the picture (the apple of her eye) and then capturing, in this blazon of her making, the young girl's ripeness; to think in light of the rich pigmentation of puns, than it is to look, supposedly prosaically, at only the thing itself, seemingly untouched by its creator. "Young Girl Peeling Apples" does not just enshrine a silent moment

of concentration, then, with poetry, as usual, doing the talking. That is, it does not just insist on its own unique status as a work of art. As an ekphrasis, a spiral of making while unmaking, winding its way into the canon, the poem urges us to see a world layered with relations, with "life's artful correspondences"[22]—to borrow the punning phrase Salter uses in "Dead Letters" as a link to her mother in the last poem from *Unfinished Painting*. "As in . . . so is."

Notes

I wish to thank the UCLA Friends of English for generously assuming permission expenses related to the artwork in this essay.

1. Mary Jo Salter, *Henry Purcell in Japan* (New York: Alfred A. Knopf, 1985).

2. Seamus Heaney, *The Redress of Poetry* (London: Faber and Faber, 1995), 9.

3. Quoted from Joseph Summers, "George Herbert and Elizabeth Bishop," in "George Herbert in the Nineties: Reflections and Reassessments," ed. Jonathan F. S. Post and Sidney Gottlieb, special edition, *George Herbert Journal* 18 (1995): 57. The letter from which the word is quoted is not included in *Elizabeth Bishop, One Art: Selected Letters,* ed. Robert Giroux (New York: Farrar, Straus and Giroux, 1994).

4. W. J. T. Mitchell, *Picture Theory: Essays on Verbal and Visual Representation* (Chicago: University of Chicago Press, 1994), 180.

5. James A. W. Heffernan, *Museum of Words: The Poetics of Ekphrasis from Homer to Ashbery* (Chicago: University of Chicago Press, 1993), 3. The historical accuracy of Heffernan's general definition is challenged by Ruth Webb, "*Ekphrasis* Ancient and Modern: The Invention of a Genre," *Word and Image* 15, no. 1 (January–March 1999): 7–18. Editors' note: Heffernan and Mitchell proposed this definition of ekphrasis at around the same time: cf. note 16 in the introduction to the present volume, 38.

6. Mary Jo Salter, "Art Lesson," in *Sunday Skaters* (New York: Alfred A. Knopf, 1994), 66–69. This edition of *Sunday Skaters* is hereafter cited in the text.

7. Mary Jo Salter, "The Jewel of the World," in *A Kiss in Space: Poems* (New York: Alfred A. Knopf, 1999), 33–34. This edition of *A Kiss in Space* is hereafter cited in the text.

8. Mary Jo Salter, "Late Spring," in *Unfinished Painting: Poems* (New York: Alfred A. Knopf, 1989), 15–17. This edition of *Unfinished Painting* is hereafter cited in the text.

9. The Western origins of this tradition are brilliantly recovered by Michael Baxandall in *Giotto and the Orators: Humanist Observers of Painting in Italy and the Discovery of Pictorial Composition, 1350–1450* (Oxford: Clarendon, 1971), esp. 78–97.

10. This is the third and final section of Salter, "Jewel of the World" (34–36).

11. Peter Humfrey, *Painting in Renaissance Venice* (New Haven, CT: Yale University Press, 1995), 211.

12. Cf. esp. James Merrill, "Notes on Corot," in *Poets on Painters: Essays on the Art of Painting by Twentieth-Century Poets,* ed. J. D. McClatchy (Berkeley and Los Angeles: University of California Press, 1988), 311.

13. Mary Jo Salter, "Up and Down: 1. *A Magnet,*" in *A Kiss in Space,* 18.

14. Mary Jo Salter, "In the Guesthouse," in *Open Shutters: Poems* (New York: Alfred A. Knopf, 2004), 23–29.

15. Mary Jo Salter, "The Rebirth of Venus," in *Unfinished Painting,* 3–4.

16. Anthony Hecht, *On the Laws of the Poetic Art* (Princeton, NJ: Princeton University Press, 1995), 28.

17. Mary Jo Salter, "A Poem of One's Own," *New Republic,* (March 4, 1991), 33–34. Hereafter cited in the text.

18. Mary Jo Salter, "Young Girl Peeling Apples," in *Sunday Skaters* (New York: Alfred A. Knopf, 1994), 10–11.

19. Mary Jo Salter, "Officer and Laughing Girl," in *Henry Purcell in Japan* (New York: Alfred A. Knopf, 1985), 6–7.

20. For William Carlos Williams's "The Red Wheelbarrow," see *The Norton Anthology of Poetry,* ed. Margaret Ferguson, Mary Jo Salter, and Jon Stallworthy, 4th ed. (New York: W. W. Norton, 1996), 1166.

21. See Salter's extended essay, "Puns and Accordions: Emily Dickinson and the Unsaid," *Yale Review* 79 (1990): 188–221.

22. Mary Jo Salter, "Dead Letters," in *Unfinished Painting: Poems,* (New York: Alfred A. Knopf, 1989), 68.

IV
Ways of Seeing

JORIE GRAHAM, SAYS WILLARD SPIEGELMAN, IS A POET WHO "FINDS herself through acts of looking." The same could be said of Rita Dove and Louise Glück; but whereas ekphrasis is an epistemological project for Graham, for Dove the stakes of ekphrasis are political and, for Glück, psychological. For all three poets ekphrasis gives rise to an oppositional, "paragonal" stance. Graham uses it, as Spiegelman explains, to examine and interrogate the mind's commerce with the visual world; instead of attempting to "read" pictures, she will turn ekphrastic occasions into opportunities for "measuring herself against a visual stimulus." According to Jane Hedley, Rita Dove uses ekphrasis to practice an art of displacement: paintings and sculptures give her a way to tackle the subject of race obliquely, "like Perseus with his mirror-shield." For Glück, suggests Nick Halpern, pictures are rival compositions: they establish "boundaries and frames that are not the poet's," to which she must stand opposed.

Jorie Graham Looking

Willard Spiegelman

HOW OR IF EKPHRASTIC POEMS BY WOMEN DIFFER FROM EKPHRASTIC
poems by men, and the entire theoretical question of whether
women and men write differently from one another (for whatever
reasons), are matters that other scholars in this volume address. A
more modest point provides the starting assumption as well as the
conclusion for my essay: namely, that Jorie Graham, a poet who grew
up looking at both external nature and the painted and sculpted
works she found around her during her adolescence in Italy, sees,
and writes about seeing, in quirky, original, and moving ways. Or,
perhaps I should say "saw" and "wrote," as her recent poems have
moved on to other subjects and other techniques. Graham was an
"art" poet a quarter century ago; now she is something much odder.[1]
At the start, she dealt directly with works by Klimt, Pollock, Rothko,
Goya, and others, as well as sculpture, tapestry, architecture, and
film. Although her interest in the visual arts seems to have waned,
from the beginning she has been obsessed with acts of witnessing and
observation. Like Elizabeth Bishop, to whom *Never,* her 2003 volume,
pays homage, Graham finds herself through acts of looking, al-
though with greater flamboyance, ambition, aspiration—indeed,
pretension—than Bishop. In all of her volumes, from *Hybrids of
Plants and of Ghosts* onward, we find poems that start thus: "Last night
I watched the harvest moon rise" ("Harvest for Bergson," in *Hybrids,*
25); "Today as I hang out the wash I see them again" ("The Geese," in
Hybrids, 38); "I watched a snake / hard at work" ("I watched a snake,"
in *Erosion,* 34); "I watched them once" ("Salmon," in *Erosion,* 40); and
"In the rear-view mirror I saw the veil of leaves" ("Steering Wheel," in
Materialism, 5).[2] Even her dust jackets attest to Graham's focus, her
interest in depiction in general, pictures in particular: covers with
illustrations by Rothko, Bacon, Eric Fischl, Mantegna, Giotto, Bartolo
de Fredi, Magritte, and Vermeer.[3]

Most ekphrastic poets retain an interest in looking at pictures
throughout their careers; I think of primarily formalist poets like
Anthony Hecht, John Hollander, Richard Howard, James Merrill,

and Richard Wilbur, and even younger ones such as Rachel Hadas
and Mary Jo Salter, both of whom figure in this volume. Graham is
unusual in that ekphrasis seems to be a phase—however important
(indeed, necessary)—that she had to go through in order to arrive
where she is today. In *Hybrids of Plants and of Ghosts* "Angels for Cé-
zanne" transforms a seen landscape into something akin to a Cézanne
painting, and it also sets the way for the various angelic figures and
annunciations that appear in Graham's later volumes. "Drawing
Wildflowers" describes, in the present tense, the act of drawing a
flower with a pencil. The flower becomes "a kind of mind / / in
process," an obvious analogy to a poem (*Hybrids*, 14). (Later in the
volume, "Penmanship" [*Hybrids*, 31] picks up the motif of working
hands.) The choice of black and gray rather than color suggests a
willed limitation, just as Graham's early poems, most of them with
short lines, seem like a kind of poetic exercise, a self-imposed chal-
lenge that they both describe and enact. "Framing" neatly develops
an analogy between form and subject matter: the poet looks at an
early photograph of herself that takes the place of the more expected
mirror as a vehicle for self-examination. The poem, a verbal self-
portrait, animates the child who was—to vary Wordsworth—the
mother of the woman, and it does so in five four-line stanzas, framed
at start and finish perhaps too neatly by two single lines (*Hybrids*, 35).

Of all the experiments in "looking" in this volume, none is more
daring than "For Mark Rothko." The cover illustration of the book is
Rothko's *Violet, Black, Orange, Yellow on Red and White*, although
the paperback edition prints it, unfortunately, in black and white,
thereby removing all sense of color. The poem is ekphrastic at one
remove. Like the Cézanne poem, it applies a painting to life. Imagin-
ing it—in memory—allows the poet to fix and understand an exter-
nal scene. She begins with a question:

> Shall I say it is the constancy of persian red
> that permits me to see
> this persian-red bird
> come to sit now
> on the brick barbecue
> within my windowframe. Red
>
> on a field made crooked
> as with disillusion or faulty
> vision, a backyard in winter
> that secretly seeks a bird. He has
> a curiosity
> that makes him slightly awkward. . . .

(*Hybrids*, 36)

Like Hopkins's, it seems that Graham's heart in hiding "stirred for a bird," and one miraculously appeared. But soon he vanishes, and she is left with only the memory of a flash of red, an imagined inheritance that puts her in mind of all kinds of visual phenomena that descend with solar light from millions of miles, and thousands of light years, away. Rothko enters the poem at the end, as his blurred, colored boxes stand in for the way any field of color replicates our visual, and our even deeper mental, processes:

> . . . Some red
> has always just slipped from
> our field of vision, a cardinal
> dropping from persian to magenta to white so slowly
> in order that the loss
> be tempted,
> not endured.

<div align="right">(Hybrids, 37)</div>

Graham has gone on to become a frame-breaking poet, one for whom the blurring and shading of boundaries is not only more important than arbitrary acts of limitation and enclosure but also more representative of our mental activities. Here Rothko allows her to understand the changes, dimmings, and final disappearances that mark all of our perceptual negotiations with the external world. She says that the strange result of the slow dropping or merging of color into color is to make us want to "tempt" rather than "endure" one kind of loss. What does she mean? How does one "tempt a loss"? The verb itself seems to combine "attempt" (we wish to replicate in our own lives what we have just seen in nature) and "provoke" or "lure," as if to say that we want to seduce that loss, and to bring it into ourselves. The bolder, more daring (and stylistically more complicated) paths that Graham's poems in the nineties will follow are all foreshadowed here.

It is in *Erosion* that Graham's most artful ekphrases appear. "Scirocco" starts a small architectural description, a "reading" of the apartment in Rome where Keats died (*Erosion*, 8–11). "Still Life with Window and Fish" is another reverse ekphrasis: the world and all its things try to come into the poet's kitchen, whose domestic interior is kaleidoscopic, all blurring and waving, a reductive rearrangement of the outside (*Erosion*, 32–33). "The Lady and the Unicorn and Other Tapestries" opens with the image of real quail in a winter scene, which become the quail woven into the medieval tapestries of the title (*Erosion*, 37). Like Mallarmé's dictum that the world was made in order to end in a volume, in Graham's poem real birds gradually recede, replaced by the eternal ones of art. "Two Paintings by Gustav

Klimt" does not even mention the specific pictures, preferring instead to use them vaguely as an occasion for a meditation on the dead, who wish to return (as in Charles Wright's "Homage to Paul Cézanne," a poem contemporary with Graham's), but who, even as revenants, call out for some kind of closure: "the dead / in their sheer / open parenthesis" (*Hybrids*, 61) set the way for Graham's later, parenthesis-obsessed work, where nothing is ever finished, no one ever buried, and even clause-heavy sentences stretch out for lines.

In *Erosion*, a single trio of poems, all based on Italian Renaissance painting, stands out. Taken together, "San Sepolcro" (2–3), "Masaccio's Expulsion" (66–69), and "At Luca Signorelli's Resurrection of the Body" (74–77) constitute not only an introduction to Graham's quirky reconstructions of, and responses to, pictures but also a condensation of the Judeo-Christian myth of birth, fall, and last judgment. All three are written in five-line stanzas, with the even lines indented for visual effect. But, interestingly, the mythic dimension of this trio of pictures is less important than Graham's phenomenology —that is, the way she uses pictures to get at surprising facts concerning the human condition. In all three (indeed, in all of Graham's ekphrastic work) mere description, an engagement with the textuality or surface of a painting, is supplemented by divagation, or a removal from the picture and entry into its immediate surroundings—a church, a chapel, an external square—into history, and into the poet's own consciousness. The poems are not so much imaginative re-creations of an object as they are unconventional fantasias based upon an external, visual stimulus.

Even more than most ekphrases, Graham's poems stimulate questions within the reader. Let me suggest a path not taken. As a counterexample, an ingenious but more conventional recent ekphrasis, consider Mary Jo Salter's "Young Girl Peeling Apples," whose thirty-line single sentence rolls along, mimicking the action depicted in Nicholas Maes's 1650 picture (see color insert); its stanzas are shaped to suggest a swerving, cutting, "peeling" motion, and its insistence on making via unmaking engages the reader as a complement to the way the picture engages the viewer. And the opening claim—"It's all an elaborate pun"—readies us *for* that pun in the penultimate quatrain, where "apple of his eye," a terminus ad quem, suggests what was probably the terminus a quo when the poet first saw the picture.[4]

Salter does not violate the picture frame other than reminding us of what painting lacks: that is, the ability to talk, specifically to make puns. One traditional kind of ekphrasis speaks on behalf of the picture, or puts words into its mouth. Salter's gentle charm is not Graham's way, which is more energetic—indeed, ferocious. Most

important, there is no first-person subject, no "I," in Salter's poem. personal tone exists, of course, but the poet does not take it upon herself to go beyond the picture or to involve herself and her reader in any extrapictorial shenanigans.

The stakes are higher in the game Graham plays. Does the activity of looking involve a desire for mastery, for possession? Or a desire to be mastered, to be possessed? Does the viewer enter the picture, or does the picture enter the viewer? There is always an exchange between subject and object. In a series of poems in her subsequent volume, *The End of Beauty* (whose ambiguous title signifies an uncertain relationship between the poet and the artifacts of high culture), Graham acknowledges more overtly that *all* pictures become occasions for self-portraiture, especially in poems with titles like "Self-Portrait as Apollo and Daphne."[5] *De te fabula narratur; de te pictura pictatur?*

Within the two coordinates of time and space, Graham turns all painting into action painting—or, rather, the act of looking at pictures becomes action reception. Most ekphrasis demands looking *at*, but Graham just as often looks *away*. Attention competes with inattention, focus with wandering. This is not always the case in more conventional ekphrases, even those that animate a picture or, for example, an urn, and endow it with words. In the widely anthologized "San Sepolcro," Graham actually *does* employ a pun (unusual in a poet who normally eschews wit in favor of high passion and the true voice of feeling), taking her title—the location of Piero's masterpiece—and using it as an occasion to contemplate the relationship between life and death, Christ's birth and sacrifice, womb and tomb, inside and outside, mind and body. It is the mind that is the holy grave:

> In this blue light
> I can take you there,
> snow having made me
> a world of bone
> seen through to. This
> is my house,
>
> my section of Etruscan
> wall, my neighbor's
> lemontrees, and, just below
> the lower church,
> the airplane factory.
> A rooster
>
> crows all day from mist
> outside the walls.

She is showing us how to read.

For example Speilgma points at the bird — perhaps a bit of notional ekphrasis — we not only reced

Seeing is believing she turns the doubting Thomas into the imaginative reader challenges us to consider possibilities.

> There's milk on the air,
> ice on the oily
> lemonskins. How clean
> the mind is,
>
> holy grave. It is this girl
> by Piero
> della Francesca, unbuttoning
> her blue dress,
> her mantle of weather,
> to go into
>
> labor.
> (*Erosion,* 2, lines 1–25)

 Strategically placed as the first poem in *Erosion,* "San Sepolcro" is a visual study in blue and white (snow and bone competing with the blue sky and the Virgin's blue dress), an experiment in synesthesia (imaginatively mingling all five senses), and a violation or expansion of two-dimensionality. "Snow having made me / a world of bone" means both that the outside world has been reduced to clean skeletal visibility (the poem seems to be set on Christmas morning) and also that the poet herself has become a reduced version of a human being, a ghostly rather than a human host and tour guide. Opening a volume of poetry, the poem also describes and dramatizes various other acts of opening, as does the picture it discusses. Located formerly in the little cemetery chapel at Monterchi, near Piero's Borgo San Sepolcro, the *Madonna del Parto* stood at the altar, which visitors could approach through the small front door (see fig. 12). We look at the Virgin, framed doubly by the picture plane and by the angels parting a curtain. And she herself is opened for us in the act of opening her dress, as though signifying the forthcoming parturition of her son. Her full body prefigures all the other bodies—Christ's and those of the living neighbors not quite awake and going about their business. We, the living, "go in," whereas she, the Virgin, will shortly expel her son. An act of entry complements one of emptying. But the approaching moment of birth signals as well the moment of death, as Graham compresses or collapses both time and space:

> . . . Come, we can go in.
> It is before
> the birth of god. No-one
> has risen yet
> to the museums, to the assembly
> line—bodies

Fig. 12. Piero della Francesca, *Madonna del Parto*, ca. 1460, fresco (postrestoration). Monterchi, Italy: Cappella del Cimitero. Photo Credit: Scala / Art Resource, NY.

and wings—to the open air
market. This is
what the living do: go in.
It's a long way.
And the dress keeps opening
from eternity

to privacy, quickening.
Inside, at the heart,
is tragedy, the present moment
forever stillborn,
but going in, each breath
is a button

> coming undone, something terribly
> nimble-fingered
> finding all of the stops.
>
> (*Erosion,* 2–3, lines 25–45)

The progressive present tense of *all* pictures ("the dress keeps open-
ing / from eternity") signifies the quickening of life, although the
present is always to be "stillborn." In a picture, by definition, time
cannot exist. We can detect even in early Graham an obsession with
gerunds and present participles (which go wild in her later work),
especially from the poem's midpoint on. In pictures we have only
happenings; things do not happen. Thus: "unbuttoning," "opening,"
"quickening," "going in," "coming undone, "finding," and so forth.
No time, no action, only the promise of each.

 "San Sepolcro" remains faithful to its provocation—that is, it does
not really embellish upon Piero's picture. "Masaccio's Expulsion"
goes one daring step farther, and in a different direction, by taking
off from an originary moment in time and space. Here follows a
section from the center of the poem. Having located our first parents
on the wall of the chapel, among both other pictures and the real life
within the church and on the streets outside, Graham begins her
fantasia:

> . . . All round them,
> on the way down
> toward us,
> woods thicken. And perhaps
> it is a flaw
>
> on the wall of this church, or age,
> or merely the restlessness
> of the brilliant
> young painter,
> the large blue bird
> seen flying too low
>
> just where the trees
> clot. I
> want to say to them
> who have crossed
> into this terrifying
> usefulness—symbols,
>
> balancing shapes in
> a composition,

mother and father,
 hired hands—
I want to say to them,
 Take your faces

out of your hands,
 look at that bird,
the gift of
 the paint—
I've seen it often
 here

in my life,
 a Sharp-Shinned Hawk,
tearing into the woods
 for which it's
too big, abandoning
 the open

prairie in which
 it is free and easily
eloquent. Watch
 where it will not
veer but follows
 the stain

of woods,
 a long blue arc
breaking itself
 through the wet
black ribs
 of those trees,

seeking a narrower
 place. Always
I find the feathers
 afterward. . . .

a form of notional ekphrasis

(*Erosion*, 66–68, lines 26–76)

Where are we? Where is the poet? Graham notices a large blue bird in the famous fresco in the Brancacci Chapel in Santa Maria del Carmine, a "Sharp-Shinned Hawk" (an American, not a European bird) that she has seen often "tearing into the woods / for which it's / too big."

The problem is that no such bird exists in the picture (fig. 13). Instead, Graham has imaginatively enlarged upon a splotch of paint:

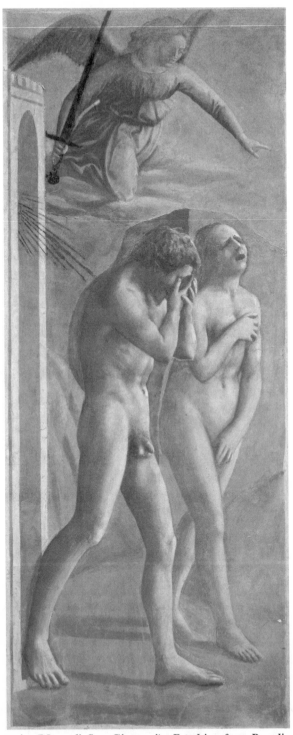

Fig. 13. Masaccio (Masa di San Giovanni), *Expulsion from Paradise*, 1424–1425, fresco. Florence, Italy: Brancacci Chapel, S. Maria del Carmine. Photo Credit: Scala / Art Resource, NY.

"perhaps / it is a flaw // on the wall of this church, or age, / or merely the restlessness / of the brilliant / young painter." But from the available visible evidence she infers her predatory bird, "seeking a narrower / place," which she urges the fallen Adam and Eve to watch, in order that they (like her) might abandon whatever is open and "easily eloquent" in favor of what is closed and broken, or eroded. Human—that is, fallen—Graham takes it upon herself to recommend to our first parents the virtues of choice, of narrowing. At the same time, she has engaged in an imaginative act of opening out and away. If art is a paradise, then the poet's mind has moved out away from Eden into the real world of all of us. What she has suffered or inherited from Adam and Eve she throws back at them. Significantly, the imagined, reconstructed bird becomes the agency of communication between the viewer of the painting and the characters within it. The bird symbolizes a principle of narrowing and also one of expansion, since it comes from the capacious freedom of the viewer's own imagination. Like so many of Graham's poems about art, this one has echoes of Elizabeth Bishop's "Poem" in *Geography III*, which relates the poet's encounter with a small painting by a great-uncle with dabs and squibs of paint that become, recognizably, animals and birds. At the end of "Masaccio's Expulsion," poet and reader seem to have returned to present life and time, as the "open prairie" and the bird's "feathers" suggest an event in life, not in art. The antecedent of the mysterious "it"—"Perhaps you know / why it turns in // this way and will not stop?" and "Whatever they are, / it beats / up through the woods / of their bodies"—seems to refer not only to the original blue splotch or the imagined hawk but also to some greater principle of imaginative energy, one that broaches all of our ideas about permanence, about eternity (*Erosion*, 68, lines 77–80, 92–95).

Such suggestions of eternity culminate in the last poem of the trio, on the subject of the resurrection of the body. It is divided into two almost equal parts, the second of which studies the painter's own painstaking effort to cut into, to enter the flesh of, his dead son in order to study anatomy and beauty, a virtual definition of Renaissance humanism. If the second part is actual, narrated history, all past tense, it is connected to the first section in part by its insistence (like that of "San Sepolcro") on active gerunds ("cutting, unfastening" in the penultimate stanza), which remind us of the constant activity of a mind working and a hand carving. The first part of the poem, however, might be taken as the presumptive occasion for Graham's re-imagining of Signorelli's experiments. Confronting his great fresco in the San Brizio chapel at the Duomo of Orvieto (fig. 14), she

Fig. 14. Luca Signorelli, *Resurrection of the Dead,* **1500–1503, fresco (postrestoration).**
Orvieto, Italy: Duomo. Photo: Scala / Art Resource, NY.

imagines the effort of resurrection as present-tense action, always in
process, never completed. The people in the fresco compete with
others—citizens of the town in 1500 as well as the living observers in
the 1980s—all of whom are in transition:

> . . . Standing below them
> in the church
> in Orvieto, how can we
> tell them
> to be stern and brazen
> and slow,
>
> that there is no
> entrance,
> only entering. They keep on
> arriving,
> wanting names,
> wanting
>
> happiness.

(*Erosion,* 75, lines 49–61)

Like "Masacio's Expulsion," but unlike "San Sepolcro" or Salter's "Young Girl Peeling Apples," Graham's poem on the Resurrection contains a rhetorical gambit we might consider a staple of certain kinds of ekphrases: the act of questioning. If simple, mere, or objective, unvarnished "description" demands or implies declarative sentences, then one means of complicating a response to pictures is to pose questions about or to them. Keats's "What men or gods are these?" "What wild ecstasy?" "Who are these coming to the sacrifice?" and so forth. In her case, Graham uses interrogation to determine value, not identification: "Is it better . . . that they should hurry so?" "is it better, back?" "Is it perfection they're after?" (*Erosion,* 74, lines 5–7). And with an implicit question she ends the first part with an affirmation: "how can we tell them . . . that there is no entrance, only entering." The progressive present, the participles and gerunds, are the signature of Graham's methodology: just like the painted figures, or the souls of the dead arising to fill their bodies, we all "keep on arriving, wanting names, wanting happiness." Even the end of the world, she implies, is something that is always happening, never completed.

All three of these poems work with similar tropes of movement: in and out, up and down. In "San Sepolcro" the living go in, whereas the Virgin opens herself up in order to release her son. In "Masaccio's Expulsion" Adam and Eve are expelled from a garden and a hawk tears into the woods, as the poet moves between the Brancacci chapel and presumably an American landscape. "At Luca Signorelli's Resurrection of the Body" offers two parallel scenes. In the first the dead are moving up, coming out, for rebirth and the living spectators are moving into the church. In the second, the artist opens the body, going into it with a combination of erotic, scientific, and aesthetic motives:

> It took him days
> that deep
> caress, cutting,
> unfastening,
>
> until his mind
> could climb into
> the open flesh and
> mend itself.
>
> (*Erosion,* 77, lines 98–105)

Graham had called the mind a "holy grave" in "San Sepolcro," and the Signorelli poem dramatizes the same relation between life and death, body and mind, but from an opposing direction.

In *The Prelude* Wordsworth calls the eye the most despotic of the senses. Like all gazers at paintings, Jorie Graham both follows and then resists the tyrannical commands of her eye. She cannot avoid looking. Neither can she resist turning away. The mind wanders where it will, as Wordsworth knew when he allowed in *Lyrical Ballads* that we cannot bid the eye be still. In responding to pictures, any poet is responding as well to something in herself, measuring herself against a visual stimulus, and looking at, or away, as she would look at a self-portrait. What may be true of all ekphrases is prominently displayed in Graham's poems: the specific fact that all pictures, even those like Mark Rothko's that are abstract, are also mirrors.[6] Some poets attempt to read pictures. Graham does something different. She observes and responds to them, and then moves beyond them and into herself. Wallace Stevens called the poem "the cry of its occasion," and for a poet like Graham a painting is an occasion for several kinds of intellectual, emotional, and creative exercises. The implicit as well as explicit questions poets pose to pictures are questions about themselves, and what we as readers see in even the most objective of descriptions as well as more dramatic encounters is a reflection of our own codified desires.

NOTES

1. This piece complements a recent essay of mine, "Jorie Graham Listening," about sound, especially birdsong, in her work. See *Jorie Graham: Essays on the Poetry*, ed. Thomas Gardner (Madison: University of Wisconsin Press, 2005), 219–37.

2. References in this essay are to the following volumes: *Hybrids of Plants and of Ghosts* (Princeton, NJ: Princeton University Press, 1980); *Erosion* (Princeton, NJ: Princeton University Press, 1983); and *Materialism* (New York: Ecco Press, 1993).

3. On the theory that one *can* judge a book by its cover, I have discussed the importance of the illustrations on the dust jackets of Graham's books in *How Poets See the World: The Art of Description in Contemporary Poetry* (New York: Oxford University Press, 2005), 174–76.

4. Cf. the essay by Jonathan Post in this volume for a more extensive discussion of this poem.

5. Jorie Graham, *The End of Beauty* (New York: Ecco Press, 1987).

6. I discuss the few relevant recent examples of ekphrastic poems written about abstract expressionist or other nonrepresentational paintings in *How Poets See the World*, 128–36.

Rita Dove's Body Politics

Jane Hedley

A PERSON GETS TO KNOW HERSELF AS A WOMAN FROM INSIDE, THROUGH inhabiting a woman's body, but also through being looked at, and through experiencing her "to-be-looked-at-ness" as an inescapable dimension of her femininity.[1] A person of African descent living in Europe or the United States comes to experience herself as "black"— by which I mean, comes to understand her "blackness" as a crucial identity marker—through being the object (or the target) of a look that racializes her. Rita Dove's ekphrastic poems take an interest in the psychological and political dynamics of the look that both feminizes and racializes its object; she turns to particular works of art for information about how that look is bestowed, received, and experienced. Ekphrasis lets her tackle the Medusan subject of race obliquely, like Perseus with his mirror shield.

Dove's 1989 volume *Grace Notes* includes a poem entitled "Medusa" that envoices the Gorgon herself. Helen Vendler has suggested that this poem is playing with "the idea of blackness as conferring gorgon-status on a black woman;"[2] and indeed, in many versions of the myth Medusa is African.[3] But Vendler's "someday America will learn that black is beautiful" reading assimilates Dove's interest in Medusa to the history of American race relations.[4] Instead, I think the challenge Dove set herself in this poem was to produce the inner life of a mythological figure whose predicament has both a longer time line and a stronger claim to "universality."[5] Her poem's speaker is a figure who has remained alive for centuries through being killed into art. She may have been decapitated and turned to stone, but death has not been an option for her: Medusa's image and its meanings are still being actively reprocessed in both high and popular culture.[6] That being so, Dove's poem sets out to imagine for us what the Gorgon herself has all this time been thinking—how she has been able, since time immemorial, to withstand her own mythification. The poem's discourse is impacted and cryptic, suggesting an inner life that has stubbornly persisted under enormous pressure:

197

> I've got to go
> down where my eye
> can't reach
> hairy star
> who forgets to shiver
> forgets the cool suck
> inside[7]

What enables Dove's Medusa to withstand her own mythification is a determination to reexperience herself, somehow, from "inside"—if not from inside the woman's body to which her head is no longer connected, then at least from within her own imagination. According to one often-cited variant of the myth, what killed Medusa was seeing her own reflection in Perseus's mirror-shield.[8] With an impulse that acknowledges, even as it resists, a Freudian reading of the threat embodied in her severed head with its snaky locks, Dove's Medusa dreams of reconnecting with the "hairy star" of her own genitalia and the orgasmic "shiver" that belongs to her as a sexual being.

Dove's interest in the figure of Medusa is of a piece with a trend toward myth in her poetry that emerged full-blown in her 1995 volume *Mother Love,* but that Malin Pereira suggests began to be apparent as early as *Thomas and Beulah* in 1986 and became even more pronounced in *Grace Notes* in 1989. Noting that "as her poetry becomes increasingly personal it also becomes increasingly mythical," Pereira suggests that "in her call to see the universal, mythical dimensions of personal experience" Dove found a way to achieve "a sensitive balancing of the racial particular and the unraced universal."[9] And yet the language of myth has its limitations for an African American poet with cosmopolitan leanings. For one thing, it is a language with its own European specificity: the last section of *Mother Love* acknowledges this by taking the poet and her husband to contemporary Sicily on a disappointing search for the archaeological and geographical remains of the myth that that volume reprises. For another, the language of myth is an atavistic language, resistant to the possibility that particular histories, whether personal or national, might transform the terms in which identity is construed, relationships are undertaken, and political life is invested with significance.

Many of Dove's poems are quasi-ekphrastic or have ekphrastic moments contained within them, but only a few are fully ekphrastic in the sense of offering to describe, envoice, reimagine the composition, or capture the impact of a particular work of visual art. Of the three fully ekphrastic poems that will receive a close reading in this

essay, two deal with European images of black womanhood that prove, like the figure of Medusa, to be atavistic and dehistoricizing. The third is a poem Dove published during her first year as poet laureate of the United States, in which this kind of figure claims the paradigmatic, superhuman authority of a mythical being yet proves capable of doing historical and political work. In that poem a Medusan "revenant" meets our eyes to deliver a distinctively American message.

Dove's engagement with her own blackness is often witty and unpredictable. A poem in *Grace Notes* that is punningly entitled "Stitches" begins:

> When skin opens
> where a scar
> should be, I think nothing but
> "So I *am* white underneath!"[10]

The poem's speaker goes off to the emergency room to get stitches, all the while continuing to feel weirdly detached and playful—she is "in stitches," in this double sense. The poem ends with the self-admonition: "*You just can't stop being witty, can you?*" In psychological terms, wittiness is a predictable response to suddenly finding herself off-balance, at the mercy of forces beyond her control. While the doctor is stitching her up she is amazed by the absence of pain—"just pressure / as the skin's tugged up by his thread." Tellingly, however, the occasion and focus of this "pressure," as well as of the sense of alienation from her own body that comes with *not* feeling pain, is her skin, which is wittily subjected, over the course of the poem, to a series of metaphoric analogies: a trout being "tugged up" by the doctor's thread, "a seamstress' nightmare" of stitching her own skin by mistake. "Stitches" calls attention to skin, and especially to black skin, as a physical surface that is arbitrarily yet inescapably fraught with meaning. In this context, the poem suggests, the physical and the metaphysical are not easily kept separate, wit and seriousness both have their uses, and metaphor can be wielded apotropaically to ward off essentialism.[11]

Dove is not a "Race Poet," says Houston Baker in his 1990 review of *Grace Notes,* and thus it is "a signal irony of United States 'culture' that [she] has only one essentialist category to house her in the popular critical imagination . . . 'Afro-American' or 'Black' poet."[12] In *The Given and the Made* Helen Vendler avers, contra Baker, that "the primary given" for any black American writer "has to be . . . the fact of

her blackness." And yet Vendler's is not an essentialist claim: black-
ness is a "given" of which something will have to be made, because
"the inescapable social accusation of blackness becomes, too early for
the child to resist it, a strong element of inner self-definition."[13] Dove
seems to confirm this reading of her own formation when, in re-
sponse to Malin Pereira's question about how "national history" and
the "personal present" are connected for her, she replies that they
both have "something to do, a lot to do, with being female and being
Black." She goes on to speculate that most children who are "in a
minority" have that status brought home to them at a young age: "It's
very strange: 'Oh, really, I'm not like you?' It usually comes from the
outside somehow."[14] These remarks suggest that for Dove being
female and being black are related and equally critical "givens"; and
indeed, whenever her poems take an interest in race they are alive to
the ways in which gender and race are mutually implicated. Her
ekphrastic poems, in particular, make it their business to explore how
these interlocking dimensions of identity are constructed in the pop-
ular imagination.

In a poem that is obliquely, tacitly ekphrastic, Dove ponders the
implications of reading an enormously popular children's story to
her three-year-old daughter. Like "Stitches," "After Reading *Mickey in
the Night Kitchen* for the Third Time before Bed" is a poem that flirts
with the possibility of getting out from under the look that racializes,
this time by calling attention to the process of acculturation whereby
a child's self-image is consolidated. It is an obliquely ekphrastic poem
insofar as the visual image of Mickey, the very white, very "boy," pro-
tagonist of Maurice Sendak's *In the Night Kitchen,* is cited as the
catalyst of that acculturation process. Dove's epigraph ("*I'm in the milk
and the milk's in me . . . I'm Mickey*") is bound to bring Sendak's un-
forgettable illustrations to mind, especially the one that uses full
frontal nudity[15] to depict Mickey falling out of his pajamas into a
giant bottle of milk. It is this image, which accentuates Mickey's
whiteness and his boy-hood and links them together, that prompts
the poet's energetic three-year-old to take her own gender identity
under advisement. After her mother has read her the story for the
third time, she "spreads her legs / to find her vagina"; having found
it, "she demands / to see mine." Her mother complies, calling at-
tention as she does so to a very short window of societally sanc-
tioned opportunity for a daughter's exploration of her own and her
mother's most "private" parts. "She is three; that makes this / inno-
cent. *We're pink!* / she shrieks, and bounds off," leaving her mother to
ponder the implications.[16]

"Black mother, cream child": the poet-mother can afford to use
language playfully in this context, color-coding her daughter's mixed-
race status relative to that of milk-white Mickey, but her choice of
words conveys that both sexuality and race are dimensions of identity
whose impact on her daughter is already beginning to be felt. Simply
by reading her daughter a bedtime story she is participating in that
process of acculturation. But whereas ignoring the larger society's
messages about race is not an option, the poem suggests that we are
not merely their passive targets. The little girl's reaction to naked
Mickey is expressive not of a sense of lack (as Freud and even perhaps
Sendak would have expected), but of an impulse toward solidarity
with her mother, one that ignores or postpones awareness of who is
"blacker" than whom. By the time this "cream child" reaches puberty,
skin color is likely to complicate their relationship in ways that give
her "black mother" pause for thought. And yet her daughter's con-
viction that they *are* the same in ways that go deeper than race is the
one she chooses to honor in her poem's witty punch line. "We're in
the pink / and the pink's in us": between the spunky daughter and
her verbally resourceful poet-mother, the winning bravado of little
white Mickey is verbally troped and trumped. In this way Dove's
anecdote calls attention to a capacity for "inner self-definition"
(Vendler's words) that comes into play differently at different stages
in girls' and women's lives.

The tone of both "Stitches" and "After Reading *Mickey in the Night
Kitchen*" is playful; "Arrow," from the same volume, is a sterner poem
with similar preoccupations. Attending a lecture with three female
students, Dove hears the lecturer, who is also a translator,[17] use "ur-
ban black speech" to render the "voice / of an illiterate cop" in one of
the comedies of the Greek playwright Aristophanes. Later in the
same reading he explains that for the Italian Nobel laureate whose
poems he has also translated, "women were a scrim through which he
could see heaven." After an exchange of handwritten notes with her
students in which she argues that because this "eminent scholar" is "*a
model product of his education*" they need to stay and hear him out, Dove
feels she must speak up during the question period to challenge the
biases implicit in both the passages themselves and his commentary
on them. When she does so she feels "the room freeze behind me,"
and his response is predictably unregenerate: his intention had been
to "*celebrate our differences*" by calling attention to "*the virility of eth-
nicity.*" The poem ends with Dove's awareness that the students she
has brought with her to the lecture will all have their own ways of
dealing with the anger and hurt that her intervention has only served

to intensify. One will have a migraine; another will show up later "in black pants and tunic with silver mirrors" wearing pointed, "wicked witch shoes":

> Janice who will wear red for three days or
> yellow brighter
> than her hair so she can't be
> seen at all.[16]

Janice's response suggests that one way for a woman to get out from under the look that sexualizes and racializes her is through parody and masquerade. Her dyed hair and flamboyant, attention-getting costumes are apotropaic, Medusan devices. Instead of offering to whoever may be looking at her "a scrim through which he could see heaven," Janice goes on the attack with a fashion statement that is both self-protective and contemptuous.

It was Athena who gorgonized Medusa in the first place and who, after Perseus had beheaded her, placed Medusa's head on her shield or aegis. In "Arrow" Dove herself takes on the role of Athena, as she directs toward the eminent scholar a "civil . . . condemnation / phrased in the language of fathers" that "freezes" the room behind her. It is a role she assumes reluctantly, and it is not clear that any-one's education has been furthered by her intervention. As a poet, however, Dove has resources that are not only defensive and self-protective, and not only the discursive resources of an academic Athena figure, but imaginative and re-creative—prophetic, even. In "Medusa," for example, metaphors have a power that is cosmic rather than merely cosmetic: Medusa foresees the day when her "hairy star" will become a new constellation, freeing her at last to "drop his memory."

Dove's two most traditionally ekphrastic poems explore the special status blackness confers in the context of a European art tradition that associates black womanhood with the exotic, primeval, or primitive, and with excess in the context of sexual desire and sexual fecundity.[19] "The Venus of Willendorf" is a third-person poem about a young American woman, studying abroad, who has come to spend a few days at her professor's summer home in the Austrian mountains and is taken to see a replica of the Venus of Willendorf, which was unearthed nearby. "Agosta the Winged Man and Rasha the Black Dove" goes inside the head of the Weimar artist, Christian Schad, as he thinks about how he will pose two sideshow performers for his painting of that name. Both poems call attention to how black wom-

anhood has been assimilated, within the European art tradition, to an ahistorical, mythologizing frame of reference.

Upon her arrival in a small, remote village in the mountains above the Danube River, the protagonist of "The Venus of Willendorf" is "taken . . . to see the village miracle," a replica of the famous statue "entombed in a glass display."[20] She is startled, even a little frightened, by the statue's frank celebration of female fleshliness—the "sprawling buttocks," the "barbarous thighs," the "breasts heaped up in her arms / to keep from spilling." For the villagers, meanwhile, she too is a miracle—their precious statue come back to life:

> *Have you seen her?* they asked,
> comparing her to their Venus
> until she could feel her own breasts
> settle and the ripening
> predicament of hip and thigh.[21]

In this passage the young woman feels herself becoming what the townspeople think they see, and it is not a wholly unwelcome sensation. The poem finds her alone at sunset, watching for the evening train to pass by in the valley below and thinking about how it feels to be looked at in this way not only by the villagers, but also by the Herr Professor himself. As she thinks about "his gaze, glutting itself / until her contours blazed," she comes to an understanding of "what made the Venus beautiful": the statue's aesthetic power is a function of "how the carver's hand had loved her, / that visible caress" (*On the Bus with Rosa Parks*, 50). She has come to understand this about the statue through knowing what it feels like not only to be desired as a woman, but to accept and even crave her own desirability.[22]

This poem's protagonist is educated into the cultural implications of her "blackness"—or, more specifically, her "black-womanness"— in an intimate, bodily way. What she learns is that for her, as for James Baldwin in *Notes of a Native Son*, it is a question of "accepting the status which myth, if nothing else, gives [her] in the West. . . ."[23] Baldwin explores the implications of this necessity in "Stranger in the Village," an essay that recalls his sojourn in a Swiss village whose inhabitants, like the natives of Willendorf, had never before seen a person of African descent. The protagonist of Dove's poem has an experience that is eerily similar to Baldwin's, but the look that mythifies Dove's protagonist also feminizes her, giving rise to a bodily experience that is both profoundly erotic and profoundly aesthetic. The poem ends with the evening train passing by in the valley below, as it does every evening at precisely 7:10—"another miracle," since the rest of the time the valley seems content to "dream / the haze of

centuries away." She has been waiting for the train to pass by since the poem's opening lines; its passage assists her to hold on to a sense of her own modernity and also to the status of someone who is only passing through. Her vision of it gliding through the darkness is the poem's final and most beautiful image: "passengers snared in light, smudged flecks / floating in a string of golden cells" (*On the Bus with Rosa Parks*, 50). Echoing as it does the image of the replica statue "entombed in a glass display," this image bespeaks an aesthetic experience that is transcendent and inclusive: it is as if she were looking at humanity's DNA. Passing from the status of object to that of subject, she has an aesthetic intuition that is finally impersonal, even though it has come to her by way of an unnervingly personal experience. The poem ends in a stasis that fails to resolve the tension between subject and object, embodiment and transcendence: "*If only we were ghosts,* she thinks, / leaning into the rising hush, / *if only I could wait forever*" (ibid., 51).

In an interview fifteen years before this poem was written, we find Dove acquiescing to her interviewer's suggestion that "a slight sense of displacement" attaches to her poems whenever they are set in Europe.[24] "As a *person* going to Europe," Dove says, "I was treated differently because I was American," and adds: "I was Black, but they treated me differently than people treat me here because I'm Black. . . . And I sometimes felt like a ghost. . . ."[25] While putting the finishing touches on the 1999 volume in which "The Venus of Willendorf" was published she speaks in similar terms of how "every one of us is alive in our skin, and at the same time we feel completely insubstantial."[26] The experience of the African American protagonist of "The Venus of Willendorf" is one that epitomizes this sense of being "ghosted" yet very much alive in her skin. It is a fragile balance of opposing forces, a balance both enabled and endangered by the young student's impending womanhood.

"Agosta the Winged Man and Rasha the Black Dove" is another poem that highlights the special status blackness confers in the context of an art tradition that associates black womanhood with the exotic and the primitive. For her second published volume of poems, entitled *Museum*, Dove obtained permission from the artist Christian Schad to have *Agosta, der Fluegelmensch und Rascha, die schwarze Taube* reprinted on its cover (fig. 15).[27] Schad is an artist who, in the words of the art critic Michèle Cone, "taunted Weimar era bourgeois society" with paintings of his contemporaries that were unnerving and uncanny, evoking "the wary disquiet of a society without bearings."[28] The central figure in a painting of his will often look out of the canvas with an unfocused, deadpan gaze—a gaze that could also, perhaps,

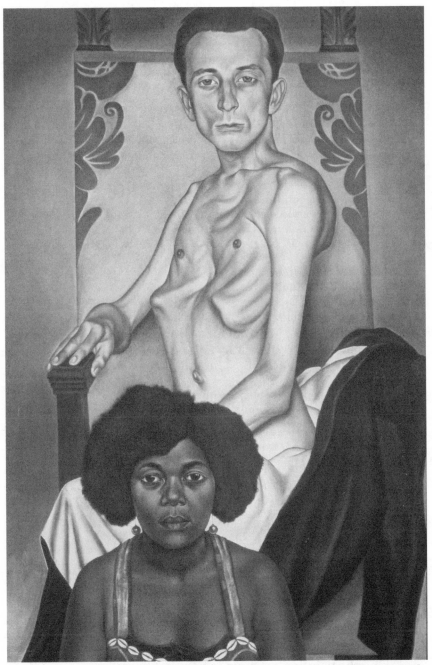

Fig. 15. Christian Schad, *Agosta, der Fluegelmensch, und Rascha, die schwarze Taube,* 1929, oil on panel. Private collection / Bridgeman Art Library. ©2007 Artists Rights Society (ARS), New York / VG Bild-Kunst, Bonn.

be described as "merciless" (Dove's word in this poem) if we think of
his paintings as mirroring a decadent society back to itself. Dove's
poem goes inside the artist's head in free indirect discourse as he
waits for his models to show up for a sitting.

 Agosta and Rasha earn their living as sideshow freaks: "the winged
man" displays his deformed rib cage; "the black dove" appears with a
boa constrictor. Agosta has also been displayed as a specimen of
physical deformity at the Charité, a medical school in Berlin—

> where he perched on
> a cot, his torso
> exposed, its crests and fins
> a colony of birds, trying
> to get out. . . .
> and the students,
> lumps caught
> in their throats, taking notes.[29]

In the context of the sideshow, Agosta's body is eroticized: he has told
Schad with a mixture of contempt and amazement "of women /
trailing / backstage to offer him / the consummate bloom of their
lust." Schad "would place him," he thinks,

> on a throne, a white sheet tucked
> over his loins, the black suit jacket
> thrown off like a cloak.
>
> (*Museum*, 42)

Agosta's posture and expression in the painting are akin to Schad's
expression and posture in a self-portrait, painted in 1927, which also
figures in the reverie Dove has constructed for him:

> He could not leave his skin—once
> he'd painted himself in a new one,
> silk green, worn
> like a shirt.
>
> (ibid., 41)

In the self-portrait Schad is wearing a translucent green singlet
through which his hairy torso can be seen.[30] The green shirt serves to
enhance the painter's detachment from his own eroticized body,
provoking the painting's viewers to become unsettlingly aware of our
own "scopic" avidity. Like Schad in his self-portrait, Agosta is posed to
emphasize that he is the object of a gaze that eroticizes him, of which
he is in turn contemptuous.

In contrast to the spectacularly deformed Agosta, Rasha qualifies as a freak merely by virtue of being African. Schad's painting calls attention to physiognomic differences that throw her "African-ness" and Agosta's "European-ness," her "blackness" and his "whiteness," into bold relief.[31] Her Medusan mane of curly black hair is right in front of his "loins," both concealing and drawing attention to the sexual center of his body, which thereby becomes a lowered center for the painting as a whole. At the same time, however, Rasha seems almost to occupy a different picture plane from Agosta: whereas he is set back into the canvas, hieratically and haughtily posed, she seems unaware of how she has been positioned and what is behind her. Agosta takes command of the painting, submitting to yet triumphing over our gaze with his regally upright posture and expression of contemptuous indifference. Rasha's indifference is by comparison unselfconscious: she is looking directly out at the viewer but her gaze is unfocused, her face empty of expression.

In keeping with the aesthetic program of "The New Objectivity," with which Schad was associated, Dove has him think of his medium as possessing certain capacities of representation that he activates dispassionately: "The canvas, // not his eye, was merciless," he thinks to himself (ibid., 41). But merciless to whom? To Agosta and Rasha, whom his canvas will put on display? What the painting is really about is his society's overinvestment in a racialized body, its proto-Fascist body politics. By the end of the poem Schad sees with his mind's eye how he will compose his painting, and revises his assessment of how its impact will be gained:

> Agosta in
> classical drapery, then,
> and Rasha at his feet.
> Without passion. Not
> the canvas
> > but their gaze,
> > so calm,
> was merciless.

> (ibid., 42)

Despite his reference to "*their* gaze," Schad has situated the German man and the Madagascan woman differently vis-à-vis the spectatorial gaze that exoticizes them both. Dove's poem calls attention to this by having the two German men, Schad and Agosta, share an attitude of knowing contempt for the viewer and an impulse toward flight, or toward leaving their skins. The African woman's attitude toward her own exoticization is more inscrutable. Impervious as she

is both to the high-art connotations of their stylized pose and to the scandal it creates in relation to the history of European painting, Rasha carries the burden of her own exoticization matter-of-factly, without defensiveness. "How / the spectators gawked," Schad thinks as he recalls her sideshow performance, but "when the tent lights dimmed, / Rasha went back to her trailer and plucked / a chicken for dinner" (ibid., 41).

Rasha's "Africanness" has been mythified; her situation is akin to that of the African American student who finds herself being hailed as a latter-day avatar of the Venus of Willendorf. But that young woman is in a position to study her own predicament, and her inner life is made accessible to us. In "Agosta and Rasha" Rita Dove, who resembles Rasha physically and whose name fortuitously echoes hers,[32] has aligned herself just as much with the German artist as with the African woman he finds inscrutable. Both in the sideshow and in Schad's painting, Dove's Medusan namesake is burdened but also shielded by her de-historicized "Africanness." The European artist is trapped within a particular place and time and tradition of representation, unable to "leave his skin." His African model, in contrast, is the bearer of a look that displaces her and renders her homeless: it seemed, Schad thinks, "as if she carried / the snake around her body / always" (ibid., 42).

The United States of America has been haunted by blackness in a different way. In America, as James Baldwin points out in *Notes of a Native Son,* "[the black man] was an inescapable part of the general social fabric;" deprived of his African past, he became caught up in an interracial drama that brought forth not only "a new black man," but a "new white man" as well.[33] "Lady Freedom among Us," a poem that was published in a special edition by the Library of Congress during Dove's first year as poet laureate, affirms this historical insight with an ekphrasis of the statue that was installed on the dome of the Capitol Building in 1863. Fortuitously, while Dove was in residence at the Library of Congress the statue was removed from its pedestal for cleaning, after 130 years of exposure to the grimy outdoor air of metropolitan Washington. Dove read her poem at a presidential ceremony after it had been cleaned, but the black-and-white photograph that was published with the poem shows the statue still black with soot, and resting on the ground (fig. 16).

Whereas in poems with a European setting we find Dove using ekphrasis to assimilate black womanhood to a de-historicizing, mythic frame of reference, in "Lady Freedom among Us" blackness gets a different kind of historical traction. The poem accosts us on behalf of

Fig. 16. Thomas Crawford, *Statue of Freedom*, photographed in front of the U.S. Capitol in 1993. Courtesy of the Architect of the Capitol.

the statue as if it were an urban bag lady who "has risen among us in blunt reproach": "don't lower your eyes . . ." the poem bluntly tells us, "don't cross to the other side of the square. . . ."[34] The look with which Lady Freedom accosts us originated *with* us: the statue mirrors back to us our own investment in democratic ideals. Meanwhile, however, she has "assumed the thick skin of this town . . . its sun-scorch and blear": her soot-blackened skin is emblematic of the beating those democratic ideals have taken over her 130-year lifetime. "She is one of the many"—and yet, as a matter of historical record, the statue's original design was modified to occlude the existence among "the many" of Americans of African descent. Jefferson Davis was secretary of war in 1863, and he objected to the "liberty cap" with

which Lady Freedom's designer had crowned her, since it originated
in ancient Rome as a badge of manumission for freed slaves. Davis
prevailed, and the statue was crowned instead with a "republican"
helmet that is also an Indian headdress and includes a circlet of stars.

Dove's Lady Freedom wears "a hand-me-down cap" she has "spruced
. . . up with feathers and stars." If she is easily mistaken for a homeless
person, that will be because she *is* still homeless in the land that was
to have been her home. She has risen among us to remind us that our
freedom is historically rooted in acts of dispossession and denial—of
American Indians, of African slaves.[35] She "will not retire politely to
the potter's field": the poem's central conceit thus presupposes and
challenges our tendency to relegate both national monuments and
national ideals to a realm of abstraction where they cost us nothing,
need not be interrogated, and suggest no course of action.

"All history is a negotiation between familiarity and strangeness,"
says the historian Simon Schama in one of the epigraphs Dove chose
for *On the Bus with Rosa Parks,* the volume in which this poem was later
included. "Lady Freedom among Us" distills a version of that dictum.
Like "Agosta and Rasha," it is a poem in which the work of visual art
looks back, subjecting the viewer's aesthetic and political priorities to
interrogation and critique. But whereas Schad's painting is a "merci-
less" mirror, Lady Freedom is a prophetic "revenant." "She who has
brought mercy back into the streets"[36] is a Medusan figure, but the
poet insists that we *meet* her "drenched gaze"—that we reaffirm our
historical commitment to liberty at a higher level of political self-
awareness. "She is one of the many / and she is each of us" (*On the
Bus with Rosa Parks,* 70): as Americans, we are all black underneath.

NOTES

I would like to thank Jane Caplan, Anne Dalke, Imke Meyer, Lisa Saltzman, and
Steve Salkever for their helpful comments when an early version of this essay was
presented at the Bryn Mawr Colloquium in Visual Studies.

1. "To-be-looked-at-ness" is John Berger's influential coinage in *Ways of Seeing*
(New York: Viking Press, 1973).

2. Helen Vendler, *The Given and the Made* (Cambridge, MA: Harvard University
Press, 1995), 85.

3. Cf. Marjorie Garber and Nancy J. Vickers, eds., *The Medusa Reader,* (New York:
Routledge, 2003), 20–21 (citing Palaephatus, fourth century BCE), 24–25 (Apol-
lodorus, second century BCE), 26–27 (Diodorus Siculus, c. 60–30 BCE), 40 (Lucan's
Pharsalia, c. AD 61–65), and so forth.

4. Cf. esp. Vendler, *Given and the Made,* 88: "When Whitman remarked . . .
that the Muse had left Greece, and had come to inhabit America . . . he, alone

among our nineteenth-century poets, might have foreseen that in one of her incarnations this American Muse would be one with the terrifying Medusa-face of slavery. . . ."

5. For an African American writer this is a vexed claim, as Malin Pereira points out in *Rita Dove's Cosmopolitanism* (Urbana: University of Illinois Press, 2003). See especially 75–80, where Pereira suggests that "revisionist universality" is "typical of [African American] writers of Dove's generation." Cf. also Lynn Keller, *Forms of Expansion: Recent Long Poems by Women* (Chicago: University of Chicago Press, 1997), for a discussion of Dove's wish to "embrace multiple cultural traditions" (110) and her "cautious" reception from black critics such as Arnold Rampersad and Houston Baker (105–8).

6. *The Medusa Reader*, a compendium of Medusan references from Homer to Gianni Versace, includes an image that is used to advertise the "Medusa" roller coaster at Six Flags Great Adventure (Garber and Vickers, *Medusa Reader*, fig. 32).

7. Rita Dove, "Medusa," in *Grace Notes* (New York: W. W. Norton, 1989), 55.

8. Cf. Garber and Vickers, *Medusa Reader*, 6.

9. Pereira, *Rita Dove's Cosmopolitanism*, 116.

10. Dove, "Stitches," in *Grace Notes*, 51. Malin Pereira, who reads the wound in this poem allegorically, suggests that Dove is wounded by the perception on the part of some black critics that she "writes white" (Pereira, *Rita Dove's Cosmopolitanism*, 132). She could also be referencing the canonical "I am black but oh my soul is white" topos of "The Little Black Boy," from William Blake's *Songs of Innocence and Experience.*

11. Vendler suggests that "blackness [has been] forgotten" by the end of this poem "in favor of critical self-interrogation" (*Given and the Made*, 84); and yet the poem is full of color references throughout: the poet/speaker's husband "pales," she is wearing a red dress, the doctor's teeth are yellow, his thread "a black line . . ." (Dove, *Grace Notes*, 51).

12. Houston Baker, review of *Grace Notes*, by Rita Dove, *Black American Literature Forum* 24, no. 3 (Fall 1990): 574.

13. Vendler, *Given and the Made*, 61.

14. Rita Dove, *Conversations with Rita Dove*, ed. Earl G. Ingersoll (Jackson: University Press of Mississippi, 2003), 150.

15. In an interview on National Public Radio in 1993, Maurice Sendak told Terri Gross that on account of this image *In the Night Kitchen* had been banned from the children's section of a number of libraries.

16. Rita Dove, "After Reading *Mickey in the Night Kitchen* for the Third Time before Bed," in *Grace Notes*, 41.

17. In view of the poem's title, it is likely this was classical scholar and translator William Arrowsmith.

18. Rita Dove, "Arrow," in *Grace Notes*, 49–50.

19. Cf. Sander L. Gilman, *On Blackness without Blacks: Essays on the Image of the Black in Germany* (Boston: G. K. Hall, 1982); and more recently, Gilman, "The Hottentot and the Prostitute: Toward an Iconography of Female Sexuality," in *Race-ing Art History: Critical Readings in Race and Art History*, ed. Kymberly N. Pinder (New York: Routledge, 2002): 119–38.

20. In "Women in Pre-History: The Venus of Willendorf," http://witcombe.sbc .edu/willendorf/willendorfdiscovery.html, Christopher L. C. E. Witcombe explains that this "most famous early image of a human," discovered in 1909 and now thought to date from around 24,000 to 22,000 BCE, "quickly [became] established as an icon of prehistoric art . . . acquiring a sort of Ur-Eve identity that focused suitably, from a patriarchal point of view, on the fascinating reality of the female body."

21. Dove, "The Venus of Willendorf," in *On the Bus with Rosa Parks* (New York: W. W. Norton, 1999), 49. Hereafter cited in the text.

22. In Dove's *Mother Love* sequence this same experience is explored in "Hades' Pitch," where a latter-day Persephone is seduced by the Parisian *avant-garde* painter whose demimondaine model and mistress she becomes. Cf. *Mother Love* (New York: W. W. Norton, 1995), 37.

23. James Baldwin, *Notes of a Native Son*, in *Collected Essays* (New York: Library Classics, 1998), 128. Baldwin's larger point is that his status in the United States is irrevocably different: "No road whatever will lead Americans back to the simplicity of this European village where white men still have the luxury of looking on me as a stranger" (129). I would like to thank my colleague Anne Dalke for suggesting the Baldwin connection.

24. Quite possibly "The Venus of Willendorf" hearkens back to Dove's earliest sojourn in Europe, on a Fulbright fellowship in 1974. The poem first appeared in *Poetry* 161 (October 1992), and was republished in *On the Bus with Rosa Parks* in 1999 (cf. n. 21).

25. Dove, *Conversations with Rita Dove*, 6.

26. Ibid., 167.

27. In an interview with Gretchen Johnsen and Richard Peabody in 1985, Dove says: "A lot of people didn't like the cover. Let's say they were uneasy," and adds: "But I wanted them to be uneasy" (ibid., 29).

28. Michèle C. Cone, "Schad's Cabaret" (review of "Christian Shad and the Neue Sachlichkeit," Mar. 14–June 9, 2003 at the Neue Galerie, New York City), http://www.artnet.com/magazine/features/cone/cone4-17-03.asp. Cf. also *Christian Schad and the Neue Sachlichkeit*, ed. Jill Lloyd and Michael Peppiatt (New York: W. W. Norton/Neue Galerie, 2003).

29. Rita Dove, "Agosta the Winged Man and Rasha the Black Dove," in *Museum: Poems* (Pittsburgh: Carnegie Mellon, 1983), 42. Hereafter cited in the text.

30. For a photo reproduction of this painting see Cone, "Schad's Cabaret," cited above.

31. Agosta's nose is much longer than Rasha's; his lips are thin whereas hers are full; the paleness of his skin is further accentuated by the black suit jacket that he wears "thrown off like a cloak."

32. In the interview with Johnsen and Peabody cited above, when the interviewers comment on this "uncanny" resemblance, Dove responds disarmingly that she had not noticed it at first: "You know how it is: you never notice that someone looks like yourself." But she recalls that when her one-year-old daughter looked at the cover of *Museum* for the first time she said, "Mama," and since "she didn't do that with every black woman she saw . . . I had to acknowledge the resemblance" (Dove, *Conversations with Rita Dove*, 28).

33. Baldwin, *Notes of a Native Son*, 125, 129.

34. Dove, "Lady Freedom among Us," in *On the Bus with Rosa Parks* (New York: W. W. Norton, 1999), 69. Dove read the poem at a ceremony commemorating the 200th anniversary of the United States Capitol and the restoration of the Statue of Freedom to the Capitol dome on October 23, 1993. The statue has "E pluribus unum" inscribed on its pedestal.

35. Cf. Vivien Green Fryd, *Art and Empire: The Politics of Ethnicity in the United States Capitol, 1815–1860* (New Haven, CT: Yale University Press, 1992), chap. 8: "Liberty, Justice and Slavery."

36. *Revenant* is the overarching subtitle of the section in which this poem was published in *On the Bus with Rosa Parks* (New York: W. W. Norton, 1999).

"To oppose myself to the declared desires of others": Louise Glück's Ekphrastic Poetry

Nick Halpern

In her essay "The Education of the Poet," Louise Glück writes of her childhood, "Then, as now, my thought tended to define itself in opposition; what remains characteristic now was in those days the single characteristic: I couldn't say what I was, what I wanted, in any day to day, practical way. What I could say was *no:* the way I saw to separate myself, to establish a self with clear boundaries, was to oppose myself to the declared desires of others."[1] Glück, who studied painting and considered becoming a painter, remembers this oppositional impulse when she writes poems about pictures: her poems about paintings and photographs are often about reluctance and disgust. "I remember my childhood as a long wish to be elsewhere," she writes.[2] For some people paintings and photographs supply an elsewhere, but for Glück they seem generally to represent a more intensified "here," which must be resisted. Pictures are rival compositions, establishing boundaries and frames that are not the poet's own, enacting containments that are not the poem's, declaring desires that are not the poet's. Glück's relationship to looking is extraordinarily charged—and she is always willing, in her poems, to leave herself the option of simply *not looking*.

Many contemporary poets write poems of opposition, but how many write poems of opposition to the visual? Glück resists the pressure to love what other writers claim to love. Thus, nothing could be less Glückian, say, than the passage from *Within a Budding Grove* in which Marcel, who is being taken for a drive in the carriage of his grandmother's most aristocratic friend, experiences what he calls an "incomplete happiness" upon seeing three trees. Proust writes: "I looked at the three trees; I could see them plainly, but my mind felt that they were concealing something which it could not grasp, as when an object is placed out of our reach, so that our fingers, stretched out at arm's-length, can only touch for a moment its outer surface, without managing to take hold of anything. Then we rest for

213

a little while before thrusting out our arms with renewed momentum, and trying to reach an inch or two further."[3]

The trees are reaching out toward Marcel, as well: again and again he repeats that "meanwhile the trees were coming toward me," building and building toward the moment when "at a crossroads the carriage left them." At this point it occurs to Marcel that the carriage "was bearing me away from what alone I believed to be true, what would have made me truly happy": "I watched the trees gradually recede, waving their despairing arms, seeming to say to me: 'What you fail to learn from us today, you will never know. If you allow us to drop back into the hollow of this road from which we sought to raise ourselves up to you, a whole part of yourself which we were bringing to you will vanish for ever into thin air.'"[4]

Glück, especially the early Glück, will take the thin air, rather than the part of herself the trees want to offer. That part is, her poems suggest, redundant or unnecessary, there's no place in the self to put it, no poem to accommodate it. Or she would prefer not to represent that part of herself that way. Or it is not, in fact, a part of herself. In any case she doesn't want to be *brought* visual images, to be solicited by them. And she absolutely does not want parts of herself delivered without warning. Never was a poet less interested in involuntary memory—or any involuntary mental operation.

What about looking at pictures in photo albums or paintings in museums? That activity seems to be, for Glück as a poet, even more problematic than seeing a landscape from a coach or car. There is always another mind, not hers, behind a picture or painting, and it wants a response from her, an answer of some kind. This would not be such a hardship if pictures did not also have a way of behaving as if they were *unanswerable.* For a poet with Glück's particular sensibility, described so vividly in "The Education of the Poet" and dramatized in her poems, this can seem intolerable. All pictures are answerable.

The form of response she most often chooses is correction. If a snapshot or painting (say, of the poet and her sister) supplies incontrovertible evidence of relations the poet wants to deny or disavow, that snapshot or painting can also be made, in her poem, to supply evidence of the unsatisfactory nature of those relations. On another level, the poem must declare the snapshot unsatisfactory because it is someone else's record, someone else's perception— "lurid, rapid, garish, grouped," as Robert Lowell put it in "Epilogue." Glück's own poem will be stately instead of lurid, measured instead of rapid, unadorned instead of garish, and composed rather than grouped: the snapshot has been corrected. Lowell writes, "We are poor passing facts, / warned by that to give / each figure in the

photograph / his living name."[5] He characteristically imagines him-
self as the first on the scene, the first to see the photographs. But for
Glück, someone else (if no one else, the photographer) has always
gotten to the pictures first and is waxing poetic about the facts,
sentimentalizing them. "About suffering they were never wrong, the
old masters," is the first line of one of the most famous ekphrastic
poems of the twentieth century: Glück would need, I think, to feel
that they were wrong, in order to start her poem.

There is always another option for the poet, but it's one that Glück
is reluctant to take. Another poet might choose to take *in* the alien
perspective rather than take it on. But Glück is, in her early poetry, a
hunger artist when it comes to other people's perspectives. She's not
hungry for perspectives; she's fasting because they disgust her. Kaf-
ka's artist says, "I couldn't find the food I liked. If I had found it,
believe me, I should have made no fuss and stuffed myself like you or
anyone else."[6] Why stuff yourself with other people's perspectives?
Glück's poetry reminds us that we don't need to. Put baldly: she
doesn't want perspectives. Images from elsewhere are not what she's
seeking. All images are from elsewhere, of course, if the "here" is the
poet's mind while she is writing.

The question, then, is: where should she go to get images (when
she requires them) and what kind of images should she get? Early on
she is drawn to scenes in which images can be controlled before they
even appear: she writes some early poems set partly in darkrooms.
These are poems, often, in which she herself has taken the pictures.
But then she starts more and more to introduce images that are
mythic, archetypal: whatever you *don't* see when you look around.
They're visual without being visible: images, yes, but deep images.
The mythic is appealing to her also because of its intensity. Keats, in a
letter to his brother, writes that "the excellence of every Art is its
intensity capable of making all disagreeables evaporate, from their
being in close relationship with Beauty and Truth." In disparagement
of a painting by Benjamin West, Keats writes that "in this picture we
have unpleasantness without any momentous depth of speculation
excited, in which to bury its repulsiveness."[7] Momentous depth of
speculation and a place where one might bury repulsiveness: the
mythic offers both.

Mythic or not, she doesn't completely trust her images. Words, at a
certain level of vividness and vivacity, to use Elaine Scarry's words in
Dreaming by the Book, are supposed to turn into pictures in our minds.[8]
But in a Glück poem, at a certain level of intensity, the opposite
happens: images turn back into language, or reveal, rather, that lan-
guage is all they ever were. For Glück, pictures can most be trusted

when they are "like language"—that is, when they can be read like language. In "Epilogue," Lowell seems to be telling us that images need captions: he wants to give each figure in the photograph its living name. In a perfect world, maybe, there would only be captions. W. G. Sebald's novels have uncaptioned photographs in them— again, nothing could be less Glückian. Pictures are most trustworthy when they come to her one by one and open to her like—open to her as—language, accepting her authority over them.

One by one: it's the *ubiquity* of the visual that causes so much difficulty. How can one have any authority when there are so *many* sources of authority in the world? "Reality is abob with centers," A. R. Ammons (with his inexplicable cheerfulness) affirms.[9] Reality, Glück agrees less cheerfully, is really countless people recording perceptions nonstop: everywhere you look there's the record of someone's perception. The natural world is liable to present itself to you abruptly as a composition (Proust's trees at the edge of a driveway), which you did not make but can only helplessly look at. Sometimes it's a landscape someone did compose, or seems to have composed. Ansel Adams used to have his wife drive him around Colorado and Utah—telling her, *wake me up if you see an Ansel Adams.* It's hard to look at nature sometimes without feeling that you are looking at a picture someone has signed, or signed for. To rephrase a famous line in Glück's poem "Mock Orange," "how can I rest when there are so many pictures in the world?"[10] She has her work cut out for her, in a sense, but, as her poems more and more suggest, she doesn't want that to *be* her work. A poet must have more to do than correct; her calling has to be a more exalted one. Mythic images have a kind of majesty about them, which is one reason she'll turn to them, and why they'll seem to suffice for so long. But they too need to be corrected. Someone has—we have—seen them before she has. As such, they belong to the visible world.

For Glück in her early poems there is something cheap, garish, lurid about the visible, about its sheer *visibility.* Anyone can see the visible world; it shows itself to everyone. In the early poem "Summer" she writes, "First the sun, then the moon, in fragments, / shone though the willow," and then adds: "Things anyone could see" (*First Four Books of Poems,* 186). For Ruskin "the greatest thing a human soul ever does in this world is to see something, and tell what it saw in a plain way." Ruskin isn't right, though. Seeing *isn't* hard-won; people are always telling us what they saw. People, in fact, are always telling you what *you* saw, finishing your sentences for you: as she tells us in "Education of the Poet," that was Glück's great complaint about her

family, growing up.[11] The poet is tired of being told, in a plain way, what she saw.

But the family album keeps telling. In her poem "Still Life," she writes about an old family snapshot where everyone is squinting because they're looking into the sun: "Not one of us does not avert his eyes" (*First Four Books of Poems*, 73). If she averted her eyes then, she does not now: it's clear that she wants to be the one who says what she saw. And she doesn't gaze or glance, she reads, translating the pictorial into language, her language. "We look at the world *once*, in childhood," she writes.[12] To look *now* would be too much—too frightening, maybe. Reading may be the best defense. It's not an easy project, reading pictures, correcting them. A picture, unlike an argument, can't actually be refuted. For Umberto Eco, "the image possesses an irresistible force. It produces an effect of reality, even when it is false."[13] Pictures seem to tell the truth, but the truths they tell (when they're not actually lying) are like the truths of wild analysis, or the truths that analysands tell each other—dubious, weightless. The truths in Glück's poems have extraordinary gravity, in part because they often dramatize the act of replacing the reality-effect with actual reality. Glück seems, in her poems, to say that the greatest thing a human soul ever does in this world is not to see, but to correct, which means to repair the damage someone else has done by seeing. Correction, too, can have Eco's "irresistible force," or it can if the poem is working.

A reader of Glück's early poems might ask: are there pictures in the world that do not require correction? What sort of pictures would the poet find in a perfect world, so that she might be tempted to write straightforward, appreciative ekphrastic poems? In "Portrait," Glück describes a child drawing the outline of a body. She "cannot fill in what she knows is there" (*First Four Books of Poems*, 122). The child cannot fill it in, or she won't fill it in, or she won't *yet* fill it in. White space has its attractions. In her essay on the poet George Oppen, Glück tells us, "I love white space . . . George Oppen is a *master* of white space."[14] Perhaps, then, the perfect picture would be a white space: such a picture wouldn't need to be read or corrected. In white space, desire would not be declared . . . unless it was a desire for white. One might be tempted to declare oneself in opposition to such a desire. Maybe the perfect picture would simply be blank.

Pictures like that are hard to find. What the poet finds, in general, are pictures she has to resist. And what she needs to develop are strategies of resistance. One way to resist is to refuse to look up. What keeps the poet from looking up, she writes, is stubbornness. In an

early poem, "Brooding Likeness," she writes of "purposeful blind-
ness" and calls herself "the stubborn one, the one who doesn't look
up" (*First Four Books of Poems*, 159). Glück is not the only poet who has
practiced this strategy. Other poets have different motives, though.
Gerard Manley Hopkins, for example, practiced "the discipline of
the eyes"—keeping his eyes cast down, looking at neither persons
nor objects around him. But he had his own reasons. Robert Bernard
Martin writes that the discipline of the eyes

> was probably a greater penance for Hopkins than fasting or fustigation,
> since it meant that he had to curb his natural tendency to look hard at
> everything he came across, so that neither his walks nor his perambula-
> tions had their usual delight for him. During that period his journal
> suffered, and there is almost nothing visual in his notes, although he paid
> careful attention to the call of the cuckoo, changing daily, and he listened
> with delight to the Lancashire and Yorkshire speech of two elderly lay
> brothers, Br Coupe and Br Wells. The latter "called a grindstone a 'grind-
> lestone' and called white bryony 'Dead Creepers,' because it kills what it
> entwines." Br Coupe "calls a basket a *whisket. —*One day when we were
> gathering stones and potsherds from the meadow Br Wells said we were
> not to do it at random but 'in braids.'" Nonetheless, because of his
> custody of the eyes, he was prevented from "seeing much that half-
> year."[15]

If he could not himself watch, the poet could listen to what other
people said about their own experience of the visible world. Hopkins
practiced the discipline of the eyes because looking for him was a
source of intense, almost delirious, pleasure—and therefore possibly
a sin. But he knew, or sometimes knew, that if he looked up, the world
would reciprocate his love. Glück isn't sure. She calls herself stub-
born, but her stubbornness begins to seem to her, as book follows
book, like anablephobia, which is the fear of looking up (according
to a Web site called Change That's Right Now). In "Self-Portrait in a
Convex Mirror," John Ashbery writes, "The soul establishes itself. /
But how far can it swim out through the eyes / And still return safely
to its nest?"[16] Nothing could be more like Glück than those lines,
though she would probably end the poem with them, and Ashbery
goes on.

Glück is afraid to see the world until "the soul establishes itself" in
the world, until she is, as a poet, completely protected *from* it or, to
put the idea another way, until she is completely protected *in* it. But
the stubborn one, she writes, the one who doesn't look up, "still
senses the rejected world." In that sense, the visual world is just as
stubborn as the poet: it doesn't go away—or rather, it goes away and

comes back. "When I shut my eyes, it vanishes. / When I open my eyes, it reappears" ("Brooding Likeness," in *First Four Books of Poems*, 159).

Meanwhile *seeing*, having to see, is hell. It is hell when people tell you, as they do in Glück's early poem, "Day Without Night," that you have to look up: "And a cry arose, / almost as though a person / were in hell / where there is nothing to do / but see" (*First Four Books*, 198). Some of the power of Glück's poetry comes from the gravity with which she evokes her own stubbornness, refusal, fear. Other voices in the culture talk about fear in a different tone. The people at Change That's Right Now tell us that we can be cured of anable-phobia by a process that "usually requires no more than ten hours. In exceptional cases . . . a favorable result in two or three." In case we may have a particularly stubborn case of anablephobia, the Web site reassures us that "because we guarantee the outcome, we will work with you for as long as it takes—five minutes, five hours, five weeks." They do this work by telephone, and "you'll need to play your part, of course . . . there will be some easy and enjoyable homework for you to do, and that will be a key part of your success."[17] The voice of the Web site is a countervoice to the voice of Glück's poetry. Why does she sound so cheerless, so severe? Perhaps because the default voice for so many of us—including poets—is the voice of the people at Change That's Right Now.

But Glück is, in her own way, resourceful—resourceful, that is, in finding alternatives to looking. She can look down, or she can write about mythological images that are not visible, or, like Hopkins prac-ticing the discipline of the eyes, she can listen to the voices of people who allow themselves to see. Or she can do what she says in her poems that her father did: simply shut her eyes. In a poem from *Ararat* called "New World," she writes of her parents, "In couples like this . . . it's always the active one / who . . . gives in. / You can't go to museums / with someone who won't open his eyes." More and more it is with her father's refusal to open his eyes at museums that she connects her refusal to see—her father, whom she identifies in her essays as a failed writer.[18] In "Snow" Glück writes about how he liked to carry her on his shoulders, "so he couldn't see me." For her part she remembers, from that vantage point, "staring straight ahead / into the world my father saw"; she was "learning / to absorb its emptiness" (*Ararat*, 58). In a poem from his last book, *Day by Day*, Lowell writes of the visual world: "it's a crime / to get too little from too much."[19] If that's a crime, what should we call it if someone gets nothing, or next to nothing, from too much? In "Vespers: Parousia," one of the poems in *The Wild Iris*, Glück writes, "How lush the world

is, / how full of things that don't belong to me."[20] There is a sense of suspense in such poems. When he renounced poetry, Hopkins wrote, "On this day by God's grace I resolved to give up all beauty until I had His leave for it."[21] For Glück, the leave or permission she wants is her own: nothing can be seen until the poet has conclusively, unanswerably spoken, has established her voice in the world. In her essay "On Stanley Kunitz," Glück asks, "At what point is the self, the voice, so wholly realized as to make its very project sacred?"[22] Another way to ask that question might be: at what point can the self trust its voice enough to take on projects that are not sacred, that are self-authorized? When will the poet decide that it's safe to look at the world with pleasure?

This is also a question the poet's friends might ask, because if this is the way you see the world, your friends will notice. They may not say anything, but you might dream that they do. In "Celestial Music," one of the poems in *Ararat*, Glück writes of a dream in which a friend reproaches her, telling her that "when you love the world you hear celestial music." Her friend tells her to "look up"—but when she does she sees "nothing / Only clouds, snow, a white business in the trees" (66). At this moment Glück is like William Carlos Williams's grandmother in "The Last Words of My English Grandmother," whose indifference is conspicuously framed by her grandson's concentrated act of looking. The moment when the grandmother's last words are spoken is oddly reminiscent of Proust's account of a moment of "incomplete happiness," cited above. The grandmother sees a row of elms out of the ambulance window:

> What are all those
> fuzzy-looking things out there?
> Trees? Well, I'm tired
> of them and rolled her head away.[23]

In this case the passenger in question is saying, let it all fall back into nothingness. She tells her poet-grandson that he doesn't know anything. What the poem implies, of course, is that he does know how to look and he's good at it, and he is not tired of it. Glück often sounds as testy as Williams's grandmother, but she isn't tired of the visible world, either. She does get tired of the demands it makes, which seem to be the same demands that people make—even poets, like Williams: *Tell what you saw in a plain way.* It seems as if figurative language were permitted only to those writers who are willing at the same time to humble themselves before the object, the image, the

picture—someone else's declared desire. Rilke can say the most fanciful things about the archaic torso of Apollo, because he's in *thrall* to it.

On this occasion, the still-dreaming poet rouses herself to meet her friend's demand without countenancing its implicit thralldom ("Not a stupid person, yet with all she knows, she . . . thinks someone listens in heaven"), and without allowing an act of looking to become Williams's sort of project, either: looking up, *she* sees "a white business in the trees" that she can liken to "brides leaping to a great height." But John, her husband, objects to this strategy, as the poem "Song," from *The Wild Iris*, dramatizes. He tells her that if it were an actual garden instead of a poem, the rose wouldn't have to be made to resemble anything but itself (*Wild Iris*, 27). What her husband doesn't understand is that if you are a person who reads the visual world rather than looks at it, you will feel thwarted and unhappy when you see a landscape in which there seems to be nothing, or not much, to read. "I cannot go on / restricting myself to images," the speaker says in "Clear Morning," another poem in *The Wild Iris*, moving immediately to the psychological. "I am prepared now to force / clarity upon you": it is as if, having spent so much energy on psychological or spiritual clarity, the poet simply doesn't have energy left for other less intense, less interesting kinds (*Wild Iris*, 8).

Glück's friends, who believe that so much depends on not seeing hills like brides leaping, tell her: *You're always trying to make it seem as though you look intensely to hide the fact you aren't looking at all.* Again, it's as if Glück had failed in some way. Either she is not visual enough or she is somehow *too* visual—or worse, more interested in language than image. Henry James called a book by Robert Louis Stevenson insufficiently visual; he complained about "the baffled lust of the eye": "The one thing I miss in the book is the note of *visibility*—it subjects my visual sense, my *seeing* imagination, to an almost painful underfeeding."[24] But a reader might imagine Glück asking, why *not* baffle that sort of lust, why *not* declare yourself in opposition to the weird lust in Ruskin and Proust and James to see things just as they are. And anyway, how plain are *their* styles? Her style is plainer, more austere, than theirs.

But friends and family don't give up. In "Rainy Morning," a poem in *Meadowlands*, the husband says to his wife: "You don't love the world." If she did, she would have images in her poems (16). In "Void," another poem from the same book, a friend suggests an antidepressant, "one of those chemicals": "Maybe you'd write more / maybe you have some kind of void syndrome" (49). In "Parable of the

Gift" when Glück's friend tells her, "Here is the world, that should be / enough to make you happy" (59), a reader might imagine Glück saying in reply, like Melville's Bartleby, *"I know where I am."*

Friends and family may be energized by a hidden ethical agenda, as much as by a therapeutic one. An ethics of just looking—what could be more appealing? It's a kind of piety for atheists—humility before the object, with Elizabeth Bishop as the patron saint. In a letter that has become well known for its description of happiness as absorption, she writes about her own patron saint, Darwin:

> "[R]eading Darwin, one admires the beautiful solid case being built up out of his endless heroic *observations,* almost unconscious or automatic— and then comes a sudden relaxation, a forgetful phrase, and one *feels* the strangeness of his undertaking, sees the lonely young man, his eyes fixed on facts and minute details, sinking or sliding giddily off into the unknown. What one seems to want in art, in experiencing it, is the same thing that is necessary for its creation, a self-forgetful, perfectly useless concentration.[25]

A similar sort of happiness is to be found in Hopkins, after he gave up the discipline of the eye and started looking again. Martin tells us that

> Hopkins could hardly help attracting some attention when he hung over a frozen pond to observe the pattern of trapped bubbles or, instead of drinking the chocolate provided as mild refreshment from the austerities of the Lenten diet, put his face down to the cup to study "the grey and grained look" of the film on its surface. Some thirty years after his death one old lay brother remembered how Hopkins would sprint out on a garden path to study the glitter of crushed quartz before the water could evaporate. "Ay, a strange young man," said the brother, "crouching down at that gate to stare at some wet sand. A fair natural 'e seemed to us, that Mr. Opkins."[26]

Innocent and pleasurable absorption, "useless concentration," is tremendously appealing in Bishop and Hopkins, but some devotees do find a use for it, and cannot resist hectoring the uninitiated about the mental health achievable by such means. Just look, they tell us. At anything, everything. But Glück won't let herself record what an eye just happens to see. In some poems she will see not like Bishop, but like Bishop's sandpiper, anxious, unhappy, sprinting and looking. "My fierce seeing of only one thing at a time," she calls it in a poem from *Vita Nova.*[27] But that isn't seeing, according to the friends and family she quotes in her poems. It isn't what they mean. Maybe it's vision, but more likely it's micromanagement.

The poet keeps trying. And she does (in the poems in *Meadowlands* and *Vita Nova*) start to see and enjoy more of the visible world. Once one enters the world of looking, the pleasures are seductively circular. In his essay "Chardin: The Essence of Things" Proust writes, "If, when looking at Chardin, you can say to yourself, 'This is intimate, this is comfortable, this is as living as a kitchen,' then, when you are walking around a kitchen, you will say to yourself, 'This is special, this is great, this is as beautiful as a Chardin.' "[28] Glück is afraid of being deceived, and of letting deceptions pass uncorrected; but in *Vita Nova* she recognizes this fear, and acknowledges that she has been living with it (and writing about it) for a long time. It seems, maybe, to be lifting: In "Descent to the Valley," a poem from *Vita Nova,* she writes, "So that for the first time I find myself / able to look ahead, able to look at the world / even to move toward it" (19).

A reader might imagine that Glück from then on wrote poems of relief and gratitude, seeing the world that anyone can see and being content with it, perhaps even acquiring a measure of receptivity toward other people's descriptions and pictures. Has that happened? Many of her most recent poems have seemed instead to return to the stubbornness, the distrust. She turns to childhood, realizing that the "whole part of yourself" Proust talked about means you when you were a child. Innocent seeing for an adult may be possible if one *remembers* looking. In "The Sensual World," a poem in *The Seven Ages,* she writes, "I stood in my grandmother's kitchen, / holding out my glass. . . . Solace, then deep immersion." She tells of a "mysterious safety."[29] But that's the past, that's childhood. Proust, for all his talk of kitchens and paintings, knew that happiness only really comes with your grandmother in the kitchen when you are young, and not again. There is no safety in the present. The world "will not respond" and "it will not minister" (*Seven Ages,* 7). It will not reciprocate your love. The people who claim that they look without reading, without correcting, are lying. Glück remains reluctant to trust the visible world. This reluctance—with so many contemporary poets cheerfully writing ekphrastic poems—may be what is most original and compelling about Glück's poetry. There are so many reasons, after all, to be wary. We need a poet who reminds us of that, and who will go on telling us what those reasons are.

NOTES

1. Louise Glück, *Proofs and Theories: Essays on Poetry* (Hopewell, NJ: Ecco Press, 1994), 10.
2. Ibid.

3. Marcel Proust, *Within a Budding Grove*, trans. C. K. Scott Moncrieff and Terence Kilmartin with D. J. Enright (New York: Modern Library, 1999), 405.

4. Ibid., 407.

5. Robert Lowell, "Epilogue," in *Collected Poems/Robert Lowell*, ed. Frank Bidart and David Gewanter (New York: Farrar, Straus and Giroux, 2003), 838.

6. Franz Kafka, "A Hunger Artist," trans. Edwin Muir and Willa Muir, in *The Complete Stories*, ed. Nahum Glatzer and Arthur Samuelson (New York: Schocken Books, 1995), 277.

7. *The Letters of John Keats*, ed. Hyder Edward Rollins (Cambridge, MA: Harvard University Press, 1958), 1:192.

8. Elaine Scarry, *Dreaming by the Book* (New York: Farrar, Straus and Giroux, 1999).

9. A. R. Ammons, "Essay on Poetics," in *Selected Longer Poems* (New York: Norton, 1980), 33.

10. Glück, "Mock Orange," in *The First Four Books of Poems* (Hopewell, NJ: Ecco Press, 1995), 155. This edition of *First Four Books* is hereafter cited in the text.

11. Glück, *Proofs and Theories*, 5.

12. Louise Glück, "Nostos," in *Meadowlands* (New York: Ecco Press, 1997), 43. This edition of *Meadowlands* is hereafter cited in the text.

13. Umberto Eco, quoted in "Ekphrasis, Iconotexts and Intermediality—the State(s) of the Art(s)," in *Icons—Texts—Iconotexts: Essays on Ekphrasis and Intermediality*, ed. Peter Wagner (New York: Walter de Gruyter, 1996), 30.

14. Glück, *Proofs and Theories*, 30.

15. Robert Bernard Martin, *Gerard Manley Hopkins* (New York: G. P. Putnam's Sons, 1991), 196–97.

16. John Ashbery, "Self-Portrait in a Convex Mirror," in *Self-Portrait in a Convex Mirror* (New York: Penguin, 1975), 69.

17. www.changethatsrightnow.com/problem_detail.asp?SDID=993:1362.

18. Glück, "New World," in *Ararat* (New York: Ecco Press, 1992), 38. This edition of *Ararat* is hereafter cited in the text.

19. Robert Lowell, "Milgate," in *Collected Poems/Robert Lowell*, ed. Frank Bidart and David Gewanter (New York: Farrar, Straus and Giroux, 2003), 773.

20. Glück, "Vespers: Parousia," in *The Wild Iris* (New York: Ecco Press, 1994), 53. This edition of *Wild Iris* is hereafter cited in the text.

21. Hopkins, cited in Martin, *Gerard Manley Hopkins*, 165.

22. Glück, *Proofs and Theories*, 108.

23. William Carlos Williams, "The Last Words of My English Grandmother," in *Selected Poems* (New York: New Directions, 1985), 140.

24. Henry James, from a letter to Robert Louis Stevenson dated October 21, 1893 (the novel referred to is Stevenson's *Catriona*), in *Letters/Henry James*, ed. Leon Edel (Cambridge, MA: Harvard University Press, 1980), 3:438.

25. Elizabeth Bishop, quoted by David Kalstone in *Becoming a Poet: Elizabeth Bishop with Marianne Moore and Robert Lowell* (New York: Farrar, Straus and Giroux, 1989), 16.

26. Martin, *Gerard Manley Hopkins*, 202.

27. Glück, "Unwritten Law," in *Vita Nova* (New York: Ecco Press, 2001), 7. This edition of *Vita Nova* is hereafter cited in the text.

28. Marcel Proust, "Chardin: The Essence of Things," in *Writers on Artists*, ed. Daniel Halpern (San Francisco: North Point Press, 1988), 102.

29. Glück, "The Sensual World," in *The Seven Ages* (New York: Ecco Press, 2002), 6. This edition of *The Seven Ages* is hereafter cited in the text.

V

Convex Mirrors

C. D. Wright, Lucie Brock-Broido, and Terri Witek have all undertaken to rethink the goals and process of portraiture, a genre of painting that gives women poets much to think about. In the first of the essays in this part Stephen Burt discusses C. D. Wright's collaborations with the photographer Deborah Luster, giving particular attention to Wright's ekphrasis of Luster's photographs of the inmates of a women's prison. Burt finds Wright and Luster working in an American tradition of documentary realism to put "photographic language at the service of literary and ethical goals." Wynn Thomas finds Lucie Brock-Broido using "notional" ekphrasis to create "post-Raphaelite" self-portraits, which she uses to look askance at a painterly tradition she implicitly convicts of having given us very few images that "answer to women's felt reality." Terri Witek's essay is written from the perspective of a poet turned painter's model; Witek sat for a series of "off-center portraits" by the artist Gary Bolding. Witek's essay is itself an "off-center" ekphrasis, focusing on a process that is ordinarily occluded by the finished work, from a vantage point that lies within—or perhaps, more precisely, *behind*—the painter's canvas.

Lightsource, Aperture, Face:
C. D. Wright and Photography

Stephen Burt

C. D. WRIGHT'S POEMS COMPARE THEMSELVES TO MANY THINGS, AND to many works of art: they take forms from high school yearbooks ("Autographs"), procedures from silent films ("Treatment"), or titles from famous jazz albums ("More Blues and the Abstract Truth").[1] Most often and most insistently, however, her poems invoke and liken themselves to photographs, and to the work photographers do. Many poems reflect collaboration with a particular photographer, Deborah Luster, whom Wright first met in the 1970s at the University of Arkansas in Fayetteville. "We fall in and out of step with each other's projects without much inducement," Wright says of Luster. "We spring from the same hills and hardwoods."[2] All three of Wright's book-length poems—*Just Whistle: A Valentine* (1993), *Deepstep Come Shining* (1998), and *One Big Self* (2004)—grew out of her work with Luster, whose photographs appear in the first and third, and on the cover of the second.

Photography and photographers have become part of Wright's figurative strategy. Though some of Wright's work fits familiar poetic genres (love lyric, ode), much of it matches, instead, kinds of photography. *Just Whistle* organized itself around nudes; *Deepstep*, around landscapes and documentary work; *One Big Self* around the portrait. All these books—*One Big Self* most of all—place their photographic language at the service of literary and ethical goals. For Roland Barthes, "Every photograph is a certificate of presence," of the presence of a person; Barthes found in the photograph "the absolute Particular," "the *This* . . . the Occasion, the Encounter, the Real," though he also saw in each photo a memento mori.[3] Wright describes apertures, lenses, frames, light levels, and sight lines; lists facts; and presents poetic lines as if they were photographic captions, in order to evoke the presence of the real persons whom she wants her work to acknowledge. To see how Wright uses photography is not just to see her poetic goals; it is also to see how her style—at once "experimental"

227

and earnest, disjunctive in its assemblages and realist in its attitudes—realizes those goals, what she, and nobody else, has done with
poems.

Almost all Wright's prose about photography also describes her
hopes for her own writings; her descriptions of her own work sometimes liken it to what photographers do. "The goal is to see better not
just to do it better," Wright told Bob Holman in a recent interview.
"My eye is what I work off. . . . Working with a photographer, spending time looking has changed my orientation. I look for the line of
the eye."[4] Wright's prose collection *Cooling Time* praises Luster, who
"can . . . render the map in the back roads of a face nailbright";
Cooling Time also lauds Sally Mann, who "sees the cleavage in the
ground; she sees the writing in the trees; she sees the light in the
blackwater, the trunk leaking, the columns disappearing" (25).
Wright construes both photographers' work as seeing, and as discovering metaphors (or metalepses): script in foliage, streaming water in tree bark, or a map in the roads of a face.

Other poems both name and emulate photographers' techniques.
The prose lyric "Dearly Belated" instructs a young poet: "Take a wide-
angled pan of the fields. Not [*sic*] lift your arm to shield the light. . . .
Then zoom" (*Cooling Time,* 104–5). *Deepstep* includes—more than
once—the etymology of "photograph," Greek for "light writing": "A
photograph is a writing of the light. *Photo Graphein*"; "*Photo graphein* of
an old plaid couch in a field."[5] Wright too, the repetition suggests, is making a special and luminous kind of writing, one distinguished from other kinds of text inasmuch as it resembles (and
raises the same aesthetic problems as) photographs. "What No One
Could Have Told Them" catalogs or captions images from the life of
Wright's son ("How the bowl of Quick Quaker Oats fits his head");
two follow-up poems, "Detail from What No One Could Have Told
Them" and "Additional Detail," focus on single images from "What
No One . . . ," much as photographic enlargements would.[6] Even
scenes in Wright's poems which make no use of technical terms or
approaches from photography often emphasize such photographic
matters as angles of view, light sources (one or many?), light-dark
contrasts (sharp or diffuse?), shadow and hue. Consider the couple
depicted in "Humidity": "They are at a point in space," she writes,
"where animate dark meets inanimate darkness," and only "Flares
from refineries ignite their faces. / There are no houses no trees. . . .
/ Pods of satellite dishes" (as if seen through the windshield) "focus
on an unstable sky" (*Steal Away,* 75).

Wright's poems often deploy photographic language in order to
show by analogy what she wants her poems to do. *Tremble* (1996),

Wright's most self-consciously lyrical book, begins with a poem whose title, "Floating Trees," might describe several of Sally Mann's photographs, though in fact Wright took it from another photographer's exhibition. Though the poem's title suggests landscape, its opening lines instead show a domestic interior: "a bed is left open to a mirror / a mirror gazes long and hard at a bed // light fingers the house with its own acoustics" (*Steal Away,* 148). Another poem from *Tremble* bears the title "The Iris Admits the Light the Iris Will Allow" (*Steal Away,* 177). Both poetry's work and the camera's work, for Wright, imitate and enhance the work of a human eye.

To make familiar in her poems the work of a camera is also to make odd the work of an eye. A passage from *Deepstep Come Shining,* for example, describes recovery from an eye operation (a treatment for glaucoma). Wright upends the cliché in which photographers make the camera their eye: instead, the postsurgical eye is a strikingly unfamiliar sort of camera, one whose registries of light and dark the patient must learn to connect to the world she has known:

> After the iridectomy
> the slow recognition of forms
>
> A shirt on the floor looked like
> the mouth of a well
>
> Spots on a horse
> horrible holes in its side
>
> The sun in the tree
> green hill of crystals
>
> (*Deepstep,* 51)

To see the world metaphorically—as this patient has—is like looking at photographs, and it is like being a photographer, too: it is, finally, like being the sort of poet Wright's stanzas tell us that she is. "The eye is a mere mechanical instrument," *Deepstep* complains, as if trying to prove itself untrue, or to prove that the eye, like the camera, works in all sorts of good and bad ways depending on how we learn to see, on how the machine is used. (The chemical compound silver nitrate, an essential component in photographic film, is—*Deepstep* points out—both "poisonous" and useful in medicine [73].)

Seeing in Wright's way, seeing what Wright's lens can show, seeing photographs as Wright can see them, is like making a vow, and like touching a person. "A Series of Actions" (whose title might describe a Muybridge portfolio) ends with a four-way analogy among an open-

ing door, a lens, an eye, and a hand, juxtapositions familiar from Herbert Bayer's much-reproduced surrealist photograph, which the closing lines evoke: "Light inside the space // The door opening as the palm / of an eye" (*Steal Away*, 166).[7] Wright sees hands in eyes, and intimacy in hands, again in "Rosesucker Retablo #1" (a poetic response to one of Luster's photographs): "As you enter the eye # in this palm / Chuparosa # bind me # to your secrecy" (*Steal Away*, 14). "Because Fulfillment Awaits" uses the technical terminology of photographs to laud the visible spirit of the human being, or beings, who stand behind the poems: "Even in touching retouching / steeped in words," she cautions, "one tends to forget one forgets / the face the human face," even as "One wants / to create a bright new past One creates it" (*Steal Away*, 154). Here we see a poet's worries about the revisions almost all poets undertake. To retouch a photograph is to alter the print, to make it something more or less than a record of appearances. Wright warns herself and her readers not to "forget" the human face a portrait, or a poem, may call to mind. At the same time she implies that the right "retouching"—like the right "touching," the right kind of physical contact—can so alter a person's consciousness as to change her sense of her own past.

 Both text and pictures in Wright and Luster's first collaboration, *Just Whistle*, take as their point of departure the photographic nude. "I wrote a long twisted erotic poem and [Luster] was trying out some toxic French technique . . . and we put that together," Wright recalls.[8] Luster treated her prints of women's bodies and body parts with a bleaching process called *mordancage*, whose "negative/positive reversal," Luster wrote, creates a "penetration zone," an "edge of line and relief." The results appear intimate and mysterious, blurred and altered: "Along these edges the bodies are gnawed and wounded; parts of arms, legs, hair are eroded and fall away into the surrounding space. The bodies, due to chemical reaction and physical rubbing, lie in wracked relief." Wright's chiasmus rearranges Luster's words: "THEY SLEEP // with tenderness, wracked . . . wracked / with tenderness."[9]

 Photographs "of nude bodies within a private space," the art historian Graham Clarke writes, have frequently relied on "female stereotypes in relation to male fantasy and expectation," making women's bodies "a sealed world open to the power of the male gaze."[10] The bodies in *Just Whistle*, however, become not transparently knowable objects for a male gaze, but unstable experiences seeking ways to understand themselves. Wright begins with "The body alive, not dead but dormant" (*Just Whistle*, 7); two pages later, "The pantied one said nothing, not even its own newly enlivened name, its own naked name,

the memory fulgurant, sheet lightning of other bodies" (ibid., 9). The paired men and women (could some be women and women?) find themselves in familiar bedrooms (or bathrooms), which Wright makes strange by withholding names and details, much as Luster's treated nudes withhold the clear lines (and story lines) other nudes might convey: "The one watching the other one a long time before it got up, the one shoving a pillow under the plums of the other, the one not removing the panties even *in situ*" (ibid., 14).

Nor are Luster's the only sexually charged photographs to which Wright refers. Wright's poem "Book Titled *The Ballad of Sexual Dependency* Found in the Hydrangea in Front of Zorabedian's Stone" speculates about a "photograph ripped out" from the volume she found:

> Odds are a thousand-odd to one
> the absent photo was a crow shot
>
> O the ballad of sexual dependency
> is very old and intensely sad
>
> (*Just Whistle*, 19)

Nan Goldin's famous 1986 collection *The Ballad of Sexual Dependency* portrays her friends, acquaintances, and sexual partners from East Coast art, punk, and drag scenes; one critic avers that *Ballad* "has slipped into the photography world's collective consciousness as a classic book of the Eighties."[11] Wright's book is also a sort of ballad, a partly songlike, partly narrative poem, about sexual oddity and sexual dependency; a crow, or a crowlike spirit, flies in and out of her text, a source of darkness analogous to Luster's *mordancage*. Wright returns to Goldin at the close of her volume: "bent to pluck the book of photographs, this ballad is known by all, crow shot ripped out of the middle, it is very old and intensely sad, the panties excoriating in their own precious time" (*Just Whistle*, 45).

Wright and Luster are hardly alone in reclaiming the nude. Gill Saunders describes British painters and photographers (among them Helen Chadwick and Sue Arrowsmith) who "work . . . with the nude to show that display need not equal availability, that the experience of the female body is not invalidated by imperfection," "reinvesting the nude with a sense of women's experience of sex and the body."[12] Like those artists, Luster and Wright concentrate on bodily secretions, on reproductive organs, on disorienting perspectives, even on "the physical experience of childbirth": their "close-ups," too, imagine "the body as source of power and energy."[13] One prose-poem segment describes parturition: "the pull the pain: the reaming:

exhaustion: the rupture: contracting: ceaseless pulling" (*Just Whistle*, 39).

Against simpler, or more judgmental, ideas about the photographic nude, *Just Whistle* suggests that bodies, poems, and (the right sort of) erotic or nude photographs all emulate one another. Scopophilia, mystery, curiosity, and even discomfort are always already part of our sexual lives, and books, photographs, poems, and bodies may all provide an important opening to the right reader or viewer:

> The body would open its legs like a book
> letting the soft pencils of light
> fall on its pages, like doors
> into a hothouse, belladonna blooming there:
> it would open like a wine list, a mussel, wings . . .
>
> The whole world would not be lost.
>
> (*Just Whistle*, 32)

Such "openings" (almost always marked as female) recur throughout the book, as Wright likens the writer's eye, the vagina, the mouth (hence, the speaking voice), a baby's first cry, the origin of the universe, and the "aperture" of a camera: "aperture to the aleph, within which all, the overstocked pond, entrance to vast funnel of silence, howling os, an idea of beautiful form, original opening, whistling well, first vortex, an idea of form, a beautiful idea, a just idea of form, unplugged, reamed, scored, plundered, insubduable opening, lightsource, it opens. This changes everything" (*Just Whistle*, 31). The apostrophe, "the figure of voice, the sign of utterance" from which (in Jonathan Culler's account) lyric itself has grown, the "O" through which poems acknowledge human persons, prompts analogies at once to women's generative powers, and to the light-accepting "eye" of a camera.[14] That eye does not, however, see things objectively, but rather as "scored," as marked by the consciousness that takes, and perhaps alters, the picture. And the "O" of the lens, the vagina, the poetic apostrophe, and the origin of the universe also becomes the "O" a mouth makes in signaling a companion—hence Wright's title: *Just Whistle: A Valentine.*

Deepstep Come Shining (1998) relies on documentary almost as much as *Just Whistle* relies on the nude. *Deepstep* grew from an automobile journey through rural Georgia that Wright and Luster took in the mid-1990s; the book includes no photographs except on the cover. (The book shares its title with Luster's exhibit Come Shining.) Wright opens her poem by evoking the car, the road, and the photographer's way of seeing, with its attention to composition and light

levels: "Beyond the windshield the land claims saturate levels of green. Illuminating figures and objects. Astonishing our earthliness. I was there. I know" (*Deepstep*, 5). In evoking the photographer's look at the landscape, Wright also attacks American blindness to the fate of the poor, to disabled veterans, to other troubled groups: "The baby sister of the color photographer had a baby girl in the hills. Born with scooped-out sockets in the head. Born near the tracks they sprayed with Agent Orange. The railroad's denials, ditto the army's" (*Deepstep*, 7). Such iterated sentences or sentence fragments suggest captions for photographs: sister, girl, hills, sockets, tracks, institutional desk, and typewriter or pen.

Deepstep (like *Tremble*) not only sets scenes as if they were photographs, balancing objects with people, light with dark, but also (like *Tremble*) notices mirrors, gazes, and light levels. Consider this descriptive paragraph (framed, as a photograph might be, by a white page): "In the ceaselessly decomposing smoke of a pool hall. Seven green tables are racked under seven naked bulbs. The jukebox in the din calls the man a blankety-blankblank. If not the exact words the exact tenor. The plate glass casts glimpses of everything that has ever happened. The genesis of direction breaks and scatters" (*Deepstep*, 35). Other, similarly laid-out paragraphs also note luminance, outlines, and silhouettes: "Private-party love. By one sixty-watt bulb. And it be blue. The cool produces an halation. . . . Some modeling on the side of the face. When directly below the bulb" (*Deepstep*, 59).

To think of documentary photography, the American South, and American writing together is to invoke James Agee and Walker Evans's *Let Us Now Praise Famous Men* (1941), still the best-known such juxtaposition. "The photographs . . . and the text," Agee and Evans's much-quoted preface asserts, "are coequal, mutually independent, and fully collaborative."[15] *Deepstep* (10, 19) both names and quotes Agee ("the swerve of smalltown eyes"). So does *Cooling Time:* "What of what Agee named 'the sorrow, the effort and the ugliness of the beautiful world?'" (*Cooling Time*, 59). Agee thought photography superior to writing in that photographs, unlike writing, constituted experience, embodiment, evidence. "Words cannot embody; they can only describe," Agee declared. "But a certain kind of artist, whom we will distinguish from others as a poet rather than a prose writer, despises this fact about words or his medium, and continually brings words as near as he can to an illusion of embodiment."[16]

For Agee any writing that seeks to manifest persons, to respect and to reproduce their presences, approaches the condition of poetry. Yet poetry, inasmuch as it adopts those goals, must approach (or envy) the condition of nonverbal arts, and especially of photography.

"If I could do it," Agee mused, "I'd do no writing at all here. It would be photographs; the rest would be fragments of cloth, bits of cotton, lumps of earth, records of speech. . . . A piece of the body torn out by the roots might be more to the point."[17] We have seen in *Just Whistle* Wright's interest in embodiment: in *Deepstep* she articulates (and avers, like Agee, that she cannot quite satisfy) testimonial hopes much like Agee's own: "In the hopeless objective of receiving the marvels that come to one by sight, sound and touch, merely in order" (*Deepstep*, 21).

Blind people and damaged eyes, including the blinding in *Lear,* are motifs throughout *Deepstep:* "Once the eye is enucleated. Would you replace it with wood, ivory, bone, shell or a precious stone. . . . So Gloucester had to smell his way to Dover" (*Deepstep*, 10, 22). Geoff Dyer begins *The Ongoing Moment,* his eloquent book about art photography, by discussing pictures of blind people: "The blind subject," Dyer writes, "is the objective correlative of the photographer's longed-for invisibility."[18] Blind subjects, he argues, let art photographers from Paul Strand to Garry Winogrand ask how a camera, a mechanical thing that only seems to see, can do justice to suffering human persons, who may not (if they are blind, who cannot) see what we have made of them. For Wright these questions apply to literary art in general, even though a page is not (quite) a lens. Inasmuch as we overlook (for example) the Southern rural poor, we too have damaged or missing eyes, and the best replacements for damaged or missing eyes are not bones or stones but cameras, used in a particular way, and literary works that function like cameras: not to depict social problems in general but to illuminate particular persons, to make them present to us.

Deepstep seems to move from exteriors to interiors, from landscapes to portraits, from the documentary or journalistic power of a photograph (showing us what we would not otherwise see) to its memorial or anamnestic powers (preventing the living from forgetting the dead). "Remember me to all of them," says somebody in Wright's poem: "Bite everybody on the lips for me" (96). The people in *Deepstep* often want their portraits made, their presences recorded: "Patty lives here. She's one of the Jumping Foxes, the Double-Dutch Champs. Can you take her picture while we're here" (49). These poems-as-pictures tell us that they can look back at us even when their subjects cannot see: "Blur in. Blur out. Just a hypothetical blind woman brought out of completest dark. Looking at a face" (ibid., 81). Wright accepts "the commission to be a friend / to the lost people," adding, "I want to / magnify" (ibid., 101).

Here the photographic genre is not only documentary, but also

portraiture: the ethical imperatives behind certain kinds of portraiture give Wright her ethical charge. When Wright gives a mission, or "commission," for photography in general, often she seems to have faces and portraits in mind. Wright's catalog essay for Come Shining emphasizes Luster's portraits: "Most of the time she photographs lives unattributed, mixed in with artist friends and photo-willing kin; otherwise, the unattributed. . . photographed only for purposes of identification: driver's license, mug shot, open coffin. Some without a graduation or wedding picture to their credit. People get sidelined. Her photographs tell you this is an occasion, *their* occasion. And the occasion adds significance. Most subjects will rise."[19]

Come Shining (the exhibit) *Come Shining* (its associated booklet), and *Deepstep Come Shining* (the book of Wright's poetry) all derive their title from Bob Dylan's 1971 song "I Shall Be Released"; *Deepstep* quotes the song. "I see my light come shining / From the west unto the east," Dylan sings; "Any day now, any day now / I shall be released."[20] For Wright and Luster, the project of portrait photography, of turning light on chemically treated paper into representations of people and places, becomes a project of releasing people from bondage. It should be no surprise, then, that Wright's essay concentrates on Luster's portraits of prisoners. She regrets that prison rules prevent these subjects from experiencing the full dignity, and the literal weight, that their portraits ought to bear:

Nor will the prisoners likely see themselves on metal plates—but only on photographic paper, as is permitted them—and might therefore never fully grasp that these portraits are intended as keepsakes, that they be not 'buked and scorned and forgotten, but cherished and remembered. Living men and living women in natural light. We are still one; one of a kind. (*Come Shining*, 10)

One Big Self: Prisoners of Louisiana marks Wright's and Luster's most ambitious collaboration. The large volume collects Luster's photographs of prisoners in three Louisiana correctional institutions. With them (but on separate pages) come Wright's prose and verse inspired by the photographs, by the interviews that accompanied their taking, and by Wright and Luster's Louisiana travels. Luster's mother was murdered in 1988, and Luster testified at the killer's trial: that experience shadows these portrayals. Most of the volume, however, concerns the claim each prisoner has on our attention not as a convict but as a human being. The epigraph and title come from the film director Terence Malick: "[A]ll men got one big soul where everybody's a part of—all faces of the same man; one big self."[21] Both

Wright and Luster use the tools and terms special to photography in order to manifest such claims.

Photography and prisons share a history, one not altogether benign. The bibliography appended to *One Big Self* includes Michel Foucault's *Discipline and Punish* and Suren Lalvani's zealously Foucauldian study *Photography, Vision and the Production of Modern Bodies*. For Lalvani camera work as such contributes to "the disciplinary apparatus of capitalist production" that Foucault saw, in microcosm, in modern prisons. In nineteenth-century portraits, Lalvani suggests, "lurks the discursive regime of the dominant culture they inhabit; power emanates from a unified, determinate space—the privileged site in front of the camera." Prisons are like photographs, and photographers are like wardens: "[P]rison architecture is . . . first and foremost a luminous form, a place of visibility that distributes the visible and invisible."[22]

One Big Self acknowledges the classifying, disciplinary work done by much photographic depiction: "My mug shot totally turned me against being photographed," an inmate says. Yet for Wright as for Luster the photograph need not discipline, nor need it serve bourgeois privilege. In these photographs, prisoners can imagine what it would be like to control their own bodies, to choose what face they show the world. Luster depicts the prisoners, never the prison; portraits have no backdrops or settings, just costumes and props. Inmates wear carnival hats, step back from the camera, pose in pairs, hold boards or signs ("missing you"), scowl, smile, or flaunt tattoos. Some wear masks, turn their backs, or show arms and hands rather than heads. Pamela Winfield poses in her full-body Easter Bunny costume, worn for Children's Visiting Day. Johnny "Ray Boy" Madison had Luster photograph a model ship he built from matchsticks rather than photograph himself.

"I chose to photograph each person as they presented their very own selves before my camera," Luster writes; "I wanted this to be as collaborative an enterprise as possible." Wright describes watching prisoners prepare to be photographed, recording Luster's (at least partial) success: "The women pass around a handmirror and a tube of lipstick. . . . They pass a stuffed bunny from hand to hand / for their turn in front of the camera" (*One Big Self*, n.p.). When Luster sets up her equipment, Wright notes elsewhere, "the inmates . . . swarm the improvised studio as if she were bringing ice to Macondo" (*Come Shining*, 8). Wright sets these largely welcome portraits beside the other images of themselves to which prisoners commonly have access: "Your only mirror is one of stainless steel. The image it affords will not tell whether you are young still or even real." "The act of

photographing and returning prints to these incarcerated persons" became, Luster says, "as important to this project . . . as any formal exhibition or publication." Yet Luster also kept other viewers in mind: "I wanted the portraits to be as direct a telling as possible—to hold up a mirror for the viewer as well as for the subject," Luster writes (*One Big Self,* n.p.).

One Big Self, in other words, tries to assemble a sort of anti-panopticon, with many views of many people, but no center, and no way to see them all at once. Wright's verbal choices serve that end as much as Luster's visual ones do: both sets of choices rely in turn on other choices (visual and verbal, in speech and appearance), which appear as the prisoners' own. Even more than Wright's other books, *One Big Self* relies on the play of diction, on contrasts between registers of language, to provide its verbal music. These contrasts also keep at the forefront of the poem the questions about portrayer and portrayed, about subjects and subjection, which come up in documentary photography: can the poem speak for, rather than just about, its prisoners? How can it let the prisoners speak for themselves? Frequently curt or jarring, in lists or short fragments, Wright's juxtapositions amplify the loneliness and the energy the quotations evidence to begin with: "I miss the moon. / I miss silverware, with a knife. / and maybe even something to cut with it" (*One Big Self,* n.p.). This inmate seems so hungry for freedom that he or she feels ready to eat the night sky.

As much as she tries to find rhythms for such feelings, Wright also tugs at the limits of identification, asking how much readers who have never been incarcerated can really know or understand how an inmate feels: "If I were you: / Screw up today, and it's solitary, Sister woman, the padded dress with the food log to gnaw upon . . . I don't have a clue, do I" (ibid., n.p.). Wright finds the prisoners' Big Selves, their revealed characters (as against their marked and damaged bodies), sometimes hard to see:

> Difficult to look at the woman
> much less photograph and not ask
> about a scar that runs from one ear
> to the opposing breast
>
> whose babies died of smoke inhalation
>
> Or the gasoline-wrecked face
> of the green-eyed black man
>
> (*One Big Self,* n.p.)

Wright's dislocated grammar, and her jarring metonym ("breast / whose babies"), implies the difficulty a photographer might have in shifting from subject to subject, portrait to portrait, when each brings his or her own disturbing story.

One Big Self also uses all Wright learned from Agee. Her poem, like his prose, finds bitter irony and high lyricism in long catalogs or catenas. One list from *Let Us Now Praise Famous Men* gives the contents of a smokehouse: "four hoes; a set of sweeps; a broken plow-frame; pieces of an ice-cream freezer; a can of rusty nails; a number of mule shoes; the strap of a white slipper; a pair of greenly eaten, crumpled workshoes, the uppers broken away, the soles worn broadly through, still carrying the odor of feet; a blue coil of soft iron wire; a few yards of rusted barbed wire; a rotted mule collar; piece of wire at random."

Wright has used such authenticating lists in her shorter poems—for example, in the page-long middle stanza from "King's Daughters, Home for Unwed Mothers, 1948" (*String Light,* 4). *One Big Self* rises to new heights of listing, finds new ways to list, and even turns lists into mantras:

> in lockdown, you will relinquish your things:
> plastic soapdish, jar of vaseline, comb or hairpick, paperback
> Upon returning to your unit the inventory officer
> will return your things:
> soapdish, vaseline, comb, hairpick, paperback
> Upon release you may have your possessions:
> soapdish, vaseline, comb, pick, book
> Whereupon your True Happiness can begin
>
> (n.p.)

Longer lists reflect prisoners' need to fill time (and their medical troubles):

> Count your grey hairs
>
> Count your chigger bites
>
> Count your pills
>
> Count the times the phone rings
>
> Count your T cells
>
> Count your mosquito bites. . . .
>
> Count the flies you killed before noon
>
> (n.p.)

Other lists try to document emotions, much as sets of photographs document things: "the perpetually pissed-off ones who just wanted to hurt somebody, the incipiently pissed who had to be roused with a broom, the well-meaners who tried to help, the feckless risks, the nearly helpful teacher, the failures that can be achieved without trying, the sick bosses, the wrong beds with the wrong ones." Wright also lists types of fingerprints, as if to reclaim this particular human variation from the police and detectives who first made use of it: "[Y]ou've got your plain loops, plain arches, tented arches, twin loops, lateral pocket loops, central pocket loops, whorls and your accidentals."

Still more important than fingers, costumes, props, or numbers, for Wright as for Luster, are the prisoners' faces. *One Big Self* plays repeatedly on the word "face"; inmates' faces, like any faces, command human respect, and Luster as a photographer seeks to offer it. "Face" in prison lingo, however, also means a hardened attitude, one appropriate to life inside: "Drawn on a wall in solitary by a young one / *MOM LOVE GOD* / *before he had a face on him*." "They keep the young ones in Eagle" (one wing of the maximum-security prison Angola) "*until they get a face on them*." To "get a face" in prison is to acclimate oneself to its rigidities, but it is also to learn the rules of a community, to become visible as a participant (rather than simply as an object of concern): "Got a face on you. / Not a part of, apart from. / Cropped out of the picture." "She was only 28 / cropped out of the picture / I know Nolan's daddy died of rabbit fever / *before he had a face on him*" (*One Big Self*, n.p.). Wright herself adds that "get a face" means "until they grew into manhood and so were less vulnerable-looking," "looking mature enough . . . to stand on their own."[24] Such claims even call to mind the philosopher Emmanuel Levinas, for whom "the meaningfulness of the face is the command to responsibility": "Seeing the face of the other . . . means that I approach the other so that his face acquires meaning for me."[25] If Luster's pictures let inmates make and show faces, or even save face, Wright's poetic responses to those faces attribute voices to them, and match or respect those voices with her own speech.

"The peculiar boon of photography," Dyer writes, "is that the model is directly involved in the finished work of art—rather than in the process of its creation" in a way that painters' models (for example) are not. In this view photographers are not so much stealing souls or auras as making them evident, giving them back to their subjects, registering that even in death the soul cannot quite be taken away: Dyer even writes of "the simple message that is also there in all photographs," or at least all photographs of people: "'You are alive.'"[26] Dyer expounds the optimistic view (it might be better to say

the aspiration) about portrait photography that *One Big Self* appears to endorse—in its construction as a finished book and in the working methods Wright and Luster used; it is also the aspiration, or asymptote, to which *One Big Self* as a piece of writing aspires.

"The portrait," Graham Clarke explains, "hovers between extremes: on the one hand . . . an identity card which stamps itself" as a means for social control, "and on the other . . . the photographer's definitive attempt to reveal an interior and enigmatic personality."[27] Skeptical critics (such as Lalvani) continue to imply that photographic portraiture (whatever the photographer intends) finally numbs or regulates subjects and viewers. More optimistic viewers and practitioners believe that the right sort of portrait photography can (still) attest to subjects' indivisible human claims. "Good photography," Lucy Lippard avers, "can *embody* what has been seen. As I scrutinize it," she continues, a particularly generous image "becomes the people photographed—not 'flat death' as Roland Barthes would have it but flat life."[28]

Such hopes go back to the origins of photography. The novelist and photographer Wright Morris has described the cultural meaning of daguerreotypes: "The enthusiasm to take pictures was surpassed by the desire to be taken," he writes, and the resulting images still attest to human uniqueness and to human dignity: "There is no common or trivial portrait in this vast gallery. Nothing known to man spoke so eloquently of the equality of men and women. Nor has anything replaced it."[29] Not only the portraits, but the language Wright accords them seeks to reinstate such experiences of equality, such claims on behalf of all or any selves. "Every portrait could be titled *you*," Wright says (*Come Shining*, 6). "The countenance directs the attention. . . . There is no negligible face, no negligible place." Luster places her subjects "in their finer, inner selves, where we are all enthroned" (ibid., 7). By printing the pictures on metal plates, Luster evokes not just the spirit but the physical feel of these earliest photographic portraits.

These ideals also bring us back to documentarians, to Agee and Evans and their thirties colleagues. The "true meaning" of an Evans portrait, Agee writes, "is that [its subject] *exists,* in actual being, as you do and as I do, and as no character of the imagination can possibly exist. [The subject's] great weight mystery and dignity are in this fact."[30] Agee and Evans thus announced their "effort to recognize the stature of a portion of unimagined existence," of "individual, anti-authoritative human consciousness," even of "human divinity."[31] Susan Sontag considered Evans "the last great photographer to work seriously and assuredly in a mood deriving from Whitman's euphoric

humanism"; his "message of identification with other Americans," she wrote in the mid-1970s, "is foreign to our temperament now."[32] Both Luster and Wright strive to prove her wrong.

Barthes, Evans, Morris, Luster, and Wright all imagine as a goal for photography (or for one sort of photography) just what other thinkers posit as a goal for poetry (or for particular kinds of poetry). Allen Grossman (drawing on Levinas) writes that "poetic reading is a case of the inscription of the value of the person, a case of the construction of the countenance, the willing of the presence of a person": in poetry "what is said is first of all the portrait of the other person present because of his or her speaking."[33] Writing in 1957, Robert Langbaum gave almost the same mission not to poetry generally but to the dramatic monologue and to its modern descendants: "[I]t is to establish the speaker's existence, not his moral worth but his sheer existence, as the one incontrovertible fact upon which the poem can rest . . . so that the speaker . . . *is* the poem."[34] Even Lyn Hejinian— who rejects the idea of "an inner, fundamental, sincere, essential, irreducible, consistent self"—argues that "the idea of the person enters poetics where art and reality, or intentionality and circumstance, meet": "[O]n the improvised boundary between art and reality . . . the person (or my person) in writing exists."[35]

In other words: the goals some poets and critics attribute to poetry, to the dramatic monologue and its descendents, or to postromantic lyric, coincide with the goals some photographers, and some writers on photography, claim for photography. Wright not only calls to mind that coincidence but incorporates it into her poetic techniques. Her invocations of aperture, exposure, and light levels; her compositions with mirrors and windows and doors; her descriptions of herself as a photographer's "factotum"; her Agee-esque lists; her vernacular quotations; her lines that double as captions, "details," and reflections; her focus on faces—all try to make the experience of reading her poems resemble the experience of taking, and of viewing, photographs, especially portraits (*One Big Self*, n.p.).

These resemblances help her poems manifest, and ask how those poems *can* manifest, the idiosyncrasies, the ethical claims, and the "faces" of individual persons. We might say, adopting Wendy Steiner's distinction, that Wright uses photography to create not a fallacious three-term comparison but rather a tenable four-term one.[36] Wright's poems wish to be, to *persons in language,* as photographs are to *persons seen.* We might more simply say that Wright wants her poems to operate as she believes that photographs ought to do. The poems thus work toward the terms and conditions of life that Wright names near the end of *Cooling Time.* "We need," Wright says, "to lower

the veneration around the terms of communication . . . and aim to see better"; "the faces," she adds, "are . . . looking back at everyone out there, daring the viewer to see them now," to see in "no one a means," in "every one an end" (*Cooling Time,* 93, 103, 107).

Wright's newest poems can find new ways to pursue this goal—and new ways in which photography can help her do so. Wright's most recent long poem (as of this writing), "Rising Falling Hovering," responds to her recent travels in Mexico and to the current war in Iraq. The poem takes up the interest in portrait photography as a means of acknowledging human persons that we saw at the core of *One Big Self,* and the fragmentary documentary-travelogue mode Wright used in *Deepstep.* One structural aspect in "Rising" involves alternating depictions of young men who have died by violence (organized crime in Mexico, war in Iraq) with depictions of Wright's (presumably or relatively safe) teenaged son: both the dead young men and the poet's child appear as if in a series of photographs. In the homemade memorial to the dead man in Mexico City, we see "The slow open vulgar mouth drawing on a cigarette // In a face once called Forever Young // Now to be known as Never-a-Man." On Wright's return from Mexico to Rhode Island, she discovers—happily, but guiltily (since other mothers are losing their sons, their property, and their lives as the United States invades Iraq)—that "The glorious photographs of their [own] son were not stolen / from their second-hand frames."[37]

Photography is both the method and the signal that all lives—especially, here, the lives of sons—ought to be cherished, and are cherished, whether or not their mothers can save them. And the likeness between poor Mexicans' image-cherishing and bourgeois Americans' image-cherishing, between the ways in which these different people treat similar (but never the same) photographs, helps Wright imagine how the "different world" of developing nations (whom Americans tend to ignore or to bomb) might be "rejoined" to ours. Late in "Rising" we return to the interest in blindness, in not-seeing, from *Deepstep,* and to Wright's focus on the human face. The climactic scene in the poem depicts illegal immigrants, in pitch-dark night, trying to cross the U.S.-Mexico border. The literal darkness through which the immigrants must move, and the other tactics by which they must make themselves hard to see (and even harder to photograph), stand for the ways in which U.S. citizens find it almost impossible to "see," to acknowledge them, as full human persons: "Mira" ("Look"), Wright's poem declares in Spanish, "you will never see faces like this again."[38]

NOTES

1. C. D. Wright, *Steal Away: Selected and New Poems* (Port Townsend, WA: Copper Canyon, 2002), 155, 42, 66. Hereafter cited in the text.

2. C. D. Wright, *Cooling Time: An American Poetry Vigil* (Port Townsend, WA: Copper Canyon, 2005), 50. Hereafter cited in the text.

3. Roland Barthes, *Camera Lucida,* trans. Richard Howard (New York: Hill and Wang, 1981), 87, 4.

4. Bob Holman, "Trace of a Tale: C. D. Wright," *Poets and Writers* 30, no. 3 (May–June 2002): 21.

5. C. D. Wright, *Deepstep Come Shining* (Port Townsend, WA: Copper Canyon, 1998), 10, 96. Hereafter cited in the text.

6. C. D. Wright, *String Light* (Athens: University of Georgia Press, 1991), 37, 39, 40. Hereafter cited in the text.

7. Herbert Bayer, "The Lonely Metropolitan." Reproduced at http://www.davis-art.com/artimages/slidesets/slide.asp?catalognum=822&partofset=746.

8. Kent Johnson, "Looking for 'One Untranslatable Song': An Interview with C. D. Wright," *Jacket* 15 (2001), jacketmagazine.com/15/cdwright-iv.html.

9. C. D. Wright, *Just Whistle: A Valentine* (San Francisco: Kelsey Street, 1993), 55, 47, 50. Hereafter cited in the text.

10. Graham Clarke, *The Photograph* (New York: Oxford University Press, 1997), 123, 125, 130.

11. Nan Goldin, *The Ballad of Sexual Dependency* (New York: Aperture, 1986); Karl-Peter Gottschalk, "Nan Goldin: Those Obscure Objects of Desire," *Zeugma,* 1996, repr. http://easyweb.easynet.co.uk/karlpeter/zeugma/review/godlin1.htm.

12. Gill Saunders, *The Nude* (New York: Icon, 1989), 132.

13. Ibid., 122–23.

14. Jonathan Culler, "Changes in the Study of Lyric," in *Lyric Poetry: Beyond New Criticism,* ed. Chaviva Hosek and Patricia Parker (Ithaca, NY: Cornell University Press, 1985), 40.

15. James Agee and Walker Evans, *Let Us Now Praise Famous Men* (Boston: Houghton Mifflin, 1960), xv.

16. Ibid., 238.

17. Ibid., 13.

18. Geoff Dyer, *The Ongoing Moment* (New York: Pantheon, 2005), 13.

19. Deborah Luster and C. D. Wright, *Come Shining* (Charlotte, NC: Light Factory, 1999), 5. Hereafter cited in the text.

20. Bob Dylan, "I Shall Be Released," in *Greatest Hits, Volume Two,* Columbia Records, 1971, quoted by Wright, *Deepstep,* 37.

21. C. D. Wright and Deborah Luster, *One Big Self: Prisoners of Louisiana* (Santa Fe, NM: Twin Palms, 2004), not paginated. Hereafter cited in the text.

22. Suren Lalvani, *Photography, Vision and the Production of Modern Bodies* (Albany: SUNY Press, 1996), 140, 63, 26.

23. Agee and Evans, *Let Us Now Praise Famous Men,* 133.

24. C. D. Wright, personal communication.

25. Jill Robbins, *Is It Righteous to Be? Interviews with Emmanuel Levinas* (Stanford, CA: Stanford University Press, 2001), 135.

26. Dyer, *Ongoing Moment,* 95, 254.

27. Clarke, *Photograph,* 109.

28. Lucy Lippard, "Doubletake," in *The Photography Reader,* ed. Liz Wells (London: Routledge, 2003), 344.

29. Wright Morris, "In Our Image," in *The Photography Reader,* 69.

30. Evans and Agee, *Let Us Now Praise Famous Men,* 12.

31. Ibid., xiv.

32. Susan Sontag, *On Photography* (New York: Farrar, Straus and Giroux, 1977), 29, 31.

33. Allen Grossman and Mark Halliday, *The Sighted Singer* (Baltimore: Johns Hopkins University Press, 1992), 344, 214.

34. Robert Langbaum, *The Poetry of Experience* (New York: Norton, 1963), 200.

35. Lyn Hejinian, *The Language of Inquiry* (Berkeley and Los Angeles: University of California Press, 2000), 201, 207.

36. Wendy Steiner, *The Colors of Rhetoric* (Chicago: University of Chicago Press, 1982).

37. C. D. Wright, "Rising, Falling, Hovering," *Chicago Review* 51, no. 3 (2005): 22, 16.

38. Ibid., 23, 30.

"The Grammar of the Night": Ekphrasis and Loss in Lucie Brock-Broido's *Trouble in Mind*

M. Wynn Thomas

"AND HERE, IN THE RED ROOM / OF MY BEAUX ARTS AND MY IRONY, all the fetishes will be safe // And in their places like the hummingbird who lives here // With me."[1] As these lines suggest, *Trouble in Mind,* Lucie Brock-Broido's latest volume, features what she somewhat ironically styles the "Beaux Arts." Of the fifty poems, almost a fifth are modeled on painting, and these invite exploration partly in the dangerously seductive terms suggested in "Fata Morgana," as ironically wrought, verbally ornate containers of the "fetishes" necessary for the safe enchantment (or suspect transformation?) of her most dangerous emotions. She is aware that the strategy has its dangers. It is, in places, as if Brock-Broido is offering a self-portrait of herself as the self-incarcerated Lady of Shalott ("And I am half sick of shadows" ["Apologue on Jealousy," in *Trouble in Mind,* 46]), and the medievalism of the Pre-Raphaelite on occasions provides the canvas for her self-testing "post- // Raphaelite" portraiture ("After Raphael," in *Trouble in Mind,* 4). In the process she exhibits a lavish, and also perhaps wayward, lyrical genius.

In "Fata Morgana" (*Trouble in Mind,* 31) she exploits a range of images, including late Victorian and fin de siècle representations of woman as seductive enchantress and as sensual femme fatale, in order to explore the ambivalent aspects of her powers as poet. *Trouble in Mind* is repeatedly concerned with the equivocal sorcery of art, particularly as sometimes impatiently viewed in the harsh light of life's most cruel depredations. She can feel "That the page is waste, all that rag // Content" ("Gamine," in *Trouble in Mind,* 17). There are several powerful moments here when, like Yeats or the late Stevens, she feels life's brutal imperative to "walk naked": "It is time now to turn off the devices in the wing / And listen to the rain" ("Some Details of Hell," in *Trouble in Mind,* 12). But then, she reflects (in lines again haunted by Stevens), "Perhaps it isn't possible to say these things / Out loud without the noir // Of ardor and its plain-spoken

245

elegance" ("After Raphael," in *Trouble in Mind*, 4). In the mannered stylistics of painting, Brock-Broido, consciously revisiting the example set by Wallace Stevens, appears to find a valuable model for considering the purpose and function of poetic forms, and in particular for assessing the adequacy of art when forensically cross-examined by life.

In these poems, deep personal loss has compelled Brock-Broido to stare directly at ruin. And, as in Berryman's *Dream Songs*, unabashed Ruin has stared right back, disconcerting the viewer into adopting a series of adaptive and deflective postures. The poetry is a record of these attitudes that are struck in this theater of emotional devastation, and the "painting poems," in particular, seem to be self-doubtingly successful attempts at making composition yield forms of mental composure. In the attempt, Brock-Broido reveals herself to stand in the American tradition of wit that includes John Crowe Ransom and Richard Wilbur. But the preeminent figures are Wallace Stevens and Emily Dickinson, the great epigrammatist of pain and tutelary spirit of Brock-Broido's remarkable collection *The Master Letters* (2002), whose many incomparable poems about death and loss were in the end only so many blank inscriptions on "that White Sustenance—Despair."[2] Like Stevens and Dickinson, Brock-Broido constantly asks what arts, if any, can help one deal with life when it has serious "trouble in mind"?

"Of loss: / You get to speak of it, once // You are its intimate, and not before": *Trouble in Mind* is that speaking, an accompaniment to the "dismantling of the spirit" by "the pathetic maledictive fear // Of loss" ("Dire Wolf," in *Trouble in Mind*, 66). The collection as a whole is dedicated to the memory of Lucy Grealy (1963–2002), an intimate friend of Brock-Broido's, a fellow artist and author of the best-selling *Autobiography of a Face*, who, having long suffered from cancer of the jaw, died of an accidental drug overdose. The nightmare experience of that dying, corroborating the death of the poet's mother, has so usurped Brock-Broido's consciousness that in places it seeps through the pores of her writing. The dread paraphernalia of clinical procedures—catheters, drips, incisions—all become metamorphosed into metaphors for understanding, and are thus partly disinfected of their hospital taint. And the chill feature of Grealy's cancer also makes its terrible presence felt. A striking example is "The One Theme of Which Everything Else Is a Variation," one of many seismographic poems registering the changes to consciousness caused by the deepest emotional upheavals. The subject is the loss of innocence, initially figured as "a catarrh of the [distressed] mind," clogging up the channels for honest encounter with the world. But this

figure then metamorphoses into a conceit for innocence's "finite-ness," woven out of the case of

> . . . the grade school teacher in Sierra Leone
>
> Whose arms were axed off only at the hand, first left
> And then the right, and then his mouth as he was making noise
>
> And should be shut. A man can learn to speak again,
> But never pray.
>> Wisdom is experience bundled, with prosthetic wrists.
>>> (*Trouble in Mind*, 9)

With that last pat epigram (a bleak parody of mental poise), this reads like a figure out of an emblem book for our monstrous times, fashioned from the kind of real-life news image to which we are all pitilessly exposed. But in the interlinear shadows surely lurks the disturbing image of Grealy, the writer who had defied cancer of the jaw only to be silenced "as [she] was making noise." And out of these two images is bred a third, a portrait of Brock-Broido herself as the newly maimed artist of experience in poignant, skeptical search of some measure of compensatory wisdom: "a girlhood gone, like a phial of ether / Thrown on the fire—just // A little jump of flame, like grief" ("Periodic Table of Ethereal Elements," in *Trouble in Mind*, 11).

Keyed to Lucy Grealy's death, *Trouble in Mind* becomes an audit of interrelated subtractions from the self, from the deaths of Brock-Broido's parents to meditations on her own aging: "I was little: I am middle" ("After Raphael," in *Trouble in Mind*, 4). As Grealy observed in *Autobiography of a Face*, "sooner or later we all have to learn the words with which to name our private losses."[3] *Trouble in Mind* is a dictionary of the terms that Brock-Broido has had to devise. And it is accordingly the sheer unsettling emotional charge of this poetry that perhaps needs most to be emphasized. Brock-Broido has justifiably been admired for her mesmeric imaginings, her sibylline utterances and the lush exotica of her phrases. Hers is certainly the gift of strangeness, but it has always been the fate of mannerist and baroque artists to be damned as essentially heartless with the faint praise of being prodigiously clever—Wallace Stevens was long suspected of being a kind of freak acrobat. But as Helen Vendler has noted, "We must ask what causes the imagination to be so painfully at odds with reality."[4] For Stevens, as for Brock-Broido, wit was an existential sta-bilizer; a psychological life-support system. Hence, to experience, as Brock-Broido does in *Trouble in Mind*, a crisis of confidence in the

preservative and restorative sorcery of wit is to be threatened by psychic and artistic breakdown. This is the threat that only occasionally dares speak its name but whose dark presence lurks within the allure of mystery in the best of these poems.

One such is the very short, but exquisite, "Lady with an Ermine" (alluding to Leonardo's portrait), which opens with lines whose sinister beauty is in their provocative elusiveness: "In the snow, white noise, a gathering / Of foxes oddly standing still in the milk broth of oblivion" (*Trouble in Mind*, 37). The unmentioned living red fur of these animals is then played off against the specific image of an ermine pelt, "slung over the carved // Oak chair, carelessly and keeping no / One warm" (ibid.). The result is a complex psychological reflection, in the manner of Keats's ekphrastic "Ode on a Grecian Urn," on the gains and losses of domesticating a vivid but unnerving living world through human arts—it may be noteworthy that during the Renaissance the hairs from the coats of ermine and stoat were used for making soft brushes.

Offering as it does an image of painting as the art of displacement (it is the ermine wrap that stands in for the lady), "Lady with an Ermine" could be read as an allegory of Brock-Broido's own poetic method and a confession of its dubious, or at least compromised, psychological efficacy and moral authenticity. Adept at the art of self-concealment as a mode of concealment from oneself, Brock-Broido as poet habitually displaces complex emotions into euphuistic phrases and baroque, fetishistic images, just as, in her verbal self-portraiture, figural representation is metamorphosed into figurative expression. This is a method that itself constitutes a kind of allegory of mourning, at the core of which, as Peter Sacks has pointed out, is the psychological "work" of substitution.[5] *Trouble in Mind* is a collection of elegies, a sumptuously rich psychoverbal brocade fashioned out of Brock-Broido's need to find what Edward Thomas memorably, and wistfully, called a "language not to be betrayed,"[6] an inalienably private language of nevertheless considerable public resonance. "If you do not fathom that, you should not be reading this"—a *Calamus*-like phrase that echoes throughout Brock-Broido's "painting poem" "Still Life with Aspirin" (*Trouble in Mind*, 6)—could be taken as an epigraph for all her poetry; the opt-out clause in her contract with her reader. She herself is fully aware of the dangers of this compulsive, addictive, and seductive practice on which her self-preservative art is fatefully predicated, deeply attracted as she is by the gravitational pull of her own inwardness. A self-styled "hunger artist," she has elsewhere vividly noted the "geometric forms" into which anorexics "have curled."[7]

Her awareness of the dangers of this incipient narcissism (aggravated, in the elegiac mode, by the "secondary narcissism" of melancholia that Freud claimed was the pathological form of mourning) is evident in poems such as "Fata Morgana" and "Elective Mutes," a poem in her first collection, *A Hunger,* based on the true story of the Gibbons twins: "[T]hey became more and more detached from the real world, eventually living and speaking in an invented world of poems, novels, and diaries based on their lives and rituals of their dolls. Eventually, their fantasies and languages became more symbiotic and more pathological. As they became impossibly and progressively intertwined and encoded, they began to turn on one another; they became arsonists, and eventually, they began to think of murdering one another" (*A Hunger,* 59). Considered in this context, therefore, "Lady with an Ermine" could be said to be partly a poem in which Brock-Broido reflects uneasily on her own practices and unsteadily nerves herself as poet for those dread encounters with life that elsewhere are experienced as potentially catastrophic.

The art of displacement, of substitution, may have its psychological dangers, but it also has unique potential. In *Autobiography of a Face,* Grealy relates a touching story about one of her father's visits to her bedside when, as a nine-year-old, she was awaiting major surgery in a New York hospital. Snatched from his hectic schedule, these visits were excruciating for daughter and father alike, as each found it next to impossible to sustain any kind of meaningful conversation. Grealy once precociously resolved this dilemma by faking sleep, prompting him to the expedient of leaving a scribbled note next to her bed recording his visit and his reluctance to wake her.[8] The story could stand as simple illustration of a commonplace paradox at the heart of human experience: that coded or symbolic acts (what else *is* art?) can in fact be the most direct and effective means of communication and even of self-apprehension.

"Lady with an Ermine" also has other important provenances of meaning. Within the ghostly Renaissance frame of the allusion to Leonardo's famous image (fig. 17), Brock-Broido paints a pointedly different picture. As she replaces his portrait of a woman with a woman's portrait, she radically alters the composition, substituting for the alluring presence of the lady sensuously nursing an ermine (a Renaissance symbol of chastity) an absence indicated by the draping of a casually abandoned animal fur over a carved chair arm. Grealy was acutely sensitized by her own physical "disfigurement" to the whole fraught issue of female beauty as sponsored by artists such as Leonardo. The familiar feminist challenge to this male deformation by beauty of female identity was one that she knew in her damaged

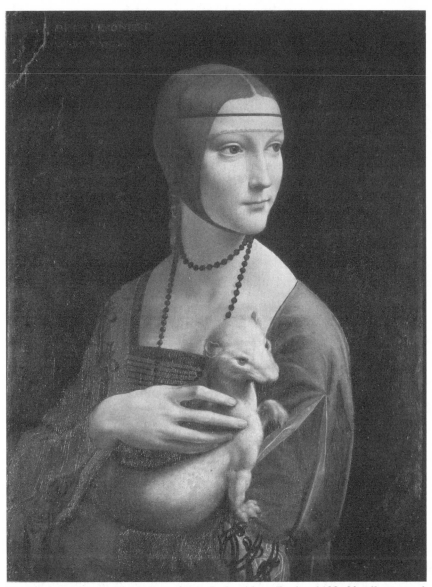

Fig. 17. Leonardo da Vinci, *Portrait of a Lady with an Ermine*, 1488–90, oil on panel. Cracow, Poland: Czartorysky Museum. Photo Credit: Scala / Art Resource, NY.

bones, and Brock-Broido's poem can be read as a commentary on a discredited aesthetic. Replacing Leonardo's "lady" at the center of her design is an enigmatic blankness that rhymes with the whiteness of the "milk broth of oblivion."

The disturbing image of loss, that empty space at the very heart of the poem's painting, could also be said to stand for the absence in female portraiture by male artists of images that answer to women's felt reality. Such an absence means that for a woman poet to attempt ekphrasis in this context it is necessary for her to do what Brock-Broido does in *Trouble in Mind*: "paint" her own textual image in the very act of attempting to take its verbal measure. This is the poetic equivalent of a strategy central to female art and feminist art history over recent decades—an attempt to overwrite male representations of women with female self-portraiture. But instead of replacing a self subject to a male artist's imagination with a representation of the "true self" of woman, female artists have been attracted to the performative, antiessentializing model of subjectivity with which Brock-Broido also experiments. Moreover, she never makes an existent painting the object of her contemplation and the subject of her revisionist address. Instead, she either produces her own, deviant version of established work(s) (as with Leonardo's *Lady with an Ermine*) or practices notional ekphrasis by producing a poem with the discursive power to call an imaginary painting into existence.

After the controlled surrealism of its opening, "Self-Portrait with Her Hair on Fire," another of Brock-Broido's experiments in verbal-visual composition, develops through lines that, impelled recklessly forward by feeling, surge unchecked over four two-line stanzas. The driving force is that of a despair as incommunicable as it is unassuageable, because its object is beyond the reach of language. And it produces a grotesque recuperative twist into the Max Ernst shape of a favorite Pre-Raphaelite motif (Mrs. Gaskell tartly but accurately characterized D. G. Rossetti, the painter of *Fazio's Mistress, Woman Combing Her Hair, Morning Music,* and *Lady Lilith,* as "hair mad").[9] The wind blindly scattering Brock-Broido's pages is "the color of her hair // Across a medieval pillow endlessly scorched" (*Trouble in Mind,* 29). The image alerts us to the violent desire lying at the desolate heart of loss, turning these poems of absence into love poems of a kind. But whereas Rossetti charged female hair fetishistically with all the allure and threat of female sexuality, in Brock-Broido's "post-Raphaelite" imagination it carries the agonizing memories of a wild, unruly female life savagely animated by its own self-destructiveness. "The singe of something living tinged with fire" (ibid.): as so often with this poet, the sounds of the words intricately conspire to pro-

duce a Gordian knot of meaning and of feeling. And in using "Hair on Fire" to characterize a woman, Brock-Broido is feminizing a phrase with a notably strong exclusively male pedigree. Believed to have originated with navy pilots to signify extreme urgency, it came to widespread public notice when Donald Rumsfeld used it in the context of 9/11. He attributed the failure to respond to warnings of the imminent terrorist attacks to the Pentagon's previous repeated experience of heightening alert in response to what proved to be false alarms: "In the three years since I've been back in the Pentagon," Rumsfeld said, "there have been people running around with their hair on fire a lot of times."[10] In feminizing such an expression, Brock-Broido emphasizes that violent, dangerous passion is not exclusively confined to a masculine theater of dramatic action.

Brock-Broido's preferred method is "notional ekphrasis"—the production of a poem representing an entirely imaginary painting. The implications of the genre are subtle and extensive. It calls the very status of traditional ekphrasis into question, for instance, by questioning whether a poem that does refer to an existent painting can in any meaningful sense represent it, in any save a purely metaphorical sense: in which case, all ekphrasis may, after all, be notional ekphrasis. To raise such a possibility is then to highlight other questions, such as how does a text representing itself as "being" a painting require to be read? Perhaps as a textual composition in space, a "painterly" emphasis on a text's "writerly" qualities of which Lucy Grealy would very much have approved. The very title *Autobiography of a Face* signaled a truth about that work that Grealy repeatedly emphasized when she met her readers. In an afterword, her friend Ann Patchett recorded a typical exchange: "'It's amazing how you remember everything so clearly,' a woman said, her head wrapped in a bright scarf. 'All those conversations, details. Were you ever worried that you might get something wrong?' 'I didn't remember it,' Lucy said pointedly, 'I wrote it. I'm a writer.'" In *Trouble in Mind,* Brock-Broido's writerly compositions are closely related to her sense of the performative self—the self not in, but as, masquerade. And if some of her textual self-portraits are *tableaux vivants,* in other poems the self is present only in the form of what is punningly called "still life."

One such is "Still Life with Feral Horse," in which the self is "stilled" into protective anonymity as the mingled pain and anger of the "relinquish" of love is distanced by being transmuted into the high conceit of a "sorrel horse loosed // On a salt marsh island" (*Trouble in Mind,* 24). As in several other poems in this collection, the most intense and potentially threatening feelings are temporarily defused by being turned into the burlesque of self-conscious melodrama. This

is one of the psychological functions of Brock-Broido's notional ekphrastic method: the trope of representing a lyric poem as a painting involves the freeze-framing of volatile words and feelings into struck "attitudes," momentarily turning the existentially suffering self into Patience on a monument, smiling at grief. But at the end of "Still Life with Feral Horse" the dissonant, disruptive first-person voice of violently unruly feeling breaks in: "I have heard tell / That you know how / To kill a man" (ibid.). And, as is frequently the case with *Trouble in Mind,* the charge of emotion is all the more disturbing because the remark is so indeterminate in character: the "you" being addressed is not specified, but left to take its place among the many other floating signifiers that make these poems so troublingly enigmatic.

"Self-Portrait with Self-Pity" features an analogous psychotextual maneuver, opening as it does, like "Still Life with Feral Horse," on a note of high sententiousness: "In the principalities / Of desire, retention of power // Is everything, even at the cost of treachery" (*Trouble in Mind,* 49). The poem then dramatizes the self's ruthless attempt to retain control of its psychic territories in face of the "barbarians outside the city's iron gate." This takes the form of its aggressive-defensive transmutation of potentially uncontrollable grief into regimented self-pity. Dangerous feeling is safely policed through the ironic deployment of one of the hoariest of poetic conventions—the co-opting of the seasons to express states of human emotion: "I'm telling you, my bleak, all / Winter long, it will be mercilessly // Iced here now, the frost is cold-cock / Cloven vixen prints on metal railroad tracks." But as so often happens in poetry, language and image double-cross the user. Whereas the speaker intends to safely burlesque the true idiom of feeling, under the spell of the magnificent rhetoric the cliché of winter as the season of sorrow recovers its old magic. Ironized self-pity unintentionally reverses itself into a desolating vista of authentic pathos: "The trains go on and on / With their whistling, with their tupelo cargo, // Their serious & pitiless, / Their limber want, their gloom." Here "tupelo cargo"—"tupelo" is a black, or sour, gum, native to Southern swampland—provides a fine example of the hard-core precision of the best of Brock-Broido's euphuistic phrases.

The model of painting provides her with a necessary paradox that serves as a compositional principle for her poetry. In a painted portrait, fixity is the very image of fleetingness (it gives permanence to a momentary impression), and the authoritativeness of the picture is the warrant of its provisionality, in that all impressions convince by their presence/presentness, but only for their moment. Her fascination with freeze-framing finds its literal expression in her fastening,

in "Self-Portrait on the Grassy Knoll," on a single frame of Abraham Zapruder's celebrated filmic record of the Kennedy assassination. It features Jean Hill, a moment before she witnesses the shooting, and provides Brock-Broido with an opportunity to grope, in the "anemic slippery light" of memory, for secure purchase on her own past, only to end up equivocating as to whether or not there ever can be as sharp a division between before and after, innocence and experience, as retrospection might care to believe. Yet, faced with failure to "gather consolation . . . from the back-talk of the dead," she finds these comforting retroactive narratives of the mind alluring. They offer to reconnect her to a lost Edenic world. And they tempt her to persist in spinning a protective cocoon of words and images. It is a temptation she once again images in terms of the allure of donning a sorcerer's abandoned coat. Such a retreat into magical narcissism is at one point textually underlined, and in a sense enacted, as an echo from Eliot's "Love Song of J. Alfred Prufrock." Prufrock's mournfully self-pitying line about the mermaids—"I do not think that they will sing to me"[12]—rings out forlornly and enticingly behind Brock-Broido's phrase about her failure to call up the dead: "they / Do not speak to me" (*Trouble in Mind*, 25).

But the change of gender from the Prufrock poem that is highlighted by this textual palimpsest is part of the meaning of her poem. Like many another in *Trouble in Mind*, "Self-Portrait on the Grassy Knoll" is a poem specifically about the kinds of self-absorption to which, in the context of a still predominantly patriarchal Western culture, women may be self-defensively prone—the temptation to play the innocent, to remain the "gamine" (the title of one of the poems), to be coyly girlish. T. S. Eliot represented this from the uncomprehending male perspective in a celebrated passage from *The Waste Land*. With a sly sidelong glance at the Belinda of *The Rape of the Lock*, Eliot enthrones his middle-class lady in "A Game of Chess" in front of her oppressively ornate mirror. But in his own act of notional ekphrasis, Eliot juxtaposes to this scene a description of the painting hanging over the "antique mantel" of the lady's boudoir. Depicting the rape of Philomel, this alternative "mirror" offers, in its image of violation, mutilation, and brutal silencing, the kind of self-portrait she in truth needs if she is to come to true self-recognition. Brock-Broido's self-portraiture, in poems like "Self-Portrait on the Grassy Knoll," is a woman's reflective response to the charge of narcissistic self-regard Eliot is leveling. By means of her own notional ekphrasis she establishes an awareness of the culturally induced temptation to do what Miss Jean Hill is imagined as having done way back in 1962—to place herself in an appropriately feminine, care-

fully self-subordinating, and safely marginalized position within the frame of a larger, male-dominated scene: "In her red rain coat, she had been hoping / To loom small and pleasing on the grassy hill / Like a poppy anemone in bloom" (*Trouble in Mind*, 25). Brock-Broido sympathizes with her, in the very act of exposing (as did history in 1962) her feminine ruse. As these poems repeatedly show, the temptation to adopt such a strategy is strong in Brock-Broido herself. And that is why the poem has the title it has: not only is she placing herself alongside Miss Hill, but at a critical distance from her, she is also in a sense seeing herself *in* Miss Hill—the portrait of the lady in red is also Brock-Broido's self-portrait of her younger, "Pre-Raphaelite," willfully innocent and stubbornly prelapsarian self, on that grassy knoll.

The absence of imagination has itself to be imagined, and it takes fictive powers to enter into the plain sense of things: Brock-Broido has learned Stevens's familiar lessons by heart. And if in *Trouble in Mind* she abjures the rough magic of her earlier writing, it is in the process of conjuring a new magic realism into being. "Self-Portrait in the Miraculous World, with Nimbed Ox" is a poem directly illustrating this. "Halo" is a key term in the private lexicon of loss that Brock-Broido develops in *Trouble in Mind*. In the present context it serves to emphasize that the "New Realism," "a bovine one with widened eyes," makes the Chagall-like miracle of the ordinary world visible (*Trouble in Mind*, 47). As for the old sorcery, it is dismissively, and yet wistfully, associated with the medieval (Pre-Raphaelite) universe, and with the nursery rhymes of arrested development: "He said: you cannot say, / Cancers be gone, // Heart be strong / As a lion" (ibid.). This is the announcement of a new poetics of duress; a reluctant indictment, wrung from "a dire love," of a poet's previous trust to the glib harmonies of rhyme and the trompe l'oeil of troping.

Awakening to a new consciousness is also the subject of another painting poem, "Self-Portrait as Kaspar Hauser" (*Trouble in Mind*, 44–45). It offers a retrospective, a recollection of previous states of dumbfounded existence ("I was a scar. A scoop of swale. / . . . The white of the paper blinded me") and of lost exhilaration (ibid., 44). The latter is in part beautifully recalled in terms of a (now lost) capacity to absorb pain through its transformation into the "objective correlative" of an image. (Eliot's term is elsewhere contrastingly appropriated by Brock-Broido to mourn her present loss of salvific symbol-making power.) Her "toy" was a small white horse that served as talisman of her grief. It was "the same grieved // Thing, wheeling & unworldly, wild as / Wheat" (ibid., 44–45). The poem's end is singularly haunting in the way it registers the vulnerability of an undefended consciousness suddenly pierced by experience: "As I

touched / The flame I did not know how to flinch, but cried" (ibid., 45). All self-portraits are mirrors not so much of the self that does the portraying as of that self's chosen self-imaging. By adopting the paradigm of a self-portrait Brock-Broido here brings out the self-conscious dimensions of such seemingly self-annihilating experiences as consuming grief and its aftermath of an altered reality. And in choosing an unsocialized figure as her alter ego, she also succeeds in suggesting the essentially genderless character of aboriginal human experience.

While *Trouble in Mind* includes several experientially complex narratives of maturation through grief, it also stubbornly includes counternarratives that insist on, and in a sense validate, the rootedness, even perhaps the permanence, of grieving. In fact, it is on this implacable note that the volume ends: the whole of the fifth and final section is keyed to the opening poem, which is again an elegy for Lucy Grealy, this time in the form of a "Portrait of Lucy with Fine Nile Jar" (ibid., 57–58). Jars were important storage vessels for the ancient Egyptians. Carefully sealed to preserve the contents, they could be crudely modeled of coarse red clay, or finely decorated with fish, crosses, plants, and human forms. For Brock-Broido they signify numinous time-proof containers of precious experiences and as such are the correlatives of mummification—the practice, here signifying the rapt inflections of chronic grieving, with which the poem closes.

"After the first death, there is no other":[13] Dylan Thomas's lines can provide entry into the mental world of Brock-Broido's "Portrait of Lucy with Fine Nile Jar." This elegy opens with memories of a precious, lost time—of the poet's girlhood in Middle America with her two sisters—and it is the early loss of this infantile refuge that provides the template for all future, adult devastations, such as the death of her friend, whose entire life had consisted of "the spectacular catastrophe // of your endless childhood" (*Trouble in Mind*, 3). As throughout *Trouble in Mind*, Brock-Broido is preoccupied with the "numinous" quality of that loss, bestowing as it did the "halo" of permanent, transfiguring significance. This is another aspect of her practice of "magic" in this particular volume: she is dealing with an experience that removes one from the realms of the ordinary, and that carries with it the aura of the sacred. Hence, in part, the hieratic and hierophantic character of the phrasing. Brock-Broido is the priestess of her own religion of death. In the case of "Portrait of Lucy with Fine Nile Jar," therefore, notional ekphrasis is being used as an attempt to fashion an icon for the soul, as if Brock-Broido were refashioning the Victorian practice of producing a miniature to com-

memorate the departed; or, alternatively, imitating Whitman and, Egyptian-like, decorating the mental walls of Grealy's "tomb." The poem is ritualistic in intent, just as earlier in *Trouble in Mind* Brock-Broido had written a most moving poem to keep her mother's soul company "between washing / and the well of burial," and to ease her passing to another world ("Soul Keeping Company," *Trouble in Mind,* 26).

It is another formative childhood loss that is recalled, and compulsively reenacted, in "Self-Portrait with Her Hair Cut Off." The recollection of the scene is yet another example of the law of eternal return: "The past happens over and over again like a kingfisher / Veering off its destined course, and hovering" (*Trouble in Mind,* 63). The sense of doom and of predestination is strong in *Trouble in Mind.* In "The One Thousand Days," a magnificently desolating poem, a resigned sense of the inescapable is textually inscribed in the form of an implacable refrain: "Yet trouble came" (ibid., 64–65). And similarly, in "Self-Portrait with Her Hair Cut Off" the textual conceit of a permanent painted image serves once more to figure that sinister psychic fixity underlying surface growth and change.

Notional ekphrasis is, then, a fixed feature of *Trouble in Mind,* necessary because Brock-Broido is writing of "dooms of love," as e. e. cummings famously put it.[14] But the relationship to painting may be even more striking and intimate than that. Jacket illustration is not usually integral to the meaning of a volume, but it may be so in this case. It features a detail from Vittorio Carpaccio's *Dream of St. Ursula,* the very same painting reproduced in its entirety on the cover of Brock-Broido's first volume, *A Hunger.* That this is more than coincidence seems to be confirmed by reference in *Trouble in Mind* to that earlier volume: "I was a hunger artist once, as well. / My bones had shone. / I had had rapture on my side" ("Pamphlet on Ravening," in *Trouble in Mind,* 67). And just as a critique of her earlier poetic self is implicit in these lines, so a like commentary on her development seems to be implied by the narrowing down of that original painting to a single significant detail in the present volume. In its entirety, the picture includes a whole medieval room, rendered in meticulous detail and featuring the angel that brings Ursula news about her forthcoming martyrdom. The fifth in Carpaccio's series of nine large paintings based on *Stories from the Life of St. Ursula,* the painting is celebrated for "its intensely lyrical sense of place, which [is] magical and enchanted."[15] In narrowing the focus, therefore, Brock-Broido excludes that magic and enchantment in a move that parallels her stated intention to revise her own poetics.

It is on the sleeping St. Ursula that attention is now fixed. And to

know of St. Ursula's dream is indeed to be fascinated by what is going on inside that slumbering head. The saint's dream is of looming, preordained disaster. She learns that, along with the eleven thousand nuns in her pilgrim party, she will be killed by the Huns when she reaches Cologne. There could scarcely be a narrative better suited to gloss the title phrase "trouble in mind" or to bring the poems into a single, unifying perspective. The dream of female martyrdom, of suffering sisterhood, of a dreadful unavoidable doom, exactly mirrors the main themes of the poetry. So perhaps we should accept the cover's invitation to enter into this dreamworld by opening the book. In other words, it could be that all the poems are "readings" of Carpaccio's painting, turning this whole volume into a single, remarkable act of ekphrasis of the "paragon" kind, as it involves a female wrestling with a male image. A recurrent figure Brock-Broido uses in these poems is that of penetrating beneath surface appearances, of exposing bone and nerve and tissue. In painterly terms, the volume could therefore be described as an X-ray of the painted surface to expose the underdrawing. The poems explore the difference between the beautiful, and beautifully painted, head of the sleeping Ursula and the nightmare of her dreams, thus offering a composite "reading" of Carpaccio's image.

This, of course, means that every single poem in *Trouble in Mind* could be considered to offer an instance of ekphrasis. But given that space does not allow for the full exploration of such a possibility, a few limited instances of its implications might briefly be considered. It is worth noting at the outset that, to modern eyes, Carpaccio's Ursula looks far less like a woman in the throes of nightmare than a peacefully Sleeping Beauty, so that—particularly given the antimale thrust of Ursula's dreams—Brock-Broido's volume could be read as a meditation on the difference between that male fantasy and the realities of female psychology. Another possible dimension of meaning is suggested by a passage in Ann Patchett's memoir of her dead friend, Lucy Grealy. It concerns one of the occasions when Grealy was undergoing serious surgery in an attempt to minimize her disfigurement, and it includes a mention of Brock-Broido's conduct at her friend's bedside: "We washed Lucy up and changed the pad beneath her shoulders, and all the while Lucie B-B made enthusiastic girl talk, as if she and Lucy were alone in a West Village coffee shop. 'You look fantastic, LuLuBell,' she kept saying, 'You are the envy of the surgical ward. . . .' Lucie B-B was a tall, slim woman, very striking, with waist-length hair. She was dressed entirely in white."[16] It is a touching vignette of an attempt by Brock-Broido, in her earlier "Pre-Raphaelite" incarnation, to reassure the stricken and prostrate

Grealy about her beauty. And it suggests there may be a sense in which the cover painting for *Trouble in Mind* stands for Brock-Broido's wish to take Prince Charming's place in a futile attempt to rescue her friend, and indeed herself, from the grip of nightmare—including, of course, that ultimate nightmare: death itself.

Like St. Ursula's dream, *Trouble in Mind* could be described as one long anxiety dream, a nightmare from which Brock-Broido struggles to awake, and a nightmare that centrally involves her fears for herself. The volume consciously and sensitively explores a central, but frequently suppressed, feature of the elegiac mode—that what is being covertly expressed is dread of the mourner's own mortality. As Gerard Manley Hopkins succinctly put it: "It is Margaret you mourn for."[17] The signs of anxious "dream work" are everywhere in these poems. Brock-Broido has learnt well from that postwar American phenomenon which might be styled "the surrealist lyric," and her "readings" of St. Ursula's dreams are for her an education in "the grammar of the night" ("Morgue Near Heaven," in *Trouble in Mind*, 18). In addition to one or two occasions when the multivocal text briefly sounds like extracts from Berryman's *Dream Songs,* the poems abound in phrases and images reminiscent of surrealist paintings. Dalí's drawing *The City of Drawers* could be lurking in the background of the opening lines of "Portrait of Lucy with Fine Nile Jar": "My torso is a cedar chest in the brief closet / Of the middle of a country, hollow . . ." (*Trouble in Mind,* 57). And what has been written about the paintings of Salvador Dalí also applies to Brock-Broido's texts: "[His] pictures are dreamscapes, and like dreams they can come and go in the mind, gnaw at you, or cry out to be interpreted, as if they were keys to a deeper meaning of an experience. Yet like many dreams his images are also weightless, interchangeable, and evanescent. With certain exceptions, they run together in the mind."[18]

Surreal images of this kind throng Brock-Broido's text. Sometimes they are eerily languorous ("So many brooding swans like floating inkstains on a lake of slender wakefulness" ["Basic Poem in a Basic Tongue," in *Trouble in Mind,* 13]), and sometimes tense with destructive violence ("blazing like a chestnut horse on fire in / The padlocked barn" ["Gamine," in *Trouble in Mind,* 17]); they can turn biomorphic ("Always the dead will be lined as sad // And crookedly as fingerling potatoes in root-cellars dank enough / For overwintering" ["Death as a German Expert," in *Trouble in Mind,* 14]); or begin unnervingly to merge, and blend, and metamorphose and proliferate ("like an addict floating on a desperate tiny river // Of open iridescent pigeons' wings and the floating poplin // Smocks of dusky, spoony girls" ["The Insignificants," in *Trouble in Mind,* 19]); or as-

sume the sinister air of a Chirico painting ("Now, it is as dark as the pathos of pushing a wheel- / Chair through the museum of a great metropolis" ["Self-Portrait with Her Hair on Fire," in *Trouble in Mind,* 29]). And they frequently function to create a "double-image"—the term used to describe that key phenomenon in surrealist art of a single image that can be read in two different ways. A powerful example is afforded by Dalí's *Apparition of Face and Fruit-Dish on a Beach* (1938), in which the features mentioned in the title are fused in a single double-image that dominates the painting's entire weird beach scene. In like manner, Brock-Broido repeatedly uses floating signifiers to produce multiple-choice texts that seem not just to sanction but positively to require multiple answers. Yet this floating world of metamorphosing forms is always confined within the iron fixities of grief. Brock-Broido's oneiric structures have something of the compulsive/repetitive character of acute anxiety states, so the enigmatic junction of verbal mobility and pictorial stasis that characterizes the ekphrastic poem turns that form into a perfect formal trope for the nexus of experiences with which all the poems in *Trouble in Mind* are concerned.

At the root of Brock-Broido's use of double or multiple imaging seems to be the need to conflate two or more different states and/or persons, particularly the two whose very names (Lucie/Lucy) invite such incestuous twinnings. It becomes impossible, for example, to tell who exactly is being identified in the title of such a painting poem as "Self-Portrait with Her Hair on Fire." And however fortuitous the similarity to Dalí's may be, it becomes even more suggestive when one recalls that *Apparition of Face and Fruit-Dish on a Beach* is a moving elegiac "portrait" of Dalí's intimate friend, Federico García Lorca, and that it has recently been claimed that "portraiture of an indirect sort is one of the unsung achievements of Dalí's work."[19]

In some of the poems in *Trouble in Mind* there may be a tendency for images to get in one another's way, and for conceits to luxuriate to no clear purpose, but this tends to be the price to pay for deliberately overdetermined writing of this densely atmospheric and richly suggestive character. The best of the poems are beautiful in the sense of the word that Lucy Grealy herself provided: "I think true beauty has to have a touch of the unknown to it. I don't mean the sort of unknown that frightens us, but rather, the unknown that we find compelling."[20] This very quality is repeatedly evidenced in the ekphrastic poems, confirming its centrality to this remarkable volume's purpose.

NOTES

1. Lucie Brock-Broido, "Fata Morgana," in *Trouble in Mind* (New York: Knopf, 2004), 31. Individual poems from this volume will be cited by page numbers within the text.

2. Emily Dickinson, "I cannot live with you—," in *The Complete Poems of Emily Dickinson,* ed. Thomas H. Johnson (London: Faber and Faber, 1977), 317.

3. Lucy Grealy, *Autobiography of a Face* (New York: Harper Collins Perennial, 2003), 52.

4. Helen Vendler, *Part of Nature, Part of Us* (Cambridge, MA: Harvard University Press, 1980), 40.

5. Peter M. Sacks, *The English Elegy: Studies in the Genre from Spenser to Keats* (Baltimore: Johns Hopkins University Press, 1985), 8.

6. "I should use, as the trees and birds did, / A language not to be betrayed." Edward Thomas, "I Never Saw that Land Before," in *The Collected Poems of Edward Thomas* (London: Faber and Faber, 1936), 100.

7. Lucie Brock-Broido, "After the Grand Perhaps," in *A Hunger* (New York: Knopf, 1988), 55. This edition of *A Hunger* is hereafter cited in the text.

8. Grealy, *Autobiography of a Face,* 59–60.

9. J. B. Bullen, *The Pre-Raphaelite Body: Fear and Desire in Painting, Poetry and Criticism* (Oxford: Clarendon Press, 1998), 130.

10. Donald Rumsfeld, qtd. in http://www.phrases.org.uk.

11. Grealy, *Autobiography of a Face,* 231.

12. T. S. Eliot, "The Love Song of J. Alfred Prufrock," in *Collected Poems, 1909-1962* (London: Faber and Faber, 1963), 17.

13. Dylan Thomas, "A Refusal to Mourn the Death, by Fire, of a Child in London," in *Collected Poems, 1934–1953,* ed. Walford Davies and Ralph Maud (London: Dent, 1988), 86.

14. e. e. cummings, "my father moved through dooms of love," in *e .e. cummings: a selection of poems* (New York: Harcourt Brace Jovanovich, 1965), 119.

15. http://gallery.euroweb.hu/html/c/Carpaccio/1ursula.

16. Ann Patchett, *Truth and Beauty: A Friendship* (London: Harper Perennial, 2005), 189.

17. Gerard Manley Hopkins, "Spring and Fall; to a Young Child," in *The Poems of Gerard Manley Hopkins,* ed. W. H. Gardiner and N. H. Mackenzie, 4th ed. (London: Oxford University Press, 1967), 89.

18. Sanford Schwartz, "The Energizer," *New York Review of Books,* May 12, 2005, 41.

19. Ibid., 44.

20. http://www.gradewinner.com/p/articles/mi_m1285/is_n2_v26/ai_18082720.

Poet as Model (A Brief Catalog)

Terri Witek

Origin Portrait

The art in my parents' house was contributed by ancestral amateurs. Great-great-grandmother Elizabeth Burr painted a large, blurry Dutch girl residing in an upstairs hallway; as a child in 1830, she'd also worked an alphabet sampler prized for its missing Q and a motto, "Where e'er I go, Where e'er I roam / I find no place like native home." The single portrait is the only painting of and not by a relation: Benjamin Wheeler, a distant cousin whose Byronic glower anchors the dark oils behind him and also, it seems, the room beyond. A burden that matches the manner of his demise: still in his twenties, he'd gone skating to visit his sweetheart, fallen through half-frozen pond ice, and drowned.

This ancestor, lost yet still vivid in my parents' living room, became for me the family's most illuminating relation. And I may be the only other member of my family known to have gone through the ice. When we were fifteen, a boy who got my attention by loaning his copy of *Beowulf* proposed skating from his family dock on Sandusky Bay, just across the peninsula from Lake Erie. In summer, the view was of Johnson's Island, where Southern prisoners in the Civil War once sweltered or froze in their POW camp, and of ferries chugging to the local amusement park. None of this was in evidence. He stepped off and skimmed away; I stepped in and through to my waist.

Rather than another small-town "Death By Water," the result was only an undignified scramble, and the embarrassment of borrowing my friend's mother's plaid wool slacks. My own mother later confessed that *her* mother had wanted her to marry that boy's father or one of his uncles. This lightly entangling genealogical footnote transfers the family romance safely back to the portrait of Benjamin Wheeler, my own kissing cousin, whose skates remain unseen in his conventional, torso-only pose. Perhaps they are already laced— perhaps he can make it to wherever he's going, if he hurries, before it gets dark.

262

ENGRAVING

J. D. McClatchy notes that poets writing about painting tend to write about style, and makes the point that "describing" a painting lets a poet "study figurative problems."[1] That since the nineteenth century poets find material as much in the media as in the objects of representation is also one of John Hollander's arguments about ekphrasis in *The Gazer's Spirit: Poems Speaking to Silent Works of Art*.[2] As a commuter to a three-week master class with Mary Jo Salter at the Atlantic Center for the Arts, I drove early to the ACA library and browsed editions of Albrecht Dürer's woodcuts and engravings, pages so crowded Mary Jo described them as "Renaissance *Where's Waldo*s." In a workshop defined by poetic form, it seemed natural to consider the prints' different methodologies, and when the workshop was ended, I sustained myself with a secondhand copy of *The Renaissance Print*, which included such passages as:

> Another aspect of woodcut design determined by the exigencies of printing are the flights of birds so often populating the open areas of sky . . . these details are present in part to float the sheet of paper evenly across the emptier spaces. . . . Failing such precautions the dampened paper would often sag into the irregularly chiseled depressions on the block and become badly smudged with ink. Impressions flawed by this sort of problem are legion.[3]

This apologia for birds—and the dire warning for makers—suggests that other arts might benefit from repeating elements, that these both lighten in tone and deepen in texture the metaphoric weight. Certainly, the technical miracle invoked bears a family resemblance to what happens in poems anchored and buoyed by some sort of repeating line.

That I was also aware of a gendered element and opportunity in writing about Renaissance prints seems clear in retrospect from some of my subject matter. The work of knife and burin suggests what in Catholic school used to be called "indelible marks on the soul." But in retrospect the method of incision—what happens when you join in perpendiculars two different strokes—also suggests a tactic for considering other joined pairs: the popular engraver Israel Von Meckenham's ill-matched lovers, say, or Giovanni and Giovanna Arnolfini's different poses, chosen from a Renaissance model book. In these cases, "figurative problems" are simultaneously "the problems of the figures as here represented" and "the problems of making figures," and we are reminded of the familial connection between all

art when this becomes as true for the poet as it is (more literally) true for the painter.

The couples I was drawn to are also, I suspect, a metaphorical way of considering dichotomous thought. Luce Irigaray, following Lacan, argues that dichotomies are themselves phallocentric: certainly I tried to find a way out of this dilemma once in a paper about Jorie Graham's self-portrait poems.[4] At the time I had no idea what I was groping for, and one of my colleagues opined that I really needed to go the long way round to see Graham as any sort of feminist. By now I can make the point from my own experience more clearly, but perhaps it is still the long way around for poetic practice to say that ekphrasis offers a third option that undoes elements of its double art. In the Catholic terms of my childhood, what occurs ekphrastically is like what happens after the Father and the Son have set up their sturdy carpentry shop. On a good day, a bird appears whose presence changes everything.

THE MODEL BOOK

When figurative problems include the literal figure of a poet, different issues emerge. I had long been an unwieldy photographic subject, a regular at grade-school photo retake days so my eyes could have another chance to open. Therefore I was hardly prepared for sitting for some of the oil painter Gary Bolding's series of off-center portraits on rich, unfigured backgrounds. Other models for other painters had suggested the situation could be fraught, and I'd read about various discomforts (in Zola's *The Masterpiece,* the outcome is tragic). More literally, Degas's working-class models were often contorted for long sessions in his cold, undusted studio, although they felt affection for the artist whose fees they so amply deserved. Several people seemed to assume I would pose naked, and asked questions as if such a close encounter was inherently sexualized (none of these, of course, were painters). And not all models were suitable: Helena Rubenstein was cruelly caricatured after she nagged Picasso, and John Singer Sargent, who had asked to paint Mrs. Gauthier, found himself morosely traipsing around with his sketchbook all summer after the fidgety beauty who at last became Madame X.

If I didn't initially have a figure of the model firmly in mind, "the portrait" aspect seemed likewise unclear. While I wasn't being paid to model, the painting wasn't commissioned, either. And because the figures in the series were all in some sort of striking relationship to a larger, apparently monochromatic background, there seemed to be a

greater subject. All this in addition to the dynamic of life painting: the positions of observer and observed imply dichotomy; the third, literalized thing between them becomes art. And of course this was also literally a working situation. My part of it meant that from a studio chair I saw the back of the canvas, the easel supports and, in my first pose, a window that I memorized like a painting, because three palm trees helped me mark the position the actual painting soon required.

I now feel that the woman in that initial portrait had already preceded me into the room. Gary mapped out proportions and filled in layers of background before I started sitting, and my dress, a blue silk Chinese robe, soon greeted me from a hanger kept in the studio. While I was sitting (or vanishing out the window) I was hardly present to myself at all. When I looked back what I saw was the painter and the studio—the work, not The Work. It's amusing now to consider a photo Nancy Barber took at the time called "Two Garys and Three Terris" (fig. 18). It steps behind the artist to observe how the room is aimed at the light source and filled with reflections: a mirror, a window as mirror, the artist's own self-portrait, in agreement with the point that a name is a gathering of made things. In the photo there seem to be a lot of us, and a lot of sheer stuff—books, rags—in that room. Who knew? And in the resulting portrait the subject is indeed

Fig. 18. Nancy Barber, "Two Garys and Three Terris" (2001), black-and-white print.

heavily decorated, with beautifully painted flowers on the robe and loose hair—indeed, an early title contender for the painting was *Woman with Dürer's Hair.* Perhaps this is one reason why, when the painting was first shown in exhibition, gallery visitors seemed compelled to say that the portrait "doesn't look like you." This has always seemed irrelevant. I was very interested, however, in what the painting looked like removed from easel to wall, how a trapdoor over the space I used to inhabit had snapped shut. And that just to one side hung Becca Albee's enigmatic aerial photographs of the marks figure skates leave on ice.

I sat for four portraits in all—or, as a model might figure it, for eighteen months of mostly three sessions a week, two and one-half hours a session. I was not the only model for this series—indeed, one of my poetry students occupied the chair right after me during the second spring. I loved not only this but the whole ritualistic nature of the enterprise: the door opening, the wonderful light, the smell of paint and solvent. And I immediately enjoyed sitting—it was restful to be thoroughly examined in a way that didn't require response. I also liked sitting still—the hard thing about sitting through Catholic Mass in elementary school became an adult pleasure in senses awakened but not wearyingly heightened—it was like listening to your breathing or heart rate instead of ignoring them.

One thing I could always turn to was the paint, blobs mixed on a piece of glass balancing the top of a movable cart. And the eye of the artist as it turned toward me, and his hand as it reached for the paint. I thus had a chance to observe how a different art literally worked (although I couldn't see the painted side of the canvas until a break in the session) and Gary and I, friends for a decade, also talked when he wasn't painting my mouth. His description of painting as a series of moments that are layered, overlapping, and consecutive but not sequential (whereas photography seeks one moment only) seemed like a lyrical statement. His penchant for tiny brushstrokes, even on huge canvases, also seemed painstakingly familiar. At the same time I envied the fact that he could talk at a certain level, or listen to music, as he worked, that some passages required less concentration than others, that he could work all over the canvas and not be trapped into syntactic progression. Yet he was much more bound to the larger physical world as a painter than I am as a poet—if it was too overcast, for example, he didn't paint. All this to say that despite my tendency to vanish out the window (a situation that changed after the first portrait), I was very aware that the northern light illuminating the painting space had at least a sympathetic relationship with the southern light falling over my shoulder when I write.

Even at the time, then, I was as interested in the situation of the artist as I was in the pose of the model, a response complicated by the fact that it seemed logical to write ekphrastically about my experience, and I had received a summer grant from my university to do so. Yet when I tried to write poems about sitting, a protective veil descended. John Singer Sargent once noted that "a portrait is a painting in which there is something wrong about the mouth," and it is true that I couldn't speak in any customary way about the paintings I was sitting for or my experience modeling.[5] I queried whether I was avoiding something in this reaction: did I suspect that I would be complicit in my own "capture" or "consumption" somehow (these metaphors are persuasive and prevalent, and I had to consider them)? I can only say that as descriptors they seemed inexact and superficial; more importantly, they seemed fearful. I was not Mary Rowlandson, house burning, on a forced march with captors driven by their own exigencies. If I was of use, I was also not able to be "used." And no matter what the subject, it seemed an unusual privilege to watch artistic meaning brought forth from materials: if the literal consequence was paintings, it was also, in my case, knowledge. And hours of collaborative stillness in which flourished, in a particular way, an inner life.

Yet I was frustrated and stymied, six months in, at not being able to write about my experience. A more autobiographical and/or narrative poet would have been able to summon different resources (perhaps she would have had an easier time of it, too). After several false starts, I remember asking Sam Gwynn for help: at least I seemed to be able to write about other women sitters, and had shown him a draft of a poem about Madame X. He suggested I write about modeling as if I were keeping a diary—this would impose some order. He then gently noted I had set myself a task before I even knew what I was learning. I remain grateful for and humbled by this observation. Gary's hand could move while mine stayed still. Nothing was lost. The mind touches all, yet takes nothing to task.

ONE GARY AND TWO TERRIS

As if in response, the beginning of the second portrait changed the terms. This time, Gary had not already painted in background, and would sketch in paint directly onto the canvas. Other aspects were less constructed as well. What Gary was initially most interested in painting had been banished: Dürer's hair was pinned back. Rather than donning a waiting dress, I took off the clothing I arrived in to

get into a black slip. Most significantly, I was to hold my face toward him but turn my eyes sideways into the room—he had in mind LaTour, as I recall.

I have always enjoyed LaTour's showy lighting, those candles opening into the contemplative face of, say, Mary Magdalene. It's not surprising that once the terms of the lighting changed (now I was not looking into the window but away from the light falling over my right shoulder), I understood modeling differently. I was now in the room with the painter, and indeed more in the room than the painter: I had lots of time to notice, for example, the rings of books and papers circling away from the doorway. And to look at other paintings. In Osbert Sitwell's lively memoir, he remembers the exigencies of sitting for a family portrait with John Singer Sargent: the bored boy often stared off at a triple portrait of the Wyndham sisters, whose children would soon be the friends of his adolescence.[6] It was my luck that Gary kept propped against one wall a large painting he'd been working on for over a year (it would be several more years before he finished it) and still considered something of a problem. A large figure of a man wielding a weed whacker in front of spiky mountains already possessed the blurred downward-looking concentration of the Dutch girl in my parents' upstairs hallway, and he was much better painted. Other paintings appeared in the space: soon Gary would begin a third, smaller portrait, and I would sometimes sit in the usual chair and find the larger, sideways-looking portrait facing me, turned upside down so he could see it differently.

The most revealing moment came in the opening days, when I turned my eyes sideways as directed and discovered I could see through the canvas. I have to say my hair stood up on my arms as I realized that I was watching my torso take form like a looming shadow. Once more layers of paint were applied, especially to the background; I vanished from my side of the canvas even as I thickened on the painter's. This was ordinary magic that didn't feel that way. A few years later, Mark Strand remarked in a workshop that a poem "must erase its sources, even if that means erasing the world." In the opening days of sitting for the second portrait, it was a thrill to watch the vanishing that paradoxically ensured material existence. I have always enjoyed Derrida's sleight-of-hand notion of existing "under erasure," but this seemed quite different: the canvas was only literally a palimpsest. Metaphysically, it was about what and when light showed what it did, and when this was hidden. And, as with what exists under erasure, nothing could ever be quite lost.

This was a difficult pose. I was often chilled by the air conditioning (it was now high summer in Florida), and turning my eyes sideways

reminded me of my mother's (and everyone else's mother's) warning not to cross your eyes or they'd get stuck. Fortunately, I only slewed my eyes to the left while they were being painted. I had to hold my head in the same position no matter what. This meant that I mostly looked right at Gary while he looked up and down and away, paint tray to model to canvas. I would watch his blue eye, very still and cool, as it stopped, then moved on. We were also very close, something I would not have said when I was looking out the window in the first portrait, though the actual distance was similar. Ease was constructed differently in this pose, then. To look back was literally restful, because it was my break from the pose. But it was also both restful and reassuring not to drop one's eyes—how often we treat gaze as a matter of hierarchy was brought home to me by sitting for *Terri 2*.

This is my favorite of the paintings, though most people prefer the next, a small one with a red background that Gary called *Watteau Terri* while he worked on it simultaneously with its larger predecessor. Some people, including my children, have a hard time looking at the second portrait, finding worry and grief too observable there. I think it shows an inner weather very accurately. More important, the painting is masterful, layer by translucent layer. That its model will some day seem young to those who still know her may assuage initial unease. Or she'll go where no one knows her and be read in a way I can't imagine.

THE MODEL BOOK AGAIN

This is already the case with the final painting, purchased from the wall at the Faculty Show by visiting writers who negotiated the sale right before their joint reading in the gallery. Maybe they sensed that the closed-eye look, the slight smile, meant that I was looking down at a book. More accurately, I was flipping through art books for a page that let me keep my head in the new pose while still giving me something to see. It was interesting to turn pages without moving neck or head—like touching a finger randomly to a Bible page, perhaps, hoping for a message. That an unmoving eye could be merely a keyhole was something I had never considered; the way blinkless birds stare so completely before turning their whole heads is disconcerting enough to a shifty-eyed human. My gaze, turned toward another readable plane, was more fixed than ever. Yet the very narrowness of its scope—just a few inches—seemed no diminishment: rather, to summon Emily Dickinson, it was a chance to spread "narrow hands." Lots of bits and pieces moved quickly past and, as

with my attempts to write ekphrastically about sitting, what I thought would work did not. I had hoped the bustling paintings of Pieter Brueghel the Elder would keep any eye working and full. But my chin kept pulling downward—the paintings' narrativity meant I didn't stay still enough. I also had to be careful not to choose a page on which interesting text flowed out of range—it was simply too tempting to drift off on the neap tide.

I had never appreciated Jean-Baptiste-Camille Corot until I spent weeks observing his treetops and realized how he provided interest two-thirds of the way up his landscapes. There were some good moments tangled among his trees. But what I remember turning to again and again, and must account for the faint, painted smile in that painting, was a book about Giorgione. I can still feel the weight of it on my lap. The painting I usually stopped at was the enigmatic *Tempesta,* which provided hours of thought—indeed, I borrowed the book so I could read about the historic disagreements in interpretation, mostly fueled by the strange space between the nymph and the baby on the right hand of the painting and the strolling man on the left. Did they know each other? Did they even see each other? The question seemed relevant, even humorous. My favorite character, though, was a tiny bird on a rooftop, singing its head off no matter what murk, what ruined columns, what river between them.

In retrospect I hardly remember the last two paintings, smaller and also done nearly simultaneously, when it was clear the whole larger series was drawing to an end. Of course, I saw them later under other circumstances, and Gary gave me the little red one, my children's favorite. But my sensory impressions of those months are especially clear, perhaps because the trinity of artist, model, and canvas opened out in another way when I switched my gaze metaphorically into a bookcase (there had been one all along, of course, nestled next to the window). Gary and I had always discussed painters, among other things, though he had to be careful to keep his thinking light enough so he could concentrate on his brushwork. And, like every good teacher, he kept loaning me books. But when I actually considered one after another in a pose (choosing for a crucial few inches), it was like I was doing a version of my own work. How easily, it seemed, I had slipped into the pose of a woman who might write poems about painting by considering a book of paintings while she is painted. Somehow I had ended up with perfect existential working conditions without writing a word.

All this was very pleasurable, and a sexual element can be provided at long last by a reader of Picasso's imagery, Leo Steinberg, who claims that a book opened on a woman's lap is a familiar trope of

invitation.[7] That the fourth and final pose opened me back into my own work as a poet at the end of a year and a half seemed pure good fortune. Of course, in the finished painting there are no books and no lap. Her hair is pinned up into a wiry tassel. She looks down at nothing we can see and seems pleased.

This painting I see now only in photos—which are always, we recall, a matter of the moment. I am reminded that Edith Sitwell, who was well and often painted as an adult, once posed for a photo with her brothers before their long-ago family portrait by John Singer Sargent. A bad idea—they look old and irritable. Perhaps this is more how they looked while they actually sat for Sargent, though then, of course, they were irritable and young. Osbert reported that Sargent kept the two-year-old baby, Sacheverall, quiet by reciting a limerick whose last line was "again and again and again." And he was kind enough to move their family tempests off into the indeterminate spaces that unsettle that strange family portrait, in which the only characters who seem connected are the two little boys playing on the floor, although after a while the squirmy youngest was replaced by a wax doll who wore the real child's clothing.

Perhaps the photographer enjoyed the comparison more than his subjects did. My own eye tends to rest either on Edith's dark hat or between the photographed Sitwells and their childhood's painted selves. There stands a sideboard, a family heirloom, which also appears in the painting: indeed, their father had it shipped to Sargent's London studio to give some semblance of home. It's too simple to say that art makes sure we craft memory into the visible. Once the sideboard appears it can be filled or emptied of anything. Inside, then, curl rolled-up plans for elaborate European gardens, in case the family patriarch needs to step outside and consult with his gardeners. Here we may find enough stacked-up bank notes to keep the thriftless mother out of debtor's prison. Also stacked, although less neatly, are the books the Sitwell children will write when they grow up. Two lines from one of Edith's poems go round and around, like a moth that has accidentally been shut in: "Jane, Jane / Tall as a crane." At the sound of the little wings, two-year-olds everywhere are transfixed.

Several years later, I saw myself in a painting at the National Gallery. In Corot's *Forest of Fontainebleau*, a woman has thrown herself down in the foreground of a terrific landscape to read. Indeed, according to the gallery card, she is a late addition and therefore part landscape herself: painted rocks and a river's edge lie beneath her. The museum card surmises that this is Mary Magdalene, repentant (but very low-bodiced), and that she would been added as a historicizing touch so the Salon would accept such a big landscape, a genre

just beginning to find favor in 1831. The history of the painting seems to lie in such elaborate rationales. But it's simpler for me. Once I rested between canvas and book. Now the painted forest lies behind me. But what could this generic woman of her century (A fake peasant? Where did she get that outfit?) be reading? A spiritual tome, the official interpretation suggests. But surely that too is a metaphor for something one chooses and need not consider the end of, something in every sense of the word "before" her. Another forest, I'd say, if I hadn't already disappeared into it.

NOTES

1. J. D. McClatchy, *Poets on Painters: Essays on the Art of Painting by Twentieth-Century Poets* (Berkeley and Los Angeles: University of California Press, 1990), xii–xvi.

2. John Hollander, *The Gazer's Spirit: Poems Speaking to Silent Works of Art* (Chicago: University of Chicago Press, 1995).

3. David Landau and Peter Parshall, *The Renaissance Print, 1470–1550* (New Haven, CT: Yale University Press, 1994), 29.

4. Luce Irigaray, *This Sex Which Is Not One* (Ithaca, NY: Cornell University Press, 1985).

5. Evan Charteris, *John Sargent* (New York: Charles Scribner's Sons, 1927), 172.

6. Osbert Sitwell, *Left Hand, Right Hand!* (London: Peter Smith Publications, 1975), 246–92.

7. Leo Steinberg, *The Interrupted Reading, or How Men Have Perceived Women with Books from the 14th Century to Modern Advertising* (New York: Whitney Museum of American Art, 1987), 104.

VI
Comings and Goings, Endings and Beginnings

THE ESSAYS IN THIS CONCLUDING PART SPEAK TO THE SUBJECT OF ekphrasis by staging the acts of attention that are solicited and rewarded by works of visual art. Mary Ann Caws, writing of the poetry of her friend Grace Schulman, is concerned with friendship both as a metaphor and as a literal context for such acts of attention. In one of her essay's most resonant moments, she turns the painting *A Young Woman Drawing,* now known to be the work of a woman artist, into an emblem of the passion for "giving birth in beauty" that Socrates lodged at the heart of friendship in Plato's dialogues. (We chose this painting as the volume's frontispiece.) Stephen Yenser's essay on "The Debtor in the Convex Mirror," by Susan Wheeler, is a tour de force of performative (re)reading. A poet himself as well as a poetry critic, Yenser has remarked elsewhere of Wheeler's poems that they "live so insistently from moment to moment, they are difficult to excerpt or to summarize." His essay also defies summary, while proving deftly responsive to the poem's "florabundant energy," its dazzling allusiveness, its intricate verbal "catoptrics."

273

Grace Schulman Seeing

Mary Ann Caws

> the truth of radiant images that rise,
> unbidden, from the bottom of the mind's
> dark waters, to survive whirlpools and surface,
> mud-soaked, tattered, worn, to beach on sand. . . .
> —"Rescue in Pescallo"

I<small>N</small> "R<small>ESCUE IN</small> P<small>ESCALLO</small>," <small>A LONG, EVEN EPIC, POEM FOUND IN</small> G<small>RACE</small> Schulman's collection of 1994, *For That Day Only,* a wooden statue of Christ is washed up from Lake Como. Its wooden body painted white, its hair and beard painted black, its survival, in the church of San Giacomo, is something of a miracle—even for those who, like the poet, don't really believe in such things. For those others of us, no more believers, poetry that rescues us—or perhaps us all—from whatever waters we are likely to be submerged in can be something like that.

What truth is is not what is to be questioned, any more than what philosophy is or a poem is. Nor does any radiance examine that. I read it something like this: that a poem's reading of radiance is sufficient to light other things, visions if you like, of a wooden statue or a carved icon, or an idea. That it is not about how (or how not) ideas or poetry are true, but about how the image lights up whatever is around it. So I am taking that poem of rescue as itself an image of what this poet can do, does, with a vision or the feeling of a vision. Its detail is my focus here at the start; for in no way is it concerned with, say, theology or religion as such, or even art as such. It is concerned with rescue. Period.

Grace Schulman, a poet who is deeply involved with the visual, has spent various times of her writing life contemplating, from close up, what paintings can bring to poems. Her poetry, from the beginning, has that rare gift of focus: on an event or a person, so that the personality and its moral tenor springs to life there on the page. The bravery of an aunt, the singular and memorable personality of a mother devoted to Proust—and whose sensitivity to the aesthetic and the moral are carried on by the daughter poet—the intense love of a husband in whose life the scientific is prime. We are there with her

vision, from *Burn Down the Icons* (1976) to *For That Day Only* (1994) and on to her more recent volumes: *The Paintings of Our Lives* (2001), *Days of Wonder: New and Selected Poems* (2003), and now *The Broken String* (2007).

My friendship with this poet is all-important to me, for every reason and for a special one. My first love is the translation of poetry, even as I know it is thought to be impossible, and my second is the contemplation of paintings and the subsequent writing about them, even again as I know the limitations of that mixture of the visual and verbal. To share in the poetic and the painterly with a friend is about as joyful an experience as I have known. It does not let you down, it is not jealous of other relations, it is always trying to do something new and better without forsaking what it already knows and has found worthy. (I should add that I started writing this piece in Bellagio, where the poet wrote her poem "Rescue in Pescallo" . . .)

Schulman's sense of the possibilities of an ekphrastic sensibility, if I can put it like that, is an optimistic one. In *The Paintings of Our Lives*, she elaborates various ways of looking at the art object, painting or thing—a vase, a table, a sofa—and each time, it seems renewed by her looking and writing. This is, surely, what ekphrastic poetry is about. "*God lives in the detail.*" So begins Schulman's "A Goldsmith in His Shop," about Petrus Christus's painting in the Metropolitan Museum. It ends as it began:

> Base objects were examined from all sides
> until they shone. *God lives in the detail.*[1]

And that is just what happens in Schulman's poems: objects, base or just small, ordinary or just occasional, are indeed examined from all sides—and not found wanting. This poem is about, among other things, balance, the one held in the goldsmith's hand. Like the balance of poems of this sort, turning in a visual and conceptual circle. But they are above all about seeing. And what makes it possible, which is, I expect, the same thing that makes us possible. The poems are all about light, the one in the mind reading and writing and seeing.

It is in no way that within them there are not terrible things. A poem about the Jewish Parisian painter Chaim Soutine makes this intensely clear: his hunger, his signing his painting in blood. "Where God had been . . ." and the painter sings over the sobbing, for Icarus falling, for the forbidden making of the graven image—Thou shalt not—for all of us, who feel both bidden and forbidden:

> Days and nights
> He jabbed red-yellow strokes on canvas
>
> to make the wingspread, damning, pitying
> wings that reach for light and, falling, rise—[2]

This spectacle of the painter's raging and consuming all around him haunts Schulman's imagination: she has recently written another poem about him—I am suspecting it has to do with the painting of his name in blood.

Here is Soutine again, then, in the oddly memorable "Repentance of an Art Critic, 1925." Here are his dead turkeys, here his creeds drying in the Paris sun. Here windows opening on other windows nearby in Kisling's painting: *Air, light*. And here, too, in the center of the poem, is the thing I was hearing, when the paint was running free, like the talk at Le Dôme, before each painter returned to each easel. I am not a painter, nor is Grace Schulman. But she knows how to interrogate, in her poems, the painters exiled in Paris, as we are all exiled somewhere, in our minds. Here is the question, whose answer is exactness, deeply moving:

> Can the most foreign of the new Parisians
> share anything besides a lost law?
> I've said no. Was I wrong? I ask Kisling,
>
> who waves at his painting. It seizes me,
> and a voice rises from so deep I know
> it cannot be my own: the sheer exactness
>
> of bowl, knife, apple, keeps us from loss
> by capturing the day that does not end.
>
> (*Days of Wonder*, 168)

And in Kisling's studio, the real one and the vision he keeps of it, the paintbrushes wait, ready for the objects that will fill them, and the new painting, and our now seeing gaze:

> poised like rockets waiting to explode,
> a pipe, a half-filled glass, and a hand of cards.
>
> (ibid., 169)

Poetry is about both sides of the thing. The beam and the rage. The revelation and the hunger. The rubies of the goldsmith's shop and the blood of a painter—or of any creator. Or creation.

Among all of Schulman's painting poems it is the one entitled
"*Young Woman Drawing, 1801*" that most appeals to my sense of the
double arts of poetry and painting. This is the work in the Metro-
politan Museum first attributed to David, then to Constance Char-
pentier, and now to Marie-Denise Villers, that shows a young lady
sitting still and leaning forward, in her "hidden / boldness." That the
name of the painter has changed so many times is in no way related
to the poem—but it deepens its possibilities of reference:

> she hopes only to gaze into a mirror
> in shadow, sunlight falling on blank paper,
>
> until her penstrokes dance, and ever after,
> to slough off names and be one-who-has-seen-
> glass-shine. . . .
>
> (*Days of Wonder,* 135)

This woman poet, Grace Schulman, is gazing at a woman painter
painted by a woman painter, first named as someone else, but whose
name has finally come to the canvas. How eager they are all three . . .
how better to picture such intensity of the will to create? God and his
light of creation, the dove and his gift, are in no way greater than this
creative will of a human so gifted with desire. All work together in this
light.

But how can it be that she, the one who has seen the radiance, is
keeping a "dark vigil"? Why is the pane "shattered" behind her? The
others, proud, laughing, and in love, are on a terrace out there, in a
brilliant sunlight, while she is gazing in shadow as the sunbeams from
outside fall on the paper inside, and it is blank.[3]

For years I, like Grace Schulman, have looked at this painting,
under its different guises, as the names were shed and altered, and
the young woman remained so young. I have aged, and she is ageless.
We have all gone away and come back to see her self-portrait, "not
setting out . . ." (ibid.). Over all these years, she has sketched and
kept vigil, as if it had been for us. She has changed her names and we
have changed our lives—but perhaps not what matters the most.

Back to the basic things. In the title poem of the collection *The
Paintings of Our Lives,* objects tell the story: just a towel, some sconces
on the wall, just some pages of a book, a window, a fire screen, some
candles . . . and the red of a tunic and a doublet. These find them-
selves in Robert Campin's *Annunciation Triptych* in the Cloisters and,
somewhere else, Tiffany lamps and relics, and a menorah, again
united by red, with desire ("The Paintings of Our Lives," in *Days of*

Wonder, 146–47). These things remind me of you, yes, and of the poet's mother, things she keeps still "like present moments," including them, keeping them and their "thisness" in a poem simply called "Things." St. Thomas's *haeccitas,* the thisness found, kept, in poetry of the everyday: Hopkins was here, as in so many everywheres, in the reader's and writer's mind.

> Write them down
> as painters caught pure light in homely things.
> ("Things," in *Days of Wonder,* 152)

"Thisness caught." But not just thisness, also a kind of thereness. The art celebrated by the painter, "of reconciling all that varies," is also what thisness is about. How, in that modest and great poem called "Steps" white roses will mingle with the hot dogs (*Days of Wonder,* 178), how, in "The Paintings of Our Lives" (ibid., 146–47) a grand piano will mingle with those watches so heartbreakingly unwound . . . how a mother's calling for her toddler to go down "'And down and down and down,'" will somehow balance the father of Icarus and his mythmaking desire—and loss. For, as the small one struggles to step down, a tall one, in the opposite direction, the one loved, holding "two hot dogs and white roses," will vault up the steps, with a broad smile ("Steps," in *Days of Wonder,* 178).

I feel the same "American largeness" (what a grand phrase) in the poem of Henry James revisiting in 1904 La Farge's Ascension painting in the Church of the Ascension, near Washington Square. Here, the disciples watch the event

> until seeing is all they are. You are.
>
> I am. . . .
> ("Henry James Revisiting, 1904," in *Days of Wonder,* 144)

And we all are, seeing with them. This is inclusion in a watching, instructive about painting and gazing and being. And, as a subtext and a clear thought in many of Schulman's poems, about rising, after falling. This small church contains, somehow, an "American / clarity," and now, so strangely after 9/11, and the fall that struck us, an "American slant on survival." Here, somehow, doom is conquered by a kind of architectural nobility, James's word, so long after 1904. I read it now like a poem for a New York revisited, as poems renew:

> . . . And now I see you struck, then stricken
> As you scrawl "doom" in fear of towers to come.
> I write to tell you that Ascension stands.
>
>
> . . . White pear blossoms
> fall. Ascension rises. Some things remain:
>
> (ibid.)

So strange, this poem read now, as if that painting were standing guard over the town:

> and this church spire, ascended till it's turned,
> things being what they are in town, immortal.
>
> (ibid., 145)

This poem about survival and rising makes a large American impression on the reader who knows how to take it in conjunction with the Icarus figure Soutine has evoked, with the exultation on the Metropolitan steps—inside which building the Young Woman is still Drawing—with all those rises and falls of our conscience and our myths. This poem stands more powerful still for every reference.

Henry James, in a poet's way, knew somehow about—was struck by—that kind of doom of falling towers. This poet knows how that fall, both mythical and real, might be finally overcome by a small church whose spire marks its Ascension. In this town.

And here, with the largeness of American imagination, and the broadness of a beloved's smile, the simplest sight can be counted on, yes, counted on, to yield a vision, however modestly, on the rise:

> where Giotto's Magi open
> hands that rise in air:
> up, and up, and up.
>
> ("Steps," in *Days of Wonder,* 178–79)

That is, in a fine moment, what paintings and poetry can do in our lives. They give rise.

The extraordinary poem called by its own name, its painter's and painting's name, "El Greco's *Saint James, the Less,*" begins with a dispersal of light, a fracturing of moonlight "into mere threads of stars"; its focus turns inward toward what the painter sees, and, more importantly, what he has taught those of us who are not indifferent, to see (fig. 19). Here is the entire poem:

Fig. 19. Domenikos Theotokopoulos El Greco, *Portrait of St. James the Less*, ca. 1595, oil on canvas. Glens Falls, New York: The Hyde Collection, 1971.18.

This moonlight fractured into mere threads of stars
shines now on eyes indifferent or turned to some
 white peak inside that none but he sees,
 he, and those taught by the painter's vision.

Light falls on blue-and-red robes whose shadows are
black mouths that cry of glare that has deepened them.
 One hand unfurls; its lambent fingers
 curve down, then curl up, a torch upended.

That hand recalls a starburst that hung from a
white pine; it turned in altering light, and its
 green needles fell away and pointed at
 random, a fan on its branch, an uncertain omen.

One day a mourning dove that was stammering
faint notes flew low, splayed out like the tangle of
 white pine. The bird, the tree, and now that
 hand of Saint James are one form. The dove gone,

light stays, its glow the mind's brightness, gleam of a
first day on earth in tales of Creation when
 one beam that God devised, before the
 sun, would have shown us the world in one glance.
 ("El Greco's *Saint James, the Less*," in *Days of Wonder,* 103)

We have to see not just how the light fractures, not just how the stars
thread their narrow blaze, but a kind of white peak: like some interior
mountain caused by the moonlight and its afterglow. A white peak,
that the vision scales.

What a painting! How the robes' shadows cry out from their
depths; how the single detail of a torch held up makes us reflect—
and that is the word, reflect, our reflection lit in its own depths and
hollows and peaks—on the up and down of the fingers' motion.

White peak, white pine . . . the stars have come down earthly, to
our forests. They hang there, right there! In our vision. Even as the
light shifts and alters, the hand guides the eye. One hand, like the
painter's hand, like our hand reaching out for something. Uncer-
tain, that something, for we don't know what the light is pointing at,
beyond the painting. The sight is not sure, suddenly, as the omen (of
what?) is unsure.

And so the poem itself must turn. Like our seeing. The narration
shifts to voice the stammering, the faint notes of uncertainty. That
dove is flying low: why? Its feathers are splayed out, why? Everything
now tangles together like a plot gone wrong or confused. Bird, tree,

St. James's hand . . . His was that hand, we didn't know. One form from all. We didn't know. And the bird departs. Yet . . . what stays is what matters, and this is a light previous to moonlight and starlight and sunlight—this is the real light, and it is with us.

Our eyes mist over. This is not just a tale of Creation, it is a parable of a painter's and a painting's creation, and what is created is not just a figure but a vision we have to learn to see.

Seeing is not simple. Seeing through art is often a tangle. White pine, white peak, green needles all atangle. All altering in the light. What is that hand pointing toward? I am not so sure we know that, even as it recalls a starburst, I am not sure we know what it is designating. What the painter's vision teaches us. I do not think this poem is about certainty.

And I am glad. How could we be so moved by something sure? For we now see the tense of the last verb: "would have shown us. . . ." How far from certainty we still are. El Greco's vision: precisely what we do not, cannot, know about. Why are those figures so strangely elongated—deformed, as some would have it? Was it his strange vision? Strabismus or something else? It is very precisely not just any saint's hand, not just any painter's vision, not just any "real" creation—this is a tale of Creation. A narration about vision. A poet's vision of a painter's vision, if you like.

Each of these amazing paintings indicates, I would venture, all creation and its terribleness quite as surely as that one beam of light glancing down and revealing everything at once. So let us read it again, in the light of uncertainty. Baroque vision singles out the strangeness, the shine as fractured, the light as unevenly threaded, the dove as stammering. God gives us eyes not indifferent, but sensitive to difference; this poem does not preach, it simply is. Like light.

And now here is what I think about it. It seems to me that this poem is like a hand, lesser or major, it matters little, pointing to what we can expect—and all we can expect—of a poem and a vision and a painting. These are, also, the paintings of *our* lives. The days of *our* wonder. Schulman's poems act through the altering and the tangling and the falling away: they themselves do what this one teaches us to do, turning often through a ferocious "cry of glare" and always through a kind of light seen in, perhaps brought by, a dove, when,

The dove gone,

light stays, its glow the mind's brightness, gleam of a
first day on earth. . . .

Poetry about painting is, at its summit, really about looking with a firstness only paintings can teach. God devises the world, but the painter devises a way to show us how to look. When we are not indifferent. We can, through reading, looking, and re-visioning ourselves, learn to look both at the detail and at the whole picture, so that we see finally as well as firstly, "in one glance."

Notes

1. Grace Schulman, "A Goldsmith in His Shop," in *Days of Wonder: New and Selected Poems* (Boston: Houghton Mifflin, 2004), 159. All passages quoted from Schulman's poems are taken from this volume. A footnote to this poem (ibid., 188) ascribes the quotation to Gustave Flaubert, perhaps.

2. Grace Schulman, "Chaim Soutine," in *Days of Wonder,* 120.

3. . . . As she sits forward, still,
 she hopes only to gaze into a mirror
 in shadow, sunlight falling on blank paper,

 . . . she keeps a dark vigil,
 while behind her, outside a shattered pane,
 proud lovers laugh on a terrace in bright sun.
 (Grace Schulman, "*Young Woman Drawing,* 1801," in *Days of Wonder,* 135)

"Pregnant and smoking": Susan Wheeler's "Debtor in the Convex Mirror"

Stephen Yenser

ONE CAN BEGIN ANYPLACE: THAT IS THE WARRANT GRANTED BY Susan Wheeler's poem "The Debtor in the Convex Mirror," which concludes her new volume, *Ledger.*[1] According to its epigraph, the poem follows in the steps of "Quentin Massys, c. 1514," whose painting usually known as *The Moneylender and His Wife* is Wheeler's point d'appui. Or one of them. As her title proclaims, she is also indebted to John Ashbery's masterful ekphrasis, inspired by Francesco Parmigianino's painting *Self-Portrait in a Convex Mirror.* The two poems reflect aspects of each other, or overlap—as the two paintings do. Indeed, it will soon be difficult, amid this maze of imbrications and catoptric images, to keep anything apart from anything else. Which is the reason one can begin anyplace.

So one might commence far afield, with, say, Douglas Hofstadter's summary in *Gödel, Escher, Bach*—a summary prompted by Escher's own self-portrait in a convex surface in *Three Spheres II*—of a fundamental Buddhist concept:

> The Buddhist allegory of "Indra's Net" tells of an endless net of threads throughout the universe, the horizontal threads running through space, the vertical ones through time. At every crossing of threads is an individual, and every individual is a crystal bead. The great light of "Absolute Being" illuminates and penetrates every crystal bead; moreover, every crystal bead reflects not only the light from every other crystal in the net—but also every reflection of every reflection through the universe.[2]

But then nothing would be "far afield" in this model of reality, familiar to us these days because of our traffic in the Internet, holograms, and fractals. In any case, one might begin with Indra's net because of Wheeler's affinity for filature—"And these coins, fragments of a web," she writes provocatively in a sentence fragment near the beginning of this poem that is itself a network. But perhaps at this point the god's net feels more like a conclusion than an inception.

285

Better to set out from the gold "coins" alluded to in that quotation, which are featured in the painting of Massys, or Metsys (fig. 20). There is an opulent pile of them before the moneylender, who is weighing others in a scale as his wife looks on. These two formally formidable figures occupy most of the painting, the rest of which is rife with lovingly rendered particulars on the table at which they are seated and on the shelves behind them: bibelots and books, a flask, scrolls, rings on a sizing spindle, a candle, a string of pearls, and so on. The wife is leafing through a codex in which we can make out— though the book is upside down to the observer in what must be a reminder that the secular world, proverbially, inverts the sacred—an illumination of the Madonna and Child. (This painting within the

Fig. 20. Quentin Metsys, *The Money Changer and His Wife*, 1514, oil on wood. Paris: Musée du Louvre. Photo Credit: Scala / Art Resource, NY.

painting is one reason that Massys's canvas has often been viewed as moralistic.[3] Wheeler's poem implicitly refutes that notion.) Among other presumably pawned items, meaningfully adjacent to the codex, is the small, oval, convex mirror, which the careful viewer will see reflects the face of the debtor, who wears a red hat and has come to the moneylender for relief. It is a face that art historians take to be a portrait of the painter, Massys, à la the self-portrait in Jan Van Eyck's *Arnolfini Wedding*. Next to the mirror, in turn, we see a round, gold étui for the moneylender's weights; its shape rhymes with those of the mirror and the coins and the pans of the scale. One suspects a chain of metaphors or metamorphoses—and might recall Wallace Stevens's notorious dictum that "[m]oney is a kind of poetry."[4] Which would also be a fine place to begin the discussion of this poem, since Wheeler calls our attention to an old, related etymological muddle:

> *Livre tournois,*
> the French would call them, units of money valued at a Roman
> pound, and *livre, book:* not the first time the two're confused.
>
> (*Ledger,* 73)

Money is a kind of poetry for several reasons: coins, like words, have value and should be weighed; like terms in a metaphor, coins or bills are quickly convertible into other coins and bills that look different but are in one sense the same; coins and bills bear symbols, sometimes mysterious ones; and currency circulates and connects people, even across national and cultural boundaries.[5] Wheeler's poem begins—as we might also begin—with a survey of coins from all over the world and the poet's own gaudy heap of similarly heterogeneous words, which overflow even her ample lines:

> He counts it out. By now from abroad there are shillings and real—
> Bohemian silver fills the new coins—but his haul is gold, écu au soleil,
> excelente, mostly: wafers thin and impressed with their marks, milled
> new world's gold the Spanish pluck or West African ore Portugal's
>
> slaves sling. The gold wafers gleam in their spill by scale.
> Calm before gale: what bought a sack a century before almost
> buys a sack now. . . .
>
> (ibid., 65)

The passage hints at a linguistic accident that Wheeler later capitalizes on: that *coin* is French for "corner," and therefore the corners of the world converge at the moneylender's table. Near the poem's end, further teasing out the bilingual pun, she also refers to an "angle" in

the painting's composition that echoes another "angle" (ibid., 80). Like this passage's internal rhymes and other sonic effects, such semantic overlappings, including that of "sack" upon "sack," reiterate the mound of coins. A *thesaurus* is literally a "treasure," in a word. The mass of money is a gorgeous, miniature translation, if you will, of Indra's net, and so is the poet's language, sumptuary and sumptuous at once.

Or one might set out from a generalization about Massys's genre painting: although it focuses on a confined interior scene to the extent that at first blush it seems somewhat claustrophobic, there is nothing in the world that is not there. The convex mirror that holds the debtor-painter's face reflects a window, a pair (so *many* pairs in this work!) of small, stained glass panels above a pair of taller, clear panes, through which we see foliage of a couple of trees, the sky, and a church steeple. When we note—thanks to our docent, the poet— that the debtor is holding a book while looking out the window, we realize that the small oval mirror contains in effect the entire world: nature, humanity, art, religion, literature. It is a synecdoche for the painting—in which we have the wife's open book with its religious scene, along with the other texts and varia, and a door ajar, through which we can see another pair of people, conversing outside, whom Wheeler imagines as awaiting the debtor with his fresh cash—which is itself a synecdoche for the world at large.

Wheels within wheels, we say. And we could also commence with the poet's surname. She subtly invites us to do so in a giddy section near the end, by which point she has introduced a figure not in the painting but contemporaneous with Massys, a "rube" she calls Charles (suitably, the name, cognate with *carl* and *churl,* means simply "man"), who like the painter has come to the city (Massys was from Parma) to make his name and fortune. In Antwerp, a vital center of commercial, industrial, and artistic activity (painting was itself a commercial venture that approached being an industry), this everyman stands in the midst of the urban turmoil, "in a cloud left by dusty wheels," and hears fragments of speech all around him, along with "strange songs of spring that reach [him] in worsted wraps, wheels clattering about his self, while each breath, immarginate, // clangs to differentiate its action from the world's" (ibid., 76). It is no accident that the first line here is so long that it requires hanging indentations and thus spills over into prose before our eyes before it reverts to verse. The poem—a microcosm of the swarm that existence is, we might eventually surmise—moves continually from the differentiated to the "immarginate" and back again.

Having noted in passing that a "wheeler" can be not only a wheel-

wright, or maker of wheels, but also a worker attendant upon a spin-
ning machine (the other two workers required are a "pointer" and a
"stripper"), as well as a needleworker who fabricates "open patterns
or decorations with radiating threads" (the *OED*), we discover that we
are back with—we have never left—Indra's net.

But rather than break a butterfly on a wheel, we can start again with
the title of Wheeler's collection, *Ledger*. When she points out the
"account books" on a shelf behind the moneylender and his wife, we
cannot but insert this very volume among them. (Wheeler provides a
tiny portrait of herself in the form of one Anna Bijns, Charles's
romantic interest, a writer of verse and doubly a "woman of means"
who has her own "whole shelf of books" and "writing-room.") As she
later implies, poets and moneylenders are both "Bookmakers." Of the
making of many books there is no end, as weary Ecclesiastes saw, and
others who have committed the act include art historians, in whose
lists, as in Wheeler's acknowledgments section, we may find Max
Friedländer, in one of whose works Massys is taken to task, Wheeler
instructs us, for his virtuosic effects, his "pyrotechnics, 'new wine
poured into old bottles,' " which effects spring perhaps " 'from a kind
of nervous energy—in any event, not from the heart' " (ibid., 68).[6]

In the critic's view, that is, the painter was himself all too precisely a
"debtor" to Leonardo and Van Eyck, who made his own "painter's
joke, / shallow as they go," when he put his face in the moneylender's
mirror. Well, "Holier than thou," one might mutter, especially in view
of the connoisseur's use of the antique phrase "new wine poured into
old bottles." So it is gratifying when, toward the end of her poem,
Wheeler rounds on him:

> What is this but an arrangement of figures of figures on an open field?
> But they *overlap*—and this is the *heart*, despite Friedländer,
>
> the heart of the bind of the debtor: a debt becoming due.
>
> (ibid., 79)

She does not need to insist that all artists, not to mention art histo-
rians, are indebted to predecessors: Massys to Van Eyck, Ashbery to
Parmigianino, Parmigianino to Van Eyck, herself to Ashbery—it is all
a mesh and mess of indebtedness. (Wheeler asserts her own debt
with ironic aggressiveness when she informs us that "Though the
lineage's strong for the sons of moneylenders / daughters don't
carry" [ibid., 79]. And, indeed, ekphrastic poems by women, so viv-
idly a part of our literature, were rare a few decades ago. Not that we
were flooded then by other poems by women.) Furthermore, as the
Christian motif in this painting alerts us, all of us since Adam and Eve

(the pastoral originals of the moneylender and his wife) have been in debt and in need of someone to bail us out. In this fallen urban world, this world of lapse and overlaps, we have all been "impressed," to borrow another of Wheeler's recurrent puns.

One could equally well begin, in other words, with this extravagant poem's most extravagant passage, a flashback to a delinquent moment in the poet's past, when she and a friend—"Thérèse: / careful, Catholic, pregnant and smoking" (ibid., 69)—colluded to shoplift some lipstick at Christmas. But then who among us should 'scape whipping? Certainly not, Wheeler insinuates (she is not so crass as to make the point explicit), a man with the name Friedländer, which in this dense linguistic context implicates its possessor in lending and borrowing. Wheeler delicately administers the coup de grâce on the poem's last page, where the phrase "Friedländer meant" yields, by way of "angles" that any billiard player would admire, to the phrase "Wheeled overland." Here is the poem's conclusion, another potential "opening," to cull a word from it, especially since it has its own "mirror," in which the New York present and the Antwerp past intersect:

Car door creaks its opening, back for a pack
of cigarettes. Side mirror loose, door slam. Wheeled overland

 from Venice
the Venetian goods—and cotton, from Levant—
are writ up

 (in the noon sun and portside)

 and certified lading.
The paper suffices for sugar and salt.

 (ibid., 80)

For sugar *and* salt: for a certain sweetness for the painter and a certain sharpness for the wound inflicted on his critic, maybe—though we also recognize the ambivalence of "salt" itself, which points us in the directions of sorrow and savor alike.

But the obvious place to embark on this essay would be the figure of the moneylender himself. As a member of the profession Jesus expelled from the temple, he shares something with the shoplifting poet, and there are other links. Both are by vocation concerned with

"numbers," with weights and measures, and as he assays his gold, so she calculates her syllables. Each is meticulous: he must be alert to scrapings and clippings, filings and fillings that would affect the coins' values, and she must take into account the origins and overtones of words. As he changes collateral into currency, she turns—for example—him into her. The coin of her realm is figurative language, to put it one way. Because he writes down his accounts, he is a "scrivener" who mirrors the writer of *Ledger*, and if he is perforce many another type—"borrower, clipper, catcher, coiner, getter, grabber, hoarder, loser, lover, raser, spender, teller, thirster" (ibid., 66), to appropriate her alphabetical list—so is she. Even as she distinguishes the moneylender from the impecunious "red-hat" (the debtor she also is), her play on words merges them:

> scrivener lays out upon collateral, but
> what has the red-hat? Zero

> and then sum.

> So *here* you are. Master.
>
> (ibid., 66–67)

And no sooner is the debtor-painter-poet "unconjoined" than he is stuck with the book he holds, whose pages blur out into "paper" money. Wheeler could have called her poem "The Artist in His Studio."

At the same time, Charles, the rube in the street, fades by virtue of his counting of ducats into the moneylender, even as he catches a glimpse, in Wheeler's subplot, of Massys. (That Charles and the painter are alter egos is the gist of the homophonic pronouncement "it's Massys he sees.") So we could have begun with Charles, who is not even in the painting, glancing at the painter, himself

> off to work in the salt-crusted air, preparing

> —away from the *shadow of a city, siphon,* you wrote, of the life
> of the studio—

> his self to be seen.
>
> (ibid., 73–74)

We could have begun with Charles because he stands in for Wheeler, who has always in the *coin* of her eye John Ashbery, who has told us in his "Self-Portrait in a Convex Mirror" how inevitably "Business is carried on by look, gesture, / Hearsay," and whose poem Wheeler quotes in the italicized words in the preceding passage. The city, on Ashbery's account, "wants / To siphon off the life of the studio, deflate / Its mapped space to enactments, island it," and he wonders whether the older Parmigianino, the man who has put the self-portrait behind him, will be able to retain his energetic integrity.[7]

The "you" Wheeler addresses, then, is Ashbery himself, an avatar of Massys as she is a shade of Charles. And that is why one could have begun with one of the minutiae in the painting, made to count several times in the poem: the barely discernible gesture of the man seen through the door behind the moneylender's wife, his "forefinger and thumb in a U." As Wheeler moves immediately from this detail to Massys's convex mirror, "In the fore of the table, a diverging mirror, gold frame, / askew" (ibid., 70), she obliquely rhymes "U" with "askew," so that when she proceeds to the mirror's reflection of the "red-hatted man who holds // a book to his chin as though he were sunning" (ibid.)—as though the mirrored man were holding a mirror, that is—the man, Ashbery, and she all reflect facets of one another. "The man hand-making his U in the yard," to cadge from a later passage in which she draws our attention to that measuring gesture (ibid., 78), calls up Wheeler making her "you" or Ashbery, her variation on the Muse. Not that she means to rival Ashbery's "Self-Portrait": "Your own [painter, Parmigianino] looked out at us, but mine, Massys—disingenuous, masquerading, stressed and damp—doesn't; weightier / things on his mind he's not got" (ibid., 74–75).

That avowed if disingenuous disparity between rube and sophisticate notwithstanding, she no less than Ashbery is "preparing . . . a self to be seen"—in him, in the moneylender, in the debtor, and so on and on. (It would doubtless be de trop to see a link between the "red-hat" and the poet as teenage thief by way of Little Red Riding Hood.) Or one might say that from her perspective Ashbery pre-paired himself with Parmigianino, or that Massys pre-paired the moneylender and his wife, for the advent of Wheeler and Massys, or Wheeler and Ashbery. Ashbery's question in his poem might be hers in spades: "can the soul *swim out through the eyes and still return safely to its nest?*" Her response ostensibly echoes Ashbery's solipsism: "I cannot leave," and "Maybe it's our internalness / we're stuck on" (Wheeler, "The Debtor in the Convex Mirror," 76). But in fact it is a triumph of this preeminently Ovidian poem that all of its elements are fungible. Wheeler's close reading of Massys's painting in the

various light of Ashbery's "Self-Portrait" allows her to liberate and transform everything that comes into her ken. One might venture that the boundaries in and indeed *of* her poem are transparently permeable and that once this dialectic, this melting of forms, this multiplication of *I*'s has begun, it can hardly be terminated. Instead of lamenting the multifarious city's siphoning or sapping of the soul's energy, the poem animates all it contacts, and since everything is connected, it sets off a vision of a chain reaction.

"He crams so much in, Massys," Wheeler exclaims. "Every surface filled with hardware, pots, jetons—a collector's box—" (ibid., 77), a term that like the painting proper conjures a *Wunderkammer,* and if she emulates the painter-collector, it is because she thinks that the aim of such a poem is to epitomize the florabundant energy in which the world's bizarre diversity manifests itself. The wonder cabinet, heuristic a metaphor as it might be, however, lacks the fluxional, processive nature of the world in which Wheeler's whirling vision participates. Perhaps another way to put the notion is that there is less room for the temporal in Massys's painting—indeed, in any painting—than in such a poem. There is no space for time, so to speak. Not that Wheeler involves herself in chronological narrative. On the contrary, another way to say that one can begin a consideration of her poem anywhere in it is that all its events happen at once. (In one amusing passage the sounds of "unrecognizable tongues" spoken by dragomen in a street of Antwerp intermingle with the "THX *clok*" of the horses' hooves in the movie of the scene.)

But there is also a sense in which words, like music, as Eliot writes in "Burnt Norton" and eloquently demonstrates over the whole of the *Four Quartets,* move "only in time."[8] Let us take another ekphrastic work, a lyrical gem: John Berryman's "Winter Landscape,"[9] which frames, by virtue of its repetitions of word and image and its single sentence, an unchanging scene, and in effect freezes anew the moment the elder Brueghel froze first in his *Hunters in the Snow.* But at the same *time,* Berryman's heavy enjambments not only enforce the proposition of language's inevitable sequentiality but even exploit his lines' inexorable movement down the page and thus insist on the passage of time. Adam and Eve came down from paradise into the fallen, temporal world, and we, or our artists, have been trying to have it both ways—immutable yet metamorphic—ever since. The problem with Stevens's stuffy protagonist in "Anecdote of a Jar" is that it wants things just the one way.[10] James Merrill's fallen vase in "Syrinx" tries to redress the balance.[11] Berryman formulates the desideratum in his concluding description of the birds in Brueghel's painting: "three birds watch and the fourth flies." The name of that

fourth bird, or dimension, must be Time. Time flies. If time is also somehow money, as the moneylender-debtor-artist seeks to persuade us, that proposition is no bar to the fundamental axiom.

Wheeler's more dramatic interventions in the name of Time resemble Ashbery's parabases rather than Berryman's final image, which is along the lines of Keats's and Yeats's oxymorons, "cold pastoral" and "golden bird."[12] "The balloon pops," Ashbery admits at one juncture, in seeming disappointment, and then "the attention / Turns dully away. Clouds / In the puddle stir up into sawtoothed fragments. / I think of the friends who came to see me, of what yesterday / Was like." Here are a couple of Wheeler's acknowledgments of comparably mediocre meditative moments, moments the aesthetic object seems flawed by banal temporality:

It's still, tonight. The peepers, out, self-
 restrain.
Sometimes a welling up: I've lost
 thought in images. Night: a blank.
 The stars just stars.
 The sternies prick like whin.
Kid's bicycle on its rim, under the road lamp chill
 as ice.
A soul could be blank as these bald things.
 Are blank. Or so we thought.

.

New York tonight
 boils in its heat wave. The sidewalks
burn soles. Haze like a coat warms up the ones out. Prague
floods.

 ("Debtor in the Convex Mirror," 74)

Prague floods. The dogs go on with their doggy life. Stuff happens— and the ambitious poet can accommodate it, without surrendering utterly to the immarginate.

Money does not smell, the emperor who levied a fee for the use of the public toilets is said to have said, but we know that there is a sense in which it does. If money is a kind of poetry, it is also an extension of the abject. Or I should say that another reason that money is a kind of poetry is that it represents the abject. The consummate poem is somehow inclusive. It welcomes the quotidian, the frightening, and even the disgusting as well as the rarefied and beautiful. If there is something religious about that proposition, we might think that we could have begun with those "wafers" of gold the moneylender fingers.

Wheeler uses the term twice, and once one has seen that the mullions in the window reflected in the mirror make a cruciform shape, the image is importunate out of all proportion to its size. (She touches on an allusion to a crucifix in the *Arnolfini Wedding* but leaves us to discover it in this painting.) Beyond the window there is the church steeple, and the wife has what Wheeler calls a "prayer book" open to the illumination of the Madonna, who holds her own book (surely a proleptic Bible) and her child, the Savior ("her hands are in God" is the poet's description of the wife, who has her own reflection in Mary). The debtor is "distressed" and has come to the money-lender for relief—as though to confession. "It's as though we were instructed to trust the lender," Wheeler muses, because he seems "more, well, *sequestered*" (ibid., 75). Since Charles, our everyman, and Massys, the debtor, have come to seem as interdependent as the biblical Martha and Mary (this pair is touched on once but dra-matically: we could well have begun with the relationship between contemplation and action rather than with that between lending and borrowing), the suppressed narrative here has to do with salvation. "The mirror" with Massys's image in it "lies between two scales—one banker's, one maker's" (the prayer book), and the one might stand in for the other, rather than represent an antithesis.

The moneylender is not a religious figure, of course, nor are the exchanges he oversees tantamount to transubstantiation, though Wheeler's ruminations encourage us to consider these possibilities. The only term that we have so far that will mediate between the moneylender and the priest is the artist, and the poem's recurrent interest in the "soul" (the word appears at least nine times, and "sole" appears in both of its senses several times) suggests that a more resonant term might be in order. The esoteric clutter on the table and the "disheveled shelves" recall early Renaissance paintings of the alchemist in his workshop, and we will remember that alchemy was as spiritual as it was empirical and that its true aim, for which the con-version of baser metals into gold was a metaphor and propaedeutic, was the conversion of mortal bodies into immortal souls. In the pur-suit of that end the alchemists' various recipes included any and all ingredients, common, rare, and abject: sugar, salt, herbs, peacock feathers, urine, eggs, red wine, red herring, excrement, onions, wafers—they all went into the alembic at one time or another in the search for the immortal soul. It occurs to me that Hölderlin might have had the alchemical model in mind when, on the brink of mad-ness, or revelation, he wrote the late but precocious fragment that begins:

Reif sind, in Feuer getaucht, gekochet
Die Frücht und auf der Erde geprüfet und ein Gesez ist
Dass alles hineingeht, Schlangen gleich,
Prophetisch, träumend auf
Den Hügeln des Himmels.

[Ripe, dipped in fire, cooked,
The fruit are proven on the earth and it's a law
That all goes in, like serpents,
Oracular, dreaming on
The hills of heaven.][13]

I think we have to deduce that as gold is the alchemist's material metaphor for immortality, so our everyman's search for name and fame figures a search for a soul. It doubles Massys's search and Parmigianino's—and no doubt Ashbery's. Of one or more of these— her pronoun is as polyvalent as it often is in Ashbery—Wheeler speculates that "Maybe it was *in* the painter's hand . . . that he sought a soul" ("Debtor in the Convex Mirror," 69). In the action, the work of the painter's hand, she must mean. Elsewhere she thinks "A soul could be as blank as [the] bald things" she has noticed in a bleak cityscape (ibid., 70), or, indeed, as blank as a planchet before the impression turns it into a coin. In what I take to be the poem's fundamental tone she writes, "The soul *negotiates* its right of way . . . but not without a bargain struck with*out*" (ibid., 76).

To negotiate: "to transact business," from *negotium*, "lack of leisure." The diligent moneylender is a negotiator, and in their own ways, quite different from each other's and the moneylender's, Martha and Mary are negotiators too. It might be more succinct to say that Mary and Martha are sides of the artist-alchemist-epistemologist who negotiates her way between matter and spirit and through such experiences as lie behind this poem. The poem is a process, a host of transactions, always in motion, always trading and radiating, so that we can begin to follow it at any juncture.[14] If there is something of his namesake in Hermes Trismegistus, who is so important to the alchemist, it has to do with the original's gift for border crossing and his offices as a messenger. (Seemingly off the cuff Wheeler notes that Massys's imitators—for imitator though he inevitably was, he was also a "master"—substitute a "messenger" for the "debtor" in their own arrangements of figures, even as they "update / the coins" [ibid., 71]). That Hermes, later Mercury, is the patron of merchants and thieves is to the point. All artists borrow, and the most accomplished steal, as Eliot observed—or shoplift. Because Hermes is also the psy-

chopomp, the conductor of souls to the other world, he has a sacred as well as a profane meaning.

Hermes' paradoxical nature relates him to "Saint Eligius, patron saint of goldsmiths" and "converter of Antwerp" (ibid., 71), the subject of a painting (1449) by Petrus Christus that appears in Wheeler's poem for just a moment—a moment as easily overlooked but potentially crucial as the debtor's face in the convex mirror. The reference to that earlier painting is in effect a tiny window onto a world that includes Massys's painting and this poem about it. Indeed, we could begin our discussion of Wheeler's poem—a study of the hermetic artist, committed at once to the corporeal and the spiritual in the course of negotiating the soul's right of way—with St. Eligius.

Whatever begins anyplace can surely end anyplace. As Wheeler's poem must. Alas for the termination. But the way to put it is that the poem keeps ending everyplace. And always with those staples, sugar and salt: important commodities and indispensable symbols. This rich and brilliant poem, perhaps formally indebted to a venerable mystical notion, sometimes attributed to Hermes Trismegistus but usually to Empedocles, strives to have its circumference nowhere and its center everywhere.

NOTES

I wish to thank the UCLA Friends of English for generously assuming permission expenses related to the artwork in this essay.

1. Susan Wheeler, *Ledger* (Iowa City: University of Iowa Press, 2005). Page numbers will be given parenthetically for all quotations from "The Debtor in the Convex Mirror."

2. Douglas Hofstadter, *Gödel, Escher, Bach: An Eternal Golden Braid* (New York: Vintage, 1980), 258.

3. For a summary of some such views and a different interpretation, see Manuel Santos Redondo, "The Moneychanger and His Wife: From Scholastics to Accounting," http://www.ucm.es/BUCM/cee/doc/00–23/0023.htm.

4. Wallace Stevens, *Opus Posthumous,* ed. Milton J. Bates, rev. ed. (New York: Alfred A. Knopf, 1989), 191.

5. Currency is intimately bound up even with our classical ideas of representation and, indeed, knowledge. Michel Foucault, as Ira Livingston reminds us, introduces his concept of classical knowledge with a reference to money: "[A]ll wealth is *coinable;* and it is by this means that it enters into *circulation*—in the same way that any natural being was *characterizable,* and could thereby find its place in a *taxonomy;* that any individual was *nameable* and could find its place in an *articulated language;* that any representation was *signifiable* and could find its place, in order to be known, in a *system of identities and differences.*" So if poetry and money can be converted into one another, so perhaps can money and knowledge. See Ira Livingston, *Between Science and Literature: An Introduction to Autopoetics,* foreword by N. Katherine Hayles (Ur-

bana: University of Illinois Press, 2006), 17. Livingston is quoting Michel Foucault, *The Order of Things* (New York: Vintage, 1973), 175. The emphases are in Foucault.

6. Wheeler's acknowledgments page indicates that she is quoting Max Friedländer, *Early Netherlandish Painting, A History of Private Life: Passions of the Renaissance,* ed. Philippe Ariès and Georges Duby (London: Phaidon Press, 1965).

7. John Ashbery, "Self-Portrait in a Convex Mirror," in *Selected Poems* (New York: Viking Penguin, 1985), 188–204.

8. T. S. Eliot, *The Complete Poems and Plays, 1909–1950* (New York: Harcourt Brace, 1952), 121.

9. John Berryman, *Collected Poems, 1937–1971,* ed. Charles Thornbury (New York: Farrar, Straus & Giroux, 1989), 3.

10. Wallace Stevens, "Anecdote of the Jar," in *The Palm at the End of the Mind: Selected Poems and a Play,* ed. Holly Stevens (New York: Vintage, 1972), 46.

11. James Merrill, *Collected Poems,* ed. J. D. McClatchy and Stephen Yenser (New York: Alfred A. Knopf, 2001), 355–56.

12. See John Keats, "Ode on a Grecian Urn," in *The Poems of John Keats,* ed. Jack Stillinger (Cambridge, MA: Harvard University Press, 1978), 372; and W. B. Yeats, "Sailing to Byzantium," in *The Poems of W. B. Yeats: A New Edition,* ed. Richard J. Finneran (New York: Macmillan, 1983), 193–94.

13. Friedrich Hölderlin, *Hymns and Fragments,* trans. Richard Sieburth (Princeton, NJ: Princeton University Press, 1984), 196. Translation mine.

14. In the process, precisely, of the *vernissage* of this essay, I came across the book by Ira Livingston, *Between Science and Literature,* referred to in note 5, which defines the "autopoetic system" in part as an "event that is really a constellating of events that are themselves complex constellations" (88). I take Wheeler's poem to be such a system.

Contributors

Stephen Burt teaches at Harvard. His critical and scholarly books include *Close Calls with Nonsense* (2008), *The Forms of Youth* (2007), and *Randall Jarrell and His Age* (2002); his books of poems are *Parallel Play* (2006) and *Popular Music* (1999). From 2000 to 2007 he taught at Macalester College in Minnesota.

Mary Ann Caws is Distinguished Professor of English, French, and Comparative Literature at the Graduate School of the City University of New York. Her many contributions to visual culture studies include *The Eye in the Text: Essays on Perception, Mannerist to Modern* (1981), *The Art of Interference: Stressed Readings in Visual and Verbal Texts* (1988), *The Surrealist Look: An Erotics of Encounter* (1997), and *Picasso's Weeping Woman: The Life and Art of Dora Maar* (2000). She has been a Guggenheim Fellow, a Fulbright Fellow, an NEH Senior Fellow, a Getty Scholar, and a Rockefeller Foundation Scholar at Bellagio. Professor Caws contributed an essay entitled "Looking: Literature's Other" to the cluster of essays "Literary Studies and the Visual Arts (The Changing Profession)" in the October 2004 issue of PMLA.

Bonnie Costello is professor of English at Boston University. She has published *Marianne Moore: Imaginary Possessions* (1981), *Elizabeth Bishop: Questions of Mastery* (1991), *Selected Letters of Marianne Moore* (1997), and *Shifting Ground: Reinventing Landscape in Modern American Poetry* (2003). Among her many articles on modern and contemporary poetry are several that deal with literature's relationship to the visual arts. Her essay for this volume is incorporated as a chapter in *Planets on Tables: Poetry, Still Life and the Turning World* (2008).

Joanne Feit Diehl, professor of English at UC Davis, is the author of *Emily Dickinson and the Romantic Imagination* (1981), *Women Poets and the American Sublime* (1990), and *Elizabeth Bishop and Marianne Moore: The Psychodynamics of Creativity* (1993). She edited *Louise Glück: Change What You See,* for Michigan's Under Discussion series (2005).

Barbara Fischer is the author of *Museum Mediations: Reframing Ekphrasis in Contemporary American Poetry* (2006). Her poems and reviews have appeared in *Paris Review, Ekphrasis, Boston Review, Western Humanities Review, Maryland Poetry Review,* and other journals; she is a frequent contributor of review essays to *Boston Review*. She has taught writing and literature at Columbia, NYU, and Marymount College.

Paul H. Fry is William Lampson Professor of English at Yale University. His first book, *The Poet's Calling in the English Ode,* received the Melville Cane Award of the Poetry Society of America. Subsequent publications include *The Reach of Criticism: Method and Perception in Literary Theory* (1984), *William Empson: Prophet Against Sacrifice* (1990), *A Defense of Poetry: Essays on the Occasion of Writing* (1996), and *Wordsworth and the Poetry of What We Are* (2008). Professor Fry is an amateur art historian who publishes frequently in *ArtNews*.

Rachel Hadas is the author of twelve books of poetry, essays, and translations; she is the recipient of a Guggenheim Fellowship in Poetry, an Ingram Merrill Foundation grant in poetry, and an award in literature from the American Academy and Institute of Arts and Letters. Her collections of poetry include *Living in Time* (1990); *Mirrors of Astonishment* (1992); *The Double Legacy* (1995); *The Empty Bed* (1995); *Halfway Down the Hall: New & Selected Poems* (1998), which was a finalist for the 1999 Lenore Marshall Poetry Prize; *Indelible* (2001); *Laws* (2004); and *The River of Forgetfulness* (2006). A collection of her essays entitled *Classics* was published in 2007. She is in the English Department at Rutgers/Newark, and has served on the poetry faculty of the Sewanee Writers' Conference.

Nick Halpern, associate professor of English at North Carolina State University, is the author of *Everyday and Prophetic: The Poetry of Lowell, Ammons, Merrill, and Rich* (2003) and editor, with Stephen Burt, of *Something Understood: Essays and Poems for Helen Vendler* (2009). He is working on a book-length study of the figure of the Embarrassing Father, focusing on Henry James, Sr., Philip Gosse, and John Butler Yeats.

Jane Hedley is K. Laurence Stapleton Professor of English at Bryn Mawr College. She is the author of *Power in Verse: Metaphor and Metonymy in the Renaissance Lyric* (1987) and *"I Made You to Find Me": The Coming of Age of the Woman Poet and the Politics of Poetic Address* (2009). Her essays on modern and contemporary women poets have appeared in *Genre, Hypatia, Narrative,* and *Raritan*.

Karl Kirchwey's first book of poems, *A Wandering Island*, received the Norma Farber First Book Award in 1990. His third volume, *The Engrafted Word* (1998), was a *New York Times* "Notable Book of the Year." Kirchwey's most recent published collection is *The Happiness of This World* (2007); his poems have appeared in *Grand Street*, the *Kenyon Review*, the *Nation*, the *New Criterion*, the *New Republic*, the *New York Review of Books*, the *New Yorker*, *Parnassus*, *Partisan Review*, *Poetry*, the *Southwest Review*, and the *Yale Review*. He has received grants from the Ingram Merrill Foundation, the John Simon Guggenheim Memorial Foundation, and the National Endowment for the Arts, as well as the Rome Prize in Literature in 1994–95. From 1987 to 2000 he was director of the Unterberg Poetry Center at the 92nd Street Y; he currently teaches creative writing and literature at Bryn Mawr College.

Elizabeth Bergmann Loizeaux is professor of English at the University of Maryland, College Park. She is the author of *Yeats and the Visual Arts* (1986; reprinted in 2003) and *Twentieth Century Poetry and the Visual Arts* (2008), and coeditor with Neil Fraistat of *Reimagining Textuality: Textual Studies in the Late Age of Print* (2002). Her essays on poetry and the visual arts have appeared in *Word & Image*, *Twentieth Century Literature*, and *Yeats: An Annual of Critical and Textual Studies*.

Jonathan F. S. Post, professor of English at UCLA, has published extensively on Renaissance and modern lyric poetry. His most recent books are *English Lyric Poetry: The Early Seventeenth Century* (1999), *Green Thoughts, Green Shades: Essays by Contemporary Poets on the Early Modern Lyric* (2002), and a coedited volume, *Forging Connections: Women's Poetry from the Renaissance to Romanticism*. He has held fellowships from the Folger Shakespeare Library, the National Endowment for the Humanities, the Bogliasco Foundation, and the Guggenheim Foundation; current projects include editing the letters of Anthony Hecht.

Willard Spiegelman is the Hughes Professor of English at Southern Methodist University, and editor of the *Southwest Review*. In 2005 he received the Nora Magid Award from PEN/America for outstanding accomplishments in literary editing. His most recent books, *How Poets See the World* and *Love Amy: The Selected Letters of Amy Clampitt*, have just been published in paperback; forthcoming are *Imaginative Transcripts: Selected Literary Essays* and *Pursued by Happiness*. He is the recipient of awards from the NEH, the Guggenheim Foundation, the

Rockefeller Foundation, and the Bogliasco Study Center in Arts and Humanities.

M. Wynn Thomas is professor of English at University of Wales and director of the Centre for Research into the English Literature and Language of Wales; he has held visiting professorships at Harvard and Tübingen, and is a Fellow of the British Academy. Professor Thomas is a scholar of American poetry as well as the two literatures of modern Wales: his books include *The Lunar Light of Whitman's Poetry* (1987), *Internal Difference: Writing in Twentieth Century Wales* (1992), *Corresponding Cultures: The Two Literatures of Modern Wales* (1999), and *Transatlantic Connections: Whitman U.S., Whitman U.K.* (2005).

Terri Witek holds the Art and Melissa Sullivan Chair in Creative Writing at Stetson University, where she is a professor of English. Her publications include *The Shipwreck Dress* (2008), *Carnal World* (2006), *Fools and Crows* (Orchises Press, 2003), *Robert Lowell and Life Studies: Revising the Self* (1993), and *Courting Couples* (winner of the 2000 Center for Book Arts Letterpress Chapbook Contest). Witek's poems have appeared in *Poetry,* the *Antioch Review,* the *Threepenny Review,* the *Southern Review,* and other journals.

Stephen Yenser is Distinguished Professor of English and director of creative writing at UCLA. He has won a Pushcart Prize, an Ingram Merrill Award in Poetry, the B. F. Connors Prize for Poetry from the *Paris Review,* and the 1992 Walt Whitman Award for *The Fire in All Things.* His latest volume of poems is *Blue Guide* (2006). He is the author of three critical books: *Circle to Circle: The Poetry of Robert Lowell* (1975), *The Consuming Myth: The Work of James Merrill* (1987), and *A Boundless Field: American Poetry at Large* (2002). With J. D. McClatchy, he is editing the collected works of James Merrill and Merrill's *Selected Poems.*

Index